Graphic Communications: Design Through Production

Delmar Publishers' Online Services

To access Delmar on the World Wide Web, point your browser to:

http://www.delmar.com/delmar.html

To access through Gopher:

gopher:// gopher.delmar.com

(Delmar online is part of "thomson.com," an Internet site with information on more than 30 publishers of the International Publishing organization.) For more information on our products and services:

email: info@delmar.com

Or call 800-347-7707

Visit the Delmar Desktop Café ™

for an online resource center devoted to graphic communications. Point your browser to:

http://www.thomson.com/desktopcafe.html

Graphic Communications: Design Through Production

Martin L. Greenwald, Ed.D.
Professor, Department of Fine Arts
School of the Arts
Montclair State University
Upper Montclair, New Jersey

and

John C. Luttropp, M.F.A.
Associate Professor & Chair, Department of Fine Arts
School of the Arts
Montclair State University
Upper Montclair, New Jersey

Delmar Publishers

I(T)P® International Thomson Publishing

Albany • Bonn • Boston • Cincinnati • Detroit • London • Madrid
Melbourne • Mexico City • New York • Pacific Grove • Paris • San Francisco
Singapore • Tokyo • Toronto • Washington

NOTICE TO THE READER

Delmar Staff

Publisher: Robert D. Lynch
Senior Administrative Editor: John Anderson
Production Manager: Larry Main
Developmental Editor: Barbara A. Riedell
Art & Design/Production Coordinator: Nicole Reamer

COPYRIGHT © 1997
By Delmar Publishers Inc.
an International Thomson Publishing Company

I(T)P® The ITP logo is a trademark under license

Printed in the United States of America

For more information, contact:

Delmar Publishers Inc.
3 Columbia Circle , Box 15015
Albany, New York 12212-5015

International Thomson Publishing
Berkshire House
168-173 High Holborn
London, WC1V7AA
England

Thomas Nelson Australia
102 Dodds Street
South Melbourne 3205
Victoria, Australia

Nelson Canada
1120 Birchmont Road
Scarborough, Ontario

International Thomson Publishing GmbH
Konigswinterer Str. 418
53227 Bonn
Germany

International Thomson Publishing Asia
221 Henderson Bldg. #05-10
Singapore 0315

International Thomson Publishing Japan
Kyowa Building, 3F
2-2-1 Hirakawa-cho
Chiyoda-ku, Tokyo 102
Japan

2 3 4 5 6 7 8 9 10 XXX 03 02 01 00 99 98

Library of Congress Cataloging-in-Publication Data

Greenwald, Martin L., 1943-
 Graphic communications : design through production / Martin L. Greenwald and John C. Luttrop.
 p. cm.
 Includes bibliographical references.
 ISBN 0-8273-6459-8
 1. Printing. 2. Graphic Arts. I. Luttropp, John C. II. Title.
 Z244.G843 1996 96-2874
 686.2--dc20 CIP

Dedication

To Reesa—This one's for you!

-Martin L. Greenwald

To my parents, Renae and Evelyn Luttropp, who always gave me the freedom and support to pursue my dreams, no matter how crazy they seemed at the time.

John Luttropp

Contents

SECTION 1: DESIGN PROCESSES

3. Basic Typography

6. *Fundamentals of Computer Graphics and Electronic Page Composition*

7. *Digitizing Data*

SECTION 2: PRODUCTION PROCESSES

8. *Line and Halftone Illustrations*

10. Offset Printing and Postpress Fundamentals

Preface

The use of computers has revolutionized not only the graphic arts industry but the educational institutions that offer programs within the graphic technologies as well. Until a few short years ago, company newsletters were routinely sourced out to specialty businesses, called service bureaus, that handled all of the design, typesetting, and printing functions. Today, much of this work, including the printing, can easily be handled in house.

For example, until recently, expensive color scanners were required to separate an original color slide or color print into the four color separation negatives needed for printing. However, using current technology, a color slide from the family vacation can be inexpensively placed onto a compact disc. From the disc, the photograph can be imported into a photo manipulation program on a personal computer. From the computer, the image can either be printed on a color printer, shown on the family television set, or output to a digital typesetter to obtain the color separation negatives required for printing. We can even forget the conventional camera. We can bring along a digital camera with us and take a picture in the regular way. The images in the digital camera can then be downloaded directly to a computer.

To keep up with the almost unbelievable pace of technological innovation, which affects both graphic designers and print technicians, curricula and equipment for courses within the graphic arts must continually be updated. Computers that were purchased only two years ago are stretched to the limits of their memory and processing capabilities when running current software packages; second- and third-generation software-driven typesetters designed and manufactured in the mid-1980s are found to be obsolete only a few years later with the advent of PostScript-driven laser printers. This early obsolescence was hastened by advances in computer operating systems, the continuing evolution of chip technology, and a 500-fold increase in disk drive capacities. Sophisticated software application programs currently have memory requirements that were thought to be impossible only a few short years ago.

Many of the courses taught in the graphic arts area, in both the vocational setting and liberal arts colleges, have evolved into two distinct categories: those that focus on creative, graphic-design-oriented activities, and those that focus on production-oriented activities. The shortcomings of this course strategy are obvious. Students graduating with a strong background in the creative arts know little of what happens to a design when it leaves the drawing board or computer screen; students with strong technical backgrounds in production-oriented programs are weak in many of the creative aspects of design and layout.

Within the business and industrial settings, these background weaknesses are often manifested in a lack of efficient communication between different levels in the production process. For example, when engineers design a product that encounters difficulty in some stage of manufacturing or production, the design engineer needs to talk to the production technologist to solve the problem. If the technologist and the engineer are familiar with each other's tasks, communication between them is easy and the problem-solving process can proceed. Similarly, when graphic artists, graphic designers, and printing technicians have a working knowledge of both design and production technologies, the entire production process is streamlined. In this environment, the graphic designer or production technologist is, by virtue of his or her comprehensive knowledge base, a more valuable employee. Also, due to the influence of the computer and associated software programs in virtually every aspect of business, a measure of graphic arts training is increasingly required for all employees, regardless of their specific job titles. People in personnel relations and training, management and control technologists, and quality controllers all need to know how to get the printed message across in an effective, efficient manner.

Given this dichotomy of traditional education in the graphic arts, the purpose of this text is to bring together the areas of creative graphic design and production technologies under a single instructional umbrella. Within the text, ideas are presented and followed from the initial inception of a job through the printed and finished product.

Graphic Communications: Design Through Production is tailored to the needs of students in the visual arts and/or industrial technology disciplines. For the graphic designer, familiarity with the options available to bring a design to completion is invaluable. For the technologist, first-hand knowledge of the design process allows for more sensitivity to the creative aspects of the printed page. The development of a mutual understanding and respect on the part of each enhances the performance and accomplishments of both. Within this framework, the authors have carefully avoided what they consider to be in-depth coverage of areas and skills that would ordinarily fall under the auspices of more traditional texts directed to the training of printing production personnel.

The text begins with an introduction to graphic communication design and production technologies, highlighting a description of the creative input and production technologies that form the graphic communication process.

It has been said that the second part of the history of the world and the arts began with the invention of printing. An historical perspective of the graphic communication process is examined, from early communication techniques and the development of moveable type to the sophisticated computer technology and satellite communications that make possible simultaneous publication of the printed page throughout the world.

Section one begins with an investigation of the principles of basic typography in chapter 3, covering type families through a variety of typesetting systems. The creative design process is covered in chapters 4 and 5. Chapter 4 highlights the steps in designing a job and focuses on the design process from a problem-solving point of view. From definition of the problem, through the development of budget and scheduling techniques, to critique, redesign, and final project review, the graphic design process is separated into distinct, manageable components. Chapter 5 looks at the creative elements involved in graphic design. From the selection of proper column formats to the use of presentation graphics, design elements that are responsible for successful visuals are presented, with many examples of what to do and what not to do.

Chapter 6 highlights the fundamentals of computer graphics. The types of graphic design programs available, along with the basic skills that are needed to get the most out of these programs, are investigated. After data has been digitized, what then? Chapter 6 examines the basics of electronic page composition and layout. The digital revolution holds the promise of a future without film. To the graphic designer and printing technician, the process of turning digital information into a finished page takes place primarily through the use of electronic page composition or layout programs. You will see how text, graphics, and design from a variety of sources come together on the computer screen through the use of programs that put all of this information together in a format that is essentially ready for the printing press. This material is covered in a generic manner, enabling the transfer of concepts from one computer program to another.

What is digital data? What makes digital data different from other types of information? These questions and others are answered in Chapter 7, which focuses on how original copy is digitized (through the process of scanning), manipulated and edited, and then output. The technology of scanning line, halftone, and color copy is examined in relation to the scanning process. Also, because compact discs are assuming an increasingly important role in graphic reproduction processes, this technology is examined in detail.

Chapter 8 examines photographic imaging, focusing on large-format graphic arts process cameras used in the production of line and halftone photography, as well as whole-page camera work. Procedures covered include camera calibration and shooting line and half tone negatives.

Chapter 9 details paste-up and plate-making procedures. Starting with rough and finished sketches, our discussion moves through the assembly and combination of the basic elements of a mechanical layout to the procedures used to make presensitized photo-offset plates.

Chapter 10 begins with an introduction to offset printing, examining the oil- and water-principle as the concept foundation for understanding the offset printing process. Our examination continues with prepress adjustments as well as important hints for successfully completing any printing job. A variety of postpress finishing and binding techniques are shown.

Chapter 11 presents three culminating experiences for students: the production of newsletters, display advertising, and catalogues and brochures. Common elements in the design and production process that link these experiences are highlighted, along with a series of alternative schemes that emphasize the wide variety of options available in both design and production techniques.

Finally, we wish to emphasize that we did not design this text as a comprehensive graphic arts textbook. The material in this book focuses first on the basic processes of creating a design and then on what is involved in reproducing it. Thus, this text should be viewed as an introduction to a complex and constantly changing field.

Acknowledgements

Delmar Publishers wishes to thank the following for their contributions to this work: Mary Dickson, Larry Lauffer, John Craft, Lynda Hang, Roll Systems, Inc., SIRS Inc., Disc Manufacturing Inc., Nuarc Corporation, Caprock Developments Inc., Lasermaster Turbores, Screen USA, Olympus Image Sytems Inc., Heidelberg USA, Microtek, Rollem Corp of America, Martin Yale Inc., Townsend Industries, Ulano Corp., General Binding Corp., Sunraise Inc., Data Disc, Kollmorgen Instruments Corp., American Museum of Natural History Library, RISO Inc., AM Multigraphics, Rosback Co., A.B. Dick, Stouffer Graphic Arts, and Printware.

The authors would like to thank Suzanne Thomas of Voltex Corporation for her excellent production work and Nicole Reamer and Barbara Riedell at Delmar for making this book a reality.

Chapter

Introduction

INTRODUCTION

Graphic communication design and production technology constitute a dynamic, continually evolving discipline, constantly adapting to technological change and innovation. To help explain these technologies and innovations in a meaningful and relevant way, this book focuses on the evolution of the graphic design process. This process begins with the initial idea and the formulation of a graphic design. From there it moves to the production of a master image and then to the reproduction of printed copies, all of which are identical to the original.

This chapter serves as an introduction to and foundation for concepts, processes, and terminologies that are examined in greater detail throughout the remainder of the text. We begin with an introduction to the major processes of printing. The ways in which things are printed have historically been classified into distinct categories. These categories depend upon the physical relationship of the printing to the nonprinting areas of the master substrate, as well as how the image is transferred from the master to the copy (see chapter 2 for an analysis of the historical development of graphic communications). Our investigation begins with a look at traditional printing processes and then newer computerized nonimpact laser and electron beam technologies. Next, an examination of the fundamentals of the printed page focuses on the design aspects of graphic arts technologies. From basic typography and typographic design to traditional and computerized page composition techniques, the reader gains an insight into state-of-the-art design and composition procedures used by all graphic arts professionals.

This introduction is not meant to be all-inclusive. Rather, it serves as a basis for examining the graphic design and print technologies that make up the fascinating world of the graphic arts.

THE MAJOR PROCESSES OF PRINTING

The basic categories of printing are: relief printing, gravure printing, planographic (wet and dry) lithographic processes, screen printing, electrostatic, and other nonimpact imaging technologies (although screen process is a major printing technology, it is beyond the scope of this book). Each of these major processes is described in more detail in this chapter and will be highlighted throughout the rest of the text.

RELIEF PRINTING

Relief printing is the oldest of the printing processes and can be dated from about the eighth century A.D. The Chinese pioneered printing from relief (raised) images cut into wooden blocks. In the relief printing process, the image area is raised above, or in relief from, the nonimage, nonprinting areas. This process is shown in Figure 1.1.

Figure 1.1. The relief printing process. Images are transferred from an image which is raised, or in relief, from the nonimage area.

Although the basic process has remained fundamentally unchanged, relief printing has gone through many technological enhancements over the centuries. From the use of wooden blocks to moveable type, whether the type was set by hand or by machine, relief printing continued to be the dominant printing production process up to the middle of the twentieth century. The traditional process of relief printing uses individual letters of type placed next to one another in a composing stick, upside down and backwards, to make up individual text lines. These

Figure 1.2. Hand-set type. Setting type by hand was the major method by which pages of text were composed dating from the invention of moveable type by Gutenberg around 1455, until the invention of the Linotype type-casting machine in 1887.

lines are then assembled to make up a complete page (Figure 1.2).

With the invention of the Linotype machine in 1887, it became possible to assemble text automatically rather than by hand. Using a Linotype machine, complete lines of text are cast onto a single lead slab called a *slug* (see chapter 2 for more information and illustrations of early Linotype machines). Individual slugs from the Linotype machine are assembled to form complete pages of text. Illustrations are incorporated onto the page by using zinc line cuts and/or halftone photoengravings. In a line cut or photoengraving, the nonimage areas are etched below the image area in an acid bath. Figure 1.3 shows a zinc line cut used for printing illustrations in the relief process.

One adaptation of the relief printing process is known as *flexography*. The flexographic process uses rubber plates to transfer the image from the plate to the object to be printed. The image areas on the rubber plate are raised in relief from the nonimage areas.

Flexographic printing is commercially well established and widely used for printing items as diverse as paperback books, labels, and packaging materials. Flexography is also increasingly being used to print newspapers.

Newly developed water-based flexographic inks dry on the surface of porous newsprint, avoiding the fuzzy edges and graying of the sheet that sometimes occur when using the traditional offset printing process. The overall quality range of flexographic printing is somewhat lower than that of high-quality offset printing. Rubber-based flexographic mats used to make flexographic printing plates are illustrated in Figure 1.4.

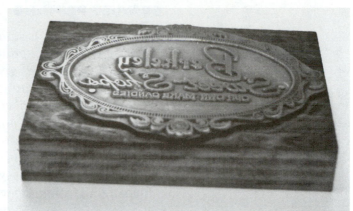

Figure 1.3. A zinc line cut used for printing relief images. Zinc line cuts were able to reproduce both line drawings and halftone illustrations. The line cut and photoengraving were replaced by photography for all but specialized printing applications.

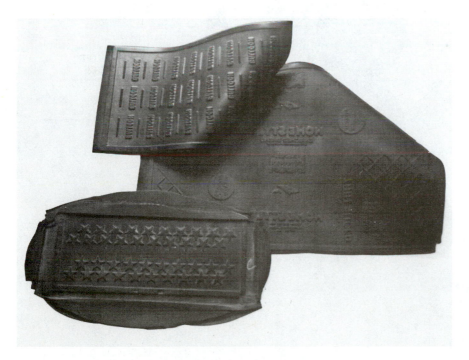

Figure 1.4. Rubber plate mat used for making flexographic printing plates.

GRAVURE PRINTING

The gravure process is sometimes referred to as *engraving, intaglio* or *etched printing*. An image plate is prepared in which the design to be printed is cut into, or engraved below, the surface of the printing plate. The entire plate is then inked. Ink is initially deposited both within the image area grooves, or cells, cut into the plate and on the nonimage surfaces of the plate. After inking, the plate is scraped clean with a doctor blade that acts as a squeegee to remove all ink on the surface of the plate, leaving only the ink that was deposited in the etched depressions. When the printing plate comes in contact with paper, ink from the image areas is lifted from the etched grooves onto the paper. Different line shades can be achieved by varying the depth and width of the engraved lines. The gravure process is shown in Figure 1.5.

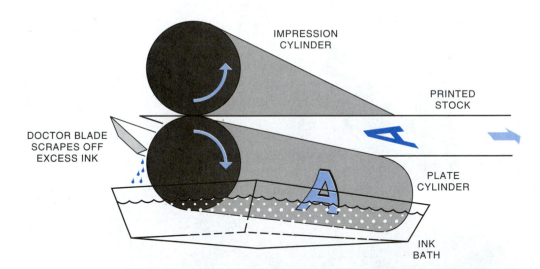

Figure 1.5. The gravure printing process. Gravure is the opposite of the relief printing process. In gravure, images are transferred from a recessed, rather than a raised, image area.

Perhaps the best-known use of gravure is in the printing of the Sunday newspaper supplements that carry the majority of the advertising and comics. This section is sometimes referred to as the rotogravure section, named after both the process and the high-speed printing presses used in this kind of printing. Gravure finds many special applications within the graphic communications and art reproduction industries, because of its clear line-transfer capabilities. The familiar wedding invitation with its raised print is one example of this process. A raised printing effect can also be achieved in the relief printing process by using special powders that adhere and fuse to printing ink to form a raised image (see chapter 10 for more information on raised printing technology). However, engraved printing is used to produce specialty items that require fine line details; the printing of money and stamps are typical examples.

Commercial gravure presses can print up to 200,000 impressions of a multipage signature per hour. This results in equivalent press runs of several millions of copies in a standard eight-hour work shift.

LITHOGRAPHY (PLANOGRAPHIC PRINTING)

Traditional lithography is a chemical printing process in which both the image and nonimage areas are located on the same plane, or height, on the printing plate. Lithographic printing is thus sometimes referred to as planography. This factor distinguishes lithography from the relief and gravure processes, which use physical separation of the image and nonimage areas.

Lithography is based on the chemical principle that oil and water do not readily mix. Developed in 1796 by Alois Senefelder, a German playwright, lithographic reproduction enabled the printer artist, working on a hand-drawn stone, to reproduce all drawn lines with a high degree of accuracy and expression. The lithographic stone was prepared in reverse, or in

the mirror image of the finished print. This was necessary because during the printing process, the stone printed directly onto a sheet of paper. A stone with an image drawn in reverse would therefore yield a right-reading picture. The artist drew on the stone with special grease-based inks and liquid media. Note the preparation of the lithographic stone in Figure 1.6.

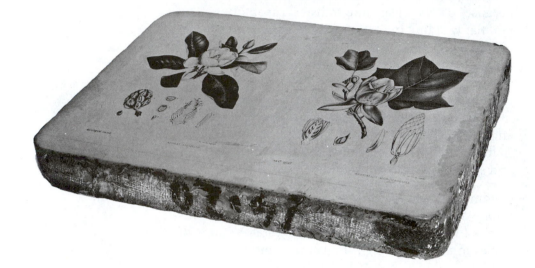

Figure 1.6. A lithographic stone. Stone lithography still finds application as an artistic medium. Images are drawn on the stone in reverse, using grease-based imaging materials. Stone lithographs are manually transferred and are usually limited as to the number of reproductions taken from the stone.

To make a print, the stone is first wet down with water. The grease-based drawn image repels the water. However, the water, in addition to being repelled by the grease-based image, is also absorbed by the stone. When ink is applied to the surface of the stone with a roller, the ink adheres only to the drawn image areas and is repelled by the still-wet stone.

Paper is then placed on the inked stone and pressure applied by a platen on the printing press. Under this pressure, the image is transferred from the inked stone to the paper.

The process of offset printing was first developed by placing a rubber blanket on the platen. The image can then be transferred from the inked stone onto the rubber blanket on the platen. The image that was transferred to the rubber platen is then printed onto a sheet of paper.

Offsetting the image from the printing plate to the rubber blanket and then onto the paper results in prints with a softer tone than those achievable with direct lithography. Offsetting also enables the litho stones to be prepared using positive rather than negative images. The present-day process of offset printing is highlighted in Figure 1.7.

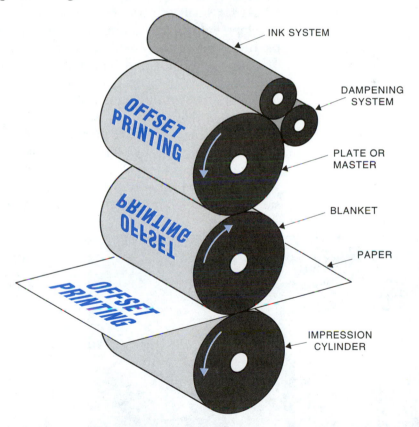

Figure 1.7. Offset lithography is a chemical transfer printing process. The image from the printing plate is transferred to a rubber blanket, which prints in reverse from the plate. When the image is transferred from the rubber blanket to a sheet of paper, it prints as a positive. Offset lithography is the dominant commercial printing process in the world.

Lithographic printing has historically had wide application as both an artistic and a commercial medium throughout Western Europe and the United States. The nineteenth century Americana lithographs of Currier and Ives, along with the well-known posters of the French artists Henri de Toulouse-Lautrec, Edgar Degas, and Edouard Manet are perhaps the finest expressions of the lithographic art form.

In the 1950s, offset lithography gained wide acceptance throughout the commercial graphic arts industry and became the dominant commercial printing process. Small offset duplicators became the workhorses for small printing companies, along with the development of large commercial offset presses capable of delivering fast, high-quality multicolor images. The offset press shown in Figure 1.8A can print 40,000 impressions per hour on both sides of the paper. The offset press shown in Figure 1.8B is fed from a roll of paper rather than individual sheets and is known as a *web-fed press*. A press that can print on both sides of the sheet simultaneously is referred to as a *perfecting press*. Note the paper travel in Figures 1.8B, 1.8C, and 1.8D, which turns the paper web as it travels, enabling both sides to be printed in a single pass through the press.

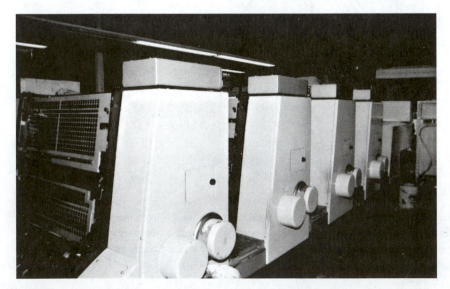

Figure 1.8A. A four color sheet-fed offset printing press. (Courtesy SIRS Inc.)

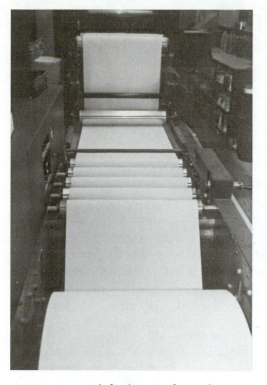

Figure 1.8B. Web feeder on a four color web-fed offset press. (Courtesy SIRS Inc.)

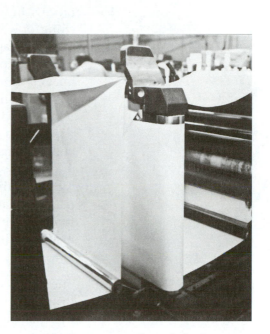

Figure 1.8C. Laying out the web feeding pattern on a web-fed press. (Courtesy SIRS Inc.)

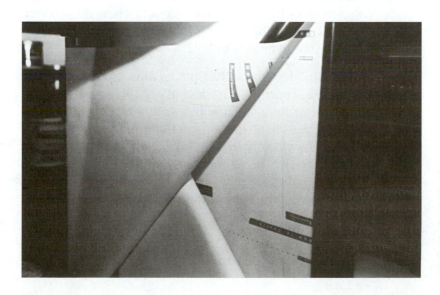

Figure 1.8D. Turning the web on a perfecting press. The paper turn on the feeding pattern enables the press to print on both sides of the sheet. (Courtesy SIRS Inc.)

DRY OFFSET (WATERLESS) PRINTING

The majority of offset lithography is carried out as a wet process, in which a fountain solution acts as the dampening, or wetting, agent to differentiate the image from the nonimage areas on the printing plate. This traditional wet process depends upon a careful balance of ink and water delivered to the printing plate (see chapter 10 for an in-depth discussion of the offset process). A modification of the offset process that works without the use of a dampening solution to separate the image and nonimage areas is known as *dry offset,* or *waterless,* printing (sometimes also referred to as *dry-ography*). Although the waterless process is presently used primarily in large format presses, several press manufacturers have begun to offer modified small-format machines that can take advantage of waterless technology in both large and small paper sizes.

The dry offset process uses a conventional offset press in which the ink delivery system has been modified by replacing the standard ink rollers with special hollow-core rollers. This allows installation of a temperature control system that precisely monitors and controls the surface temperature of the rollers to maintain temperatures of between 80°F to 86°F. Dry offset inks have a higher viscosity than do conventional offset inks, but ink viscosity begins to drop below temperatures of 86°F.

Specially designed offset plates must also used in the waterless process. Waterless plates incorporate a layer of ink-repellent silicone that is sensitive to ink viscosity and resists ink deposits in the nonimage area, based upon the viscosity of the ink. The viscosity is in turn controlled by the temperature control unit. Multicolor waterless presses incorporate a temperature-controlled roller system in each of the color printing heads.

In the waterless process, temperature regulation replaces the use of a dampening solution to control adhesion of the ink to the image areas on the printing

plate. The rollers and associated temperature control unit set-up for the dry offset process are shown in Figure 1.9A. Figure 1.9B illustrates the cross-section of a waterless offset plate.

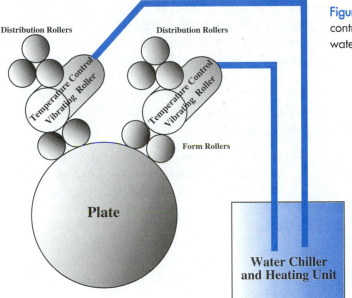

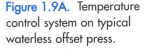

Figure 1.9A. Temperature control system on typical waterless offset press.

**Waterless Offset
Temperature Control Systems**

Silicone swells are removed during plate development over the image areas of the plate

← Positive Film

← Clear Plastic Sheet

← Silicone Layer

Photopolymer

← Aluminum Base

Silicone remains in non-image areas

Figure 1.9B.
Cross-section of waterless offset plate.

Waterless Plate Development: During exposure the photopolymer bonds to the silicone layer in response to light passing through the negative. In the development process, the clear plastic sheet is removed and the developer causes the silicone layer to swell up over the image areas of the plate. These swelled areas of silicone are removed by brushes except in the nonimage areas of the plate (see above). The silicone replaces the dampening solution in waterless offset.

Cross Section of Waterless Offset Plate

13

Other than temperature control of the ink rollers, the remainder of the dry offset process is identical to conventional offset printing. Ink is offset from the plate cylinder onto a blanket cylinder and from the blanket cylinder is printed onto either a sheet or paper web. The elimination of water from the printing process results in less press preparation time (called makeready) as well as more usable final printed copies, because there is no dampening solution and ink balance to adjust when first setting up the press (in effect, the silicone coating on the waterless plate replaces the dampening solution to repel ink in the nonimage areas).

There are several advantages to waterless printing over its conventionally dampened counterpart. Interviews with plant managers running dry process offset highlight some of these:

• Faster makeready times on the press
• Greater color consistency and higher quality than conventional offset, due primarily to dot control
• No fountain solution to dilute and otherwise cause the typical halftone dot to spread
• Less paper waste due to faster makeready times
• Continuing improvement in plate quality and long run capabilities
• Less environmental impact in the plant due to the elimination of plate-processing chemicals and alcohol-based dampening solutions

Some disadvantages of the waterless process include:

• The cost of conversion
• The higher cost of waterless versus conventional offset plates inks
• The current limitation of long run capabilities of the plates used on web offset presses

Regardless of the pros and cons, the use of waterless technology within the printing industry will continue to increase because of the numerous advantages and quality benchmarks of the waterless process.

NONIMPACT ELECTRONIC IMAGING

The decade of the 1980s gave rise to almost daily improvements in computer processing power and associated end-user technologies. Nonimpact printing began with the invention of the xerographic process in 1938 and has spread to many different technologies that focus on printing the page electronically rather than mechanically. The nonimpact segment of the graphic communication industry accounts for increasingly larger shares of the market as processing power and output capability grow.

PHOTOCOPY PROCESSING

No process exemplifies nonimpact printing better than the traditional photocopy machine. The operation of the plain-paper copier is outwardly familiar to almost everyone. At present, high-speed photocopy machines, using variations on the original photocopy process, can print more than 6,000 copies per hour, on both sides of the sheet, in either black-and-white or color, collate and then bind the job according to the operators' instructions. Figure 1.10 illustrates an attachment to a high-speed copier that enables the

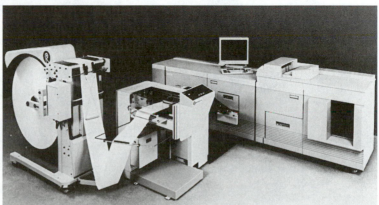

Figure 1.10. Web-feed attachment on a high-speed Xerox® copier. Using a web feed on this high-speed copier gives the copier some of the flexibility and speed characteristics of web-fed offset printing presses. (Courtesy Roll Systems, Inc.).

copier to print from an endless paper web. This attachment enables the copier to operate in a manner similar to that of web-fed offset printing presses.

The photocopy process appears on the surface to be deceptively simple. An original document is placed on a glass surface. When the copy button is pressed, the glass table moves back and forth, scanning the original document with a high-intensity light source. At the same time, a sheet of paper is fed from the paper tray, goes through the machine, and comes out the opposite end with the copied image.

When a photocopy machine operates, there are actually eight separate processes that occur in rapid succession. Figure 1.11 highlights the various machine components involved in the photocopy process.

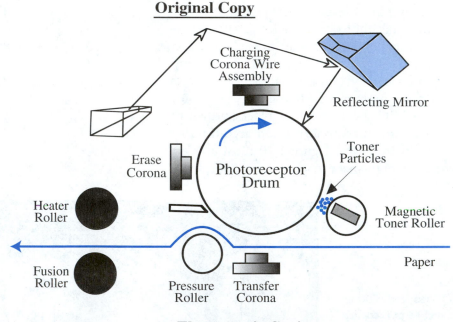

Original Copy

Charging
Corona Wire
Assembly

Reflecting Mirror

Erase
Corona

Photoreceptor
Drum

Toner
Particles

Heater
Roller

Magnetic
Toner Roller

Fusion
Roller

Pressure
Roller

Transfer
Corona

Paper

Electrostatic Copier

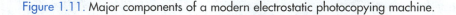

Figure 1.11. Major components of a modern electrostatic photocopying machine.

1. Main Charging Process: During main charging, the surface of the photoreceptor drum is exposed to a high positive electrostatic charge from a corona wire. The corona wire emits an electrostatic field along its entire length. As the charging drum passes in front of the wire, the drum surface retains this electrical charge.

2. Image Exposure Sequence: During the exposure sequence, light is reflected from the original document, off a mirror, and onto the surface of the photoreceptor drum. The surface of the drum is made of a photoresistive material (selenium, for example). This material loses electrical resistance when exposed to high-intensity light and retains its electrical resistance at lower light intensities. The rotation of the drum matches the movement of the glass exposure table. The white areas of the original (the nonimage areas) reflect more light than the darker image areas. The surface areas of the drum that are exposed to high-intensity light (nonimage areas of the original) lose their electrical charge. Conversely, areas of the photoreceptor drum where the reflected light intensity is low (from the darker image areas of the original) retain a static charge. After being exposed to reflected light from the entire original, the drum retains what is known as an *electrostatic latent image*. This image is an exact duplicate of the original copy, but in an electrostatically charged form which is invisible to the eye at this point in the process.

3. Visible Image Development: As the drum continues to rotate, it pulls toner particles from a toner roller assembly. The toner, which is available in either dry powder or liquid form, is made up of carbon and resin particles that are carried on the toner roller assembly by small iron particles within a magnetic field. Only the toner particles in this mixture are transferred from the toner roller assembly to the image drum. The toner adheres only to the electrostatically charged image areas on the drum.

4. & 5. Transfer and Separation: Transfer of the image from the drum to a sheet of paper is done by first passing a sheet of paper through an electrostatic charge given off by a transfer corona wire. The paper retains this charge and attracts the toner image off of the receptor drum surface and onto the paper. The paper is next separated from the drum by a mechanical guide that prevents the paper from adhering to the drum. From here the paper enters the fixing section of the copier.

6. Image Fixation: In the fixing section, a band of heat and pressure is applied to the paper. Heat applied to the toner particle softens the resin around the carbon particle. Pressure between an upper and lower roller forces the toner particle into the paper, resulting in a permanent, undistorted copy of the original image.

7. Charge Erasure: The drum is next exposed to light and an electrical charge to lower its resistance. Although a few toner particles still adhere to the drum at this point, the electrostatic latent image is very weak.

8. Cleaning: Toner is deposited on the developer roller, because the electrostatic attraction of the developer roller is greater than the charge left on the image roller after the image roller has been erased. The drum is now clean and ready to process a new image.

Modern photocopy machines are able to print in either black-and-white or color. The steps involved in traditional photocopy processing define the basic operating sequences of most modern electrostatic and laser-driven typeset-quality devices.

LASER PRINTER TECHNOLOGY

The quality of output from high-resolution laser printers virtually matches the quality of traditional photo and digital typesetting devices. Laser printer development is in part based on the original photocopy

process. Unlike a simple photocopy machine, however, the laser printer must also be capable of interpreting instructions from a computer. These instructions are then translated into the movement of a laser beam exposure unit, which precisely moves paper through the machine to achieve high-quality output. Figure 1.12 shows the major components of a typeset-quality laser printer. Note the similarities in the processing technology of laser printers and photocopiers.

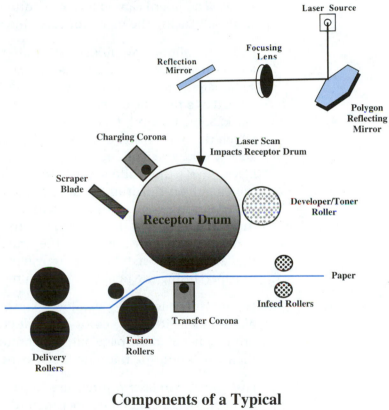

**Components of a Typical
LaserWriter**

Figure 1.12. Major components of a typical laser printer.

The laser printer utilizes a device called a *printing engine* that is similar in operating concept to a photocopy developing unit. The heart of the printer engine is the photoconducting, light-sensitive cylinder, usually referred to as the *drum.*

Exposure of the image from the computer onto the drum is accomplished by a narrow laser beam. The laser beam reflects off a mirror in a line across the drum. The laser flashes on and off to create a series of charged dots that eventually make up the printed image. The laser beam exposes the drum line-by-line while advancing the paper for each line.

As in the photocopy process, the pattern of charges left on the drum by the laser beam leaves an electrostatic latent image on the drum. Toner particles are attracted to the image areas of the drum that will print black. Some laser printers use a write-black system, in which the dots on the drum that represent the image areas in the original copy are sensitized and appear black. In a write-white system, the laser beam alters the charge on the drum in the nonimage areas only. Laser printing consists of six distinct steps: charging the drum, removing the charge from the nonprinting (white, or nonimage, areas) of the drum, developing the latent electrostatic image, transferring the image to paper, fusing the image, and cleaning the drum.

Laser printer technology allows for printing both black-and-white and color reproductions. When printing in color, the page output per minute is slower than when printing traditional black-and-white copy.

First-generation laser printers used a paper advance of $\frac{1}{300}$ inch, yielding a 300 dot per inch (dpi) resolution. Three hundred dpi laser printers are not considered to be typeset-quality printing devices, however, because their output, upon close examination, shows ragged edges on letters and illustrations.

Second-generation laser printers uniformly deliver 600 dpi output on the low end of the market. High-resolution typeset-quality laser printers can deliver image resolutions of approximately 2,000 dpi that rival digital typesetting equipment.

Figures 1.13, 1.14, and 1.15 compare the output of a variety of common laser printers. The type in each of these illustrations has been enlarged 300 percent to better show the output quality of the images.

Figure 1.13. 300 (dpi) laser-writer output magnified at 300 percent. Note the edges of the letters. Although the uneven edges of the letters are not easily noticeable when viewing the copy at same-size reproduction, this resolution is unacceptable for quality printing applications.

Figure 1.14. 1200 dot per inch laser printer output magnified at 300 percent. Note the even edges of the letters, which make output at this resolution acceptable for many commercial printing applications.

Figure 1.15. 1800 dot per inch laser printer output. Although not readily distinguishable from its 1200 dot per inch counterpart at 300 percent magnification, high-quality printing applications require 1800 dot per inch resolution as a minimum.

Note the edges of the letters in Figure 1.13. Even though the ragged edges of these letters are not readily apparent when reading standard text copy set in 10-or 12-point sizes, this quality is unacceptable as camera-ready copy for most typesetting and graphic design work. Contrast the edges of the copy in Figure 1.13 with those produced by a 1200 dpi laser printer in Figure 1.14.

The quality of copy produced in Figure 1.15 using a 1200 dpi laser printer, shows, upon close examination, few irregularities in the edges of the type. This 1200 dpi laser printer or imagesetter output is acceptable as camera ready copy for many graphic arts and design applications. Note that it is hard to distinguish any difference in a 300 percent enlargement between the 1200 dpi output in Figure 1.14 and that of a laser printer whose output is 1800 dpi, shown in Figure 1.15.

As the output quality of laser printers continues to improve and resolutions increase, the designer should keep in mind that the output resolutions of between 2500 and 4000 dpi, delivered by high-quality imagesetters, are a prerequisite for high-quality graphic design work.

ELECTRON BEAM (ION-DEPOSITION) IMAGING

Electron beam printing, also referred to as *ion-deposition imaging*, is a technology used primarily in high-performance, high speed printing applications. Electron beam printing is a simpler process than that used in laser printers, because fewer steps are used in exposing and developing an image. Instead of the six printing steps outlined previously and used in conventional laser technology, electron beam ion-deposition printers require only four steps: generating the image on the drum with electron beams, developing the image, transferring and fusing the image, and cleaning the drum. The components of a typical electron beam printer are illustrated in Figure 1.16.

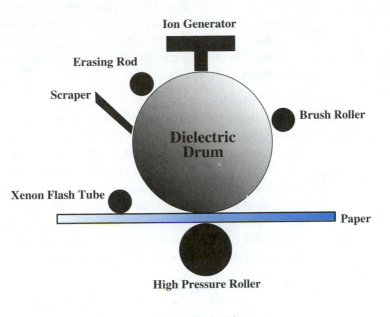

Ion Printing

Figure 1.16. Electron beam ion-deposition printer.

The heart of the printer is an electron beam cartridge that uses high-voltage and frequency that fires a stream of electrons at a rotating dielectric drum. The control grid of the printer determines when the electron beam is turned on. In this way, a puddle of electrons on the drum forms a latent image that attracts toner away from the toner assembly and onto the drum.

Electron beam printers use a cold fusion process in which a static electric charge draws toner particles onto the paper. High pressure then fuses the toner to the paper. This transfer and fusing process is much more efficient than the conventional heat fusion process used in ordinary laser printers. Because of this high efficiency, an ordinary scraper can be used to remove excess toner from the drum. Following the fusion process, an erasing rod removes the remainder of any latent image left on the drum, preparing the

printer for the next copy. Cold fusion does not produce as strong a bond between the toner and paper as is produced with the hot fusion process. Because of this, cold fusion images do not hold up well to excessive abuse or handling.

INK JET PRINTING

Ink jet printing technology continues to grow in popularity for use in output devices for a variety of software application programs, as well as for color proofing. Coupled with high-resolution color computer monitors, the use of ink jet printers for both black-and-white and color output will continue its fast growth rate, as it is a low-cost and proven technology. Several different types of color ink jet printers are available, with various prices and applications.

CONTINUOUS INK JET PRINTERS

Continuous ink jet printers are high-end devices capable of producing near-photographic quality at a relatively low cost per page. In continuous print technology, a pump forces a continuous stream of ink through a nozzle under constant pressure, producing very fine ink droplets at a rate of more than one million droplets per second. When used for color printing and proofing, four separate inks—cyan, magenta, yellow and black—are supplied in continuous streams through the print nozzles. This continuous ink jet process is shown in Figure 1.17.

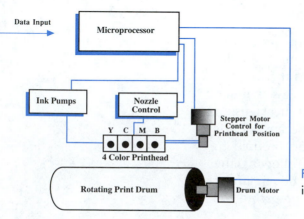

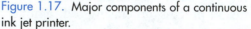

Figure 1.17. Major components of a continuous ink jet printer.

DROP-ON-DEMAND INK JET PRINTING

Drop-on-demand (DOD) printing is a technology found in many ink jet printers used for proofing purposes. Two major technologies are used in drop-on-demand printers: liquid thermal/bubble jet and solid ink jet systems.

LIQUID THERMAL/BUBBLE JET PRINTING

Bubble jet printing employs dozens of very small nozzles in the print head. In the printer, an electrical current passed through a small electrical resistor heats ink in a tiny tube. Heat from the element vaporizes the water in the ink, which causes many bubbles to form that fuse into a larger bubble. As the bubble expands, pressure inside the printing nozzle pushes the ink droplet onto a sheet of paper (Figure 1.18).

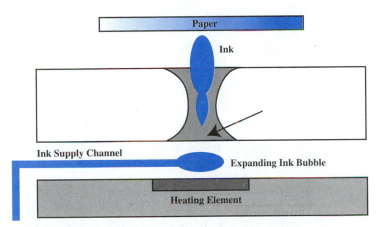

Bubble Jet Printing

Figure 1.18. Principle of a bubble jet printer.

After ink is pushed from the nozzle, the ink bubble contracts, which lowers the pressure in the printing head, drawing in more ink. This process occurs several thousands of times each second and can be controlled precisely to yield very high-quality print results.

SOLID INK JET PRINTERS

Solid ink jet systems are sometimes referred to as *phase change ink jet printers*. In this process, the ink is kept in a solid, crayon-like form. During the printing process, the ink is heated and quickly melts. The print head travels across the paper, spraying the ink droplets onto the paper. The ink solidifies on the paper almost instantaneously and prints with little or no smudging. Solid ink jet printers are versatile, in that they can print on a variety of paper stocks and transparency media. The term *phase change* refers to the fact that the ink starts out in solid form and changes to a liquid during the actual printing process.

WAX THERMAL TRANSFER

Wax thermal transfer printers are typically used for prepress color proofing, desktop publishing, and business presentation applications. The print head consists of an array of many individually controlled tiny heating elements. The elements in the print head heat and melt a ribbon that is coated with wax-based color inks. The ink transfers from the ribbon onto specially coated paper stock.

In most wax thermal processes, each color prints in a separate pass of the print head. The paper is repositioned for each pass of a different color on the ribbon.

DYE SUBLIMATION THERMAL TRANSFER

Dye sublimation printers produce photographically realistic output images. The coloring agents in these systems are contained in a plastic film transfer roll. The print head contains thousands of tiny heating elements, each of which can produce up to 256 different temperatures. The hotter the temperature, the more dye is transferred during the printing process.

During the dye sublimation process, varying amounts of dye are transferred to specially coated paper stock, based on the temperature of heat energy delivered to the print head. When the sublimal dye is heated, it changes into a gas from a solid in a chemical process

called *sublimation*. When the gaseous dye comes into contact with chemicals in the specially coated paper, it changes back to a solid. By precisely controlling the amount of heat, and thereby the amount of dye transferred to the receiver paper, the intensity of each color dot is precisely monitored. The different colored dyes are deposited on top of one another for full color process and continuous-tone printing.

Dye sublimation printers are low-end market devices, used primarily for color proofing and multicolor desktop publishing. Their relatively low price makes them ideal choices as alternatives to expensive, conventional color proofing systems.

With an understanding of the major processes of printing and image transfer technology, let us take a look at some specific applications where computerization has changed forever the way printed images are generated and produced. We begin our discussion with a look at conventional desktop computers.

PCS, WORKSTATIONS, AND DEDICATED COMPUTER SYSTEMS

Computer systems fall into one of three categories: personal computers, computerized workstations, and dedicated computer systems. The personal computer, using specific application software, enables the user to assemble documents via a word processing program and create graphic images using paint, draw, and rendering programs (Figure 1.19).

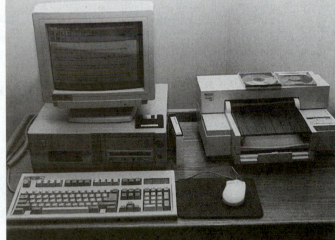

Figure 1.19. Stand-alone personal computer workstation. (Courtesy SIRS Inc.)

The graphic and text elements created are then assembled into completed pages using page composition programs. These software programs are not exclusive in their focus. That is, many page composition programs are capable of producing graphic images, and also perform word processing tasks to varying degrees, depending upon the sophistication of the particular software program. Similarly, many word processing programs can bring in (import) text and graphics images from other programs, create their own graphic designs, and assemble pages in a manner similar to page composition programs. Most of these programs are capable of working in either black-and-white or color formats. As the power of these software packages increases, the personal computer begins to overlap the computer workstation.

Workstations are computer terminals that are linked together (networked). The work terminals are driven by a remote computer that contains more processing power, storage capability, and application software than a stand-alone personal computer. The workstation usually consists of a monitor, keyboard, and mouse (Figure 1.20).

Figure 1.20. Networked computer workstation. (Courtesy SIRS Inc.)

Workstations are able to handle larger and more complicated jobs than personal computers, because of their more powerful central processing capabilities. However, as personal computers increase in processing power, memory storage capability, and software sophistication, the line between stand-alone PCs and workstations continues to fade.

Dedicated systems consist of a bundled package that contains a central processing computer, screen, keyboard, and software that is designed to handle specific functions only. For example, some computer systems are dedicated to handling typesetting and imaging functions only, whereas others may be used for generating and editing graphic elements only.

Dedicated systems are usually reserved for specific, memory-intensive and complicated functions, and are not ordinarily used to run general computer application software packages.

FRONT AND BACK ENDS

In all of the computer systems described, the computer terminal (the front end) outputs information to an imagesetter (the back end), which converts the information from the computer into a printed document or piece of film. An imagesetter contains two units that convert the input data from the computer into a printed image. The first of these units is a processing computer that converts the text and graphics from the computer into a page description language (see the following section). The page description language is a set of instructions that tells the second unit, called a *raster image processor* (RIP), where to print the text, lines, and graphics onto either a sheet of paper or film. In most instances, the imagesetter and the RIP are two separate units. This allows the end user to update either unit as improvements in processing technology or changes in the RIP occur.

IMAGESETTERS

Of all components in the publishing environment, the imagesetter is probably the most important. The imagesetter had its roots in early-generation photo-typesetting machines. These early typesetters were part computer and part photographic exposure unit. They were restricted to outputting text copy only and were able to perform only typesetting functions. The term *imagesetter* is an interesting designation, and by definition describes the abilities of these machines. All images, from drawn artwork to line and halftone illustrations and text, are electronically transferred to the imagesetter from the computer. Imagesetters can output this information onto photographic paper, photographic negatives, or directly onto offset printing plates ready for the press. Figure 1.21 shows an imagesetter with an external raster image processor connected via a light-tight link to an automatic processing unit.

From an operating perspective, imagesetters fall into two categories: capstan and drum devices.

Figure 1.21.
Imagesetter with external raster image processor (RIP) and processor. (Courtesy SIRS Inc.)

CAPSTAN IMAGESETTERS

Capstan imagesetters are sometimes referred to as *roll-fed devices*. The laser diode light-sensitive material is fed from a supply roll housed in a light-tight cassette over the imaging system. In the imaging unit, the media travels over a laser diode exposure unit and into a take-up cassette. A series of transport rollers keep the material under tension and move it from the supply to the take-up cassette while the imaging takes place. In the early-generation imagesetters, the constant pressure applied by the transport system sometimes caused the imaging material to stretch or distort very slightly, causing registration problems. This problem was addressed in later capstan drive devices. Figure 1.22 shows one type of capstan used on photographic imagesetters.

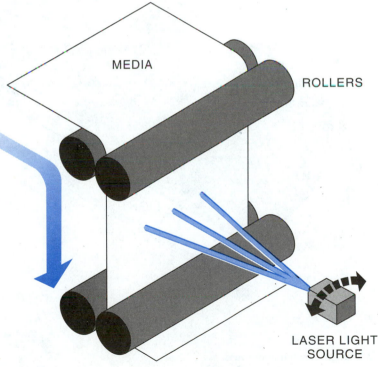

MEDIA

ROLLERS

LASER LIGHT
SOURCE

Figure 1.22. Capstan
drive imagesetter.

DRUM-TYPE IMAGESETTERS

Drum-type imagesetters differ from capstan units in their method of exposure and media transport. The imaging material is fed from the supply roll onto a drum, where it remains during the exposure sequence. Drum-type units are built with either an internal or external drum exposure unit. On internal drum units, the medium is cut and held in place on the inside of the imaging drum during exposure. On external drum units, the film is cut and held in place on the outside of the imaging drum. The drum spins at high speed as the imaging head moves across the drum. Figure 1.23 shows an external drum design; Figure 1.24 illustrates the internal drum unit.

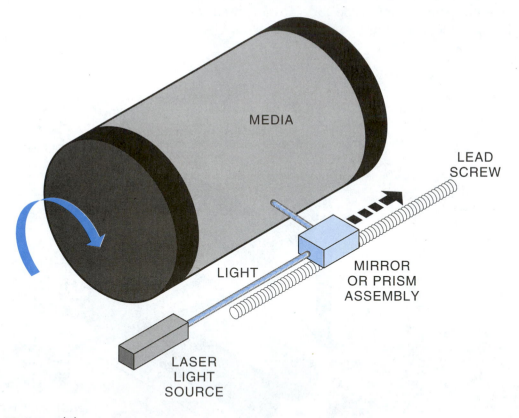

Figure 1.23. External drum imagesetter.

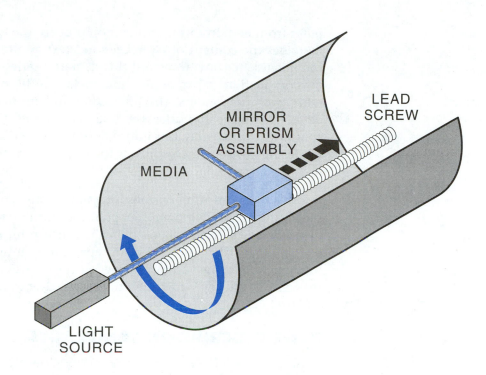

LEAD
SCREW

MIRROR
OR PRISM
ASSEMBLY

MEDIA

LIGHT
SOURCE

Figure 1.24. Internal drum imagesetter.

Both capstan and drum-type imagesetters are in wide use throughout the industry. Drum-type units are the system of choice over capstan devices in shops where most of the work is high-end color separation.

LIGHT SOURCES

Several light sources are used to expose the media in imagesetters. Among the most popular are helium /neon lasers, argon lasers, laser diodes, and light-emitting diodes (LEDs). Each of the different light sources requires a specific type of film, paper, or plate material, and are not interchangeable. Film material manufactured for imagesetters with LED exposure systems cannot be used in imagesetters equipped with argon lasers, and so on.

RASTER IMAGE PROCESSORS

The raster image processor, or RIP, interprets the data for the imagesetter that has been sent from the com-

puter front end. In this interpretation process, the RIP describes the content of all images and text and tells the imagesetter how to record this data as a series of dots on the film, paper, or plate material. The RIP contains two components, the interpreter and the renderer. The interpreter takes the image data from the computer and encodes this information for use by the rendering device, which controls the operation of the imaging system.

A low-volume printing business or source house concentrating on book or pamphlet publication will have different needs from a book publisher, or a printing company specializing in full-color separation printing products. Given the variety of imagesetting devices on the market, the key is to match the imagesetter to the end use.

PAGE DESCRIPTION LANGUAGES

Information from a computer must be interpreted in order for a printer to take the text and graphics composed on the computer screen and properly place them on the printed page. For example, the printer must know how far down to begin to set the first line of type, and where the various elements of a graphic display or photograph will appear. Computer programs that contain the commands telling the printer where to place page elements, including all text, graphics, and photographs, are called *page description languages* (PDLs).

Computerized printing technology developed a great deal of sophistication during the 1980s, from rather humble beginnings. When personal computers began to be used to compose printed pages in the early 1980s, dedicated typesetting equipment had been in use for approximately twenty years. Early attempts to use general-purpose personal computers for graphic design and text composition were restricted by the first generation of dot matrix and daisy wheel printers. Although daisy wheel printers gave the page a fin-

ished, text-like appearance, their output was limited to the type fonts available in the interchangeable wheels. Also, they were unable to print graphic images. The Diablo 630 daisy wheel printer established the first widely used printer control language, which essentially told the printer which letter to print and when to print it.

When dot matrix printers entered the marketplace, they offered far more flexibility than conventional daisy wheel devices. Because dot matrix printers defined a smaller grid on a page which could be printed either black or left white, the printer had the ability to print not only text, but graphic images as well. The printer control languages governing the action of the pins in the matrix printing head grew more complicated than the old Diablo printing protocols. Computers were now able to draw simple shapes, graphs, and different type styles. The output quality of early dot matrix printers was generally judged to be poor, and the printing process was relatively slow—pages could take several minutes to compose and print out.

The introduction of the first Hewlett-Packard Laserjet printer was accompanied by a corresponding page description language known as its Printer Control Language (PCL). Continually being revised, PCL shares the marketplace for page description languages with the industry-dominant language, PostScript, by Adobe Systems. An additional language, the Hewlett-Packard Graphic Language (HPGL) is used primarily for plotting devices, rather than conventional laser printers linked to computers running page composition software.

In spite of all of the advances in computer technology in the late 1970s and early 1980s, typesetters were still chained to specific output devices until the introduction of the PostScript page description language by Adobe Systems in 1985. PostScript uses a mathematical outline description of each typeface and graphic element on the page. Drawing commands within Post-Script include arcs, lines, and Bezier curves, all of

which can be processed in a number of ways. The advantage of PostScript over other PDLs is that Post-Script is universal in application, enabling the designer or typesetter to output to either low-resolution laser printers or high-resolution imagesetters. The ability to output to high-resolution imagesetters was demonstrated in the middle 1980s, when Linotype, in partnership with Adobe and Apple Computer Corporation, demonstrated the same PageMaker file outputting to a 300 dpi Apple LaserWriter and a Linotronic Imagesetter at 1270 and 2540 dpi. There are currently several hundred devices that use PostScript as the PDL core, from plain-paper laser printers to color slide and high-quality, full-color dye sublimation output devices. An area of increasing importance in the PostScript arena is high-speed laser printers, made by companies such as Kodak and Xerox. The speed of these PostScript printers (in the range of 135 pages per minute), matches that of small offset presses. As color capability rather than black-and-white becomes the standard in laser-driven printers, enabling increased productivity, Post-Script is well positioned to become even more influential within the graphic arts in the future.

An additional alternative in typeface technologies is the use of TrueType developed by Apple Computer. TrueType was developed to overcome the deficiencies of incompatible type formats and to enable the printed characters to match what was on the computer screen in other than Apple Macintosh computers. TrueType is a scalable font technology that can be used by DOS format computers running Microsoft Windows. True-Type is a typeface display and printing solution but is not a complete page description language.

DIGITAL PRINTING PROCESSES

In the past few years, duplicators that rely on digital processing rather than traditional offset techniques have been introduced. Still, mostly in the small-format stage for sheet sizes of 11 x 17 inches and smaller, and

designed primarily for short-run color printing, the acceptance of the digital printer forecasts significant inroads by digital printing techniques into the world of traditional offset printing processes. Today's digital presses offer high-quality, multicolor imaging with outputs of about 130 pages per minute (ppm). This output is essentially the same as that of a high-speed office copier.

One approach to digital press printing is typified by the Xeikon digital press pictured in Figure 1.25.

Figure 1.25. Xeikon digital printing press. (Courtesy AM Multigraphics.)

This unit features a web-fed perfecting printing engine that can print two-sided, four-color work at 600 dpi resolution in a single pass. When printing from digital data input in the form of PostScript files, all intermediate preparation steps, such as camera work, film processing, stripping, and platemaking, are eliminated. The press uses fixed light-emitting diodes (LEDs) to capture the image on organic photoconductor drums. The drum images are then developed with the appropriate color of toner, which is then transferred to the paper. Figure 1.26 illustrates the charging and printing process; Figure 1.27 shows the location of the dry toner color cartridges and the paper travel through the Xeikon press.

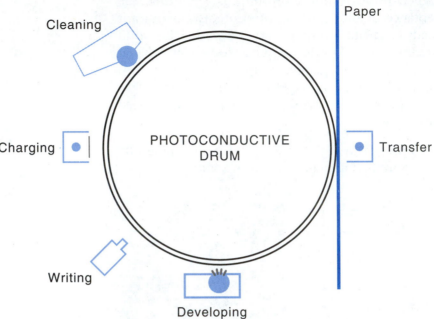

Figure 1.26. The charging/printing process on a digital printing press. (Courtesy AM Multigraphics.)

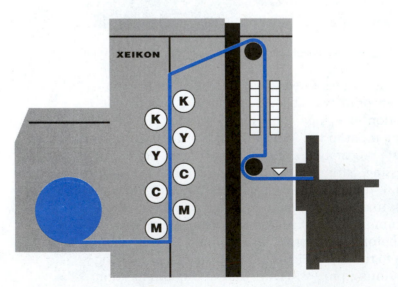

Figure 1.27. Paper travel through a four color perfecting digital printing press. (Courtesy AM Multigraphics.)

A somewhat different digital printing technique from the Xeikon press is employed with a digital Risograph, shown in Figure 1.28.

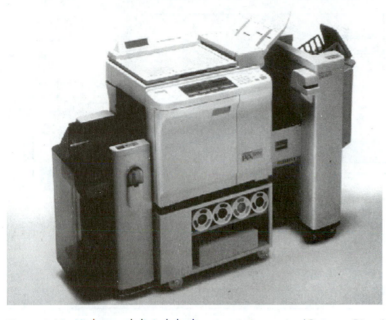

Figure 1.28. High-speed digital duplicator printing press. (Courtesy Riso, Inc.)

To begin the printing process with a Risograph, the original document is placed into a tray that feeds it into a high-resolution scanner built into the unit. The original copy is read by the scanner and image signals from the scanner are sent to the image processing unit. Here, the digitized image is converted into electrical impulses, which are sent to a thermal head. The thermal head consists of a heating element which is used to burn holes in the master material which are identical to the light and dark areas of the original copy (Figure 1.29).

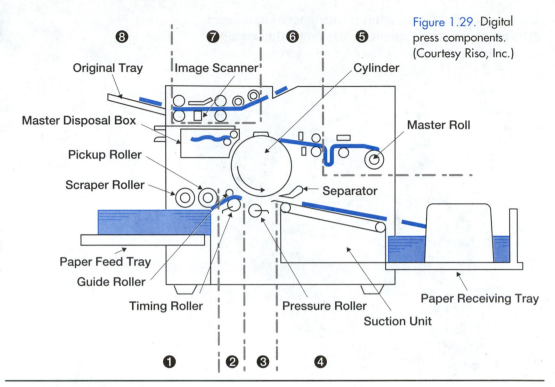

Figure 1.29. Digital press components. (Courtesy Riso, Inc.)

Original Tray
Image Scanner
Cylinder
Master Disposal Box
Master Roll
Pickup Roller
Scraper Roller
Separator
Paper Feed Tray
Guide Roller
Timing Roller
Pressure Roller
Suction Unit
Paper Receiving Tray

❶ **First Paper Feed Area**Feeds single sheets of paper to the second paper feed area via the Scraper, Pickup roller, and Stripper plate.

❷ **Second Paper Feed Area**Controls the vertical print position and feeds paper to the print area via the Timing and Guide rollers.

❸ **Print Area**Uses the Pressure roller to press paper against the master on the Cylinder. The Drum rotates with the Pressure roller and prints an image on the paper.

❹ **Paper Receiving Area**Separates the printed paper from the Cylinder, and transports the paper into the Paper receiving tray.

❺ **Master making Area**Carries an original and scans that original with the Image scanner. Converts the image information into digital data, and makes the master with the Thermal print head.

❻ **Carrier and Clamp Area**Feeds the prepared master material to the Cylinder, loads it on the Cylinder, and cuts it to an appropriate length.

❼ **Master Disposal Area**Separates the used master from the Cylinder and disposes it into the Master disposal box.

❽ **Drive Mechanism Area**Drives all the operations other than those in the Master making area.

A series of registration sensors (see Figure 1.30) maintain proper position of the original during scanning. This ensures that the printed image will be in registration compared with the original copy.

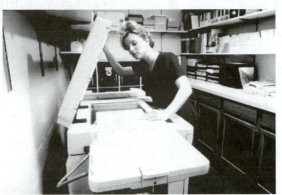

Figure 1.30. Scanning original copy into a digital printing press. (Courtesy Riso, Inc.)

Loading and removal of the printing masters is fully automatic. As a new master is being processed, it is temporarily stored until the previous master is automatically removed into a master disposal box. During the printing process, ink from the ink cartridge is forced through the screened master (similar in many respects to a silkscreen process). When the printing is finished, the old master is removed and a new master is loaded.

The Riso prints only one color in a single pass. To print additional colors, ink cartridges stored below the unit are changed and the paper is fed through the press again for each additional color to be printed (Figure 1.31). Digital presses are also available to print multiple colors in a single pass through the machine.

Figure 1.31. Changing ink colors for multicolor printing on a single-color digital printing press. (Courtesy Riso, Inc.)

41

DESIGNING AND PRINTING A JOB

Now that we have some understanding of both conventional printing processes and the role of computer technology within the graphic communication process, let us get a quick overview of the production of a typical multicolor job. Graphic artists and designers all follow the same basic procedures to bring a printed page from an idea to a completed, printed product. Chapter 11 goes into the principles of graphic design as they apply to the design and production of a variety of graphic design pieces. To illustrate this process in overview, consider the promotional box shown in Figure 1.32.

Figure 1.32. Four color promotional box. (Courtesy SIRS Inc.)

Bringing this project from the initial idea through to the final design and printed product involved many intermediate stages. Initial ideas for the project are discussed and brainstormed. Part of this brainstorming process involves the generation of thumbnail and rough sketches. Thumbnails and roughs (shown in Figures 1.33A and 133B) allow for the expression of a variety of ideas and help the designers gain an initial feeling for what will and will not work in any given project. Figure 1.33A shows a first-generation sketch of the box, and Figure 1.33B illustrates how the box has been refined. This refined sketch also shows the first of the graphic elements to give a feeling for size and placement of the visual elements.

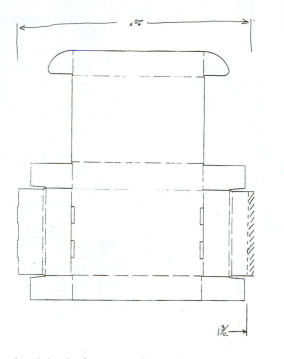

Figure 1.33A. Thumbnail sketch of promotion box. (Courtesy SIRS Inc.)

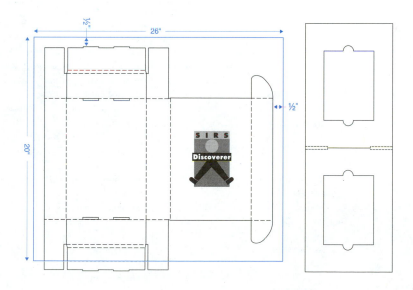

Figure 1.33B. Refined sketch of promotional box. (Courtesy SIRS Inc.)

JOB SPECIFICATION SHEETS

As initial ideas become more refined, the designers can begin to put together the pieces that will make up all of the components of the finished piece. Most of the thumbnails and roughs will be discarded or used to refine the design to a point where basic decisions as to what the piece will look like can be made. At this point, a job specification sheet is made up which contains all the various components of the design, from which the generation of all images follows. The job sheet for our promotional box is illustrated in Figure 1.34.

SCP COMMERCIAL PRINTING

IMAGING ORDER

SiRS 1973 · 1993 Twenty Years of SIRS

Information

Name *SALLY HATTON*

Department *MARKETING* Ext. *413*

Job #/ Project *BOX DESIGN*

Date *4/20/93*

Time In *3:01*

Due *(ASAP)*

Computer Information

Mac Disk: ☐ 3.5 hd ☐ 3.5 dd

Removable Media: ☐ Syquest ☐ 88 mb ☐ Tape

File 1 Information	File 2 Information
File Name: *DISCOVER BOX DESIGN*	File Name:
PostScript or Application: ☑ PS ☐ Application	PostScript or Application: ☐ PS ☐ Application
Which Application: *QUARK* Version: *3.3*	Which Application: Version:
Page Size: ☐ Letter ☐ Legal ☑ Tabloid ☐ Custom ___ x	Page Size: ☐ Letter ☐ Legal ☐ Tabloid ☐ Custom ___ x
# of Copies: */* Page Numbers: */* to */*	# of Copies: Page Numbers: to
Crop Marks: ☐ Yes ☐ No	Crop Marks: ☐ Yes ☐ No
Orientation: ☐ Tall ☑ Wide	Orientation: ☐ Tall ☐ Wide
Proof: ☑ Matchprint ☐ Blueline	Proof: ☐ Matchprint ☐ Blueline
Line Screen: *150*	Line Screen:
Image ☐ Positive ☑ Negative	Image ☐ Positive ☐ Negative
Resolution: ☐ 1200 ☑ 2400 ☐ 3251	Resolution: ☐ 1200 ☐ 2400 ☐ 3251
Prep File Version:	Prep File Version:
Process Separations: ☑ C ☑ M ☑ Y ☑ K	Process Separations: ☐ C ☐ M ☐ Y ☐ K
Spot Colors: *4/*	Spot Colors:
Knockouts: ☑ Yes ☐ No	Knockouts: ☐ Yes ☐ No
Fonts *N/A*	Fonts
Special Instructions:	Special Instructions:

• Remember to include all TIFF, EPS or other format graphic files that you used! •
Percent size will be output @ 100% unless special instructions are given.

OPERATOR USE ONLY

Operator Name	System Time
# of Pieces of Film Used & Size	Proofing Material & Size
Total Time for Job	

Figure 1.34. Job sheet and imaging order for promotional box. (Courtesy SIRS Inc.)

COMPREHENSIVE LAYOUTS

In some instances, depending on the complexity of the job, actual production of the design may begin after approval of the roughs. However, in many instances, the customer needs to see a refined sketch to more accurately visualize the appearance of the final printed product. In these instances, comprehensive sketches or designs are prepared by the graphic artist or designer.

Comprehensive sketches, or *comps,* are renderings produced by the designer that closely resemble the final, printed product. Actual proofs of the display or headline type, or transfer letters that resemble the final type style and sizes, are included in the comprehensive. Body text is generated with specially prepared pencil points that match the size of the body text, without actually hand-lettering or preparing the actual copy, or from actual text proofs. The comprehensive design for our box appears in Figure 1.35.

Figure 1.35. Comprehensive design for promotional box. (Courtesy SIRS Inc.)

MECHANICALS AND DIRECT-TO-FILM/PLATE TECHNOLOGY

After comps have been approved, the job will progress either to the preparation of a mechanical, which includes all camera-ready copy, or will be output directly from the computer work terminal to film or plate media.

Mechanicals are time-tested methods for assembling the various components of the job on a piece of mat or illustration board, using final camera-ready proofs and copy. Line illustrations and text can be photographed directly from the mechanical. Continuous-tone halftone illustrations are either photographed separately and added to the final photographic flat or exposed separately onto the final printing plates.

With computerization, an increasing percentage of jobs goes directly from the computer screen to final printout on a high-quality laser printer for a final check before printing. This final plain-paper printout is the computer equivalent of the mechanical. The printout can be either in black-and-white or color, depending on the specifications of the job. Color proofs are usually made for multicolor jobs, so the customer can critically examine the color rendition of the job before it goes to press. This proof is the same size as the final printed product and is sometimes referred to as a *dummy*.

Assuming approval of the final proof, the job can be output directly to an imagesetter to produce either negatives or plate media. If the job is output onto film, it will be examined and stripped onto a flat, which is used to make the printing plates. Output onto plate material takes place on an imagesetter equipped with plate media or on a special platesetter. Platesetters resemble imagesetters in appearance, but are capable of outputting only to plate material. The final output for the multicolor box includes the five printing plates shown in Figures 1.36B through 1.36F:

cyan, magenta, yellow, and black, as well as one background plate for the color of the box. Figure 1.36A is a composite proof of all of the printing plates.

Figure 1.36A—Composite proof

Figure 1.36B—Yellow printer

47

Figure 1.36C—Magenta printer

Figure 1.36E—Black printer

Figure 1.36D—Cyan printer

Figure 1.36F—Color background

EMPLOYMENT OPPORTUNITIES IN GRAPHIC DESIGN AND PRINTING TECHNOLOGY

Explosive technological developments within the design and communications industries continue. Accompanying this development are increasing opportunities for employment.

The graphic design and printing industries are composed primarily of small- to medium-sized businesses, usually employing fewer than 25 people. There are a few large corporations within the industry that employ several hundred people. Also, many large corporations contain in-plant print and design facilities for printing their own literature. In terms of employment opportunities, these types of facilities usually fall somewhere between small and large communications businesses. Depending upon the geographical area of the business and the specific job description, union membership might be required for employment. For example, businesses in large metropolitan areas may require union membership, whereas smaller businesses in suburban or rural areas might not.

Employment within technical areas such as graphic design and computer-intensive applications usually requires some type of college training. This training is available at either community colleges or vocational training centers in which design and printing are incorporated into the curriculum. Middle and upper management level positions often require a four-year baccalaureate degree that provides training in both the technical and business aspects of design and printing technologies. Schools that incorporate apprenticeship and job training components into the curriculum, such as internships or cooperative education, enable students to be exposed to real-world work situations during their education, and are a valuable asset to traditional classroom instruction.

Also, there are numerous trade and industrial organizations, with chapters throughout the country, whose basic purpose is to promote professional opportunities within the graphic design and printing technology disciplines. Appendix I contains a comprehensive list of professional associations within the design and printing industries that are an excellent source of information concerning job and educational opportunities.

SUMMARY

This chapter introduces the reader to the basic concepts and processes within the graphic communication design and production technologies discipline. Since the development of moveable type more than five hundred years ago, printed communication has relied on four basic reproduction processes: relief printing from a raised image, gravure printing from a recessed image, the chemical process of oil and water separation known as lithography, and stencil duplicating or screen process printing. During the twentieth century, the dominance of offset printing has been achieved primarily at the expense of both gravure and letterpress technology. Specialty areas within the design and printing industries enable flexography, a letterpress process utilizing rubber plate printing, and screen process printing to continue to thrive within the packaging, labeling, and advertising markets.

Assembly of all of the elements of the page, called page composition, can be done either manually or on a computer terminal. Principles of page composition and design technique underlie all the processes introduced in this chapter.

The chapter concludes with a brief description of employment opportunities within the graphic design and printing production industry. These opportunities continue to expand, linked to the explosion of technologies that have affected the graphic design and printing production and communication industries more than any others.

AN HISTORICAL PERSPECTIVE OF

Graphic Communications

Chapter

2

INTRODUCTION

The history of communications, from the early use of pictures to represent ideas or things to complex digital communication systems, is a history of the evolution of technology. This history follows humankind from its beginnings as hunters and gatherers, through the development of agricultural systems that allowed for permanent settlements, to the development of complex technologies that allow for instantaneous communication of thoughts and ideas.

The history of any technology at first appears to be an isolated series of events that seemed to occur by good fortune and timeliness. Closer examination shows, however, that these events are solidly linked to one another in an evolutionary pattern, each development enabling and setting the stage for future achievements and advances.

Two achievements in this communications technology historical jigsaw puzzle stand out as landmark events in the history of humankind: the development of the printing press by Johann Gutenberg in 1455 and the invention of the transistor in 1948 by Bell Laboratory physicists Walter Brattain, John Bardeen, and William Shockley.

The printing press, coupled with the invention of moveable type, nurtured the spread of literacy and provided the foundation for what would later become mass communication. The transistor, which enabled the development of electronic miniaturization, clearly represents a shift in the direction of human history. The computerization of virtually all facets of human existence has forever changed both the nature and direction of social and political events.

Let's take a closer look at some of the events that have brought us to where we are today. A timeline of selected major developments that chronicle communication technology and the graphic arts is highlighted in Figure 2.1.

A TIME LINE OF GRAPHIC COMMUNICATIONS

Cave Painting	Hieroglyphic Texts	Chinese Develop Paper	Chinese Relief Printing from Wood Blocks	Woodcuts Used to Print Textiles	Johann Gutenberg Publishes the Gutenberg Bible
15,000 BC	3100 BC	200 AD	600–800	1400	1455

First Printing Press in England	First Book Printed in America	Statute of Anne	Caslon Typefaces	Baskerville Roman Typefaces	Senefelder Lithographic Press	Stanhope all-metal Platen Press	Koenig Flat-Bed Cylinder Press
1476	1640	1709	1734	1757	1796	1800	1811

Camera Obscura Used as Photographic Camera	Hoe Rotary Press	Halftone Screen	Linotype Machine	Kodak Camera	Ira Rubel's Three Cylinder Offset Press	Television Picture Transmitted	First Color Film
1826	1844	1800	1887	1888	1904	1926	1930

Paperback Book	Xerography	IBM Mark I Computer	ENIAC Computer	Polaroid Land Camera	The Transistor	Univac Computer	Photon Typesetting Machine	Integrated Circuit
1936	1938	1943	1945	1948	1948	1951	1954	1959

Telestar I Communication Satellite	Geosynchronous Satellite	Microprocessor Developed	Compact Disc	Altair Personal Computer	IBM PC Introduced	Apple Macintosh Computer	Compact Disk, Scanner and PC Technology	Heidelberg Direct Image Offset Press
1962	1963	1971	1975	1980	1981	1984	1990	1991

Power PC Introduced	Multi-Gigabyte Removable Disk Storage Devices	Erasable CD-ROM Drives Developed
1994	1995	1996

Figure 2.1. A timeline of graphic communication technology.

PREHISTORIC ART AND WRITING

A study of the evolution of graphic communications begins more than 35,000 years ago with Paleolithic art. This art took the form of crude drawings and engravings made on clay. Paleolithic art lasted from approximately 15,000 to 10,000 B.C. The existence of any artistic ability on the part of primitive cultures had been largely dismissed until the discovery of cave art at Altamira, Spain. As more and more caves were found—some sealed since the Stone Age—the authenticity of Stone Age art was gradually established. The subject matter of these early paintings ranges from animals of the period, including bison, wild cattle, and goats, to finger drawings and hand imprints. The paintings were executed by mixing natural colorants such as manganese, iron oxide, and charcoal with a vehicle such as animal fat, natural juices, or blood. The mixture was then painted onto a clay tablet or cave wall using either a stick or a brush. Figure 2.2 shows a cave painting from Spain depicting a deer hunt; Figure 2.3 is a pictograph from the American Southwest showing stenciled hand prints.

Figure 2.2. A deer hunt as seen by early cave dwellers in Spain (Courtesy American Museum of Natural History).

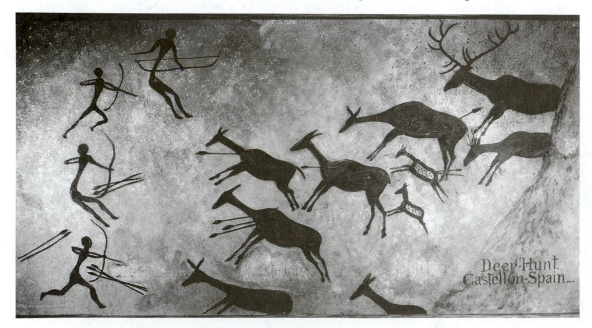

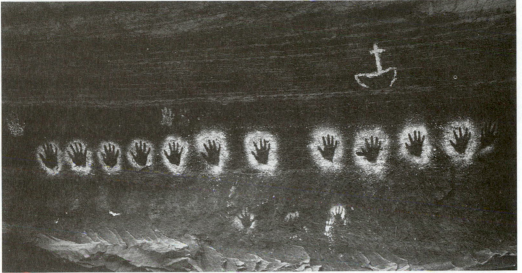

Figure 2.3. A pictograph of stenciled hand prints from the American Southwest (Courtesy American Museum of Natural History).

Cave paintings are sometimes referred to as *pictographs,* literally meaning "writing with pictures." Pictographs are limited in their ability to communicate. Only simple messages can be communicated, because it would take too many pictures to transmit long messages or complicated ideas.

Cave painting led to the development of rock painting, a tradition that continued through the Mesolithic (Middle Stone Age) period, Neolithic (New Stone Age) period, and the Bronze and Iron Ages. These dates range from approximately 10,000 B.C. to 4,000 B.C. Different styles of rock art are found all over the world. The greatest concentrations of this communication form are found in Europe and the Saharan and Libyan deserts in Africa. Both North and South America contain numerous paintings and engravings in caves and on rock faces as well.

HÏÊROGLYPHICS

Pictorial symbols that are used to represent objects or animals in a formalized writing system are known as *hïêroglyphics.* This term comes from the Greek *hieroglyphika grammata,* which means "sacred carved let-

ters." However, hïêroglyphic texts dealt with things other than those that were religious in nature. Many hieroglyphic texts have been discovered, although many remain undeciphered due to insufficient information for analysis. The major key to deciphering ancient Egyptian hïêroglyphic texts came with the discovery of the Rosetta Stone. The Stone contains a decree issued in 196 B.C. and is written in three languages: Greek, Egyptian hïêroglyphics and Demotic, (a cursive evolution of hieroglyphic text and symbols). The Stone was eventually deciphered by a French scholar, Jean Champollion, in 1822.

Hïêroglyphic texts evolved from pictorial art as various societies developed the increasingly complex writing systems necessary to record ideas and objects. Hieroglyphic texts are composed of ideograms; each sign or drawing represents some object or concept that is derived from the graphic. Many hïêroglyphic texts are also phonetic and represent basic grammatical expressions. Although ideas can be represented in this system, it still requires many ideographs to communicate a message. For example, the Chinese and Japanese systems of writing, which still contain ideographs, require more than 10,000 symbols to make up their languages. Figure 2.4 illustrates some Egyptian hïêroglyphic symbols, along with their letter and symbolic counterparts.

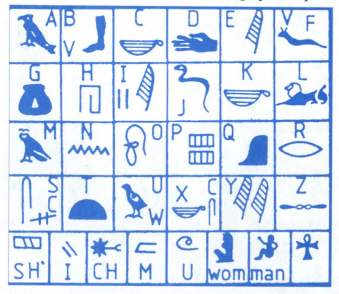

Figure 2.4. Some common hïêroglyphic symbols.

THE ALPHABET

The evolution of hïêroglyphic ideographs led to the invention of letters. The use of alphabetic writing began to appear in Egypt in about 3,000 B.C. The Phoenicians are generally thought to have introduced the system of representing sound with written symbols. The Phoenicians, who were trading widely throughout the Middle East, were importing papyrus from Egypt around 1100 B.C. and most likely adopted Egyptian alphabetic letters as well.

By the fourth century B.C., the Greeks had adopted and modified the Phoenician system and added vowels to the alphabetic. The Greeks reversed the facing of some of the letters, as the Phoenicians wrote from right to left. The Greeks also changed the names of some of the letters. The Romans later took the Greek alphabet and adapted it to their own language. This alphabet remained in use for nearly 1,200 years and is what we continue to use today.

THE DEVELOPMENT OF PAPER

The development of both paper making and printing from moveable type converged at the end of the fourteenth and beginning of the fifteenth centuries. These developments lay the foundation for modern civilization's communications.

When humankind first began to explore the processes of visual communication, almost any material that would hold a brush stroke, a relief image, or a carved figure could be used as a writing tablet. Clay tablets eventually gave way to the use of natural materials such as papyrus for holding images. Most of the Egyptian hieroglyphic texts are printed on papyrus, which remained in use in Europe into the twelfth century. Parchment, made from animal skins, was also used extensively for writing until paper made from interlaced plant and cloth fibers mostly replaced it.

The development of paper making is credited to a Chinese court official named Tsai Lun, about 105 A.D. The Chinese kept the art of paper making a secret for more than 500 years. Eventually, knowledge of the process spread and by the sixteenth century paper mills were established throughout Europe. The paper-making process at this time was, of course, manual. Linen was shredded and reduced to a pulpy mass suspended in a water solution. A wire mesh screen was then dipped into the pulp vat. When the screen was removed, it contained a thin layer of pulp. As the water drained through the screen, the fibers of the pulp meshed together to form a sheet of paper. The sheet was then pressed and dried. The manual process limited paper making to single sheets, which restricted the supply of paper for printing.

In 1798, a mechanical process for making paper was invented by a Frenchman, Nicolas Robert. Robert's machine used an endless wire mesh screen that was fed a pulp mixture from a vat. The screen vibrated along its entire length as it moved, which helped in removing excess water from the pulp mixture as well as allowing the water to drain through the screen. The pulp fibers locked together to form an endless web of paper. The paper web was then sent through a series of rollers to establish uniform thickness and surface finish the paper web.

The Fourdrinier brothers built the first commercially successful paper-making machine in England. Modern paper-making machines still bear their name.

THE PRINTED WORD

It has been said that the second part of the history of civilization can be traced to the development of printing. Until a process for mass-producing the printed word was developed, information was accessible only to the relatively few people who were wealthy enough to afford either block-printed or hand-scribed manuscripts. The problem with block-printed manuscripts

were that each block could only be used to print a single page. Carefully handcrafted, the blocks eventually flattened out under continued pressure from the wine-press type of printing presses of the day. As an alternative to block-printed texts, hand-scribed manuscripts were very expensive to produce, because scribes were in short supply and demanded high wages for their craft.

Fifteenth-century Europe was ripe for the invention of moveable type and the printing press. The process of making paper had been perfected to the point where paper was far cheaper than parchment. Relative affluence, a byproduct of European recovery from the bubonic plague a century earlier, resulted in an abundant supply of linen for paper making.

The invention of moveable type and the printing press is attributed to Johann Gutenberg, a German goldsmith. Gutenberg's great contribution to the history of civilization lies in his development of a method to produce moveable type. Drawing upon his skills as a goldsmith, Gutenberg introduced the process of replica-casting individual pieces of type. In this process, each letter of the alphabet was engraved in relief to form a master letter punch. The master was used to punch the letter into a brass mold matrix. Type was then cast, one letter at a time, in the matrix. Both the mold and matrix were designed to be reusable, so that many letters could be cast from the same matrix. The mold could be used for any letter matrix, an early forerunner of the principle of interchangeable parts. Gutenberg adapted wine presses of the day for use in printing assembled pages of type and illustrations. He also developed a printing ink that would adhere to the type alloy. Ink that was used to print from this new type had to be different in composition from the printing inks that were used to make prints from wood blocks. One of the few references to the design of early printing presses of Gutenberg's era is illustrated in Figure 2.5 from a woodcut, "The Dance of Death."

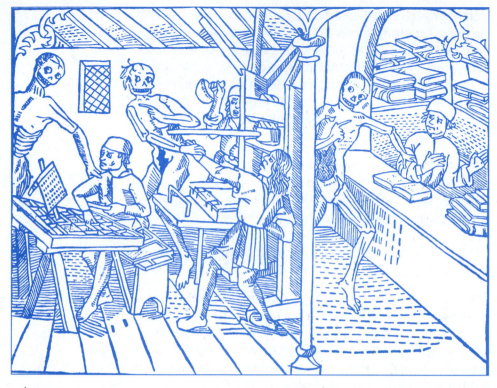

Figure 2.5. An early printing press as depicted in a woodcut, "The Dance of Death" (Courtesy The Smithsonian Institution).

The Gutenberg Bible, sometimes referred to as the 42-line Bible because of the number of lines of text on each page, was published about 1455. This Bible, more than 1,300 pages long, was printed two pages at a time, by hand, on Gutenberg's first-generation printing press. There is some question as to whether the Bible was published by Gutenberg or by Johann Fust and Peter Schoffer. Fust and Schoffer took over Gutenberg's press and materials after Gutenberg defaulted on the repayment of a loan. The Bible was published during this period.

In spite of what can rightfully be regarded as a milestone achievement in the history of technology, Gutenberg abandoned printing in the 1460s and died in 1468 in relative poverty. His invention led to the spread of knowledge throughout Europe by enabling the distribution of inexpensive reading matter, as well as laying the cornerstone of the modern printing industry.

Early type designers were at work throughout all of Europe during the latter fifteenth and early sixteenth centuries. One of the most famous of these was Aldus Manutius, a Venetian printer who pioneered the production of inexpensive books that could be carried easily—the first-generation pocket book. Manutius translated all of the Greek classics and is responsible for the development of what is known as the *italic* typeface, designed originally as a graceful, slanting letter that mimicked handwritten characters.

Another Venetian printer, Nicolas Jenson, began his work around 1470. Jensen was a celebrated artist who perfected the form and beauty of the Roman typeface. The style of Jenson's letters are essentially those used today in the design and appearance of Roman typefaces.

Type-casting as an activity separate from that of the print shop came about through the work of Claude Garamond, a French printer and typographer. Garamond, a student of Geofroy Tory, a prominent early French printer, modeled his typefaces after those of Manutius. Garamond eventually focused all his energy on designing and producing typefaces for other printers. The development of the type foundry as a separate entity freed printers from the chore of designing and casting their own typefaces. This allowed the printers to concentrate more on the process of printing and graphic design.

William Caxton was a merchant and writer who, while visiting Belgium, was introduced to the new art of printing. While in the city of Bruges in Belgium, Caxton produced the first book printed in the English language. Caxton later returned to England, bringing his printing presses with him. He set up a printing shop in London and produced the first dated book printed in England in 1477.

Throughout the eighteenth century, English printers were forced to rely primarily on imported Dutch type, as there were no type foundries in England. In the

early eighteenth century. William Caslon, using his background as an engraver, established the first type foundry in London. Caslon printed a type specimen sheet in 1734 that included typeface designs that still bear his name. His work eliminated the need for imported typefaces.

John Baskerville, a contemporary of Caslon, was a writing master who later became a type designer and printer. Baskerville's contributions to typeface and typographic design during the eighteenth century were impressive, spanning the development of newer, rich-tone printing inks and glossy-surfaced paper. During his tenure as official printer to Cambridge University, Baskerville printed the Bible in 1763, a book which is generally thought of as one of the finest examples of eighteenth-century printing.

COPYRIGHT PROTECTION

The Statute of Anne, passed by the British Parliament in 1709, extended the right of copyright protection to all citizens. The statute established the precedent that intellectual property is, in effect, the property of the author. United States copyright laws are based on this statute. The main purpose of these laws is to encourage the wide dissemination and spread of information while protecting the rights of the creator of the book, photograph, or product.

The notion of copyright protection for intellectual property was born shortly after the invention of the printing press. European governments, fearing that wide dissemination of printed information would undermine their authority, granted copyright protection to the printers of the time. In this arrangement, the government allowed printers to publish and sell their materials only if they followed government censorship rules.

Familiarity with all phases of current copyright law is essential for those working within the graphic design

and associated technical industries. Current U.S. copyright law allows the creator of an intellectual property to control and distribute the creation, earn income from it, and prevent others from using it without permission. Copyright protection is a critical issue for the graphic designer, because questions often arise as to what property rights exist for materials whose origins are unknown. As barriers between people and countries continue to break down with increasing computerization, the issues of copyright protection as they apply to image creation, manipulation, and use will become increasingly complicated. Although the graphic designer and printing technologist needs to become thoroughly familiar with copyright law, a good rule of thumb on these issues is the "man on the street rule." This rule states that if someone with no graphic arts or technical training feels that two images bear a striking resemblance to one another, it is reasonable to assume that a coyright infringement has taken place. Therefore, if you didn't create the image, assume that you are using someone else's materials; unless you have permission to use the material, you are likely in violation of the law.

THE DEVELOPMENT OF PRINTING IN NORTH AMERICA

The printing industry in the North American colonies began in 1638. Stephen Daye, a locksmith from Cambridge, England, contracted with the Reverend Jesse Glover, a New England minister interested in promoting an understanding of the Bible, to set up a print shop in the British colonies. Glover died on the voyage from England to the New World, before the shop was established. Glover's wife took over the responsibility of setting up the press, and Daye fulfilled his contract. In 1640, he published "The Book of Psalmes," the first book printed in British North America. Taking almost a year to finish, only 11 of the 1,700 copies of this 300-page book remain. After the death of Glover's widow (who had since re-married a

Harvard University president), the press was moved to Harvard. This marked the beginning of the oldest continuously operated press in the United States, the Harvard University Press.

Perhaps the most famous of all American printers was Benjamin Franklin (Figure 2.6). Franklin wore many hats, including that of printer, essayist, civic and government leader, statesman, inventor, and philosopher. One of 13 children, Franklin began his career in his father's trade as a mechanic and candle maker, but soon began to work as an apprentice for his brother James, who published the *New England Courant*. A prolific reader, Franklin began his writing career with pieces that he wrote for the *Courant*. These articles satirized religion, authoritarianism, and society. Franklin then left his brother's employ and moved to Philadelphia, where he established the *Pennsylvania Gazette*. He began printing *Poor Richard's Almanac* in 1732, expanding his business and influence at the same time. His other accomplishments, including his career as a diplomat, abolitionist, and one of the designers of the Constitution, are well known by students of American history.

The nineteenth century brought about dramatic changes in communication technology. At about the same time that Alois Senefelder was

DR FRANKLIN.

Figure 2.6. Benjamin Franklin: statesman, politician, inventor, printer, and graphic designer (from "Dr. Franklin after Chamberlain" Courtesy The Smithsonian Institution).

experimenting with lithographic images on limestone rock in Bavaria, printing press construction was moving along rapidly in America. Early printing presses were usually constructed from a combination of wood and metal and could be easily disassembled and reassembled. This feature made them adaptable for transportation as Americans moved westward. Robert Hoe, working with his brothers-in-law as a furniture manufacturer, bought the patents to several press designs of the time and began to manufacture what was known as the Washington Press in the 1830s.

Contemporaries of Hoe, Isaac and Seth Adams designed one of the first printing presses to run on steam power, in 1830 (Figure 2.7). A steam engine was used to power the movement of the press, which proved to be much faster than the typical hand-operated presses. Printing press technology continued to evolve with the development of the rotary press by Hoe and Company in 1844, and the use of stereotype plates (rather than original type beds) on cylinder presses in the early 1860s. The use of stereotype plates enabled printers to run several different presses printing the same thing at the same time. These presses used cast replicas from the original type forms, printing from these cast replicas called *stereotype plates*.

Figure 2.7. Adams steam-powered printing press (Courtesy The Smithsonian Institution).

The first steam-driven lithography press was developed in the 1860s. Steam power was used to power presses on which lithographic stones were used for image transfer. Soon afterward, on March 4, 1880, the first halftone picture to be printed appeared in the *New York Daily Graphic*. For about 100 years, the Washington Press was the standard for high-volume printing, a design that remained viable into the 1930s, when it was replaced by higher volume sheet and web fed designs.

PHOTOGRAPHY AND ELECTROSTATICS

The introduction of the Kodak camera in 1888 forever changed the face of communications. Photography has played an integral role in communication technology, both as a direct art form and as a foundation process used in all the major printing processes. Hundreds of years prior to the development of the Kodak camera, artists were using a device called a *camera obscura*. The early camera obscura was essentially a dark room with a pinhole opening in one of the outside walls. Light from an object that was illuminated outside of the camera passed through this small hole and was projected upside down on the opposite wall of the room (Figure 2.8). Early experiments with the camera obscura led to the replacement of the darkened room with a light-tight box. A lens replaced the pinhole in order to invert the projected image so that it was right side up. Film was added to the back wall to capture the picture and the modern camera was born!

After the camera obscura came the development of the first commercial camera by Louis Daguerre, a Frenchman. In a process called *daguerreotype*, a photographic plate capable of holding and fixing the projected image was placed inside the light-tight box. Daguerreotypes and their successors were referred to as *wet-plate processes*. These wet plates required extremely long exposure times because of the low sensitivity of the photographic emulsions.

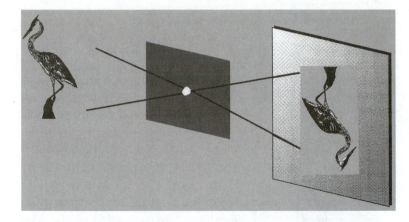

Figure 2.8. The principle of the modern camera from the early camera obscura.

The development of the flexible film base, coupled with dry emulsion technology, set the stage for the Kodak camera. The Kodak camera came from the factory prepackaged with enough film for 100 exposures. After taking the pictures, the camera was sent back to the factory, where the film was processed. The camera was then reloaded and returned to the customer. Continuing improvements in film technology and miniaturization eventually led to the fully automatic, highly sophisticated point-and-shoot and professional cameras with which we are familiar.

One-step photography, pioneered by Edwin Land, was developed by Land's Polaroid Corporation in 1947. Land began his work with polarized light and applied this technology to automotive headlights, reduced-glare filters, glasses, and three-dimensional motion pictures. The single-step Polaroid Land camera was first introduced by Polaroid in 1947; marketing of the camera began the following year. The color version of the Polaroid camera became available in 1963.

About the time Land was conducting his pioneer work with polarized light, another American inventor, Chester Carlson, was developing electrostatic printing technology. Carlson invented what was later to become known as *xerography*. He sold the rights of his process to the Xerox Corporation in 1938.

HOT-TYPE COMPOSITION

The ancestry of modern typesetting machines can be traced back to the development of the first typewriter by Christopher Sholes, during the post-Civil War era. Although several patents were issued for mechanical typesetting devices during the nineteenth century, mechanical production of the printed word is clearly defined by the invention of the Linotype machine by Ottmar Mergenthaler. First installed in the *New York Tribune* in the late 1880s, the Linotype machine produced lines of type cast onto a lead slug, which enabled compositors to quickly make up complete pages of text. The Linotype machine (Figure 2.9) and a typical hot-type shop using Linotype casting machines (Figure 2.10) set the standard in typesetting for the next 60 years.

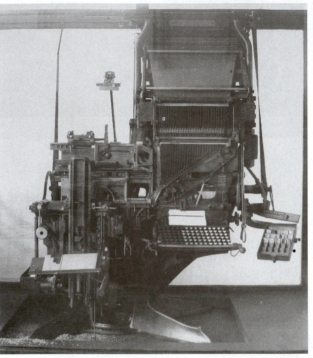

Figure 2.9. The Mergenthaler Linotype machine (Courtesy The Smithsonian Institution).

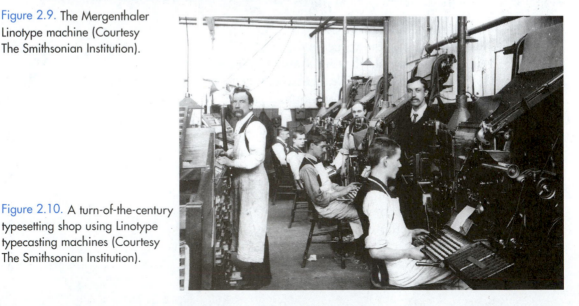

Figure 2.10. A turn-of-the-century typesetting shop using Linotype typecasting machines (Courtesy The Smithsonian Institution).

68

One limitation of the Linotype was that it could only set standard point sizes of type and could not be used to set the larger point sizes required for display type. To fill this gap, a machine was developed by Washington Ludlow in 1913, simply called the *Ludlow*. The Ludlow machine enabled compositors to set individual lines of display type in a composing stick (see Figure 1.2) and then cast the individual line into a slug similar to that produced by the Linotype. With these two typesetting machines, pages complete with both text and display type could be quickly assembled.

Both the Linotype and Ludlow encountered competition from a variety of other manufacturers during their tenure in the production of newspapers and magazines. However, by the late 1960s and early 1970s the era of hot-metal typesetting was over; such systems were replaced by phototypesetting machines, which were made possible by the transistor and succeeding generations of microelectronic capabilities.

LITHOGRAPHY

The process of chemical printing called *lithography,* explained in chapter 1, was developed around 1796. Lithography—printing images from a flat surface rather than from raised images—was invented by a Bavarian artist, Alois Senefelder. Senefelder worked with a water-absorbent stone as the image carrier. The stone was painted with a greasy image and then wet down. The water was repelled by the greasy image but absorbed by the stone. Ink applied to the stone while it was still wet adhered to the greasy image and was repelled by the wet stone. The image, whether simple or highly detailed, was transferred to paper with great accuracy. Figure 2.11 shows the standard array of tools used for making direct image stone lithographs.

Lithography started out as an artistic medium, reaching its greatest success during the late nineteenth and early twentieth centuries. Its appeal as an artistic medium continues to the present day. Developments

Figure 2.11. An assemblage of lithographic printing materials. Lithography continues to be a major medium for artistic expression as well as the dominant commercial printing process (Courtesy The Smithsonian Institution).

in lithographic printing, however, have had a profound effect on the process, resulting in its position as the premier production printing process.

The development of the offset lithographic process is generally attributed to Ira Rubel, a Nutley, New Jersey, paper manufacturer. During a printing run, he accidentally "offset" an image from the plate cylinder of the printing press to the blanket-lined impression cylinder. When the next sheet was fed into the press, an image was printed on both sides of the paper. One image came from the printing plate and the other from the rubber blanket, which was printed on the back side of the paper. Rubel's offset printing press is shown in Figure 2.12.

Offsetting an image rather than printing it directly from the plate offers several advantages. Primary among these is the ability to prepare plates and other media in positive rather than negative formats. When using direct imaging, the plate must be prepared in the negative, as the plate will print in reverse onto the paper, producing wrong-reading copy. In the offset process, however, the printing plate is prepared as a positive. During the printing process, the right-reading image on the plate prints a wrong-reading image onto the blanket. The negative image from the blanket transfers as a positive image back onto the paper.

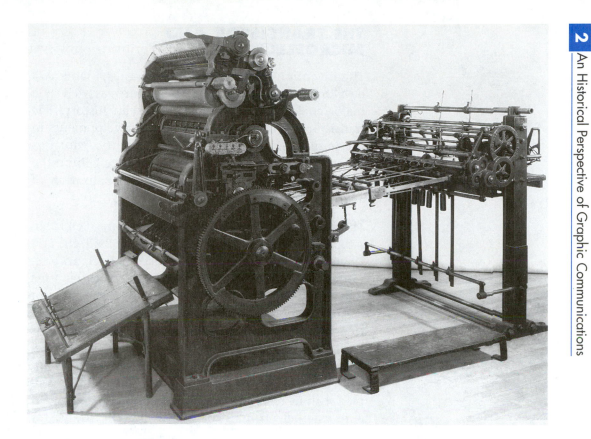

Figure 2.12. The Rubel offset printing press (Courtesy The Smithsonian Institution).

Offset images yield softer tones than do direct-image lithographs. *Scum,* a term for the mixture of paper lint and ink that builds up on the printing plate during press operation, is moderated through the transfer process between the plate and the blanket. Also, in the offset process, printing plates, because they are in contact with soft rubber blankets rather than directly with paper, tend to last longer.

Offset printing gained steadily on its letterpress and gravure competitors, and finally became the dominant printing process by the 1950s. During this time, advances in color film and printing technology made the printed page the only medium for advertising in color until the development of color television.

THE TRANSISTOR AND MICROELECTRONICS

The invention of the transistor stands as a landmark development of the twentieth century, as well as a major enabling achievement in human history. The transistor set the stage for all future developments in the miniaturization of electronic circuitry. Miniaturization in turn has been the driving force behind the computerization of society and the globalization of almost all aspects of human endeavor.

The transistor was invented in 1948 by three Bell Laboratory physicists, Walter Brattain, John Bardeen, and William Shockley. The transistor is, in effect, an electronic valve. It is able to control large electrical currents that flow between two areas within a semiconductor crystal by applying a relatively small electrical current to a third region. In this way, the transistor performs the same functions as a vacuum tube, acting as either an amplifier or switching mechanism. Given the transistor's small size and minimal heat generation, coupled with its reliability, the era of the integrated circuit and microelectronics began when the transistor appeared.

The transistor was invented shortly after the first ENIAC computer. ENIAC, an acronym which stands for Electronic Numerical Integrator And Computer, was developed at the Moore School of Engineering of the University of Pennsylvania. Built to perform the mathematical calculations necessary to create ballistic firing tables for the military, ENIAC contained more than 17,00 vacuum tubes, and was able to perform 5,000 calculations per second, an astounding feat for the time (Figure 2.13). (As an interesting sidenote on the ENIAC, the term *bugs,* referring to computer problems, originated in the fact that insects were often found to be stuck in the contacts and switching terminals of ENIAC—hence the present-day meaning of the term.) In 1951, John Mauchly and John Eckert, the engineers responsible for building the original

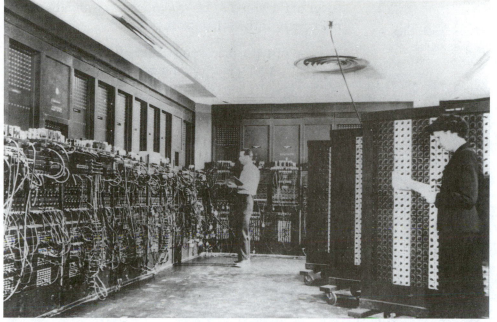

Figure 2.13. The ENIAC (Electronic Numerical Integrator And Computer) developed at the Moore School of Engineering of the University of Pennsylvania (Courtesy The Smithsonian Institution).

ENIAC computer, who were by then working for Remington Rand, delivered the first UNIVAC (Universal Automatic Computer) to the United States Census Bureau.

The first computers were built with vacuum tubes, but transistors were dominant features of computer construction by the late 1950s. The introduction of the integrated circuit by Robert Noyce, a physicist working for the Fairchild Semiconductor Corporation, in 1959 led to both a reduction in the size and increase in efficiency of the computer. When the central microprocessor chip was introduced by Intel in 1971, the stage was set for the development of extremely powerful personal and laptop computers. The central microprocessor replaces dozens of separate integrated circuits, enabling further reductions in size and efficiency (Figure 2.14). Figure 2.15 shows a typical computer central microprocessor chip. In Figure 2.16, the

Figure 2.14. A computer chip (Courtesy The Smithsonian Institution).

cover of the chip has been removed to show the internal layout of the microprocessor.

The first personal computer to gain any degree of widespread acceptance was the Altair 8800. The Altair incorporated an Intel microprocessor and was offered to hobbyists as a do-it-yourself kit. Other companies, such as Apple and Kaypro, then entered the market, followed by machines like the Apple 2 series. The infant personal computer market received its biggest boost, however, with the introduction of the IBM personal computer (PC) in 1981. An almost unbelievable explosion in accompanying digital technology has taken place in the ensuing years.

The introduction of the Apple Macintosh computer in 1984 is especially noteworthy. The Macintosh showed, through its graphical user interface (GUI), that icon-based intuitive computing is an elegant alternative to arcane command strings that strain the memory. The effectiveness of the GUI was borne out several years later when Microsoft introduced its Windows inter-

Figure 2.15. An Intel 8080A microprocessor (Courtesy The Smithsonian Institution).

face. With the introduction of Power PCs by IBM and Apple Computer, as well as the continued evolution of the Windows operating environment, the GUI remains an integral part of personal computing.

The communications industry continues to experience change on an almost daily basis as the industry reacts to the explosion of information-processing technology.

SUMMARY

When we view technological developments in the communication arts from our present-day vantage point, one might wonder why things seemed to move so slowly during the first 50 years of the twentieth century and so quickly since that time. For example, the process of offset printing, developed around 1904, today remains similar in its most fundamental respects to when it was first developed. Digital printing presses, however, which didn't exist five years ago, can electronically print directly from a computer, bypassing all the intermediate steps involved in traditional typesetting, camera work, stripping, and plate making. What separates the development of technology and subsequent achievements of the two halves of the century is the invention of the transistor.

However disconnected the rate of development between the early and later twentieth century might seem, it should be kept in mind that events usually occur in a natural progression, each one building on the other. Also, devices and technologies often appear years before any practical applications are available for them. For example, the transistor was developed several years before it was used in the computer.

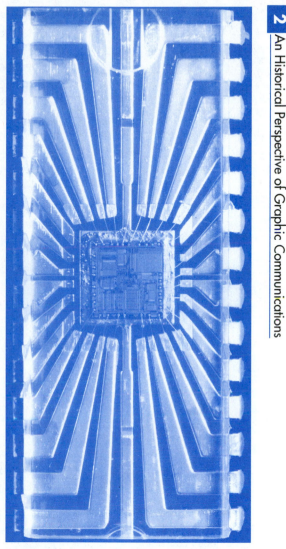

Figure 2.16. Intel microprocessor 8080A with cover removed to show basic chip configuration (Courtesy The Smithsonian Institution).

It is interesting to note that ancient picture writing, perhaps the earliest symbol used for communicating thoughts and ideas, is the format increasingly used in modern computers. Icons representing ideas on cave walls are essentially the same communication form used on computers operating under the Windows graphical interface environment. The importance of icons was demonstrated by NASA in 1972, when Pioneer 10 began its journey as the first spacecraft designed to leave our solar system. The picture on Pioneer's gold plaque is shown in Figure 2.17. The plaque goes beyond any written languages to describe our planet and solar system in a universal, icon-oriented manner.

The illustration highlights a man and woman, the hydrogen atom and its wavelength. An illustration of our solar system indicates where the spacecraft's journey began and the relationship of Earth to the rest of our solar system. The information on this plaque is simply yet elegantly depicted.

In looking at other links to the past, consider that the Roman typeface, developed by the Italian typographer and printer Nicolas Jenson in the latter half of the fifteenth century, is still the type of choice for most text applications.

Figure 2.17. Earth announces its existence to the universe via the Pioneer X plaque (Courtesy National Aeronautics and Space Administration).

The practitioner in the graphic arts industry will of necessity be forced to keep a sharp eye out for changing patterns and development. History will continue to unfold before our eyes. Computers will increasingly become multimedia tools, incorporating all of the standard applications with telephone, audio, and video components and an increasingly interactive mode of operation. Regardless of all these sophisticated electronic technologies, the historical roots and development of the graphic arts will continue to exert subtle, but nonetheless important, influence on all future developments.

TYPE DESIGN AND FAMILIES

The history of type design dates back to the early stages of printing. Many early type designs were simply metal versions of hand-lettered type. As printing technology improved, type design allowed for better readability and easier use of type for printers. A large number of early typefaces are still in use today. Typefaces such as Caslon, Goudy, and Bodoni were designed in the 1700s and continue to be popular today.

The heart of printed matter is the text, because written information makes up the majority of most printed communication. Although photographs, illustrations, and other graphic elements support the text, the personality of the printed page is created largely through the choice of typeface. It is that which conveys the message to the reader. *Typography* is the art of selecting the proper typeface for the job at hand. On a very basic level, type speaks for itself. Consider the typeface examples in Figure 3.1.

Thousands of type families are available from type foundries and software houses. Given this variety to choose from, a problem arises as to how to make knowledgeable decisions regarding which typeface to use in a given design situation. There are three principles that can help provide a framework for understanding the art of typography:

1. Use the right typeface to properly communicate your message. Some typefaces are elegant, such as those used for wedding invitations. Others vary from the less formal to those that are humorous. Type specimen books are available from type vendors. Look at these specimen books and try some different selections for communicating specific messages.

2. Type size should be related to the importance of your message—the more important the message, the larger the size of type. Type size is measured in units called *points*.

I'm tragically Hip!
I'm rather Conservative.
I'm quite feminine!
I'm old-fashioned!
IM OUTTA MY MIND!

Figure 3.1. Type speaks for itself.

Chapter

3

BASIC

Typography

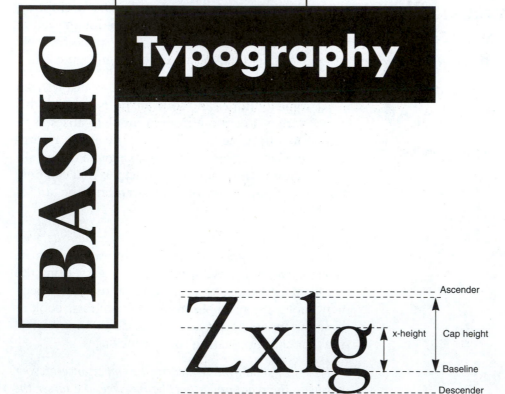

A point is equivalent to ½ inch. Therefore, 72 point type is approximately one inch high on the page—36 point type is one-half inch in size, and so on. Headlines and captions should stand out from the body of text in order to highlight the central idea of the page or column. Headlines and captions that are highlighted in this way help the reader to organize information as it is being read—the message gets through clearer and more quickly than when reading undifferentiated captions and headlines.

3. Typefaces throughout a document should be used with consistency. With the great number of typefaces available and resident in a computer, there is a tendency for inexperienced graphic designers to use too many typefaces on a page. This practice results in a graphically confusing page design. In general, headings, subheadings, captions, and text should be set in the same typeface. No more than three or four different typefaces should be used on any one page. This rule applies to consistency of typeface variety throughout an entire document. It is best to use only a few faces and sizes for text in one design piece.

Following these three principles will help to give a document a distinct personality and identity within the boundaries of type usage in any given design project.

HOT TYPE

For almost 500 years after the invention of moveable type by Johann Gutenberg, the printed page was produced in basically the same way. Individual pieces (letters) of type that were cast in a type foundry and assembled by hand into words, lines, and pages. Foundry type is stored in wooden cases. In the United States the type case came to be called the California Job Case (Figure 3.2).

Figure 3.2. A California Job Case.

The California Job Case was designed to hold thousands of individual pieces of type, stored in individual compartments by letter, number, and symbol. Each type case holds a specific point size and style of a family of type, referred to as a *type font*. For example, the type case in Figure 3.2 stores 10 point Caslon Italic type; 12 point Caslon Italic type would be stored in a separate case; 14 point Caslon Bold would be stored in a third case, and so on. As cumbersome as this procedure is, it dominated the printing industries until the invention of the Linotype typecasting machine by Ottmar Mergenthaler in the United States in 1886.

To understand the nature of type, it is important to know the basic principles behind its design. A typeface consists of more than just the 26 letters of the Roman alphabet. It includes both upper- and lowercase letters, numbers, punctuation, and accent characters, along with items such as ligatures and special characters. Figure 3.3 shows a complete typeface with all of its characters.

Times Roman

ABCDEFGHIJKLMNOPQRSTUVWXYZ

abcdefghijklmnopqrstuvwxyz

1234567890

!@#$%^&*()_-+=[]{}:;"'<>,.?/

œ∑´®†¥¨ˆøπ"'«åß∂ƒ©˙∆˚¬…æΩ≈ç√∫˜µ≤≥÷

`/¤‹›fifl‡°·‚ ±Œ„´‰ˇÁ¨ˆØ

∏"'»ÅÍÎÏ˝ÓÔÒÚÆ¸˛Ç◊ı˜Â¯˘¿

Figure 3.3. A complete typeface.

Type is designed so that each of the individual characters in the font will work with one another. The weight, shape, and size of each character are carefully proportioned to balance and complement one another on the printed page.

In addition to the typeface itself, type designers often expand a face to create a type "family." In a family, various weights and styles, such as bold and italic, are created from the original face. In creating a family, the type designer is concerned with having the entire family of typefaces complement one another.

Traditionally, a type designer would draw each character for a typeface by hand. These drawings would then be converted to type molds in a type foundry. Type foundries still exist, but the term "foundry" no longer applies in the traditional sense of casting type in a metal alloy. Most typefaces today are designed on computers using programs such as Altsys Fontographer. Typefaces are then distributed digitally via computer disk or CD-ROM.

Some type foundries make their faces accessible over the telephone. Using a modem, the graphic designer simply calls the type distributor and charges the typeface to a credit card or business account. The font is then downloaded electronically to the designer's computer.

There are also many typefaces available for free or for small "shareware" fees over the Internet and through services such as America OnLine and CompuServe.

FOUNDRY TYPEFACES

Before typefaces were computerized, type was set in a variety of other ways. Early typesetting was done with fonts cut from wood. Later, metal type was found easier to use, in that it could be made in smaller sizes, had a longer life span, and could be melted down and recast. Further technological developments, such as phototypesetting, allowed for quicker setting in lines of type, and this method was in use until the advent of computer typesetting.

TYPE ANATOMY

The anatomy of a piece of foundry type illustrated in Figure 3.4, is the foundation upon which all rules of typographic design are based. Whether the type is set by hand or machine, type nomenclature defines many of the parameters of the typographer, graphic artist, and designer.

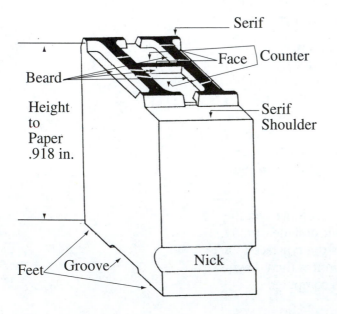

Figure 3.4. Anatomy of foundry type.

SERIF AND SANS SERIF TYPE FACES

Type design can be categorized as either serif or sans serif. A *serif* is the finishing stroke at the end of each letter. A *sans serif* typeface (sans, from the French word meaning without) has no finishing stroke. Note the comparison between serif and sans serif typefaces in Figure 3.5.

Serif face–Palatino

Sans-serif face–Futura book

Figure 3.5. Serif and sans serif typefaces.

Serif type faces, such as the typeface used in the production of this book, are generally used as text typefaces. Serif typefaces, by virtue of their finishing strokes, break up the uniformity of the page and increase its readability. Sans serif typefaces, in contrast, can give the page too much uniformity, making these typefaces more difficult to read in a textbook format. Sans serif faces are generally used for display and advertising purposes, where their relative simplicity of design is an asset and attention grabber. They can also work well when used for smaller amounts of text copy, as in a catalog or brochure.

Several typographic principles are used for determining the proper positioning of type, as well as the adjustment of the space between individual characters, words, and lines of type. The typographer must be aware of all of the basic design parameters to ensure maximum readability and legibility of the printed page. These principles cover word and letter spacing as well as the arrangement of text on the page.

COMPUTERIZED TYPEFACES

First- and second-generation computerized printing attempted to mimic the action of the mechanical typewriter. Dot matrix and daisy wheel printers were the first devices in widespread use to interpret computer input to produce text and graphic images.

Although the type images generated by daisy wheel and dot matrix printers are not digitally reproduced, as is the case with laser printers and digital typesetters, they do interpret digitally stored text information, and serve as an introduction to digital output.

DAISY WHEEL AND DOT MATRIX PRINTERS

Daisy wheel printers were the first devices to gain widespread popularity for printing text applications from personal computers. The daisy wheel printer uses a separate printing wheel for each type font. Each character in the font is located on a separate character arm. A hammer behind the wheel is activated to strike a particular character when it is called upon to print. The action of the daisy wheel is similar to that of a conventional electric typewriter. Although many typefaces are available for most daisy wheel printers, such printers can print only one font at a time—whichever font wheel is loaded onto the machine. Most daisy wheel printers are noisy as a result of the mechanical action of the hammer against the print wheel mechanism. In spite of their relatively low page-per-minute output, daisy wheel printers yield letter-quality results, because fully formed letters are transferred from the raised letters on the daisy wheel to the paper.

Figure 3.6. How a dot matrix printer works.

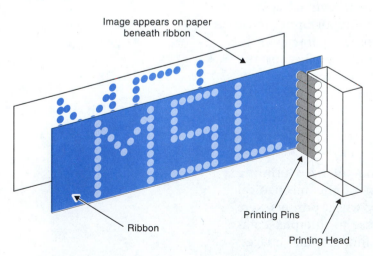

Image appears on paper beneath ribbon

Ribbon

Printing Pins

Printing Head

Dot matrix printers generate characters by selectively firing an array of pins or wires to form printed characters (Figure 3.6). Dot matrix printers are available with differing numbers of pins in the print head. The most common print heads are made up of either 9 or 24 pins. The greater the number of pins, the greater the clarity of the finished print. The pin configurations of typical 9 and 24 pin print heads are shown in Figure 3.7.

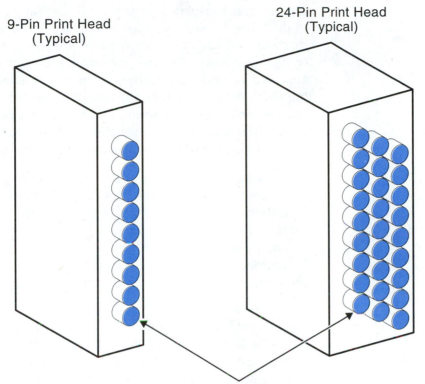

9-Pin Print Head
(Typical)

24-Pin Print Head
(Typical)

Printing Pins

Figure 3.7. Configuration of 9 and 24 pin dot matrix printers.

To print letters with reasonably high quality, a print head with 9 pins will have to make several passes over the letters, whereas a print head with 18 or 24 pins can print high-quality letters with only one pass of the print head. Figure 3.8 shows a single-pass letter from a 9 pin head, a double pass with the same head, and a single-pass letter with a typical 24 pin print head.

Most dot matrix printers can also operate in a graphics mode, in addition to the text mode, to reproduce graphics that are drawn on the computer screen, within the resolution capability of the printer. A specific application program that runs on the computer or is resident in the system folder builds a bit map of the page which is then output to the dot matrix printer.

Figure 3.8. Single- and multiple-pass printing.

85

The computer display of type fonts in the early stages of digital technology resulted in characters that were made up of a matrix of bits written into the memory of the computer. On the screen, these characters appeared as dots that corresponded to the memory bits. In this type of system, the character display hardware of the computer determines what you see on the screen. The idea of "What You See is What You Get," referred to as WYSIWYG, was waiting in the wings.

First- and second-generation phototypesetting machines used separate film type fonts that projected light through individual letters in the film font onto a sheet of photographic paper, one letter at a time. As cumbersome as this might seem, production capacity via the phototypesetters was a great improvement over the most sophisticated hot-type-casting machines.

DIGITAL TYPE FONTS

Digital type fonts are defined as typefaces that are represented and stored as digitized electronic data. Refinements in technology enabled typesetting to move away from the phototypesetter, where the full-featured letter was photographically transferred from the film font to photographic proofing paper, to type fonts stored as digital information residing within a computer. With the development of Macintosh computers, the generation and display of characters by the computer changed forever. Digital typefaces are currently provided in several different formats.

Figure 3.9. A bit-mapped typeface (enlarged).

BIT-MAP TYPEFACES

This is the original type format created for the computer. Bit-mapped typefaces use the screen resolution of 72 dots per inch (dpi) to display on the computer screen. Figure 3.9 shows an enlargement of how a bit-mapped face is constructed. To display correctly on screen, the computer requires a bit-map of each point size of the typeface that will be used. Otherwise, the computer will just enlarge the pixels, leaving a jagged screen image of the type.

POSTSCRIPT TYPEFACES

PostScript type fonts use both the bit-mapped font and a special PostScript file containing information that describes the outlines and fills of the typefaces. The PostScript file works together with the bit-mapped file, and both are necessary for proper display and printing.

Programs such as ATM (Adobe Type Manager) interpret the PostScript information for display on the computer screen at any point size. With ATM, only one size of the bit-map is required, and ATM and the PostScript file will do the rest.

TRUETYPE FACES

TrueType was developed by Apple Computer for use with Macintosh computers and Apple LaserWriters. TrueType files work with the Macintosh system to create any size type on the computer screen and for printing. It is recommended that TrueType files and PostScript files for the same font not be used together, as the system will default to the TrueType font, even though the PostScript file and ATM will display a more accurate representation of the font on screen.

OUTLINE TYPE FONTS

Increased flexibility for more typefaces, point sizes, and rotational qualities is gained from the use of outline type fonts. An outline font generates characters from mathematical descriptions of the letters and symbols in the font. Because outlines can be scaled up or down or rotated in virtually any direction, only one outline is needed to represent a specific character in any size or style of type.

Most printers print type in a bit-map format, so a large amount of processing power is required to change the outline font description to a bit-map format. This processing slows down the overall speed of most printers when working with outline fonts.

STROKE FONTS

Stroke fonts are sometimes referred to as vector fonts. *Character vectors* are the paths that a pen would follow along the spine of a character to generate a specific letter or symbol (Figure 3.10). Stroke fonts are similar to outline fonts in that they can be proportionally sized and rotated.

Character Spines

Pen Shape

Figure 3.10. Construction of a stroke font.

The memory storage requirements of stroke fonts are the smallest of the three types of digital fonts. One major drawback to stroke fonts is that very few typefaces, out of the tens of thousands currently available, can be drawn with just even stroke weights and plain round or square ends.

DEVICE-SPECIFIC FONTS

Many printers and typesetters have type fonts built into the machine. For example, printers in which PostScript is resident come preloaded with a number of fonts. The user can install more fonts by purchasing them separately and adding them to the system. Still other types of printers come with separate font

cartridges. These cartridges plug into the printer and offer a limited number of type styles and point sizes. These cartridges are usually designed to fit only one model of printer. Additional typefaces and styles must be purchased in the cartridge format. In most instances, the computer screen display does not match the output style of the printer when using device-specific fonts.

Similar to the cartridge fonts are soft font sets. Soft fonts sets must be configured for a specific printer and then sent over (downloaded) to the printer by either a specific application program or a printer driver that resides in the computer's system.

SCALING FONTS

Almost every computer program has the capability to scale fonts by compressing or extending the characters in either direction. Scaling fonts can be used to fit more type into a smaller space or to extend type to fill a larger one. Scaling should be done carefully, as a typeface will become distorted if it is scaled too much, as shown in Figure 3.11. As you can see by comparing the original type on the left to the scaled type on the right, certain parts of the type become too thick, while others thin out. Beginning computer users often use scaling too often. Type scaling should be used sparingly because it can easily destroy the proportions of the letter form.

g g

Figure 3.11. An example of how scaling distorts a letter.

TYPE NOMENCLATURE AND DESIGN

THE POINT SYSTEM OF MEASUREMENT

Type is measured using the point system. The basic unit of this system is the *point,* which measures approximately $\frac{1}{72}$ of an inch.

The second basic unit of measure, the *pica,* is used for measuring line length and column size. A pica consists of 12 points. Graphic designers use the point sys-

tem because it is more precise in measuring small distances, such as the space between letters and lines, than the inch or metric system.

LINE LENGTH

Proper line length is an important element in typesetting. Too short a line will result in choppy readability. Too long a line will make it difficult for the reader to achieve the continuity to easily read to the next line. Although some graphic designers have proposed an optimum line length to follow, it is not difficult to see if either if these problems is apparent (Figure 3.12).

"Increasingly, meanings and attitudes are transmitted and made memorable by aural association–the jingles, the oohs and ahs of m o d e r n advertisement–and by the pictorial means of billboard and television. The read sentence is in retreat before the photograph, the television shot, the picture alphabets of comic books and training manuals. More and more, the average man reads captions into various genres of graphic material. The word is mere servant to the sensory shock."
George Steiner, *Literature and Post-History*

"Increasingly, meanings and attitudes are transmitted and made memorable by aural association–the jingles, the oohs and ahs of modern advertisement–and by the pictorial means of billboard and television. The read sentence is in retreat before the photograph, the television shot, the picture alphabets of comic books and training manuals. More and more, the average man reads captions into various genres of graphic material. The word is mere servant to the sensory shock."

George Steiner, *Literature and Post-History*

Figure 3.12. Overly short and long line lengths.

FONT MEASUREMENT (TYPE SIZE)

Many different elements make up a typeface. We will use Figure 3.13 to illustrate the elements of type measurement.

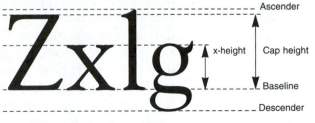

Figure 3.13. **Elements of a typeface.**

The size of a font is measured from the top of an ascender to the bottom of a descender. Because of this, two typefaces may look to be different sizes even though they measure to be the same size. Figure 3.14 illustrates this principle.

60 pt. Futura regular 60 pt. Viking

Figure 3.14. The same size character looks different set in different fonts.

TYPE SPACING

LEADING

Leading is the space between lines of type. The term *leading* comes from the thin strips of lead that were used by typographers to separate lines of foundry type when type was set by hand. Although now most type is set by computer, this term has carried over to the new technology.

Leading is measured in points. The process works as follows: The amount of leading is measured by adding the point size of the type to the number of points of

"lead" from the bottom of a descender to the top of an ascender. If you are specifying this to someone else, it is written as a fraction, with the point size on top and the leading below. For example the leading for this book is 10/13 (ten on thirteen). Leading of "0" means that the descenders of one line will touch the ascenders of another. Although this sounds like it might not look correct, the chances of ascenders and descenders touching is rare, as can be seen in Figure 3.15. With computers, leading can even be set slightly into the negative without totally compromising the appearance of the page.

As a general rule, minimum line spacing should be the same as the point size of the type used. When the leading equals the point size of the type, the job is said to be set solid. One rule of thumb for determining the spacing between lines is to use one-third of the point size of the type on the current line, plus two-thirds of the point size of type on the next line. Thus, if the copy being set is all 12 point text, the minimum leading is 12 points, measured from baseline to baseline. However, in a line of 12 point type followed by a line of 24 point type, the minimum spacing is calculated as follows:

$$\tfrac{1}{3} \text{ (12 pt. type)} + \tfrac{2}{3} \text{ (24 pt. type)} =$$
$$4 + 16 = 20 \text{ points leading}$$

KERNING AND LETTER SPACING

Before the invention of moveable type, books were hand-copied by scribes, one at a time. The correct spacing between letters was done manually, as each line was hand-lettered. By the time moveable type was being cast, it was recognized that the space between certain pairs of characters needed to be balanced to achieve a proper, legible appearance. The adjustment of spacing between certain pairs of letters is called *kerning*. Most word processing, page composition, and professional typesetting programs contain information within the software program to adjust these

"If we seek to communicate a situation or event, our problem is not to capture the *reality* of that situation, but to record or create stimuli that will affect the home listener in a manner similar to a listener's or viewer's experience in the real situation. What counts is not reality, as a scientist might measure it, but the ability to communicate the situation in a believable, human way."

Tony Schwartz–The Responsive Chord

Figure 3.15. Leading of "0."

spaces automatically. Figure 3.16 illustrates some of the kerning pairs of letters.

AT AY AV AW Ay Av Aw A' FA F. F, f' ff
TO TA Ta Te To Ti Tu Ty Tw Ts
Tc T. T, T: T; T- LT LY LV LW L'
PA P. P, VA Va Ve Vo Vi Vr Vu
VY V. V, V: V; V- RT RV RW RY Ry
W. W, W: W; W- YA Ya Ye Yo Yi
Yp Yu Yv Y, Y, Y. Y: Y- " 's 't "
re ro rg rc rq rd r. r, y. y, v. v, w. w,

Figure 3.16. Kerning pairs.

Kerning is most important when setting a word in a large point size. Here, the characters should fit together to look even. Although computer typefaces have built in kerning pairs, this feature often does not work well through standard setting at large sizes, so the designer often has to manually kern the letter spacing for headlines or logos. In body copy, kerning is not needed because the letter spaces do not look uneven in the smaller type sizes.

WORD SPACING

The amount of space between letters and words affects the appearance of the printed page as well as its readability. If the space between words is too great, then each line of type tends to break down into individual elements, rather than a single line of type where one word flows into the other. In paragraphs where the spacing between words is greater than the spacing between lines, reading becomes difficult, as the eye

tends to move from the top of the page to the bottom rather than from left to right. Word spacing can be set either manually or automatically through justification on the computer. To fit copy into a smaller space, or to fill a larger space, word space can either be condensed or expanded.

When text is justified, the word spacing will be adjusted automatically to either condense or expand the word spacing for each line. Notice in Figure 3.17 how each line has slightly different word spacing to allow the copy to be justified. It is important not to set a narrow column of type justified, because the words will be forced to space themselves too far apart in some lines and too close together in others, leaving gaps in the column (Figure 3.18).

"If we seek to communicate a situation or event, our problem is not to capture the *reality* of that situation, but to record or create stimuli that will affect the home listener in a manner similar to a listener's or viewer's experience in the real situation. What counts is not reality, as a scientist might measure it, but the ability to communicate the situation in a believable, human way."

Tony Schwartz–The Responsive Chord

Figure 3.17. Justified text.

Figure 3.18. Poorly justified text.

"If we seek to communicate a situation or event, our problem is not to capture the *reality* of that situation, but to record or create stimuli that will affect the home listener in a manner similar to a listener's or viewer's experience in the real situation. What counts is not reality, as a scientist might measure it, but the ability to communicate the situation in a believable, human way."

Tony Schwartz–The Responsive Chord

WHITE SPACE

White space is an important part of the layout of display type. In using type at larger sizes, white space should be treated as it would for any graphic layout. Figure 3.19 shows an example of how white space is used in a graphic type layout.

The Montclair State 1992 Student Film Festival

This year the Festival will take place at 8 p.m. on Thursday evening, May 14th, in the Calcia Auditorium (Room L135) of the Calcia Fine Arts Building. The evening will be highlighted by the premiere showing of graduate student **Darren Hudak**'s completed version of *"Sex, Nuns and Comic Books,"* a short 16mm color film humorously exploring the sexual frustration of a young comic book writer.

Other productions of note include **Leon Martin**'s film entitled *"Metaphor and Meaning: The Story of Brenda."* This black and white and color theatrical short is a boldly experimental work of complexity and humor. **Maureen Uphoff** is contributing *"The Nap,"* a visual essay on the problems of getting some 'shuteye.'

Also of note will be two films by **Farhad Zamani**, and films by **Francesca Bremner**, **Mark Kalet**, **William Clemis**, **David Anderson**, **Vince Kozlowski** and **Shavaun Pizar**.

The Festival and the film program at Montclair State are conducted by **Michael Siporin**, Associate Professor of Fine Arts. The works shown at the festival have been produced in classes taught by Siporin and Professor George Chase.

Figure 3.19. White space in a graphic text layout.

HORIZONTAL POSITIONING OF TEXT

The horizontal position of text, as well as paragraph description are as follows:

A line of type set flush left

<div align="right">A line of type set flush right</div>

<div align="center">A line of type that is centered</div>

A paragraph is *justified* when the type is set evenly between the right and left margins. Justified type gives a very even and balanced appearance to the text. In narrow-width paragraphs, justified type may result in large spaces between the words. This is the result of the computer inserting enough space between the words to make the lines even on both ends. This effect is noticeable in many newspapers that use narrow column widths and justified columns. The wider the paragraph, the less noticeable the justified space between letters will be.

A paragraph is said to be set *flush left/ ragged right* when the left margin is even and the right margin is ragged in appearance. Breaking up the right margin makes the paragraph less uniform, but also adds to its readability.

Paragraphs are set *flush right, ragged left* when the right-hand margins are uniform and the left-hand margin is ragged. This paragraph arrangement is often used when alignment along the right-hand edge is critical, as in setting up formats used in restaurant menus or advertisements, for example.

NOTATIONS AND PROOFREADING SYMBOLS

To aid communication among writers, editors, and designers, a system of proofreader's marks has developed. This saves each person time by being able to quickly "mark up" text changes.

Correction needed	Mark in margin	Mark in text
Period	⊙	∧
Comma	^,	∧
Apostrophe	˅	∧
Open quotes	˅˅	∧
Close quotes	˅˅	∧
Semicolon	;/	∧
Colon	⊙	∧
Hyphen	=/	∧
Dash	1/N	∧
Parentheses	()	∧
Brackets	[]	∧
Delete text	ℓ	/ or ℓ or —— through text
Insert omitted text	out	∧
Disregard correction	stet	dot under character
Make new paragraph	⌗	∧
Indent	□	⊐
Remove paragraph, run text together	run in	⌐⌐
Move right	⊐	⊐
Move left	⊏	⊏
Raise	⊓	⊓
Lower	⊔	⊔
Center	ctr	⌐ ⌐
Flush left	fl L	⊏
Flush right	fl R	⊐
Align horizontally	=	lines at correction
Align vertically	‖	lines at correction
Transpose	tr	⌐⌐
Insert space	#	∧
Equalize space	eq sp	∧∧∧
Wrong font	wf	circle
Lower case	lc	/ through characters
Capitals	cap	≡
Small caps	sc	=
Roman text	rom	circle
Italic text	ital	—
Bold text	bf	∼∼∼
Superior character	v/3	∧
Inferior character	∧/3	∧
Broken type	×	circle
Invert type	୨	circle
Move type down	⊥	circle
Spell out name	sp	circle
Question for author	au?	∧ or circle

Figure 3.20. Proofreader's marks.

In marking up text, two sets of marks are used. One is placed in the margin area, where it can easily be seen. This should be placed in line with the text to be corrected. The second mark is placed at the point of correction. The chart shown in Figure 3.20 shows a full range of both sets of proofreader's marks.

COPYFITTING TECHNIQUES

Copyfitting is the process of determining how much text of a chosen typeface will fit into a given amount of space. The amount of space needed for a given amount of text varies from typeface to typeface (Figure 3.21).

Helvetica Regular 10/11

"Increasingly, meanings and attitudes are transmitted and made memorable by aural association–the jingles, the oohs and ahs of modern advertisement–and by the pictorial means of billboard and television. The read sentence is in retreat before the photograph, the television shot, the picture alphabets of comic books and training manuals. More and more, the average man reads captions into various genres of graphic material. The word is mere servant to the sensory shock."

George Steiner, Literature and Post-History

Avant Garde Book 10/11

"Increasingly, meanings and attitudes are transmitted and made memorable by aural association–the jingles, the oohs and ahs of modern advertisement–and by the pictorial means of billboard and television. The read sentence is in retreat before the photograph, the television shot, the picture alphabets of comic books and training manuals. More and more, the average man reads captions into various genres of graphic material. The word is mere servant to the sensory shock."

George Steiner, Literature and Post-History

Times Roman 10/11

"Increasingly, meanings and attitudes are transmitted and made memorable by aural association–the jingles, the oohs and ahs of modern advertisement–and by the pictorial means of billboard and television. The read sentence is in retreat before the photograph, the television shot, the picture alphabets of comic books and training manuals. More and more, the average man reads captions into various genres of graphic material. The word is mere servant to the sensory shock."

George Steiner, Literature and Post-History

Figure 3.21. The same amount and size of type set in several different typefaces.

In setting the type for a book, for instance, choosing one typeface over another purely by look may add several pages to the length of the book. As clients are usually working with a predetermined amount of space, it is important that the way the designer sets the type will fit into the correct limits.

Before computers were available, designers used a system of type character sizes, line counts, and column widths to determine how much copy would fit in any given space. This information would then be sent to the typesetter along with the final copy. After the type was set, the designer would check to make sure it was set correctly and paste it into the design.

Now that computers are in the hands of designers, this process has changed dramatically. Most graphic designers today have retired their type gauges and are now able to try a variety of copyfitting styles immediately. This gives the designer more options on how the text will look. It also allows the designer to make fine adjustments in leading, size, kerning, and tracking to make the type fit where it needs to be in the design.

THE E GAUGE

One of the tools previously used in calculating copy is still very handy for the graphic designer. This tool is referred to as an *E gauge* (Figure 3.22). It is simply a clear piece of plastic printed with a capital "E" in various point sizes, along with scales marked with different leading amounts. The E gauge is most useful when the designer must reproduce an existing printed piece, such as an ad or page layout. Rather than guessing at the point size, leading, and column width, the E gauge can be placed over the existing copy to determine these measurements. It is then an easy task to reproduce the design, either manually or by computer.

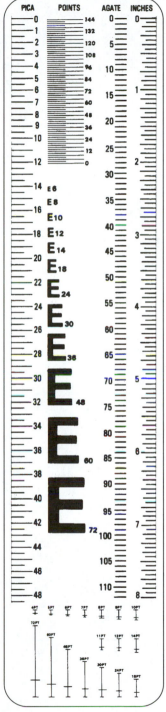

Figure 3.22. An E gauge (not to scale).

E gauges are available in varying qualities of manufacture. Inexpensive ones are less accurate than expensive ones, but work well for basic measurements. High-quality gauges are printed with fine, accurate dimensions on a special thin mylar. They will not shrink or expand with temperature changes and are also flexible to measure curved surfaces.

SUMMARY

In this chapter, we have discussed the fundamental principles used in working with type. The ability to create exceptional graphic design works with type is a learned art. Through an understanding of the basic principles of type use, the beginning designer has a foundation from which to build. As you work with type in your designs, you will begin to see how the many facets of its design and use can be manipulated to create original, exciting graphic communication.

THE

4

Chapter

Design Process

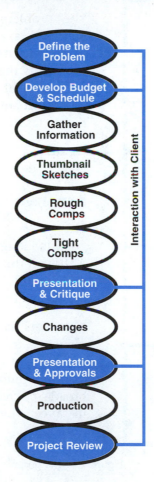

Define the Problem

Develop Budget & Schedule

Gather Information

Thumbnail Sketches

Rough Comps

Tight Comps

Presentation & Critique

Changes

Presentation & Approvals

Production

Project Review

Interaction with Client

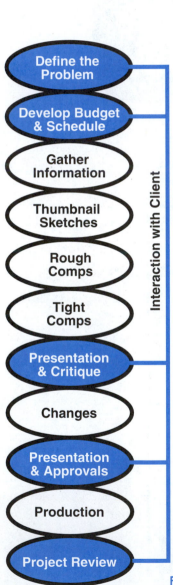

INTRODUCTION

This chapter discusses the basic problem-solving techniques applicable to a graphic design project. We will examine four graphic communication design problems and explain how to approach these projects using the problem-solving model, from initial design concept to execution of the final printed piece. Our final example uses a specific design project and follows it through from beginning to end, showing you how a designer used the problem-solving model in actual work.

THE GRAPHIC DESIGN PROBLEM-SOLVING MODEL

The problem-solving model explained here is a method that graphic designers use to provide the best possible solution to a given graphic design problem. It highlights the decisions faced by a designer in creating a typical design job. Following this model will assist you in creating better designed projects in a timely fashion.

Figure 4.1 shows a graphic representation of the graphic design problem-solving model.

DEFINING THE PROBLEM

The most important step in creating an effective graphic design is to properly define the problem. Although this may appear easy, decisions made at this stage affect later phases of the project and relate directly to the success or failure of the job.

All clients have a basic idea of what they are looking for when they hire a graphic designer. For example, the designer may be asked to design a specific item—a logo, a billboard, or the like. The job may be more broad—to create graphics for an upcoming event, for instance, when the choice of what those graphics are

Figure 4.1. The graphic design problem-solving model.

102

to be is up to the designer. In either case, this is the time for the designer to ask specific questions to determine the client's exact expectations for the project.

This part of the design process can be confusing if the client is vague in his or her expectation and simply states, "I want a new logo." In this case, the graphic designer needs to find out what the client feels a new logo will accomplish and assist in deciding if that is the best form of communication for the client's business. For example, the client may want the new logo to reflect a change in his or her business, to bring in new clients.

In designing the logo, you would also need to know how the new design will be implemented. Will it be used only on business cards? If so, how many cards has the client given out in the past? If only a few have been disseminated, the designer might want to recommend other ways of implementing the logo so that more potential customers will be exposed to it. For a small business, this might mean taking out ads in the local newspapers or sending out flyers. For a larger business, it might mean national television spots and billboards for more extensive coverage.

Properly defining the problem means first finding out what the design should accomplish, and then determining the best form for the design to take to accomplish those ends. As a graphic designer, clients will look to you to assist them in choosing the best way to communicate their messages. Professional expertise in handling the job will build a good designer/client relationship.

DEVELOPING BUDGETS AND SCHEDULES

After determining the basic parameters of the job, a budget and time schedule must be developed to successfully complete the project. These two areas have a major effect on the project's outcome, so they should be carefully considered at the start of the job.

BUDGET

The project budget is developed with the client. After the initial meeting to determine which services will be provided, the designer develops a preliminary budget. Charges for time, costs for other people who work on the project (production help, illustrators, or photographers), and costs for materials and production of the final design piece all have to be taken into consideration.

COST-ESTIMATING TECHNIQUES

Many references are available to assist graphic designers in estimating costs. These references range from consultation with other designers about their fees to books and periodicals published by the design industry. Large design firms will have set rates for charges; if you work for such a firm, you will not have to be involved in the process except to estimate your time for the job. When you work for yourself, however, there are some basic steps that will aid you in determining what you should charge.

A simple way of figuring what you need to charge for a job is to first determine what you need each month to run your studio or office. The costs for rental of space, equipment, insurance, and general monthly office supplies should be included in this figure. This amount is divided by the number of hours you plan on working each month. This results in an hourly rate needed to make ends meet. Of course, this will not be enough to make a profit! Therefore, you will need to increase that amount to make a fair profit.

Another cost estimation method is to charge on a per-project flat-rate fee. To do this, you will have to do some research into what project charges currently are in your geographical area. Most local design organizations have discussion groups or printed information available to help in this process. It is important to remember that design fees will vary from state to state and from job to job. A large corporation should pay more for a logo than a local business, because the large company's logo will be used more extensively.

When figuring out your personal design fees, do not undervalue your own work. If you charge too little, you will not get satisfaction out of the job, and you will not gain the client's respect. Graphic design is a business, and treating it as one will increase your chances of success in the field.

Charges for others directly involved in the design process, such as illustrators or photographers, must be included in your bid, so you will need to get a firm estimate from these persons. It will be your responsibility to pay your subcontractors, so it is not uncommon to add an additional charge to their bids to cover your costs.

Costs for paper, printing, and production materials for the final production run round out the final cost estimates. These costs can be listed as a lump sum on the bid or itemized if requested by the client. Most design studios add a 10 to 25% surcharge to all supplies they buy for the client. In effect, they are making a loan to the client by purchasing the materials. By doing so, they are justified in charging an interest fee for this "loan." If the client wants to take care of the printing charges himself, you can quote the actual charge, but be sure to specify on the bid that it is the client's responsibility to have the work printed.

When the bid is presented to the client, go over it item-by-item to ensure that the client understands all the charges involved. It is important to have the client sign off on the bid. Signed copies should be made for each of you, to minimize any misunderstandings over cost at a later date.

It is good business practice to get from 15 to 50% of the costs of the job from the client after the bid agreement is signed. For the designer, it indicates that the client is comfortable with the price of the job. A client that is unwilling to pay any money at this stage may be reluctant to pay later as well!

The bid process is both challenging and constraining. Not only does it lock the client into the amount to be paid, but it also locks the designer into the same figure. If you underestimate the job, the money comes out of your pocket! In time, however, you will find that bidding a job becomes a normal part of the design practice.

DEVELOPING A SCHEDULE

A project schedule helps keep the project on track and assists the designer in juggling more than one project at a time. In most design offices, schedulers take a graphic approach to create a weekly or monthly chart, which can be posted where it can be easily referred to. Figure 4.2 shows a sample schedule for a job.

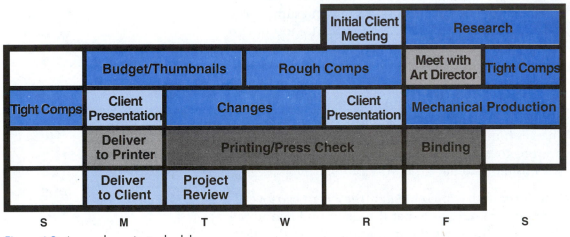

Figure 4.2. A sample project schedule.

In developing a schedule, it is best to work in reverse, starting with the delivery date of the job to the client. From there, it can be determined how much has to be done to get each phase of the project finished. Here are two very important tips when working with schedules:

- Do not assume that the people outside your office who will be involved in the project will be able to adapt to your schedule. Call the illustrator, photographer, paper supplier, and printer to get approval for the dates required. Certain

items, such as paper, may have to be specially ordered, and the time needed for such special orders should be factored into the schedule. Most printing firms reserve time on the press for each job. Be sure you get your job to them on time, or you will have to pay for time the press is sitting idle.

- Do not procrastinate. You may be able to design a job overnight, but you are rarely the only one involved. Remember, everything takes time to get finished, and missing one deadline can cause the entire project to suffer!

GATHERING INFORMATION

Information gathering is an integral part of the design process. This research takes many forms, from talking to the client to hiring a professional research firm. What research is needed depends largely on the size of the job, the budget, and the time frame allowed for the project.

WHY RESEARCH?

The answer to this question is easy. Research helps you to better understand the project, to see variations that others have done, and to see what options are available. With the proper research, a mediocre project can become an outstanding one.

WHAT TO RESEARCH

Although the exact areas to gather information on will vary for each project, some basic things must be done for each project. These include looking into what has been done before, seeing what the competition is currently using, and determining what the potential is for your job—past, present, and future.

Past. Design has a rich history. Many design books are available, with wonderful photographs of items created for all types of needs. For instance, if you are designing a logo, you could easily find thousands of examples of logo designs printed in books. Looking at

these examples can give you a sense of how logos have been used for many different and various-sized companies from around the world.

It is important to remember, when doing historical research, that you are looking for inspiration—not the answer to your problem. Plagiarism in design, as in any area, is frowned upon and can end up getting you in trouble if either your client or the originator of the design happens to see the same design elsewhere!

Present. Competition is everywhere. You want to make sure your design stands out from the competition, but not so much that it looks like something entirely different in context. For example, you would not want a liquor bottle label to look like a liquid soap bottle label! The best way to see how your ideas fit in is to find out what other companies that sell the same or similar products are using in their designs. Go to libraries, supermarkets, and stores where the competition's products can be found. Many design publications feature good examples of contemporary design. It is a good idea to subscribe to a few of them (see the listing of suggested readings in Appendix II).

Future. This category is the most important of the three, because well-executed research here will affect the final outcome of your design. Research of the future is essentially research of the present, with a focus on finding the best available materials for your design-in-progress. It may mean calling paper merchants for the latest samples, talking to an architect or industrial designer to find out about innovations in materials in their respective industries, visiting trade shows, or even looking at an old material from a different perspective. By doing this, you can create a design that will stand out above the competition.

WHERE TO RESEARCH?

Gathering information can take a great deal of time, so it is a good idea to keep a listing of local contacts who can assist you in the process. Some large design studios have full-time research assistants. If you are working alone, make a list of telephone numbers and contacts at local public and college libraries, design studios, paper merchants, and printers. These sources can be helpful in answering particular questions that may arise during your workday.

It is important to begin building a library of reference materials at an early date. In addition to books and magazines, you can include files on different subject matter that you would like to see yourself working with in the future. Files of photos and illustrations can come in handy when you have to prepare a quick comp and need a visual reference.

Although the idea of networking is a negative one for some people, making an effort to introduce yourself to others at social and professional functions can pay off later. You never know when you will meet someone who may be able to assist you with a problem at a later date! Because the design profession works in an interdisciplinary manner and deals in communications, almost anyone can be a valuable ally when you need specialized information.

STARTING TO DESIGN

THUMBNAIL SKETCHES

Initial sketches, referred to as *thumbnail sketches* or simply *thumbnails,* are the first part of any design project. Thumbnails were introduced in Chapter 1 of this text, and here we show how they fit into the problem-solving model.

The creation of thumbnails can start at any time—even at the first meeting with the client—but primarily are done during and after the research phase. These sketches are used as part of the conceptual process. In

creating thumbnails, you are generating ideas and approaches to solving the problem, not just looking for "the answer." Therefore, the sketches are often small, nondetailed, and quickly executed, as shown in Figure 4.3.

Figure 4.3. Thumbnail sketches.

Thumbnails can be done anywhere and on almost anything. Many designers say that their best ideas have been developed on napkins at restaurants. Because no special materials are needed to produce them, thumbnails are often the part of the process graphic designers enjoy the most. Thumbnails help the designer to visually think about the problem at hand and are the first step to a creative solution.

ROUGH COMPS

Taking one or more of the thumbnail ideas, the designer develops a *rough comp*. This is first used to see how a thumbnail idea will work at actual size and is more detailed than the thumbnail sketch. Typefaces are drawn more accurately, color is introduced, and

110

decisions about photography or illustrations are implied in the rough. Roughs may also be done on a computer. The designer should always remember that although the computer can produce a finished-looking work, this is still a rough, not a fully developed idea, at this stage of the process.

Depending on how detailed a rough comp is, it may also be used for initial presentations, either to superiors in a design firm or to the client. It is often a bad idea to show clients roughs that were executed on the computer, as they will see such samples as being too finished. Figure 4.4 shows an example of a rough comp.

Figure 4.4. A rough comp.

TIGHT COMPS

Tight comps are the closest example of how the final job will look. These are most often done on computer, using the actual typefaces and colors of the final design. See Figure 4-5. Tight comps of several of the best concepts are mounted on boards for presentation to the client.

Figure 4.5. A tight comp.

SUMMARY

Notice how the design changes with each phase of the project. Ideas created at the thumbnail stage are evaluated, refined, and developed into tight comps, with many changes along the way. Rarely, if ever, does a thumbnail idea make it through to a final design without significant changes. The problem-solving model assists the designer in developing the best ideas to the final stages, allowing time for evaluation during the design process.

THE FIRST PRESENTATION

The initial presentation to the client is very important. It is your opportunity to show the client how your design solutions address his or her concerns and at the same time get feedback for any changes. The presentation should be approached professionally. All work should be mounted to same-sized boards protected with overlays of tissue or paper.

Usually, several of the best design ideas are presented to the client. A few others are prepared in reserve if the client responds negatively to the initial ideas. Most designers try to pick three or four good ideas that will show a variety of approaches to the problem, rather than variations of only one idea. This way they can get feedback on the entire process instead of risking it all on a single concept.

The success of the first presentation depends on the designer's ability to answer any questions the client has about the designs. It is a good idea to prepare a short verbal introduction of the work to be displayed, briefly going over your development process and stressing how your solutions best meet the client's needs. Design jobs are often won by a well-thought-out verbal presentation that complements the visual one.

After the presentation, the client should initial any approvals or minor changes to be made. If the client does not approve any of the designs, it is important to discuss the project further before proceeding. Generally, most designers will meet with the client for a second presentation at no extra charge. More than one round of changes often requires that the client pay an additional fee. Charges to clients for changes should be spelled out carefully in your budget proposal.

Clients may sometimes be more involved in the design process and want to see rough ideas as well. A word of caution: be careful not to show the client too many ideas. This may weaken the effect of your best

ones. Also, never present anything to your client that you are not happy with yourself. There is no point in designing something that you would not be proud to include in your portfolio!

CRITIQUE

At the presentation, the client will have the opportunity to critique your work. This can often be a nervous time for you as a designer, unless you are confident that you have done what is best for the client. Critique of your work should never be seen as a negative event, but one to allow for the exchange and refinement of your ideas with the client. Be open to the comments given and do not be afraid to explain your concepts when necessary. During the critique, make notes and changes to the work on an overlay so that you will remember what should be altered when you get back to the office.

CHANGES AND CORRECTIONS

When you are asked to make changes or corrections in your design, be careful to make only those changes requested by the client. Everyone is tempted to further refine the design after the presentation. If the client does not like changes you initiated, however, you will be required to change it back on your own time. If you feel it is necessary to make changes other than those specified by the client, go back for approval before proceeding.

FINAL PRESENTATION

A final review is necessary if many changes were required by the client and approvals were not given at the first presentation, or if the client requests it. Depending on the client, this presentation may have to be even more polished than the first one. For example, in a package design job, you might have shown mounted renderings at the first meeting and actual models of the packages for the final presentation. If the client signs off on the project after this presentation, it is time to go into production.

PRODUCTION

Production techniques vary from one project to another (This is discussed further in chapter 11). What is important here is that the production method chosen best fulfill both your and your client's expectations of what the final production design should be. As a graphic designer, you will always be looking for the best quality at the lowest price. Making sure the production mechanicals are executed professionally and accurately will ensure that the final project is completed correctly.

FINAL PROJECT REVIEW

After the job has been produced, it is important that you give it one last look before moving on. The client may be involved in this critique, or it may be done with a design team or by you alone. This is an opportunity to review how well the project met its intended goals. Also look for problems that should be kept in mind for the next job, and evaluate your involvement and the involvement of others in the design process. It is valuable to make notes of the problems and successes of each project so that you can learn what steps will aid you in the future.

APPLICATIONS OF THE GRAPHIC DESIGN PROBLEM-SOLVING MODEL

Following are four examples of the problem-solving model as it is applied in graphic design. Each step of the process is explained as to how it applies to that piece of design.

DEVELOPING A RESUME

A resume (Figure 4.6) is a simple piece of graphic design. As you are both client and designer in this case, many of the steps are handled informally.

Defining the problem is important. The purpose of a resume is clear—to get you a job. What you need to

think about is what the resume will say about you in its design and how this is reflected in the style of the resume. Also, who will the resume be sent to? What would they be interested in?

George Zimmerman 201 555-6501
660 Macintosh Avenue
Montclair, NJ 07042

Graphic Design Experience

Identity for the following companies: Gilo Photography; Terminal Neon; Milne Photography; Gartzke Photography; Montclair State College; Someglas Opticians; "Atlas" jewelry line for Spaz/Pixel among others

At Zimmer State College, I have served as an advisor and designer for printed materials within the Fine Arts Department and the School of Fine and Performing Arts. This includes work on special event logos, newsletters, posters and flyers for visiting artists

Free-lance Macintosh computer production for Marner & Associates and Steve Jasmine Design

Icons for Silicon Beach's "SuperWriter 9.0" manual

Three page color Macintosh illustration for promotional catalog for Milwaukee Institute of Art & Design

Promotional design for the design/performance group DDT including design of posters, passes and T-shirts

Poster, program and identity for Great Shakes Film Festival, "Japanese Culture through Cinema."

Posters, programs, trophies and identities for the "American Finger-Style Guitar Festivals."

Posters and program for Mount Mary College Interior & Industrial Design Seminars

Teaching Experience

Professor, Zimmer State College, Fall 1988-present. Responsibilities include organization and development of graphic design program, hiring and advising of 6 to 8 adjunct instructors, supply and equipment ordering, administration of 20 station Macintosh lab, advising students and teaching four 3 credit classes each semester. Courses taught: Graphic Design and Macintosh Computer Graphics

Instructor, Milwaukee Institute of Art & Design, 1984-1988 Typography, Package Design, History of Design, Visual Communications, Problem Solving, Basic Design, Color Theory, Computer Graphics , and Silk-screening

Instructor, University of Wisconsin-Milwaukee, 1987 Graphic Design

Instructor, Mount Mary College, Milwaukee, WI, 1986 Exhibition Design

Publications

Work included in the book Visual Literacy by Richard Wilde, published 1991

Work included in the book American Corporate Identity/7, published 1991

Featured with the group DDT in the annual design issue of Design Journal, a Korean design magazine, 1988

Professional Affiliations

American Center for Design (ACD)

American Institute of Graphic Arts (AIGA)

Art Director's Club of New Jersey (ADCNJ)

Electronic Design Committee, ADCNJ

Educational Preparation

MFA Syracuse University, 1991

Architecture in Japan, through Pratt Institute, 1987

BFA Milwaukee Institute of Art & Design, 1982

Honored in Who's Who in American Colleges and Universities, 1979-1982

Figure 4.6. A resume design.

Budget and schedule are easy in this application. How much can you afford? Can you afford to have it printed, or should it be photocopied? When do you need to send it out? These questions will determine your budget and schedule.

Some points to consider: Although a printed resume will look better, it is more expensive and does not readily allow for changes. Also, the printing process may take up to a week to complete. Whether the resume is printed or photocopied, what kind of paper should it be on? If the paper is special order, how much of it will you need? How long will it take to get it? This list could go on, but you can see that there are quite a few decisions to be made for even a simple project.

Regarding the research aspect of the job, you may want to look at resumes of other people in the same field. This is not always an option, but if you have friends looking for similar positions, ask to see theirs. You can also check with employment services for assistance in resume preparation for different jobs.

In the design process, you should do a few quick thumbnail sketches of various layout ideas. Also, look at several typefaces and try them together in a sample layout.

For feedback in the presentation phase of the job, show the rough design to friends. Ask them if they find it clear and easy to understand—the most important part of resume design. Carefully examine the resume for spelling and consistency errors. For example, all phone numbers and state names should be listed the same way throughout the resume. A common mistake is to put "NJ" in one place, "N.J." in another, and "New Jersey" in yet another. This inconsistency disrupts the flow of the document. If you know people who own a business similar to the one you are applying to, be sure to ask them for feedback. Their opinion will be important because they are likely to see many resumes from job applicants.

After any necessary changes are made, get your resume produced and send it out. In this case, you will know how well you have done by the response you get!

BUSINESS LETTERHEAD

Designing a letterhead may also involve designing a logo, or one may be supplied for you by the client to apply to stationery. In this example, we use the latter case and discuss the process involved in applying a pre-existing logo.

A letterhead (Figure 4.7) is a fairly straightforward design. You want it to reflect the style of the business and allow enough room for correspondence. In defining the problem, ask your clients the following questions:

- What is the average length of the letters they write? This will help you to determine whether to use a full or half sheet, or if you will need a second page.

- Do they hand write, use a typewriter, or use a word processor? Each has its own format considerations. With a word processor and laser printer, for example, you could design a file with their logo for them to print at any time.

- How many sheets do they plan to have printed? This will help you to figure costs. It is cheaper per item to print a large number of multicolor pieces than to print only a few.

- What can they afford to spend? Along with the previous question, this will aid you in determining how much you can afford for printing and paper. The client may not always be ready to answer this question immediately, but may want you to price the job several ways and then compare those costs.

Figure 4.7. A business letterhead design.

In gathering research information, look to design books on letterhead and to letterheads of other businesses dealing in similar goods or services.

Creating thumbnails for a letterhead is like playing with a kit of parts. You have a few elements: logo, address, phone and fax numbers, perhaps an Internet address. You want to put them together in a way that makes the best sense for your client. In your sketches, try various placements to see the visual effects they create, testing symmetry/asymmetry, foreground/ background, and so on. After the exploration of thumbnails, create several tighter versions to present to the client.

In your presentation, show each letterhead in context. Place a fictitious letter (or a real one from the client) on the page to show how the stationery will look in use. Mount each design on a separate board so that you can easily eliminate any designs that are not in the running. Listen to the client and note any changes needed. Have the client sign off on the design if it is approved.

After the final design is approved, you only need to create the mechanicals and have the letterhead printed.

In reviewing the final project, make note of the following: Was the design produced accurately to your specifications? Are the colors correct? Is the printing crisp and the type sharp? How does the paper work with the design? How well does the design work in use? Is it easy to use, fold, and send?

LABEL DESIGN

In designing a label for a package (Figure 4.8), the designer must take several more considerations into account than with a resume or letterhead. In this example, we show how these considerations fit into the design process.

In defining the problem, the designer should find out the pre-existing product specifications, including

package size, materials, and copy to appear on the label. Further questions about budget and deadlines should also be asked.

A schedule and budget should be developed. In preparing the budget, the designer needs to speak with a package design printer. This is a very specialized printing field, and labels for different products have to be printed in different ways. Things to consider here include whether the label is to be printed on a box, attached to a bottle, or applied directly to a surface, such as silk-screening on glass.

In addition to the printing research, the designer also needs to investigate the design of competing brands. Usually, the easiest way to do this is to make a trip to a local store that carries competing products. While at the store, be sure not only to examine the competitor's packages individually, but also to notice how the packages are displayed on the shelf. Packages, when displayed as a group, can create a different visual impression than when viewed individually. You may want to purchase several examples of the competition so you can later test how your design will look alongside them in your studio.

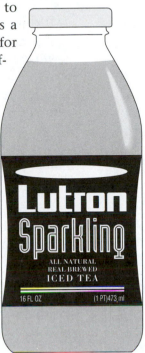

Figure 4.8. A package label design.

When starting the thumbnails, check the notes you have made thus far. Does your research suggest a more thorough design than the client originally suggested? For instance, you might now feel that the bottle should be redesigned to make it stand out more distinctly from the competition. If so, you should make the client aware of your concerns before going further. If not, be sure to work on an idea that will make your design stand out above the rest, but yet have good shelf presence. Think about how to use color and typography to create a distinctive package.

Again, based on the client's needs, review your thumbnails to determine which designs should be worked up to a rough stage. In the rough, you will be able to see which of your designs will work best at actual size, with color and typography treated more accurately.

At the first presentation, you will be showing several of your best concepts. For packaging at this stage, you will probably be showing only a rendering of the front of the package. The objective here is to give the client an impression of the overall look of the package, not to show every side of the package in detail. If the client chooses one or more of the designs for you to take further, you will bring a completed design to the final presentation meeting.

When changes or corrections are made in a label, it is time for you to get to the specifics of the final label. There are many rules for applying nutritional information and requirements for the Universal Product Code (UPC or bar code), all of which must be followed precisely. This final design is often mocked up to resemble the package in three-dimensional form, either constructed as a foamboard box or applied to a bottle to present to the client.

Once the client approves the final design, mechanicals must be made to send to the printer. This is most often done on the computer; a computer design can be given to the printers as an electronic file for them to create the color separations.

In conducting a final project review, go back to the store and see how the product looks on the shelf. Does it stand out from the competition? Does it meet the client's expectations? Is the printing of high quality? If you designed the package itself, check the fit and finish of its construction. Take notes on your observations for reference when doing similar projects in the future.

DESIGNING A BROCHURE

Here we trace an actual job and present a case study for a brochure created for a car club (Figure 4.9). The brochure used for this example included photographs and illustrations. The steps reflect how these elements came together to create the final brochure.

In an initial client meeting, the basic needs of the client were discussed: What will the piece be used for? How many are to be printed? What is the budget for the piece? With this information, printing estimates from several printers were requested to determine the best way to produce the brochure.

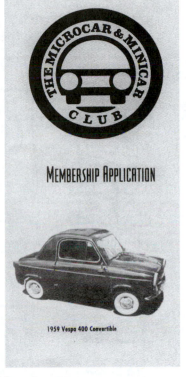

In the example shown, the designer found that the client had a limited budget, so the brochure was created to follow these specifications: standard three-fold, 8.5 x 11-inch paper; one color ink printed two-sided. The budget did allow for special paper, so different stocks and weights were investigated.

The client in this example was an international car club for small cars, The Microcar & Minicar Club. They already had a logo, and gave the designer a variety of images from their archives to use in the brochure. Additional research for imagery was unnecessary in this case, as the designer had more than enough images to choose from. The designer did, however, talk extensively with representatives from the club to determine which cars were the most popular and should be featured in the brochure. As this brochure was to be used as a membership application, some additional research into form design was done at the local library.

Figure 4.9. A brochure design.

Thumbnail sketches were done, exploring different placements of the logo, photos, and text (Figure 4.10).

From the thumbnails, three rough ideas were worked up to size on the computer. The designer, referring back to notes made at the initial client meeting and to specifications given to him by the printer, determined that two of the roughs best met the client's needs, and these were completed as final comps to show to the client. For the final comps, the designer laser-printed the designs on several types of paper and folded them to give the client some different perspectives on how the design could look.

The client decided to go with an uncoated paper that had a light blue fiber woven into it. To complement this, the designer suggested using a dark blue ink rather than black. This was approved by the client (a Pantone color ink guide was brought to the meeting to show the client different ink choices). The client signed off on the final design and the piece went into production.

Figure 4.10. Thumbnail sketches for brochure.

In reviewing the final printed piece, the designer checked ink quality, how well the paper folded, ink coverage across the folded areas, and alignment of the paper when folded (one element was designed to cross over a folded section as shown in Figure 4.11). Feedback from the club was very positive. The brochure was easy to mail, and the professional look of the piece helped to increase the membership!

Thank you for your interest in the Microcar and Minicar Club! The Microcar and Minicar Club, Inc. is a not-for-profit social club dedicated to the enjoyment and preservation of small and unusual cars, both foreign and domestic. It is not necessary to own such a car to join.

We define a "small" car as one less than 11 feet long and/or having an engine with less than 1000cc displacement. How do we define "unusual"? We'll leave that one up to you, but to give you an idea of what we consider to be unusual, some of the typical makes of cars found in our club include the BMW Isetta 300, Citroën 2CV, Crosley, Daf, Goggomobil, King Midget, Messerschmitt Kabinenroller, NSU Prinz, Subaru 360 and Vespa 400. The primary focus of the club is on the post-WWII "bubblecars" (so-called because of their semi-spherical shape), in particular the Isetta (the original, Italian-designed Iso Isetta and its derivatives the BMW Isetta, BMW 600 and 700 series) and the Messerschmitt.

Isetta

We can trace our Club's ancestry back to the Heinkel-Messerschmitt-Isetta Club of the 1970s and early 1980s, but the present organization dates from Fall 1991. Since then, the Microcar and Minicar Club has steadily grown in size, with members all across the United States, Canada, Great Britain, Germany, Norway, Brazil, Argentina, Guyana, Australia, and Japan.

The Club publishes a quarterly magazine called MINUTIA (pronounced "min-NEW-sha"– defined by Webster's as "a minute, precise, or minor detail"), which is the thread joining all our members together. MINUTIA features current small car news, details on member-oriented events, technical information, reprints of period literature and road tests, restoration and maintenance tips, small car trivia, photos of members' cars, sources for parts and service, and a classified ad section which reaches the largest single group of small car enthusiasts in the world!

Come Join Us!

1959 Messerschmitt KR200

Figure 4.11. Detail of folding design.

SUMMARY

This chapter has shown how the graphic design problem-solving model can be applied to various design jobs. You will find that using this process in your own design jobs will help you to be better organized. It will also help you to create more appropriate solutions for your clients and assure that your solutions meet the expectations of both you and your clients.

Chapter 5

ELEMENTS OF Creative Graphic Design

Article Title

It's been over a year since the end of the '80s. This gives us some distance, some perspective. The '80s are now, officially, history.

The '80s were a decade of comebacks: suspenders, mini-skirts, Roy Orbison, Sugar Ray Leonard...But the reality big comeback was history. We got rid of history in the '60s, saw what the world looked like without it in the '70s, and begged it to come back in the '80s. And it did, it came back with a vengeance.

In design, history came back as well. Suddenly, there were countless books-big, glossy, oversize volumes - and starchy little journals devoted to the history of design. Careers were constructed around this fascination. Conferences, too.

And there's nothing wrong with studying the history of design. In fact, it's healthy and smart, especially for design professionals. At the same time, the indiscriminate use of history has produced some really bad, unhealthy design. History in itself isn't bad, but its influence can be

There are two problems with design history. The first is how design history is written, but how history is written affects how the past is seen and understood. How history is written also affects how the past is used. And that's the second problem. Most design history is not written, it's shown. There's a lot to look at, but not much to think about. Maybe this is because designers don't read. That particular cliché (which, like most clichés, has a basis in truth) provides a good excuse for a lot of hack work in publishing: collections of trademarks, matchbooks, labels, cigar boxes, you name it - volumes and volumes of historical stuff with no historical content. And since these artifacts are mostly in the public domain, unprotected by copyright, such books are a bargain for the publishers and a godsend to designers who are starving for "inspiration."

We seem to be lucked into a self-fulfilling prophecy: Designers don't read, so designers don't write. Isn't it unreal that They write captions. Sometimes they write really long captions, thousands of words that do nothing but describe the pictures.

Books of design history that are packages for a supposedly illiterate audience only engender further illiteracy. Visual literacy is important, but it isn't everything. It doesn't teach you how to

think. And as enormous amount of graphic design is made by people who look at pictures but don't know how to think about them.

The study of design history is a way of filtering the past. It's a way of selecting what's important to remember, shaping it and classifying it. It's also a way of selecting what's important to forget. In a way, historians are inventors. They find a design movement, a school, an era, and if it doesn't already have a name, they make one up: Depression Modern. The American Design Elite. Populuxe.

Design historians construct a lens through which they view design - and we view design. This lens is selective. It zooms in on a subject and blocks our peripheral vision. What we see is a narrow segment of design history: one period, one class of designers within that period. What we don't see is the context, both within the design profession and within real history.

Design history provides us with terminology, a shorthand for thinking about the design of an era. We come across phrases like the "New York School," under which Philip Meggs, in his book "The History of Graphic Design," groups innovators like Paul Rand, Bradbury Thompson, Saul Bass, Otto Storch, Herb Lubalin, Lou Dorfsman, and George Lois. The New York School is made

INTRODUCTION

Good communication is simple and direct. Just as it is hard to pick out one voice in a crowd, so it is difficult to see the message in a overly complex piece of graphic design. Yet, most inexperienced designers often try to put too much into their work, as in Figure 5.1. This leaves the viewer trying to figure out what is being communicated, which can quickly lose the viewer's attention.

Figure 5.1. An overly complex design.

Achieving simplicity in design is not always easy, however. Clients sometimes want the graphic designer to fit a large amount of information into the given space, which can be a challenge. This chapter helps you find some ways to organize space, combining type and imagery on a page to create good design.

TYPE AND IMAGE

Type and image are the two major elements that every designer works with. Type communicates written information, and image supports the text and adds to the visual interest of the piece. It is important to understand how each of these elements works, both individually and with the other.

Type is a part of virtually every piece of graphic design. It is the element that directly informs the viewer of your message. It is the most challenging of the two elements, and the most easily overlooked by

126

beginning designers. Working with type creatively is a learned art. Therefore, it is important that you never think of type as something that you are forced to "deal with," but rather as the most important design element.

Image, unlike type, can rarely stand on its own and still communicate a complete idea. Except in the case of pictograms, such as road signs, visual images work hand-in-hand with the written information, first to attract the viewer's attention and then to supplement the text. A good designer chooses images that work with the text to create well-communicated ideas and messages.

Two categories of images are used in graphic design: photography and illustration. The designer chooses which category will best work with the design in his or her mind. This decision is made during the initial stages of the project—generally when making thumbnails and more specifically when creating roughs. In designs where accurate representation is needed, a photographic image is usually the choice. Where more freedom is available, or when a concept that cannot be photographed is required, illustration can add extra punch to a design.

There are no hard-and-fast rules when it comes to choosing photography or illustration in a piece of graphic design, as there are many different styles of both. Also, with the use of computer imaging, the line between the two categories can sometimes blur.

Although it is the designer who chooses and lays out the typeface and photographic or illustration elements, most of these elements usually come from outside sources. For example, typefaces are available for computer typesetting from many vendors. Most design studios have libraries of books showing examples of photographers' and illustrators' work, so that professionals can be hired when their style is appropriate.

STYLE

In well-designed pieces, type and image work together. For example, in an article on Victorian interiors featuring antique photographs of rooms, you would try to pick a typeface that has the character of the Victorian age for the headline. See Figure 5.2. The correct typeface ties the text and imagery together, creating a personality for the layout. This personality is called *style*.

Figure 5.2. Type and image working in support of one another.

In the selection of both type and image, style plays an important role. The variety of styles for type and imagery is almost endless. With the dominant role of computers in today's graphic design profession, more type styles become available each day. Therefore, today's graphic designers must keep abreast of new developments in typeface design, photography, and illustration to know where to find the styles necessary for their work.

When getting a project to the rough stage, the designer must decide what style an image will take. For example, let's say you drew a thumbnail sketch of a basket full of apples on a poster for an orchard. When you take that sketch to the rough stage, will that basket of apples be represented as a photograph? If so, will it be black-and-white? Sepia-toned? Color? Hand-colored? Or will it be an illustration? In pastel? Oil paint? Gouache? From what angle will the basket be shown? How many apples will be in the basket? As you can see, the list could go on and on. It is the designer's responsibility to choose the best representation of the basket of apples for that particular client.

There are always factors of time and budget to be considered as well, which may help to narrow the choices. Nevertheless, it is up to the designer to produce the best image for the client. Your reputation, as well as the client's, is riding on it!

RULES, BORDERS, BOXES, AND SHADING

In addition to the two major elements of type and image, designers also work with another category of elements, which act as accents to type and image. Rules, borders, boxes, and shading can help to organize a design and give it visual weight. Each of these elements has its own uses.

Rules are used to separate information or to provide a base for a page. When placed horizontally between lines of text, they can show a break of information. They can be used in the same fashion to create a barrier between text and image. Used vertically, rules provide the same functions, in addition to defining columns on the page. See Figure 5.3.

Rules are measured by weight in points from a hairline (the thinnest line that will print evenly—.025 point) on up. The width you use depends on how well it integrates with the text and imagery in your design. See Figure 5.4.

Figure 5.3. Vertical rules used to define space on a page.

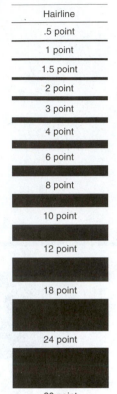

| Hairline |
| .5 point |
| 1 point |
| 1.5 point |
| 2 point |
| 3 point |
| 4 point |
| 6 point |
| 8 point |
| 10 point |
| 12 point |
| 18 point |
| 24 point |
| 30 point |

Figure 5.4. Rule weights using a point measuring scale.

Borders work as a frame to separate one element from another. If an element, such as a chart or graph, should be emphasized in a design, placing a border around it can help it to stand on its own. On a photograph, borders can define the edges of the photo as well as separate it from the text. This is especially helpful when the photo does not have a well-defined edge (see Figure 5.5). Borders can range from simple lines, again measured by points, to complex decorative elements. See Figure 5.6.

Figure 5.5. How a border helps to define a photograph's edge.

Figure 5.6. Examples of borders.

Boxes are simply borders that are filled in. Often the box will even exist on its own, without a separately defined border. You can fill in a box with a color, or use a tint of color to fill it. Boxes work best with larger type sizes and graphic elements, as small type sizes may get lost against the box's fill. Because a box has a fill, however, type can be reversed out of this fill to compensate for readability problems (see Figure 5.7). Boxes are used for the same purpose as borders—to separate an element within the design.

Shading, or the use of tinted screens that are positioned behind type, is accomplished by using screens with built-in rulings that are graduated in darkness from a light (10%) tint to a dark (90%) tint. These percentages refer to the amount of space that the black tint dot occupies within an allocated matrix or box. For example, a screen or box with a 50% tint means that the black dot occupies 50% of the white space within the matrix area. Increasing the tint screen to 90% means that the dot occupies 90% of the available space. Boxes with tints, or shades, that range from 10 to 80% are shown in Figure 5.8. Commonly used screen sizes range from 65 to 150 lines per inch. For example, a 133-line screen means that there can be a maximum of 133 dots per linear inch across each inch of the screen area. A 100-line screen is coarser than the 133-line screen, with only 100 dots per inch available for detail or for shading. Screen sizes higher than 150 lines per inch are used in reproductions where high detail and quality, such as in artistic reproduction, are required.

> **When using a dark or black box, bold reversed type is most legible.**

Figure 5.7. Using reversed type in a box.

Figure 5.8. 10% to 80% tint screens.

- 10%
- 20%
- 30%
- 40%
- 50%
- 60%
- 70%
- 80%

The designer should keep in mind that type is harder to read when placed over a shaded area, because contrast between the type and its background are reduced. Also, if a shade pattern is too dark, the type becomes almost unreadable. Compare the readability of type placed over a 20% tint as opposed to the readability of the same type over an 80% tint (Figure 5.9).

Figure 5.9. Readability of type over a 20% and an 80% tint screen.

TYPE SELECTION

Selecting the proper typeface can at first be an arduous task. However, as you learn more about the character of type and how it works, this task becomes easier. In every piece of graphic design, the designer deals with levels of textual information that make the choice of typefaces very important. Let's look at type choice in context.

In a book, there are chapter titles, section titles, body copy, page numbers, and other text elements that have to be distinguished from one another on the page. The designer needs to make decisions as to how these elements will look on the page and how they will work with one another.

Take this book, for example. The chapter titles are set in Stone Serif Italic and Futura Bold, the body text in Stone Serif, and the page numbers in Futura Regular. The designer of the book had to make choices to make the layout work visually. Because this is a textbook, it must be easy to read and study. Therefore, the design

is more conservative than you might find in a consumer fashion magazine, where photographs play a larger role. A designer must be aware of how the piece of graphic design will be used before the typefaces are chosen.

The designer works with a client first to determine the style of the piece, as well as which elements of the text are most important. He or she then prioritizes the different elements of text in the design. By choosing typefaces that work well together, the design should be successful. After a while, you will find that successful choices are not that difficult to make. Although thousands of typefaces are available, following some simple rules can make the decision easier.

One primary rule for picking good typefaces is to try to use only a few for each design. The right combination of typefaces for the job allows variety without creating visual chaos. When looking at different faces to use with one another, you can either choose faces that work well together because of their similarities (Figure 5.10), or choose ones that complement each other due to their differences (Figure 5.11).

Figure 5.10. Typefaces that complement each other due to similarities.

Futura extra bold
Gill Sans light

Univers 75 Black
Times Roman

Figure 5.11. Typefaces that complement each other due to differences.

When choosing dissimilar typefaces, it is best to set the majority in similar faces, with one different typeface as an accent element. If you use too many different typefaces on one page, you can easily end up with a "ransom note" look that will surely be confusing to the viewer.

TYPE STYLING

Each typeface is available in different styles, such as weight (i.e., light, medium, bold, extra bold), italics (usually regular and bold), and different cases (i.e., all caps, small caps). This gives the designer options within each set of typefaces (called a *family*) to create variety. In a family of typefaces, each of the styles was created by the typeface designer to complement one another. Although strong differences may be apparent between a face's regular and italic styles, they still belong to the same family. The designer can even create variety in a design through the use of different styles of the same typeface family. Figure 5.12 shows an example of the type family Futura.

Most computers are equipped with options for styling type with shadows, outlines, or underlines. Although the novice designer may be tempted to use these computer-applied styles, they are not as well constructed as the original family; the computer applies the instructions to the typeface rather than the typeface's designer in creating the style. It is better to find a type family that offers you these options within itself. The computer option of shadowing or outlining is best used for headlines or display type that is large enough to be read easily, as seen in Figure 5.13.

Futura Condensed Light
Futura Condensed Light Oblique
Futura Condensed
Futura Condensed Oblique
Futura Condensed Bold
Futura Condensed Bold Oblique
Futura Condensed Extra Bold
Futura Condensed Extra Bold Oblique
Futura Light
Futura Light Oblique
Futura Book
Futura Book Oblique
Futura Regular
Futura Oblique
Futura Bold
Futura Bold Oblique
Futura Heavy
Futura Heavy Oblique
Futura Extra Bold
Futura Extra Bold Oblique

Figure 5.12. A portion of the Futura type family.

Figure 5.13. Shadowed type used as a headline.

COLUMNS

All type fits into a column of some sort. A *column* is the width and height of the block of text. When a graphic designer determines how the type will be worked into the design, a grid is set up which shows a column number and width. When dealing with large amounts of type, the type will normally be broken into several columns on the page. The designer has several decisions to make when working with column formats.

First, a decision must be made as to how many columns will be used. This can often be a simple matter of measuring the width of the page and considering the size of the type. The design objective is to make the length of each line of type easily readable, so that the lines will be neither short and choppy, nor too long. If a line of type is too long, it is hard for readers to find their place when moving from the right end of the column back to the left, as discussed in chapter 3.

Columns are generally of equal width on the page so that a consistency of reading is established. The designer wants the reader to be able to follow the text smoothly and effortlessly, without having the design get in the way of readability.

The designer also deals with the height of columns on a page. Most often, an upper and lower column boundary is set for a design, but columns can also vary in height to allow for variety and image placement on a page, as shown in Figure 5.14.

Figure 5.14. Varying column lengths.

Also, text can easily be made to wrap around an image. This changes the width of the column and can also add variety to the design. However, the designer must ensure that the type does not become too compressed or expanded as it wraps around an image. Figure 5.15 shows proper and improper uses text wrap.

Chances are, at some time in our life we will be faced the situation of having to talk with some-one who has cancer. While there are no hard and fast rules of etiquette in dealing with this sometimes uncomfortable situation, there are way to ease the awkward-ness, and help you in

Chances are, at some time in our life we will be faced the situation of having to talk with someone who has cancer. While there are no hard and fast rules of etiquette in dealing with this sometimes uncomfortable situation, there are way to ease the awkwardness, and help you in your relationship with someone who has

Figure 5.15. Improper (left) and proper use of text wrap around an image.

Figure 5.16. A grid design for a magazine.

GRIDS

To create a strong design that ties all of the graphic elements together visually, the designer uses a system of grids. In a one-page design, such as a poster, grids are not always necessary. For any design with repeating pages (for example magazines, catalogs, and brochures), a grid is an extremely valuable aid to the designer.

A grid (Figure 5.16) gives the designer boundaries within which to work. On a page, it shows basic information such as the left and right margins, top and bottom margins, and column layout. It can also show where the page number, titles, and subtitles are to be placed. It can even show where images will be placed. With a well-thought-out grid design, a magazine or catalog can be laid out quickly and efficiently. The grid as the design foundation ties the pages together and creates the publication's personality.

It may sound as if the grid is a very limiting device, which causes every page to look alike, but this is not the case. A well-designed grid allows great flexibility, and many different layouts can be made from a single grid. See Figure 5.17.

Figure 5.17. Examples of three layouts designed from the grid shown in Figure 5.16.

IMAGE PLACEMENT

At the beginning of this chapter, we discussed decisions that have to be made in the selection of images. In dealing with the layout, the placement of images comes into play. Depending on the grid structure of the design, a logical placement for images may or may not be obvious. Remember, the main issue for the graphic designer is the balance between the placement of text and graphics.

The balance between type and image is an important one, and varies with the intent of each individual piece. The designer must determine which of the elements is most important and adjust the visual balance accordingly.

WHITE SPACE

As you can see, in the previous examples there is a great deal of unused space on the page. This *white space* is the negative area of the page—the areas with-

out text or image. This white space acts as a visual "rest stop" for your eyes. White space around the edges of the page acts as a frame, holding the design together and separating it from its surroundings.

Imagine one poster placed among many others on a wall. White space around the edges can help to make that one poster stand out from the others by separating it from the visual clutter of the wall.

On a magazine or book page, white space allows the reader room to hold the edges of the page while reading an article. In this way, white space not only visually separates graphic elements, but also serves a functional purpose as well.

White space should be thought about from the beginning of any project and evaluated with each step. This is especially important during the design of the page grid.

Although there are no set rules as to how much white space is needed in a piece of graphic design, it is important to understand how this negative space works in a design, and how it assists the viewer in understanding the message. A contemporary design from *Automobile* magazine is shown in Figure 5.18. Note how the white space is used to draw attention to the various elements on the page.

Figure 5.18. Use of white space in a contemporary magazine page layout.

COLOR

Color can play a central role in graphic design. The designer creates with various combinations of color, from a simple black-and-white project to multicolored pieces. Most often, work falls into one of the following categories.

One Color. A one color piece does not necessarily mean black-and-white, although it can. It means that only one ink color will be applied to the paper. This can be any color of the designer's choosing.

Two Colors. The next step up from a single-color piece, a second color can often be used for emphasis without costing much more. Often, "two colors" refers to black ink plus one additional color ink, but this need not always be the case.

Three Colors. Not used as frequently as one or two color designs, it allows the placement of any three colors on the piece.

Four Colors. Four color design is how most color photography and full color design work is printed. Technically, it means that four separate inks are printed. Cyan, magenta, yellow, and black inks make up the four process colors that are used to reproduce full color images (see chapter 10 for more details on four color process printing). It can also mean that four separate colors are chosen by the designer.

More Than Four Colors. Sometimes the designer may want to print full color along with special colors, metallic inks, or varnishes. To do this, a press capable of printing more than four colors is required. Many large offset print shops have six to eight color printing presses available for this type of work. An alternate method, if you are printing sheet-fed work, is to run the job a second time through a smaller press to add more colors.

CHOOSING COLOR

Colors should be chosen to accent a design and not because of the personal preference of either the designer or the client. Color should be tied in with the concept of the piece. The designer should try to stay away from picking a color just because it is currently fashionable, or because it was used in a similar piece. Every once in a while, it is helpful for graphic designers to lay out all their recent work to observe how they have used color. Is there variety, or does the designer rely only on a certain range? By doing this periodically, you will become more aware of your use of color as a designer.

Color choice can be challenging. Also, in addition to picking the colors, as a prospective graphic designer you must also be aware of how they will be affected by the paper on which they will be printed.

CHOOSING PAPER

For printed work, paper is another very important factor. The right paper can add depth to a piece of graphic design. Conversely, the wrong choice can ruin a good design concept. Paper suppliers offer samples of all the papers they carry, and it is a good idea to build your own library of samples for use in determining which paper will be right for the job.

Paper has a visual side and a textural one as well. If you are designing a piece that will be held, think about how the paper will feel in the viewer's hands. A paper that works for one project may not work well for another. For example, if you are designing a brochure for a nature conservancy, you may want to pick a more textured, recycled paper rather than a slick, glossy sheet. In this way, the actual feel of the piece aids in communicating your concept.

SUMMARY

Understanding the basic elements of graphic design gives you a "kit of tools" to use in constructing strong layouts. Good graphic design composition comes with use of the elements discussed in this chapter: white space, proper typeface and image choices, design and application of grids, and supplemental elements of rules, borders, boxes, and shading. With practice and evaluation of your work (by yourself and others), you can develop your own methods of refining these basic principles to create effective communication through graphic design.

Chapter

6

FUNDAMENTALS OF

Computer Graphics & Electronic Page Composition

INTRODUCTION

The computer has become an indispensable tool for graphic designers. It speeds the production process, allows for easy changes in typography and layout, and gives the designer more control over work than ever previously possible. Most entry-level design jobs now demand computer skills as part of the production process. Hand skills are still important and looked for in a beginning designer, but most employers also want designers to be comfortable working at the computer.

The most popular computers for graphic design are the Macintosh and IBM-compatible (Window/ Graphic Fundamentals) machines. Most software companies now make their software for either computer platform. Which one to choose is a matter of personal and professional preference. If you are trying to decide which platform you should learn or buy, call local design studios and find out what most of them are using. Although both platforms are moving closer together, it is still important for you to be trained on the one most popular in your area, to increase your marketability. Many young designers now learn to work on either platform, which can be a benefit when looking for a job.

This chapter discusses the types of computer programs designers work with and explains the unique characteristics of each. This chapter is not geared toward any one platform, but rather speaks to the general use of various computer design programs.

COMPUTER GRAPHIC DESIGN

Although computers have been in use for many decades, their impact in the graphic design profession was not felt until the mid-1980s. At that time the personal computer, together with the availability of specialized graphics software, reached the point of being useful in a professional setting. Programs such as PageMaker made it easy to produce page layouts com-

bining both type and graphics. From the mid-1980s to the early 1990s, advances in hardware, software, and printing technologies quickly increased the quality standards of the industry. By the early 1990s, most graphic design firms had made the switch from traditional typesetting and hand preparation of mechanicals to computerized graphic design.

Because of the relative ease of use of the computer and the low cost of equipment, the term *desktop publishers* was coined to describe a new group of low-budget graphic designers. Although most design firms shy away from use of the term, desktop publishing has opened up the graphic design field to many people who would have never been involved in the traditional sense. Some say this has lessened the professional quality of graphic design, but it has also brought in new influences and competition, and made traditional designers rethink the ways in which we communicate.

TYPES OF DESIGN PROGRAMS AVAILABLE

Computer programs used in graphic design can be divided into three categories: drawing, painting, and page layout programs. Although this list by no means describes every type of program available for the computer, it highlights the program types most frequently used by graphic designers. In the following section, each type is discussed and examples of each program are given.

DRAWING PROGRAMS

Drawing programs are used for creating hard-edged graphics. In a drawing program, you create lines through the use of connected points (Figure 6.1). These elements are referred to as *object-oriented,* meaning that the computer sees them as complete and separate elements which may be moved around on the page intact.

Figure 6.1. Connected points create a line.

Curves are made through use of the Bezier process. Each curve has an "anchor" point and two "control" points, as illustrated in Figure 6.2. The control points can be selected individually, and changing their position relative to the anchor point changes the arc of the curve. Neither the anchor point nor the control points are visible in the final print.

Figure 6.2. A Bezier curve.

Shapes are created by connecting a series of points to create a single closed shape, as in Figure 6.3.

In any design job, planning the page in advance is the most important step. As discussed in chapter 4, the design process involves working closely with the client to develop ideas to meet the requirements of the job. In production, it also involves choosing the computer program that will best create the kind of images you want to produce. Popular drawing programs include Adobe Illustrator, Macromedia Freehand, DeskDraw, and Deneba Canvas.

Figure 6.3. **A closed shape.**

Advanced drawing programs give the ability to create three-dimensional (3-D) shapes and to render these shapes with lighting, shading, and reflection. The basic principles of these programs are the same as the drawing programs previously mentioned, but their sophisticated controls require much more memory to render the created objects. Strata's Vision 3D, Adobe Dimensions, Alias

Sketch, and Ray Dream Designer are some of the 3-D drawing programs currently available. Figure 6.4 shows an example from a 3-D drawing program.

Drawing programs handle type well, but not in large amounts. Currently, these programs cannot create multiple pages of linked text. In dealing with text, however, drawing programs have the ability to convert type to outlines, making type into a graphic format. This is handy when designing logos, because type converted to outline will not require the typeface's individual PostScript files for printing.

Because of their strengths in creating hard-edged graphics, drawing programs are used for producing package designs, logos, charts and graphs, and other "single-item" designs. Finished drawings can easily be saved as Post-Script files and imported into other programs to combine them with other elements (see section on page layout).

PAINTING PROGRAMS

Painting programs allow the user more freedom than drawing programs in creating softer surfaces. They also function quite differently from drawing programs. Painting programs use a bit-map process for display and printing. Items are not individual elements, as in a drawing program, but are composed of individual pixels, or "bits," making up the whole image. In a black-and-white image, pixels are turned either on or off to create black or white. Color programs use pixel depth, changing the color of each pixel on your screen, to create illustrations with a wider use of color, texture, and

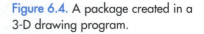

Figure 6.4. A package created in a 3-D drawing program.

focus than possible with a drawing program. The Macintosh screen, for example, has a resolution of 72 pixels per inch, but painting programs allow for much higher resolutions. Painting programs are most often used for photo retouching or illustration. See Figure 6.5.

In a painting program, the tools used by the designer on the computer mimic the traditional ones artists and designers are used to working with. Brushes, pens, and airbrushes have been converted to a digital format. The results are familiar to the traditional artist, yet the process is completely electronic. No mess to clean up when you're finished, either! There are also many tools available that photographers will recognize: special filters, focus, dodge, and burn tools, to name a few.

Figure 6.5. An illustration created in a painting program.

Many of the more interesting computerized tools are completely new to the designer, and are time savers. There are tools that allow you to quickly change the color in a given area, to apply textures, or to layer images and blend them together. Figure 6.6 shows some of the specialized tools that painting programs offer.

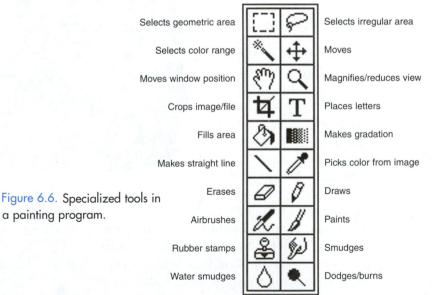

Figure 6.6. Specialized tools in a painting program.

Selects geometric area	Selects irregular area
Selects color range	Moves
Moves window position	Magnifies/reduces view
Crops image/file	Places letters
Fills area	Makes gradation
Makes straight line	Picks color from image
Erases	Draws
Airbrushes	Paints
Rubber stamps	Smudges
Water smudges	Dodges/burns

Although painting programs have the capability to create type, it can neither be edited easily nor checked for spelling errors. It is better to create your type in a drawing or word processing program and bring it into a painting program only if you need to apply special effects to it (Figure 6-7). Popular painting programs include Adobe Photoshop and Fractal Design Painter.

Figure 6.7. Special effects for typography created in a painting program.

Some painting programs allow the designer to open a drawing program file. This feature enables you to create an item, such as a logo or label, using the strengths of the drawing program and then to bring these elements in for placement on a scanned-in photograph. See Figure 6.8.

PAGE LAYOUT PROGRAMS

Page layout programs, which feature great flexibility, are available to assist the designer in creating computerized mechanicals. In a page layout program, you can quickly bring together text and images to create layouts for magazines, books, brochures, flyers, or posters. The most popular page layout programs are QuarkXPress and Adobe PageMaker.

The backbone of a page layout program is its ability to set up grids for many different kind of page layouts. As discussed in chapter 5, grids make up the skeleton of the page and allow the designer to work faster while keeping consistency in the design. A good page layout program allows you to create several different grid layouts as "master pages," which can then be applied to the document's pages. These grid lines show up as light lines across the page on screen, although they do not print on the document. See Figure 6.9.

File created in drawing program

Figure 6.8. A drawing file placed within a painting program.

147

Page layout programs contain text tools, which offer a degree of flexibility in setting type. Provisions for fine adjustments in kerning, tracking, and leading are standard in most page layout programs. Together with controls for typeface, type size, and justification, these tools give the designer control over the typography in the final layout. These freedoms, which traditionally would have been communicated to a typesetter, also demand more of the designer's time for production. Therefore, many studios hire specific computer production people to handle the "typesetting" portion of the design job. Often, entry-level positions start the beginning graphic designer out in computer production before moving up to a designer level.

It is also important for a designer to be a good proofreader. Although spell-checking features exist in most word processing and page layout programs, the designer must take care also to check for grammatical and punctuation errors, which were once the typesetter's responsibility.

Figure 6.9. A grid design created in a page layout program.

Page layout programs offer only the most basic of drawing tools. It is expected that complex illustrations will be done in either a drawing or painting program and then imported into the page layout. Because of this, page layout programs are set up to allow the designer to easily place graphics created in different file types.

Page layout programs often contain many different kinds of placed images and many typefaces and give the designer the option to collect all of the files together for output. In doing this, copies of the layout

file, plus copies of all images used, are placed in a single folder, along with a report telling the designer all typefaces and images used in the layout. This double-check comes in handy when the files must be sent out for film or paper output.

Because page layout programs form the core of so many operations within the area of computer graphics, let's examine some of the techniques associated with electronic page composition in greater detail.

FUNDAMENTALS OF THE ELECTRONIC PAGE

Designing a page electronically allows quick design and production changes, which can be of great benefit to the graphic designer. It does, however, pose problems as well. This section discusses the process of page design on the computer.

Initial sketches may be done by hand or on the computer. A drawback to using the computer for thumbnail sketches is the temptation to spend too much time refining an idea, when the time could be better spent developing many quick ideas to explore a variety of possibilities. Another problem can be that the designer, when using the computer in the initial sketch phase, will use "design formulas"—common layout ideas—rather than trying to develop specific concepts for a particular project.

The main points to consider when planning the layout are page size, type use, image use, and how the piece will be printed. These factors should be narrowed down before going to the computer. It will be helpful to make up a few "dummy" pages to assist in making typeface, type size, column width, and margin decisions. These elements do not have to be finalized at this stage, as they often change during the course of the design. It is important, however, to have a good idea of what general style the publication will use from the beginning.

DESIGN CONSIDERATIONS

Once initial concepts have been completed, the graphic design can be started using the computer. Through the use of a page layout program, the designer can create the basic structure for the layout.

GRID AND COLUMN SIZES

The grid design is the first phase of the project in a page layout program. A well-designed grid allows flexibility in placement of both text and graphics, and can be used for successive issues of the publication.

In a page layout program, the grid should be set up on the master pages. These master pages allow you to set up guides for the grid in one place and then apply them to all of the pages automatically. Repeating elements, such as page numbers, volume and issue numbers, dates, and repeating rules, should be set on the master pages. Take the time to read the manual that came with the page layout program you use. You will even find ways to make the pages self-number in the correct order!

Some page layout programs enable the designer to set up several different master pages. This is handy when using different grids or element layouts for different sections within the same publication. Empty text boxes can also be made on the master pages. These boxes will later be filled when text is imported onto the pages.

REPEATING ELEMENTS

GRAPHICS AND ARTWORK

Elements such as titles or logos may become a permanent part of the layout. These items may be placed on special master pages or on the publication's regular pages. It is important that their placement be part of the initial layout so that they do not have to be squeezed in later.

OTHER REPEATING ELEMENTS

In most publications, there are several elements that tend to be repeated in each issue. These include the masthead and the statement of publication, which should be included in the initial layout.

DESIGN CRITERIA APPLIED TO THE JOB

As in any graphic design job, it is important to review and evaluate the work as it progresses. This may be done by the designer independently, or by a group consisting of the designer, client(s), and postproduction people. In a publication design, evaluation is a crucial part of the process, because the design will be in use over a longer time period than most other types of graphic design. Principles such as readability, flexibility, and cost should be carefully examined.

Once the design has been approved by the client, creation of the actual publication can begin.

DESIGNING TEMPLATES

If the layout will be used for a regularly issued publication such as a monthly magazine, it may be desirable to create a template for the design. A *template* is a stripped-down version of the publication that can be used each time the magazine is produced. The template contains all the repeating elements that are featured in each issue of the publication.

In a page layout program, the design can be saved as a specific template file. When saving a design this way, the program will open the template as an untitled file, forcing the user to save it under a new name and protecting the template as a master for future use.

IMPORTING TEXT

Most of the text in publications is prepared using a word processing program and then imported into a page layout program. Often, the design studio receives

all of the copy for a publication on disk, proofed and ready for use in the layout. This is the preferable way of working, as it leaves the responsibility for typographic errors with the client. This method does have its drawbacks, however. Sometimes the client may not deliver the latest version of the file, thus shifting the proofreading responsibilities onto the designer.

Page layout programs have special features called *filters* that allow text to be imported from a variety of word processing programs. This makes for easy placement of text from different sources. For example, the Macintosh computer also reads PC files with a special program called "PC Exchange." Thus, even though the text was created on a different computer platform, it can still be imported into the Mac, while leaving the disk in its original PC format.

IMPORTING GRAPHICS

Graphic images can also be imported from a variety of sources. The most important part of importing graphics is whether the files will be used for final output or simply "for position only" (FPO). FPO graphics will later be replaced with high-quality images at the printer or prepress house. High-resolution color photographs are the most common graphics used for position only in a layout. This is because the technology for scanning color photographs is generally too expensive for most design studios, and the files created by them are too large to be used on the average designer's computer.

FPO images are scanned into the computer at a resolution of 72 dots per inch (screen resolution) so that they will display well on screen while keeping the file size small. Color images may also be scanned in grayscale to hold down the file size.

When working with a combination of images to be used for printing—logos, line art, etc.—and FPO images, it is a good idea to assign an unused color to all of the FPO images, just to keep track of them.

Some page layout programs enable the marking of image files so that those files will not print, although text set to wrap around them will continue to do so upon printing. This is a handy feature, which most designers take advantage of often when using FPO images. A printed file with images marked not to print is shown in Figure 6.10.

Figure 6.10. On-screen and printed views of photos tagged "not to print."

REWORKING TEXT AND GRAPHICS

Text and graphics often have to be altered for use in a layout. This section discusses some of the many and various ways each can be changed for use in a page layout.

TEXT CHANGES

After importing, the text is changed by the designer into the typeface and style of the final publication. To aid in this process, page layout programs have the ability to create style sheets, as discussed in detail later in this chapter. By creating style sheets for each of the different type elements in a layout, text can easily be changed. This is very important, as the type imported from the word processing program rarely, if ever, matches that of the publication.

Other text changes may be necessary during the course of the publication layout. These changes may include editing for length or content or last-minute replacements for stories. (Unfortunately, writers are as busy as designers and can rarely provide completed

153

copy when it is needed.) Although these changes are not always welcomed by the designer, page layout programs have built-in aids to assist the designer in making last-minute changes.

A *search-and-replace feature* helps when a name or word has to be changed throughout the publication. For example, if a name was misspelled in the original file, it will have to be replaced in every occurrence throughout the document.

A *linking feature* can link the placed text to an original word processing file, so that if any changes are made to the word processing file, the page layout program will automatically make the necessary changes within the text.

Using the special features of a page layout program can make text changes much easier to deal with. With practice and knowledge of the page layout program, the designer can make any necessary changes without it becoming a time-consuming task.

GRAPHICS CHANGES

Changes in graphic images may come from two sources. In the first instance, an original graphic file may have to be changed or replaced because of alterations in material content. In the second instance, the designer may decide to make changes to the graphic within the program to enhance the visual appearance of the layout.

If changes are made to the original graphic file, the process is the same as the text changes mentioned earlier. The file can simply be updated, or the page layout program can be configured to automatically update graphic file changes.

The designer may also decide to make changes to a graphic file after it has been placed in the page layout program. Changes such as color and size are fairly simple to make. Certain graphics files, such as those

saved in TIFF format, may have a wide variety of changes made to them within the page layout program, including contrast, brightness, color, and size. Using these abilities of the page layout program, the designer can screen a TIFF image into the background or convert it to a high-contrast image for special graphic effects. See Figure 6.11.

Original TIFF Image

Manipulated TIFF image: 30 line screen/45°

Figure 6.11. A TIFF image altered from within a page layout program (screened and made high-contrast).

COMBINING COMPUTER DESIGN PROGRAMS

A designer's familiarity with all of the programs and their features aids in making decisions as to which program best fits the requirements of the job. Most often, the designer uses a combination of two to four programs in producing a job, so it is important to know how the programs work together. There is nothing more frustrating than trying to get a program to do something it was not designed to do! Although you may be able to create a drawing in a page layout program, it is easier and requires less time to do it in a drawing program and then import the drawing into the layout.

Let's take a sample design job and trace the uses of the computer in its production. To produce the cover shown in Figure 6.12, a drawing program was first used to produce the logo. The logo was then wrapped onto the sphere in a 3-D drawing program. The image

of the car was scanned in and cleaned up in a painting program. The two illustrations were then brought into a page layout program, where the type was created. Through the use of these four programs, the designer was able to achieve the desired results in a timely fashion.

Figure 6.12. A design combining several programs.

FILE FORMATS

In order to create and save various kinds of files, many different file formats were created for the computer. Some of the major formats used in electronic page composition are described here (chapter 7 also discusses file formats in more detail).

Encapsulated Postscript (EPS). EPS files are actually two files in one. One file contains the PostScript information that the file needs for printing, the other the QuickDraw information that the computer uses for display of images on the screen.

TIFF. TIFF stands for Tagged Image File Format. It is a good way to save scanned images. The TIFF format allows for changes in contrast, density, and color to be made easily. A TIFF file is saved in bit-mapped format, but unlike the standard 72 dpi bitmap, the TIFF file can be any resolution you choose. The main drawback to saving a file in TIFF format is that, because of the large amount of information saved, the file may be quite large.

PICT. PICT files are common on the Macintosh computer and contain QuickDraw information that the Mac converts into an image. A PICT file may contain bit-mapped or object-oriented elements.

GIF (Graphics Interchange Format). The GIF format was developed by CompuServe, an information service. It is a standard file format that works on all computers. GIF images are also used for display on the Internet.

BASIC SKILLS USED IN COMPUTER GRAPHIC PROGRAMS

Next, let's examine some of the primary skills a designer uses when working with computer programs.

INITIAL LAYOUT

The first step in working in any computer program is to plan out the design. This is done using your thumbnails or rough sketches as guides, which will save a great deal of time in producing the job.

The initial layout requires, at a minimum, choosing the size of the page and the method of measurement (inches, picas/points, agates, or millimeters). The designer must also select guidelines to help in aligning elements or for creating a grid in a page layout program. (See chapter 5 for further information on grid design.)

Multipage documents may also require the creation of style sheets for typesetting. Style sheets allow the designer to easily and quickly apply a typeface, point size, leading, and other type characteristics to a paragraph of type. Also, once the basic styles have been selected, the designer can go back and change the style sheet. All of the text that was defined in that original style will then change to match the new style sheet definition. This feature is very handy when working on a catalog, book, or magazine design.

RULES, LINES, AND SHAPES

Rules are one of the most common elements a designer uses. In a computer program, making a rule is as simple as making a beginning point and an endpoint. Rule thickness can be set or changed quickly and the rule can be duplicated easily.

Lines in a computer program can be made using the same technique used for making rules, or can be curved by using multiple points along the line. The common way to do this is through the Bezier method.

Many programs offer the ability to quickly make geometric shapes by using specific shape tools. These shapes usually include squares, rectangles, circles, and ellipses as minimum choices. Other choices may

include pentagons, hexagons, octagons, or shapes with any number of sides. Some programs even include the ability to make special shapes such as stars!

Free-form shapes are simply a series of curved or straight lines made into a solid shape by connecting the last point to the first and making it a solid.

SHADES AND FILLS

SHADES

Most shapes created in a program can be either shaded or filled. By specifying a color and shade, a shape will take on greater definition. Although the designer can create any shade from 1% to 100% in increments of 1, it is best to use shades in 10% increments. (It's almost impossible to see a real difference between a 10% and 11% shade in printing.) Larger shading increments help to separate various elements on the page.

When working with shades, it is a good idea to do a test of a sample shade scale on the printer that will be used for final output. Computers and printers are not perfect in their shading controls, and what is specified to be a particular shade in a computer program may end up being either lighter or darker when actually printed.

FILLS

Fills may be a color, a pattern, or an image. All programs allow color to be set as a fill. Many programs also allow patterns or images to be used as fills and usually offer a choice of fills. Some programs allow the operator to create custom fill patterns.

When using an image as a fill, a shape is first created using the method described earlier. An image is then placed into that shape (although the method of doing this varies from program to program). The result of this process is shown in Figure 6.13.

Figure 6.13. An image placed inside a shape.

AIRBRUSHING TECHNIQUES

Airbrushing is a technique available only in painting programs, although drawing programs can sometimes mimic the effect. The method is very similar to the traditional way of using an airbrush to apply paint. However, because this is a computer, the tool is infinitely more versatile than the real thing! An airbrush on the computer can be used to erase, dodge or burn, tint, lighten or darken, or even reveal parts of an underlying image.

THE RIGHT TYPE FOR THE JOB

There are thousands of typefaces available for the computer, and each design studio will own different faces. The designer should not always depend only on the typefaces available on one computer; fonts can easily be ordered and are not very expensive. A good designer will determine which type is best for the job and get that typeface rather than relying only on those readily available. When doing a large job, the price of the typeface can often be charged to the client. It is a good idea to keep up to date on new font releases, and many type companies will put you on their mailing lists once you buy from them.

Inexpensive CD-ROMs are available with "hundreds of fonts" for a low price, but these are not often well constructed, and may not set well for professional use. They may, however, be a good starting point for a design student.

COMBINING TYPE AND IMAGE

As discussed in chapter 5, type and image are the mainstays of graphic design. The computer gives the designer a great deal of flexibility on how these two elements can be combined, and we discuss some of those options here.

SEPARATING

Separating the text from the image is easy to do on the computer. Figure 6.14 shows a simple example of a separated text and image. One advantage to placing an image on the computer is that you can set the text to automatically break over and below the image. In this way, text editing is easier and does not have to be reset if text changes are made.

WRAPPING

Wrapping text around an image, also referred to as *runaround,* is also easy to do in a page layout program. There are settings for method of wrap (around the image box or around the image perimeter) and for the distance the text will wrap around the image (Figure 6.15). The designer should be careful not to wrap the text too close to the image, as this makes the type less readable. In this book, eight points of space is used when wrapping text around images.

The BMW Isetta

The BMW Isetta was built from 1955 through 1962. It was powered by a one-cylinder BMW motorcycle engine capable of speeds up to 60 mph. The Isetta sat two adults, with entrance to the car through a front-hinged door. Unusual in its design and appearance, the Isetta sold well in Europe as a city car for people who preferred an economical all-weather car over the purchase of a motorcycle. Although they were sold in the United States, they were not very popular, and were sometimes even given away with larger automobile purchases.

Figure 6.14. Separated text and image.

Figure 6.15. Text wrapped around an image.

SUPERIMPOSING

Placing the text on the image, or *superimposing,* is another design method (Figure 6.16). It is important that the image be light enough or of a contrasting color, so that the type will stand out from the image and be easy to read.

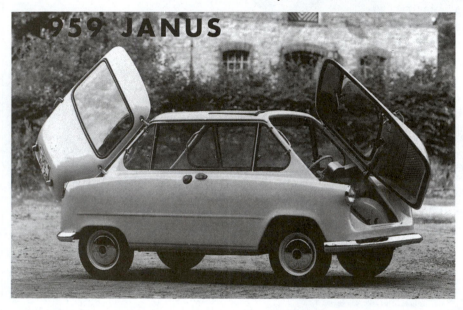

Figure 6.16. Type superimposed on an image.

KNOCKING OUT

Knocking out the type from the image is readily accomplished on the computer by setting the type color the same as the background (Figure 6.17). Again, readability should be the main criterion, and the designer must be sure the type is of sufficient size so that it will not close up during printing.

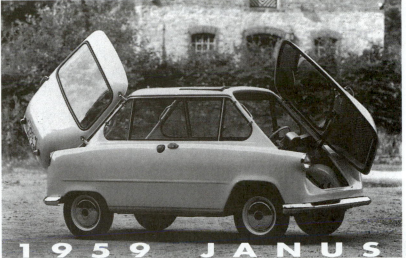

Figure 6.17. Type knocked out of an image.

GHOSTING

A popular computer manipulation of type is to *ghost* the type over the image. This can only be done when the type is large enough to read easily, and involves using a painting program to construct a word as a graphic with the image as its fill. The type image is then darkened or lightened and matched to the original image, as shown in Figure 6.18.

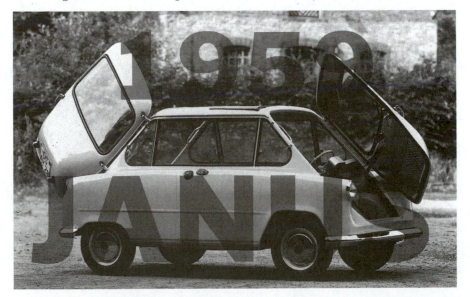

Figure 6.18. Type ghosted over an image.

163

SUMMARY

This chapter provided you with some insights into the basic operations of computer graphic design and page layout tools. These principles lay a foundation for your future design work.

The computer has changed the way graphic designers work and will continue to do so as new technologies and applications are developed. The development of electronic page composition has opened up the design, printing, and publication field, which heretofore was restricted to the world of the printer and traditional graphic designer.

It has been predicted that the computer may mean the end of printed communications in the future, as we rely more on electronic technologies for communication. Whether this proves to be true cannot be known. However, even if this comes to pass, designers will still be necessary for providing the visual interface necessary for good communication.

Digitizing Data

```
0010111101001110100001001010000011101010011110010111
0101110100010010100011110101001111001011101001110100
0000101000111101010010011100001011110100111010010001
0100001011110101001111001011101011101000011001010001
1101010011110010111101001110100000001011101001110000
0001010001010001111010100001111001100101111010011101
1000010100100011110101001101100101101010101010100000
1010001111010011100100101101101001101001100010010000
1101101010000111100001011011010011101001010010100000
1111010100111100101111010111010010000101010001011010
0110011001011101010011010010010000101111010011101001
0001010001010001111010100001111001001011110100111010
1000101010000101110101001111001011110101110100001001
0001101101010011101011110100111101000011001010001111
0101000011110000101101101010011101001010001010000011
1001111001011011010101110100001001010001111010100111
1101010011101000010100010100110011010011101000100010
0100011001101010000111100100101111010011101001000010
0001101101010011110101111101011101110100000101001011
1010011011001011110101001101000110001010001111010100
0111000010111101001101000100010010001111101010011110
0101111010111010000001010001111010100111100101101101
```

INTRODUCTION

This chapter looks at some of the ways in which text and illustrations are changed from their original format into the digital data required by computers. Data must be in a digital format to be processed for either storage or printing.

Most data input devices rely on some form of scanning. Scanners interpret the intensity of light reflecting from either text or continuous tone copy into digital format. Once digitized, the copy can be manipulated, modified, and enhanced to meet a wide variety of specifications. Blue skies can become pink, red shirts yellow, and so on. Before examining the options available for digitizing copy, let's take a look at what *digital* really means.

WHAT IS DIGITAL DATA?

The world around us is analog—shades of gray rather than distinct blacks and whites. For example, the traditional speedometer on an automobile which uses a needle moving along a circular path as the car changes speed, is an analog instrument. However, if the speedometer displays the speed of the automobile in numbers rather via a moving needle, the readout is digital rather than analog. Because natural phenomena are analog rather than digital (different color shades in a color photograph, or shades of gray in a black-and-white photo), they must be converted into a digital format if they are to be understood and processed by computers.

Almost all natural and manmade phenomena can be digitized: colors, shades of gray, and the letters of the alphabet. Digital circuits use a numbering system referred to as *binary*. In the binary system, all numbers are composed of zeros and ones. Figure 7.1 shows the binary equivalents of the numbers 0 through 9 and the 26 letters of the alphabet.

Character	Binary Equivalent	
0	0011	0000
1	0011	0001
2	0011	0010
3	0011	0011
4	0011	0100
5	0011	0101
6	0011	0110
7	0011	0111
8	0011	1000
9	0011	1001
A	0100	0001
B	0100	0010
C	0100	0011
D	0100	0100
E	0100	0101
F	0100	0110
G	0100	0111
H	0100	1000
I	0100	1001
J	0100	1010
K	0100	1011
L	0100	1100
M	0100	1101
N	0100	1110
O	0100	1111
P	0101	0000
Q	0101	0001
R	0101	0010
S	0101	0011
T	0101	0100
U	0101	0101
V	0101	0110
W	0101	0111
X	0101	1000
Y	0101	1001
Z	0101	1010

Figure 7.1. The binary numbering system.

The trick to understanding the binary numbering system lies in the idea of weighted number positions. In the decimal system, the value of a number depends on how many places to the left of the decimal point the symbol is. For example, the number 5.0 = five ones; 50.0 = 5 tens; 500.0 = 5 hundreds; and so forth. Each move to the left of the decimal point multiplies the value of the symbol by 10.

The binary numbering system also has weighted symbol positions, starting to the left of the binary point (the binary equivalent of the decimal point), but uses multiples of 2 rather than 10. Thus, 1 = one 1; 10 = one 2; 100 = one 4; and so forth. The weighted positions of an eight-figure binary number are: (128) - (64) - (32) - (16) - (8) - (4) - (2) and (1). Using this system, the binary number 10000101 means 1 x 128 plus 0 x 64 plus 0 x 32 plus 0 x 16 plus 0 x 8 plus 1 x 4 plus 0 x 2 plus 1 x 1, which equals 128 + 4 + 1 = 133.

The digital circuits in a computer represent a binary "0" with 0 volts and the binary "1" with 5 volts (dc). In this way, circuits are turned on and off, sounds are generated, and video pictures are displayed in full color and stereo. The longer the digital code, the more information is carried and the greater the clarity of the sound or resolution of the picture.

HOW IS ORIGINAL DATA DIGITIZED?

Several methods are used to convert, or *digitize,* data for graphic reproduction purposes. Most of these methods rely on scanning technology. Figure 7.2 lists ways in which a variety of original copy can be input and output in digitized form. We discuss each of these technologies in more detail later in this chapter.

Note from Figure 7.2 that although the device used in the input process varies based upon the type of original copy, the output options are much less selective. Almost all original copy can either be output to an imagesetter, laser printer, or digital copier or used in direct-to-plate or -press systems.

Original Copy	Digitizing Technique	Output Device
Color Slide	Transparency Adapter on Scanner Slide Scanner Photo CD Scanner	Computer Computer to Imagesetter to Film, Paper or Plate Media Computer to Digital Press Computer to Digital Copier Computer to Large Format LaserWriter
Color Photograph	Flat Bed or Drum Color Scanner Internegative to Slide to Slide Scanner Photo CD Scanning	Computer to Imagesetter to Film, Paper, Plate Media Computer to Digital Press or Copier
Original Color Artwork	Flat Bed or Drum Color Scanner	Computer to Imagesetter, Press, Copier, or LaserWriter
Black-and-White Photograph	Black-and-White or Color Scanner	Computer to Imagesetter, Press, Copier, or LaserWriter
Text	Black-and-White or Color Scanner with Optical Character Recognition Software	Computer to Imagesetter, Press, Copier, or LaserWriter
Digitized Copy		Computer for Further Processing

Figure 7.2. Methods of digitizing various kinds of original copy.

Different scanning techniques are used to scan black-and-white, as opposed to color, originals. Although adaptations are made to ensure the accuracy of original color artwork when scanning, outputting a color file to a laser printer is the same process as outputting a file that contains only a black-and-white white pen-and-ink drawing.

Let's examine the input process more closely. Our discussion begins with a look at the foundation of digital input, the process of scanning.

THE BASICS OF A DESKTOP SCANNING SYSTEM

There will always be differences of opinion as to what constitutes the ideal combination of components for a complete scanning system. Some generalizations can be made, however, concerning the basic components required.

Minimum computer system requirements are recommended in what is known as the *MPC* (for Multimedia PC) *specifications*. Level 3 MPC specifications call for a 75 megahertz Pentium or Power Mac equivalent (both systems include a built-in math co-processor). Computers equipped with 486DX processors also work well with most software programs, as well as game and entertainment titles. MPC-3 recommends a quad speed CD drive, although two-speed drives will handle all but high-end data retrieval tasks. On the PC platform, the CD drive can interface with the computer either through a small computer systems interface (SCSI) terminal or a proprietary interface card that should offer high-speed data transfer. SCSI-2 terminals are the minimum, with SCSI-3 data transfer systems now beginning to appear. Macintosh computers use a SCSI interface that is built into the computer. Many PCs have to have a SCSI interface card installed in the computer if this interface is chosen.

Minimum computer memory requirements call for a low end of 16MB of RAM (32MB is preferred) with 1 to 2MB of video RAM and an accompanying screen resolution of 640 x 480 pixels running 65,000 colors. Video playback should incorporate MPEG decoding capability (see MPEG under data classification later in this chapter). Hard disk size should offer a minimum of 1 gigabyte of storage, especially if working primarily with color images and video. (One gigabyte is equal to 1,000 megabytes.) When working primarily with video and multimedia production software, an "AV" rating on the hard drive is preferable. The AV rating means that the hard drive will only recalibrate,

or make self-adjustments, during idle periods and not when data transfer is taking place. For audio playback, a 16 bit sound card is recommended in MPC level 3.

External storage devices should be provided if possible, either in the form of hard drives, optical disk drives, or removable hard drive media such as recordable CD-ROM drives. Storage space is an important factor to consider when purchasing a computer system for desktop use, because digitized color images generally take up large amounts of disk space. Although file compression software can reduce individual file sizes, disk space will quickly be used up if only a few scans are made each day.

Color balance and color accuracy are an absolute must for all computer monitors. The computer monitor should have a maximum dot pitch of .28mm (the dot pitch is the space between the dot structures on the screen). Anything higher than a .28 pitch is merely a television screen dressed up in a computer monitor case and should be avoided. Also, the monitor should be noninterlaced (an interlaced monitor refreshes only half of the lines on the screen during each refresh cycle, which limits overall resolution and image quality on the screen). Color calibration hardware and software packages are available as monitor options and should be considered if a large amount of color separation scanning and image processing is to be done.

Scanners and imagesetters are discussed a bit later in this chapter. It should be kept in mind that inexpensive desktop scanners have limitations that will affect the quality of grayscale and color output. Imagesetters should be able to output at least a 150 line per inch (lpi) screen at a minimum resolution of 1200 dpi, the minimum resolution required for camera-ready work.

PROCESSING AND DIGITIZING COPY: INTRODUCTION TO SCANNER TECHNOLOGY

Few devices in the design and prepress area offer as much flexibility or enable the designer to achieve as much productivity as do desktop scanners. Desktop scanning technology evolved from devices originally known as *scanner/recorders,* which were designed to produce color separations from original slide or reflection color copy. This technology relies on the skill of the operator in mechanically adjusting the scanner /recorder to produce accurate color separations.

Desktop scanners today are far more sophisticated, much less expensive, and far easier to operate than their earlier counterparts. Medium-quality color desktop scanners are available for less than $750, and a buyer has literally dozens of different types of units to choose from. Scanners are not networkable devices. They are connected and dedicated to one computer, although the finished scan files can be transferred from one workstation to another on most networks.

The availability of low-cost desktop scanners has revolutionized the design and printing industry. In traditional processing, artwork is supplied to a camera operator who produces halftone and line copy to be combined with other components of the job to be printed. With a scanner however, line art and halftone images can be digitized and combined with other text and graphics. The complete file is then output to an imagesetter or laser printer. The scanning process, in combination with page composition software, eliminates the need for camera work, traditional page composition, and paste-up procedures. This increases both the productivity and the flexibility of the graphic design and printing technician.

Some of the features of scanners that have made them an indispensable part of the graphic design and print technology industry follow.

172

COLOR AND BLACK-AND-WHITE SCANNERS

The choice of which type of scanner to purchase was formerly made on the basis of the majority of the work to be performed by the unit. For example, most office work consists of black-and-white copy. When desktop scanners first became widely available in the mid-1980s, the scanner was used primarily for archiving purposes. Most scanned documents were saved on optical disks for future use or reference. In these instances, a black-and-white scanner was usually the unit of choice. The additional money required for a scanner capable of capturing color as well as black-and-white originals in this instance was usually not justifiable.

Conventional black-and-white scanners are usually limited in resolution ability and grayscale capabilities. These units usually cost just a few hundred dollars. Because of these limitations, black-and-white scanners are not well suited for use with detailed line art of more than 300 dpi or continuous tone photographs. With the geometric fall in the price of desktop scanners, coupled with advances in scanning technology, however, a good-quality color scanner has become the purchasing standard. Medium-quality scanners, capable of working with both black-and-white and colored originals, are priced well below $750.

Today's color scanners are capable of scanning, recognizing, and reproducing more than 16 million individual colors (including 256 shades of gray) with up to 48 bits of color information per picture element (pixel). During the scanning process, the amount of red, green, and blue light reflecting from the original copy is determined and stored in the scanned file. In this way, changes in the hue, saturation, and intensity of the scanned image can be manipulated to precisely define how the finished scanned image will appear. This process of color scanning is depicted in Figure 7.3.

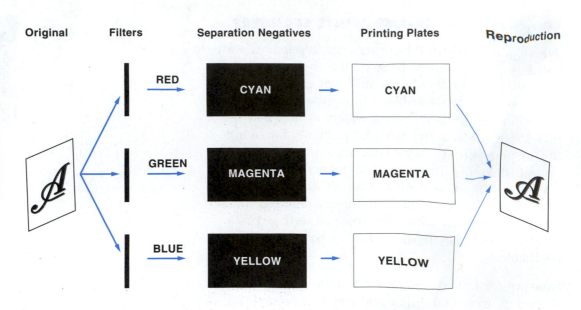

| Original | Filters | Separation Negatives | Printing Plates | Reproduction |

Figure 7.3. The process of color scanning. Red, green, and blue filters are used to break up an original into its component primary colors. Subtractive primary plates using cyan, magenta, and yellow inks reproduce the colors of the original.

COLD AND HOT SCAN TECHNOLOGIES

Two types of light sources are currently used in scanners. These light sources are known as either hot or cold. *Hot scanners* use a fluorescent or xenon light source coupled with a cooling fan for the lamp. Hot scanners are less expensive than scanners using cold scan technology. *Cold scanners* use cold cathode bulbs that limit light deterioration when working with color separations. Cold scanning eliminates the need for cooling fans, as the bulbs are sealed in a dust-free enclosure that enhances overall scan quality.

SINGLE- AND THREE-PASS SCANNERS

Single-pass scanners capture all of the color information from the original using one pass of the scanner head. Three color filters capture the red, green, and blue data of the original. Three-pass scanners have three lights

...off during the scanning process to
...red, green, and blue data separately.

FLATBED SCANNERS

Flatbed scanners resemble traditional photocopy
machines in appearance. The original copy is placed on
a flat glass bed and is scanned from beneath by a mov-
ing beam of light. The light beam
strikes the copy and is reflected off a
mirror and sent through a focusing
lens. The lens focuses this light onto a
light sensor converter, which changes
the light signal into electrical
impulses. This light sensor converter
is referred to as a *charge-coupled-device*
(CCD). The CCD can yield a maxi-
mum density of about 3.0 (on a scale
of 0 to 4.0). The electrical impulses
from the CCD are converted into dig-
ital code, which can then be modified
as the designer wishes. Figure 7.4A
shows a flatbed scanner with a trans-
parent media adapter. When scan-
ning with the adapter, the scanner
light source is turned off and
the light source in the adapter
is activated, ensuring proper
exposure through the transpar-
ent medium. Figure 7.4B illus-
trates a 35mm slide scanner.
This scanner yields an optical
resolution of more than 1800
dpi. Software enhancement of
the image further increases the
resolution to almost 4000 dpi.
These resolutions are suitable
for prepress color separations
or image databases.

Figure 7. 4A. Flatbed scanner with transparent media
adapter (Courtesy Microtek Lab, Inc.).

Figure 7.4B. Slide scanner (Courtesy
Microtek Lab, Inc.).

DRUM SCANNERS

In a drum scanner, the original copy is mounted on a cylindrical drum that rotates under a light-sensing device inside the scanner body. Some drum scanners have fixed rotating drums; others have removable drums. Removable drums simplify the mounting of different types of original copy, such as transparencies, color negatives, photographs, and illustrations.

Drum scanners use photomultiplier tubes (PMTs) to sense light from the original copy. PMTs yield a density of approximately 3.8, as opposed to the smaller density range of approximately 3.0 from a CCD flatbed scanner. This higher density range from the PMTs allows the drum scanner to pick up greater detail in the shadow areas of an original and thus extends the overall contrast range of the finished scan. Figure 7.5 shows a typical drum scanner. High-end drum scanners use four PMTs: one for each of the primary colors (red, green, and blue) and a fourth for unsharp masking, which places an unseen outline around objects, creating a greater sense of detail.

Figure 7.5. A rotating drum scanner (Courtesy Screen USA).

LINE ART AND GRAYSCALE SCANNING

In spite of the inroads made by inexpensive color copiers and scanners, a majority of printed materials are still reproduced in one color. Line art and grayscale images make up the majority of monochrome scanning jobs. For line art work, the scanner senses each pixel as either black or white, regardless of the shading characteristics of the original. For grayscale work, the scanner detects shades of gray in the original.

that flash on and off during the scanning process to generate the red, green, and blue data separately.

FLATBED SCANNERS

Flatbed scanners resemble traditional photocopy machines in appearance. The original copy is placed on a flat glass bed and is scanned from beneath by a moving beam of light. The light beam strikes the copy and is reflected off a mirror and sent through a focusing lens. The lens focuses this light onto a light sensor converter, which changes the light signal into electrical impulses. This light sensor converter is referred to as a *charge-coupled-device* (CCD). The CCD can yield a maximum density of about 3.0 (on a scale of 0 to 4.0). The electrical impulses from the CCD are converted into digital code, which can then be modified as the designer wishes. Figure 7.4A shows a flatbed scanner with a transparent media adapter. When scanning with the adapter, the scanner light source is turned off and the light source in the adapter is activated, ensuring proper exposure through the transparent medium. Figure 7.4B illustrates a 35mm slide scanner. This scanner yields an optical resolution of more than 1800 dpi. Software enhancement of the image further increases the resolution to almost 4000 dpi. These resolutions are suitable for prepress color separations or image databases.

Figure 7. 4A. Flatbed scanner with transparent media adapter (Courtesy Microtek Lab, Inc.).

Figure 7.4B. Slide scanner (Courtesy Microtek Lab, Inc.).

175

DRUM SCANNERS

In a drum scanner, the original copy is mounted on a cylindrical drum that rotates under a light-sensing device inside the scanner body. Some drum scanners have fixed rotating drums; others have removable drums. Removable drums simplify the mounting of different types of original copy, such as transparencies, color negatives, photographs, and illustrations.

Drum scanners use photomultiplier tubes (PMTs) to sense light from the original copy. PMTs yield a density of approximately 3.8, as opposed to the smaller density range of approximately 3.0 from a CCD flatbed scanner. This higher density range from the PMTs allows the drum scanner to pick up greater detail in the shadow areas of an original and thus extends the overall contrast range of the finished scan. Figure 7.5 shows a typical drum scanner. High-end drum scanners use four PMTs: one for each of the primary colors (red, green, and blue) and a fourth for unsharp masking, which places an unseen outline around objects, creating a greater sense of detail.

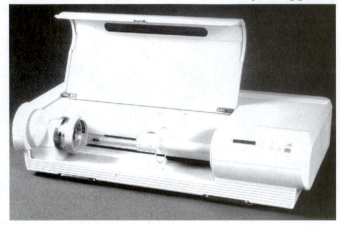

Figure 7.5. A rotating drum scanner (Courtesy Screen USA).

LINE ART AND GRAYSCALE SCANNING

In spite of the inroads made by inexpensive color copiers and scanners, a majority of printed materials are still reproduced in one color. Line art and grayscale images make up the majority of monochrome scanning jobs. For line art work, the scanner senses each pixel as either black or white, regardless of the shading characteristics of the original. For grayscale work, the scanner detects shades of gray in the original.

Most scanners contain a prescan feature. Prescanning allows the operator to first scan an original at low resolution, which appears on the computer screen. After the image has been prescanned, the operator can adjust the cropping, set enlargement and reduction ratios, and set highlight and contrast controls, all of which help to reduce the amount of work and time needed for the final scan.

SCANNING LINE ART

For scanning line art work, the scanner needs only one piece of information per pixel (picture elements): whether it is black or white. To make this on-off, black/white determination, the scanner relies upon a density threshold, set by the scanner operator. The scanner compares the reflected density from the copy to the threshold. If the density is above the threshold, then the pixel is assigned *black;* if below the threshold, the density is assigned *white*. Proper threshold settings are especially important in helping the operator to eliminate unwanted blemishes and other stray marks from the original artwork or when scanning copy that is either very light or faded.

When scanning black-and-white line art, the operator is only concerned with whether a given pixel is black or white. In this instance, the pixel requires only one computer bit of information, which results in relatively small file sizes for line art illustrations.

Because line copy is defined primarily by its edges and outlines, the resolution for line art must be higher than for halftone pictures and grayscale art work. The minimum acceptable resolution for scanning line copy is 1200 pixels per inch (ppi), whereas halftone illustrations can be scanned at 300 ppi for a 150-line halftone illustration.

SCANNING GRAYSCALE COPY

When scanning grayscale copy, the scanner is sensitive only to the overall density of each pixel. When using

color scanners for grayscale work, the scanning process takes place in one of several ways. Some scanners have dedicated grayscale sensors and filters; others use all three sensors (red, green, and blue) to scan the image and average the densities detected by each of the sensors. In some systems one of the color sensors (in either the red, green, or blue channel) is used for scanning. In others, a full-color image can be scanned and later changed into a grayscale image with postprocessing image manipulation software.

Quality grayscale scanning requires an 8 bit scanner capable of capturing 256 levels of gray. The important factor in grayscale scanning is how gray each gray area is. In this instance, each pixel is assigned 8 bits (which is equivalent to one byte) of computer memory allocation. This allows the computer to interpret 256 shades of gray. There are advantages, however, to capturing more information than 8 bit processing allows. More information yields improved image manipulation and enhancement during postscan processing. Using a 12 bit scanner for the initial scan, for example, allows a higher quality of final scanning than does an 8 bit scanner. Although 12 bit scanners can capture 4096 shades of gray, final PostScript processing is currently limited to 256 shades. Modern scanning technology allows for up to 36 bit scanning. The evolution of scanning technology continues to increase scanning resolution while prices continue to decline, for both flatbed and drum scanners.

SCANNING TEXT COPY

A major use for scanners has always been in archiving information. In this process, original copy is scanned and then saved on removable optical hard disks. These disks can be stored for long periods of time with virtually no deterioration in the quality of the stored information. The procedure involves scanning the text copy in a normal fashion, using optical character recognition (OCR) software. The use of this software

in the scanning process enables the computer to compare the letters of the scanned text to predefined patterns for the letters of the alphabet stored in the OCR program. Once scanned, the document can either be stored immediately, or brought into a word processing program where it can be reformatted if necessary. Figure 7.6 illustrates text copy scanned using OCR software. It should be noted that even though OCR software is highly accurate (more than 95% accuracy), this still represents approximately 1 error in every 15 words. Therefore, all scanned text should be run through a conventional spell-check program to ensure the accuracy of the finished document prior to storage or printout. Even with highly accurate spell-check programs, final proofreading of all scanned material is still required (see chapter 3 for further information on proofreading and proofreading symbols).

Figure 7.6. Scanned text copy using optical character recognition (OCR) software.

SCANNING COLOR ORIGINALS

Color scanners are available in either flatbed or drum configurations, and use either CCDs or PMTs to sense light reflected from the copy in the red, green, and blue ranges. Although some color scanners use a separate scanning pass for each color to capture the colors of the original copy, most color scanners use a one-pass scan technique. High-quality color scanners feature 12 bits per color (for a total of 36 bit scanning depth) with resolutions of more than 4000 lines per inch. These units produce color as well as black-and-white and grayscale scans. High-end color scanners use white-balanced light sources such as xenon for exposure, whereas lower-end scanners use special fluorescent lights as the exposure source. A high-resolution (4000 dpi) scanner is shown in Figure 7.7. Note the keyboard adjacent to the scanner; most scanners are installed as dedicated units to one computer terminal or workstation.

Figure 7.7. High-resolution 4000 dpi flatbed scanner. (Courtesy SIRS, Inc.).

UNSHARP MASKING

Unsharp masking, referred to as USM, creates an invisible outline around an image. This outline gives the image a greater sense of detail. In high-end scanners, the ability to perform unsharp masking "on the fly"— that is, during the actual scan—can save considerable time by eliminating postscan processing. An additional photomultiplier tube is incorporated into the scanner hardware to accomplish on-the-fly masking.

SCANNING RESOLUTION

The resolution of the scanner is listed as the number of pixels per inch (ppi), usually also referred to as dots per inch (dpi). The higher the resolution in ppi or dpi, the greater the detail that can be captured by the scanner. The resolution of scanners continues to improve with refinements in scanning technology. To put scanner resolution into perspective, consider the standard dpi requirements of printed products listed in Figure 7.8.

Item	Resolution Required
Newspaper Photograph	55–100
Textbook Illustration	133–150
Standard Halftone Photograph	150–330
Digital Typesetter	2500
Early Monochrome Scanner	300
Color Drum Scanner	600–5200

Figure 7.8. DPI resolution required for various printed products.

OPTICAL AND INTERPOLATED RESOLUTION

In the late 1980s and early 1990s, low- and medium-quality black-and-white scanners were usually limited to 300 dpi of resolution. Capability has increased consistently since that time. Scanners operate at two different resolution rates: the optical, or hardware, scanning resolution and the interpolated scanning resolution.

The *optical scanning resolution* is the actual resolution ability of the scanner, utilizing its built-in optical and hardware power to distinguish physical numbers of dots per inch. Almost all scanner manufacturers supply software programs to boost the optical resolution of their scanners. This is called *interpolated resolution*. Interpolated resolution is software-driven and uses a mathematical formula called an algorithm. The algorithm analyzes the original scan and adds pixels to fill in the space between the original pixels. This increases the resolution and detail of the scan. Although software-interpolated resolution usually works well, it should be kept in mind that the software program is essentially a guess, and not an actual measurement, of what the additional detail of the scan should look like.

These two scanning figures—optical resolution and interpolated resolution—are both given as specifications of the scanner. For example, a scanner may be listed as having an optical resolution of 600 x 1200 dpi, with an interpolated resolution of 1200 x 2400 dpi. It is important to note that the interpolated resolution is of a lower quality than the true, optical resolution. When scanning quality is a high priority, the optical and hardware resolution of the scanner, rather than the interpolated resolution, should influence the purchasing decision. Figure 7.9 lists a typical set of specifications for several models of color scanners, along with their optical and interpolated scanning resolutions.

CALCULATING OPTIMUM RESOLUTION FOR HALFTONE OUTPUT

We have stated that the scanner resolution required for line copy is higher than for halftone scanning. This is due to the necessity for fine detail in the outlines of objects in line art. When working with halftone photographs, if the scanning resolution is too low, then the quality of the finished scan will obviously be poor. Conversely, if the scanning resolution is too high, then the resulting scanned file will be very large. Large files slow down image manipulation and transmission time between the computer and

laser printer or imagesetter. The optimum resolution for most scanned images can be determined rather easily.

24 BIT COLOR SCANNERS*

Product Number	Platform	Maximum Scan Area	Optical Resolution DPI	Interpolated Resolution (Software)	Passes for Color
1	Mac Windows	8.5x11	400X800	1600x1600	1
2	Mac	8.5x14	300x300	1200x1200	1
3	Windows	8.5x11	400x800	1600x1600	1
4	Windows	8.5x14	300x600	1200x1200	3
5	Mac Windows	8.5x14	600x1200	2400x4800	1
6	Mac Windows	8.5x11	300x600	1200x1200	3
7	Windows	8.5x11	300x600	1200x1200	3
8	Mac Windows	8.5x14	600x1200	2400x2400	1

Features available as of 9/94

Figure 7.9. Optical and interpolated resolutions of a variety of different 24 bit scanners.

For copy to be scanned at 100% (that is, the same size as the original), use the formula:

Scanning resolution = Screen size x 2

For example, if the screen size of the reproduction will be 150 lines per inch, then the scanning resolution should be:

Scanning resolution = 150 x (2) = 300 dpi

When copy is to be either enlarged or reduced, the enlargement or reduction factor should be entered into the equation:

**Scanning resolution =
Screen size x 2 x Enlargement/Reduction**

Using the same screen size as the previous example, let's assume that we are going to scan our original at 75% of the original size, giving us a reduction factor of .75. Entering this figure into the equation, we get:

Scanning resolution = 150 x (2) x (.75) = 225

Note from this example that reductions require lower scanning resolutions than do enlargements.

DIGITAL CAMERAS

Digital cameras are a relatively new entry into the graphic arts field, although they have been used for some time in newspaper publishing. Digital cameras are similar in appearance and ease of use to the familiar 35mm camera. Rather than recording the picture on film, however, the camera stores the visual images as digital data. Given the manner in which they operate, these cameras fall into the category of scanning devices. As digital cameras decrease in price and increase in resolution capability, they are bound to impact on many of the functions for which conventional scanners are now used. Most of these cameras record in 24 bit color and offer millions of pixels of resolution, using standard exposure times. Depending upon the model, these cameras use conventional photographic lenses, with exposure indexes that fall between the ASA ratings of black-and-white and color films, and produce high-resolution images.

After the pictures have been taken, the images are downloaded from the camera to the computer. From the computer, the images can be manipulated, analyzed, and imported into a variety of supported application software. Digital cameras are available as small

point-and-shoot designs or as higher end units used for newspaper and photographic studio applications. The color camera shown in Figure 7.10 uses a 4-inch x 5-inch digital film back. The digital camera back is interchangeable with a standard film back, so that camera operation can be switched over to conventional film, and offers a resolution of 2048 x 2048 pixels.

Figure 7.10. Camera with a digital film back. A variety of different types of digital cameras are currently available. Some resemble the familiar point-and-shoot cameras, whereas others, like the unit shown in this figure, are for professional use. The digital back on this unit comes off and can be replaced with a 4-inch by 5-inch film back for conventional photography (Courtesy Screen USA).

Although the resolution of digital cameras is still somewhat limited compared to conventional silver-emulsion-based film, it is likely that an increasing amount of work within the desktop publishing area will be done with digital cameras. Prices continue to drop while the storage capacities, pixel depth and detail resolutions increase rapidly.

HARDWARE AND SOFTWARE COMPATIBILITY

Although most first-generation scanners were designed to interface only with Macintosh computers, virtually all scanners can now connect to Macintosh, Windows and DOS platforms. Two types of interfaces are predominantly used between the scanner and the computer: the Small Computer Systems Interface (SCSI) and the General Purpose Interface Board (GPIB).

SMALL COMPUTER SYSTEMS INTERFACE (SCSI)

SCSI (pronounced "scuzzy") interfaces are built into all Macintosh computers produced within the past six to eight years. Increasing numbers of IBM PCs and PC clones also use SCSI interfaces for connecting peripheral devices. SCSI devices are connected to one another in a daisy-chain arrangement, as shown in Figure 7.11.

Figure 7.11. A daisy-chain arrangement for connecting several SCSI devices together.

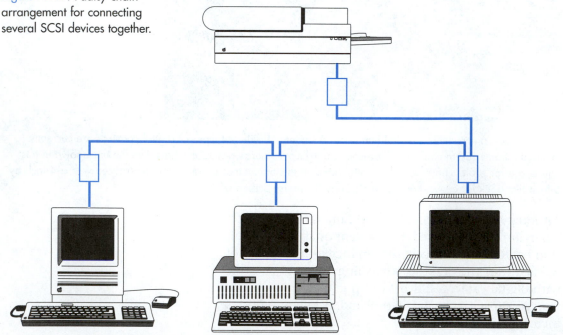

Up to seven devices can be connected in a conventional SCSI chain (special hardware and software configurations are available that allow more than seven devices to be connected). Each device is assigned its own number in the chain, enabling the computer to differentiate among them. When booting up a computer, each SCSI device must be turned on before the computer, so it can be recognized when the computer comes on line. The original SCSI-1 specification was developed in 1986. The SCSI-1 protocol was revised in 1992 and is now referred to as SCSI-2; it can transfer information at speeds up to 10MB per second (MBps) under normal set-ups. Some manufacturers use what is called an Ultra SCSI-2, which allows data transfer at rates up to 40 MBps using 16 bit SCSI cables. A faster, SCSI-3, interface is now offered in selected newer machines and drives that can handle up to 100 MBps of intermittent data (called a *burst rate*) and sustained data transfer rates of 50 MBps.

GENERAL PURPOSE INTERFACE BOARD (GPIB)

General Purpose Interface Boards (GPIBs) are usually purchased separately from the scanner or other peripheral device. The GPIB is installed into one of the expansion slots on the PC motherboard and the scanner is then connected to the board.

TWAIN SOFTWARE PROTOCOL

To ensure compatibility between the largest number of hardware and software combinations found in desktop scanners, manufacturers began to adopt what is known as the TWAIN protocol in 1992. TWAIN is a software protocol, or instruction package, that enables a user to scan a wide variety of printed material directly in a software application. This eliminates the need for special software drivers for each type of hardware platform. For example, a TWAIN-compliant spreadsheet program would allow you to scan a full-color bar graph from a printed report directly into a

spreadsheet, without any need for editing or converting the bar graph. Increasing numbers of word processing, spreadsheet, database, and desktop publishing packages are adopting the TWAIN compatibility standard, making a variety of scanning tasks easier and more productive.

IMAGE MANIPULATION

The features of modern scanners and associated image processing software make the scanning and image editing process simple and uncomplicated. The following discussion, which highlights the basic steps of scanning and editing a black-and-white image on a desktop flatbed scanner, is presented as an orientation to the scanning process. The specific steps illustrated will, of necessity, vary between types or brands of scanner, as well as the specific editing and processing software used.

Before placing the original in the scanner, make sure the scanner glass is clean. Although it is always best to align the original with the register marks on the scanner, most scanning programs will automatically straighten and align a crooked original as long as the item being scanned has true edges (Figure 7.12).

Figure 7.12. Placing original copy on a flatbed scanner. Copy must be placed carefully on the scan window. Although most scanning software can straighten crooked illustrations, some application programs cannot. Therefore, ensure that copy is as square as possible before scanning takes place.

To begin the scanning process, the original artwork or photograph is placed within the image processing area on the scanner screen. The software package on the computer is opened, bringing up the scan information palette. This palette contains a scan window with tools for image manipulation, along with the scan control menu (Figure 7.13).

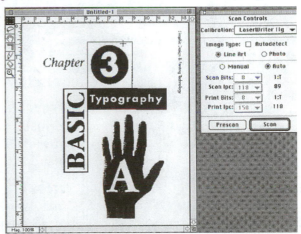

Figure 7.13. Scan control window and tool palette. Note the option for selecting either the prescan or autoscan, manual and automatic settings for line art and continuous tone illustrations. In the autoscan mode, the computer will automatically make the determination for line and halftone copy.

When beginning the scanning process, the operator has the choice of either prescanning an image to determine overall quality and contrast, or beginning the scanning process right away. In the prescanning process, the scanner will automatically determine whether the original artwork is line or continuous tone copy and select proper default settings. The scanned image will appear in the window as shown in Figure 7.14.

Figure 7.14. Line art image after prescanning. Note that if the image is placed upside down on the scanning window, it will appear that way in the scan control window.

Depending on the features of the image processing software bundled with the scanner, the scanner will automatically adjust the image detail, straighten the image if it is crooked, and crop it to eliminate unwanted white space. A status box appears on the screen during this process to keep the operator informed of what stage the scanning process is in.

After the scan is complete, the operator can resize or modify the image using the tool palette. After adjustments, the image is ready to be saved.

SAVING SCANNED IMAGES

When the Save option is selected from the File menu, the operator has a choice of several formats in which to save the scanned image. These options appear in the Save dialogue box (Figure 7.15).

Figure 7.15. File format save option box.

Figure 7.15 shows the file formats that would appear when using a Macintosh computer. Different file formats are available in the PC platform. (An explanation of each of the file formats used for scanning images on either the PC or Macintosh platforms follows.) The choice of file format is important, because the format selected determines how easy it will be to move or exchange images between different operating systems and hardware platforms.

MACINTOSH PLATFORM FILE FORMATS

PICT: The PICT format is the basic file format used in virtually all Macintosh applications. Many programs offer PICT as the default format when the SAVE command is highlighted.

TIFF: TIFF, which stands for Tagged Image File Format, is used to store bit-mapped images in a number of different resolutions. Also, in many programs the

TIFF format allows you to make changes in contrast, color saturation, and so on which are not possible in many other formats.

EPS: EPS is the acronym for Encapsulated PostScript. The EPS format is useful when images are to be printed on PostScript printers, as EPS files contain all the information directly in PostScript form. The EPS format is commonly used for saving object-oriented graphics.

MacPaint: The MacPaint format is that used by the familiar Macintosh paint program. The MacPaint format is only for black-and-white images in the screen resolution of 72 dpi. The size limit on this format is 8 x 10 inches.

GIF: Graphic Interchange Format (GIF) was developed by CompuServe to enable hardware-independent transfer of color image files for its subscribers.

PC PLATFORM FILE FORMATS

EPS and **TIFF:** formats similar to those on the Macintosh platform.

PCX: The PCX file format is the format used for saving Paintbrush files. PCX works with all Windows drawings created in Paintbrush and works with drawings created in many non-Windows applications as well.

BMP: BMP is the bit-map file format used by Windows. Many drawings and illustrations done in PC paint programs are automatically saved in the Windows BMP format.

Monochrome bitmap: The format of choice for illustrations done in black-and-white and when a monochrome monitor is used on the computer.

16 and 256 color bitmap: Choices to be made depending upon the type of graphics monitor and video card installed in a particular PC. If the computer uses a Super VGA monitor with 256 color capability

on the graphics card, then 256 color bitmap would be the format of choice. Color rendition in this mode is far superior to the 16 bit color option.

24 bit bitmap: Used when maximum color resolution and interpretation are required and where computer memory supports this option.

GIF: Graphic Interchange Format for the PC platform.

TGA/SunRaster/SGI: Formats developed by manufacturers of high-end workstations Targa, Sun, and Silicon Graphics, for their own equipment.

VIFF: Visual Image File Format or VIFF is the image file format for the Khoros imaging package used for scientific imaging purposes.

PRINTING SCANNED IMAGES

The process of printing scanned images is similar to printing text, graphics, or combined images from word processing, spreadsheet, database, or page composition programs. Images on the scanner can be printed either before or after they have been saved.

MODIFYING SCANNED IMAGES

It is often desirable or necessary to make changes to scanned images, to accommodate space requirements or otherwise enhance or modify the images prior to printing. Although different software packages have different tool or palette controls, many of the edit commands are similar in both appearance and execution, some of which are described in this section.

RESIZING IMAGES

To resize an image, a "Re-size Image" dialog box is selected, which highlights the present size of the image. To resize, simply enter the new dimensions of the image in the appropriate boxes, or change the "%" number to a different value. Figure 7.16 shows the Set Size selection control used for determining the size of a

printed document using optical character recognition software. Controls for setting the size of illustrations are basically the same as those shown in Figure 7.16.

Figure 7.16. Resizing an image. Notice that in addition to the height and width of the image, selections in percentages can be made as well. Some application programs also offer an option to constrain file size and/or maintain the proportions of the original image. Note that the size options box shows the storage size of the file.

SHARPENING IMAGES

The "Sharpening" option allows you to add more definition to a scanned photograph. Many software packages have a sharpening option that can be activated during an autoscan procedure. Choosing the Sharpening command from the menu options enables the computer to interpret the scanned image through software interpolation. This process adds definition and clarity to the image based on calculations performed by the scanning software.

IMAGE EDITING

Image editing includes erasing and modifying the black-and-white pixels on the screen to enhance, smooth, or eliminate sections of the illustration. The tools to accomplish these changes are selected from the tool palette and then applied to the scanned image. As you make changes to the scanned image, be sure to continually save your changes.

ROTATING IMAGES

There are a number of ways in which images can be rotated. In many scanning and photographic refinishing packages, the angle of rotation is selected from a menu. For example, the picture in Figure 7.17A is the original, followed by two 90 degree clockwise rotations in Figures 7.17B and 7.17C. Scanning programs also have several rotation options available that allow the operator to change the center of the axis of rotation and impose a grid over the illustration. This grid aids in selecting the proper angle of rotation.

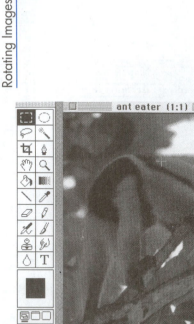

Figures 7.17A. Rotating and image. This figure shows the original position of the scanned image.

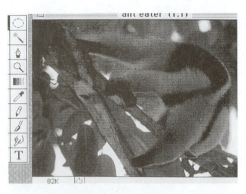

Figure 7.17B. 90-degree clockwise rotation from the original scanned image position.

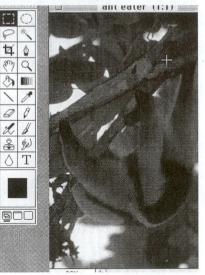

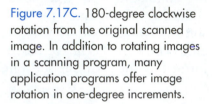

Figure 7.17C. 180-degree clockwise rotation from the original scanned image. In addition to rotating images in a scanning program, many application programs offer image rotation in one-degree increments.

194

CROPPING THE SCAN

To crop an image, the cropping box is selected from the tool palette and drawn around the sections of the image that you want to keep. The final cropped area is represented by a box with a dotted outline. The outline changes to a scissor icon when the mouse moves into the selected crop area. A second click of the mouse button usually enables the crop selection, redrawing the screen to show the new image. Figure 7.18 shows an image in which the cropped area has been selected.

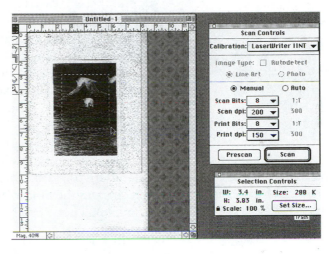

Figure 7.18. Selecting the cropping area in a scan.

OUTPUTTING DATA

Other than archiving, data is useful only if it is utilized in some manner. In the communications technologies, data can be sent, or *output,* to a variety of devices, depending upon whether the data exists in final form or has to be modified and/or combined with other material. This next section covers a variety of output devices and media.

OUTPUTTING TO COMPUTERS: STORAGE DEVICES

Floppy disk drives, hard drives, and tape drives are the most common types of computer storage devices. These drives use magnetic material called *media* for storing information and all operate in essentially the same way.

FLOPPY DRIVES

The floppy disk drive may arguably be the most widely used information storage device. Floppy disks come in two sizes, 5¼-inch and 3½-inch. The disks are made from a soft plastic that is coated with a metallic oxide. The 5-¼-inch disks are placed in a special flexible protective sleeve; 3½-inch disks are housed in a rigid plastic case. Both of these disks are shown, with their respective protective cases, in Figure 7.19. During drive operation, information is transferred from the computer to the disk through the disk drive head, which changes the binary information in the computer into small magnetic patches on the disk.

Figure 7.19. 5¼-inch and 3½-inch floppy disks. The 3½-inch disk has become the standard disk size. Many computer manufacturers no longer offer 5¼-inch disks as standard equipment with their computers, and software companies supply their programs on 5¼-inch disks only by special request.

As the disk rotates in the drive mechanism, the drive head produces circles of information on the disk. These circles are called *tracks*. The tracks are divided into individual sectors. The tracks and sectors can be likened to a file cabinet with individual file folders; the tracks are the drawers of the filing cabinet and the sectors are the

Figure 7.20. Component parts of a 3½-inch floppy disk.

individual file folders where the information is stored. The component parts of a typical 3½-inch floppy disk are shown in Figure 7.20.

HARK DISK DRIVES

Hard disk drives are so named because, rather than using thin flexible plastic disks for data storage, a hard platter coated with a metal oxide is the actual disk. Depending on the storage capacity of the disk, more than one platter may be mounted inside the drive casing. The electromagnetic read/write drive heads float on a cushion of air about a millionth of an inch above the disk, and never actually touch the disk surface. The drive heads are located at the end of actuator arms which move the heads across the surface of the disk to retrieve or write information on different tracks of the disk.Whereas first-generation hard disk drives were able to store five megabytes of information, current drives are commonly equipped with multiple-megabyte storage capability. A multiple-platter hard disk drive arrangement is shown in Figure 7.21.

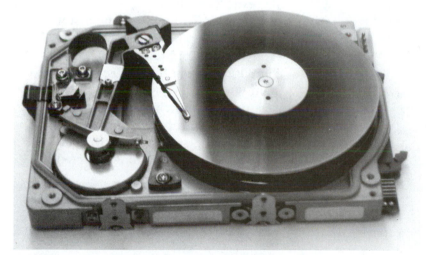

Figure 7.21. Typical hard disk drive configuration. The storage medium on the drive consists of a series of platters; the more platters, the greater the storage capacity of the hard drive.

RAID DRIVE TECHNOLOGY

The purpose of a redundant array of independent (or *inexpensive*) disks (RAID) system is to increase system speed and performance as well as provide a degree of data security. RAID systems are used primarily where data-intensive applications, such as high-speed video, image processing, and other disk-intensive applications, are required. A RAID system uses a series of hard drives that are usually stacked together in a single cabinet. Six different levels of RAID technology (levels 0 through 5) are used for writing to and retrieving data from the hard drive array. For example, in level 0, segments of successive data are written to successive hard drives. This process is called *stripping*. In level 1, two hard drives are used. All data that is written to one drive is automatically duplicated on the second drive, providing continuous data back-up. This process is called *mirroring*. The higher the RAID number, the greater the sophistication in data storage as well as data security.

MAGNETIC TAPE DRIVES

Magnetic tape drives were the first medium used for storing information on computers. Tape drives dominated large mainframe computers during the 1960s. Currently, the main use for magnetic tape drives is for backing up and archiving information. Figures 7.22A and B show internal and external tape back-up drives featuring storage capacities of several gigabytes (depending upon the model selected).

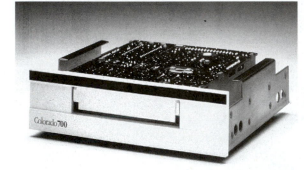

Figure 7.22A. Internal digital audio tape back-up drive. (Courtesy Colorado Memory Systems, Inc.).

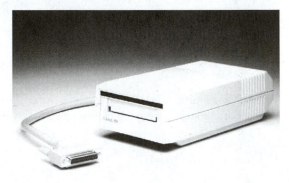

Figure 7.22B. External digital audio tape back-up drive. (Courtesy Colorado Memory Systems, Inc.).

MAGNETIC/OPTICAL DRIVES

Magnetic/optical (MO) drives are available in both 5¼-inch and 3½-inch cartridge sizes. MO drives use removable cartridges that resemble fat floppy disks. The data recording process for MO drives uses a laser to heat a magnetic alloy recording layer to approximately 150 degrees. At this temperature the alloy can be magnetized. The 5¼-inch disks are two-sided, whereas the 3½-inch disks are single-sided only and hold 128MB of data. Some small MO drives support the optical CD-ROM recording specification, in which the MO disk is recorded in a manner similar to conventional CD-ROMs (see next section). Early generation MO discs were limited to 44MB of storage. Newer drives hold several gigabytes (GB) of information and continue to increase in storage capability.

MO disks are somewhat slower in writing and retrieving information than are conventional hard disk drives. For this reason, MO drives are used primarily for archiving data and storing large files that have to be loaded only once. These drives make excellent choices for backing up files on a computer's internal hard drive. Since most of these drives feature both removable and erasable cartridges, they enable almost infinite storage capacity at a very low price. An MO drive with an optical storage cartridge is shown in Figure 7.23.

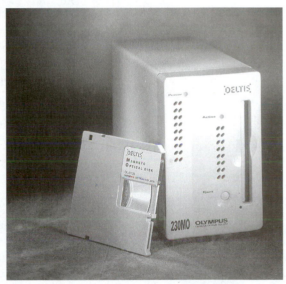

OUTPUTTING TO IMAGESETTERS

The term *imagesetter* has a long history, a story of technological refinements beginning with the development of the Linotype machine and automated typesetting. The evolutionary pattern traveled from the photographic or optical typesetter to early digital typesetters and then to present imagesetter technology. The term *imagesetter* can be confusing, because conventional laser printers can

Figure 7.23. Magneto-optical drive and optical storage disk. As the storage capacities of the MO disk increase, these drives become, in effect, removable hard drives. (Courtesy Olympus Image Systems, Inc.)

199

also be used as typesetters depending on the quality or resolution of the output. Also, imagesetters actually combine two functions: that of setting type and generating images together on a variety of output media (film, paper or plate material).

True typeset quality requires that images be output at resolutions no less than 1200 dpi. Early generation laser printers were designed to handle output resolutions between 240 to 300 dpi. Because this output was acceptable for printed pieces such as newsletters, where the quality of printed text and illustrations was not critical, this type of output was called *near-typeset quality*. However, 300 dpi is not fine enough for most printed material. Thus, in the era of 300 dpi laser printers, typeset-quality output was still relegated to dedicated phototypesetters and digital imagesetters.

The climb to high-resolution digital output of more than 3,000 dpi eliminated the distinction between laser printers and imagesetters. Any output of more than 1200 dpi, whether it comes from a laser printer or a specially designated imagesetter, can be said to come from an imagesetter.

LARGE- AND SMALL-FORMAT IMAGESETTERS

The format or output size of the imagesetter varies, depending upon the requirements of the end user. Small-format imagesetters operate with film, paper, and plate sizes in the 10- to 12-inch width range. The small-format imagesetter shown in Figure 7.24 outputs at 1800 dots per inch over a full 11-inch x 17-inch sheet of paper.

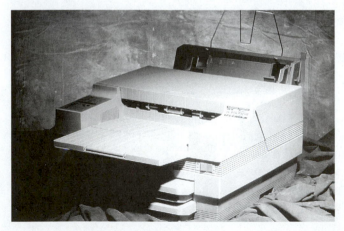

Figure 7.24. Small-format imagesetter (Courtesy Lasermaster, Inc.).

200

Where design and printing press requirements are greater, large-format imagesetters can handle several imposed pages on the same sheet of output medium. Large-format imagesetters can output an imaging area of 40 inches x 50 inches, large enough to capture 16 8½-inch x 11-inch imposed pages on a single sheet of film or paper. The memory and disk drive requirements of imagesetters in this range are substantial. A typical large-format imagesetter can come with 256MB of RAM and a disk drive with several gigabytes of storage capacity. Note the output size of the large-format color laser printer in Figure 7.25.

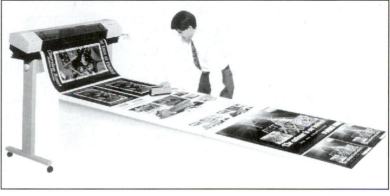

Figure 7.25. Large-format image-setter (Courtesy Lasermaster, Inc.).

FILM, PAPER, AND PLATE MEDIA

Most imagesetters currently produced offer the user a choice of materials on which to output images. The decision to use paper, film, or plate media depends upon the use of the imagesetter output.

Outputting to Paper. For many years, the standard output medium has been photographic paper. Early generation phototypesetters output to photographic paper, which was then used in the paste-up process to assemble complete pages in order to prepare mechanicals. In these units, the photographic paper is exposed to a laser-diode exposure unit and processed to bring up the image.

Photographic paper for imagesetters is sold in rolls of various lengths and widths, based on the particular

job and the requirements of the imagesetter. Image-setters can output on either photographic paper, photographic film, or, in some instances, plate media, which enables direct-to-press operation.

Outputting to Film. Outputting to an imagesetter using film as the output medium enables the graphic artist or technician to completely eliminate all stages of process camera work. The ability to bypass traditional camera processing came about with the introduction of high-resolution imagesetters that almost match the image quality associated with standard photographic techniques. Figure 7.26 shows a page composed of both text and halftone illustrations as it appears on the computer screen during image assembly using Pagemaker software. In Figure 7.27A, the image has been output onto film; Figure 7.27B shows the same imagesetter output to photographic paper.

Figure 7.26. Composite image of text and halftone illustrations as it appears on the computer screen during page assembly.

Figure 7.27A. Screen image from Figure 7.26 output to film.

Figure 7.27B. Screen image from Figure 7.26 output to photographic paper.

Outputting to Plate Media (Direct-to-Plate Technology). As computerized front-end systems continue to dominate prepress processing, the move continues to eliminate film and paper as middle stages in preproduction image processing. Sending digital data from the computer directly to an imagesetter loaded with plate media, or to a specialized laser diode plate maker, is often referred to as either *direct-to-plate* (DTP) or *computer-to-plate* (CTP) technology. These technologies represent a growing trend in the graphic arts industries.

CTP is used primarily by small printers using sheet-fed presses with press runs of less than 10,000 although large format CTP systems are becoming available for use by high volume commercial printers. At present, there are three ways in which to use CTP technology:

1. Imagesetters or film-setting equipment using conventional silver-halide-based printing plates.

2. Conventional laser output devices that have been modified to accept paper-based plate media.

3. Dedicated platesetters that use paper-based or polyester-based plate media.

Each output device has unique advantages. Traditional imagesetters are flexible in that they can handle a variety of imaging media: paper, plate, or film. Also, the output resolution on these units is high, enabling screen rulings of up to at least 150 lines per inch on most units. Conventional laser printers modified for plate output must usually be at least 11-inch x 17-inch or larger to handle the plate format for many of the smaller offset printing presses. Dedicated platesetters such as the unit shown in Figure 7.28 produce higher quality plates than can be delivered from modified plain-paper copiers.

Figure 7.28. Dedicated platesetter, enabling direct computer-to-plate output. (Courtesy Printware, Inc.)

The move to CTP technology does not stop with platesetters. In 1991, Heidelberg introduced the pace-setting GTO-DI, a waterless offset press that produces its own printing plate directly on the press cylinder (Figure 7.29A–C). The Heidelberg technology for direct press platemaking continues to evolve, changing from initial spark discharge imaging to a laser diode exposure system. This technology is sometimes also referred to as direct-to-press printing.

The initial CTP technology is aimed at low-run, medium-quality color printing. As the technological barriers are removed and both quality and speed increase, prepress processing without film will become the norm.

Figure 7.29C. Plate exposure laser diodes

Figures 7.29 A–C. The Heidelberg GTO-DI. The waterless offset press broke the barrier of direct-to-press technology, enabling assembly of the image on a computer and output directly to the printing press. The implications of eliminating photography, stripping, and platemaking continue to unfold as refinements in direct-to-press technology take place (Courtesy Heidelberg USA).

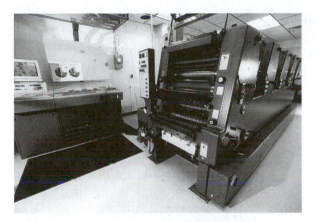

Figure 7.29A. A Heidelberg GTO-DI Press

Figure 7.29B. Imaging station for GTO

CD-ROM TECHNOLOGY

The use of CD-ROM technology for a variety of storage and output tasks speaks to the great versatility of the compact disc as a flexible storage medium. Since its introduction in 1980 by the Sony and Phillips Corporations, as a means of playing back digital audio, the compact disc has become a major method for storing archival information and is emerging as the primary audiovisual/multimedia playback device. The "ROM" in CD-ROM means "read-only-memory": once the disc has been produced, it cannot be altered in any way, although several companies have announced an erasable CD format (CD-E) to be available by late 1996 or early 1997.

The storage capacity of a compact disc is quite large. The typical CD-ROM can store 635 megabytes of information, which is equivalent to more than 1800 360K, or 800 800K, conventional floppy disks. The large amount of storage in such a small disc is accomplished by recording the data in a series of pits and lands (indentations and nonindentations) of varying lengths along a continuous spiral track, which if stretched out into a straight line would be more than three miles long!

We will take a closer look and see how the technology of CD-ROM data storage works.

PHYSICAL SPECIFICATIONS OF COMPACT DISCS

All compact discs follow the same specifications as to size and layout. The typical compact disc layout is illustrated in Figure 7.30.

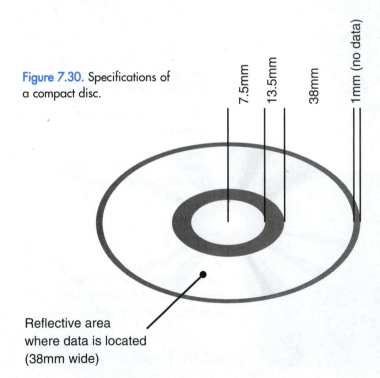

Figure 7.30. Specifications of a compact disc.

7.5mm
13.5mm
38mm
1mm (no data)

Reflective area where data is located (38mm wide)

The term *CD-ROM* refers to a set of standards rather than a specific product. The discs are made from masters which act as a mold in a stamping process (the manufacturing process is discussed later in this chapter). All compact discs conform to the standards illustrated in Figure 7.30.

The diameter of the compact disc is 120mm (approximately 5½ inches). A newer format compact disc, introduced by Kodak, is 80mm in diameter (approximately 3½ inches). These newer, smaller discs are designed for use in laptop computers, personal digital assistants (PDAs), and notebook computers.

DATA CLASSIFICATION

Most compact discs contain a variety of data, depending upon the use of the disc. Although most information on a typical CD is text and still-image graphics, an increasing number of discs also contain motion graphics, video, and audio, as multimedia applications capture a larger share of the CD market.

The compact disc industry began in 1980, when Sony and Phillips introduced the digital audio standard, sometimes referred to as the *Red Book*. All compact discs found in music stores today are manufactured according to the *Red Book* standard. Because of this standardization, all audio CDs can be played in any conventional CD player, a major factor in the rapid growth of the audio CD industry. The Red Book standard was further refined in 1984, when Sony and Phillips introduced a CD-ROM standard, commonly known as the *Yellow Book standard*. The Yellow Book adds two new types of tracks to the traditional audio CD. These tracks are Mode 1 for computer data, and Mode 2 for compressed audio and video/picture data. Mode 2 is sometimes referred to as XA. The XA standard, which allows audio and computer data to be placed on the same data track on the CD, was officially introduced in 1989 by Microsoft, Phillips, and Sony.

The types of data commonly found on the compact disc are as follows.

TEXT DATA

Text data is the most used form of data, and is entered either by keying in the data, or by scanning printed pages into a computer and using optical character recognition and spell-checking software to ensure the accuracy of the data.

GRAPHIC DATA

Graphic images are stored in many different formats on a computer. Some of these are:

- **Bit-Map Images.** Sometimes called *computer raster images*, pictures in bitmap are made up of individual dots or *pixels* (pixels stands for picture elements). Bit-map images are the type generated by painting programs for which a specific number of bits of memory is required to make each dot on the screen. In simple black-and-white illustrations, one bit is turned either on or off to create white or black on the screen. For shaded images, more bits are required to create the proper shading characteristic for each dot. In color images, even more bits are required to generate a specific color for each dot. File sizes are important in bit-map images, because the size of the file required to store the image is dependent upon the size of the image, the number of colors and type of format used, and whether the image is compressed when it is generated or stored. Figure 7.31 shows the different file sizes required for the same graphic, depending upon the type of format and resolution used.

- **Objected-Oriented/Vector Images.** These types of images are generated in computer-aided drafting (CAD) and drawing programs. An image is generated in the program and stored as connecting lines and shapes. Object-oriented images require less storage space than do bit-map images.

Image Size (Pixels)	Format	# of Colors	Size of File
680 x 440	Bit Map (BMP)	16	141KB
680 x 440	Bit Map (BMP)	256	282KB
680 x 440	Bit Map (BMP)	16 Million	845KB
680 x 440	PCX	16	31KB
680 x 440	TIFF	16 Million	845KB
680 x 440	TIFF	16	141KB
680 x 440	GIF	16	9KB
680 x 440	GIF	256	10KB

Figure 7.31. Storage size of a file as a function of file format and color requirements.

- **Scanned Images.** Scanned images are stored as conventional text files or as various types of bit-mapped or object-oriented files, depending on the nature of the original text or artwork and on the type of software used by the scanner.

- **Video Frame Capture Images.** Full-motion video is captured at 30 frames per second by the computer and stored in a raster (object-oriented) format. Capturing full-motion video requires a huge amount of memory. One frame of video can require approximately 1 megabyte of memory, running the memory requirements to more than 30 megabytes for a one-second video sequence, depending upon the size of the stored picture (larger pictures require larger memory requirements). Because of the high memory requirements of full-motion video, several methods of file compression are used to accommodate the relatively modest storage capacities of the average computer. The file compression schemes used for video capture are referred to as *codecs. Codec,* which means "compression-decompression," is a

mathematic algorithm or formula that fills in the blanks from frame to frame in video pictures. This reduces the size of the video file. Some of the popular compression algorithms in use are:

—**JPEG** (Joint Photographic Experts Group): The JPEG is a still-image codec that removes repeated elements between frames. This is called *intraframe compression.*

—**MPEG** (Motion Picture Experts Group): MPEG uses the same algorithms to create one compressed *interframe,* and then removes repeated elements from succeeding frames and codes only the differences. MPEG was created for digital video and consists of two standards, one for CD-ROMs and the other for studio-quality video playback.

—**Cinepak:** Compression software developed by SuperMac Technology.

—**Indeo:** Compression software developed by Intel.

—**QuickTime and QuickTime GX:** Software developed by Apple Computer Corporation for playing back compressed video images on a standard desktop Apple computer.

—**QuickTime for Windows:** The Windows version of QuickTime.

—**Video for Windows:** The Microsoft version of QuickTime that allows compressed video to be played on desktop computers running Microsoft Windows.

—**PAL standard** (Phase Alteration Line): The PAL standard uses 25-frame-per-second video, which is used in most of Europe and South America.

—**NTSC standard** (National Television Systems Committee): NTSC is the color television standard for the United States, Japan, Canada, Mexico, Taiwan, and other countries, based on 30-frame-per-second video.

—**SECAM:** Television standard used in France.

- **Computer Animation:** Animation programs are normally used to move objects from one part of the screen to another. These programs typically run at frame rates between 5 to15 frames per second (fps). Slide-show motion is another type of animation program, in which motion is achieved by displaying successive video frames on the screen in rapid sequence.

AUDIO DATA (CD-DA)

High-quality audio both produced and played back on a personal computer, through a compact disc is referred to as Compact Disc-Digital Audio (CD-DA). The quality of sound on a personal computer depends upon three variables: the quality of the original sample or recording; the recording rate on the computer, in thousands of cycles per second (KHz); and the quality of the computer audio playback system.

Audio can be used in many ways in a computer environment. Regular music CDs are the most common format, although music can also be used as a soundtrack while the computer is displaying other information. Narrated material is increasingly popular as more and more educational and informational CD titles (sometimes referred to as *edutainment*) become available.

Audio can be imported into the computer by either digitizing the sound directly through a microphone or using an external source such as a cassette tape, record player, or CD player. Macintosh computers were born with sophisticated sound capability, and current AV-Macs, and Power PCs, and Macintosh Quadras can record CD-quality sound without the need for add-on sound cards. On the DOS and Windows platform, add-in sound cards are available that plug into the computer's system board and yield CD-DA-quality sound recording and playback capabilities.

The higher the sampling rate (and quality) of the sound, the greater the amount of memory required to store the digitized audio. Figure 7.32 shows a comparison of different types of audio, along with their sampling rates and the amount of memory required to store one minute of stereo audio.

Quality Level	Sampling Rate (KHz)	Resolution (bit)	Bytes Needed to Store 1 minute of stereo audio (Mb)
CD Audio	44.1	16	10.09
ADPCM Level A	37.8	8	4.33
ADPCM Level B	37.8	4	2.16
ADPCM Level C	18.9	4	1.08
Digitized 22 KHz	22.0	8	2.52
Digitized 11 KHz	11.0	8	1.26

Figure 7.32. Bytes needed to store one minute of digital audio as a function of sampling rate and resolution.

MIDI. MIDI is an acronym for Musical Instrument Digital Interface. The MIDI process is often used to enhance compact disc products by adding computer-generated music and musical effects to a product. MIDI files can be stored on a compact disc or as a recorded digital audio track. If the MIDI files are not recorded in the CD-DA format, a MIDI interface card is required to play back the sound files. Many MIDI sound files are available as public domain software and from bulletin board systems.

MMCD (MULTI-MEDIA COMPACT DISC)

A collaboration of Phillips and Sony, this high-density compact disc format enables a total of 7.4 gigabytes of data storage on one side of a standard compact disc. This is more than 10 times the data capacity of conventional CDs, and provides enough room for 4½ hours of full-motion video. Special drives are required to access data in the MMCD format. Continuing refinements to this standard will undoubtedly continue.

DIGITAL VIDEODISC (DVD) FORMAT

A further enhancement of the CD disc format, digital videodiscs (DVDs), will eventually provide about nine hours of full-motion video, stored in a whopping 17GB of digital data. DVDs (sometimes referred to as digital versatile discs), will come on a disc the same size as present CDs, but can be double-sided, with two data layers on each side of the disc. The initial discs, due in the fall of 1996, will be single-sided and single-layered, and hold about 4.7GB of data. This is enough data for over two hours of full-motion, full-screen video. Picture quality is expected to be higher than that offered by the laser disc, using the MPEG-2 standard. MPEG-2 is the same standard used in the highly successful digital satellite system (DDS) home television receivers. Other features of the DVD standard will offer stereo surround-sound, different aspect ratios, and the ability to view different ratings versions of the same movie on one disc. Look for the introduction of the DVD format to have a great impact on all aspects of entertainment and educational offerings, including audio CDs, game CDs, information retrieval systems, as well as leisure time viewing habits.

COMPACT DISC ERASABLE FORMAT (CD-E)

A format for producing erasable, rewritable compact discs is currently in the development stage and due for release by 1997. This format is based on phase change technology, in which high-energy laser light is focused on a phase change material. When exposed to the laser, the material changes into a crystalline state. During the reading process, the crystalline phase reflects light, whereas the unexposed background scatters the light, imitating the pits and lands of a conventional laser disc. New CD-E discs will, in all likelihood, not be compatible with conventional CD-ROM drives, although the new CD-E drives will be able to read conventional CD-ROMs.

ENHANCED CD FORMAT (CD PLUS)

Since CDs were first developed, audio CDs were used to store only digital audio information. An audio CD usually contains between 50 to 60 minutes out of the 74 minutes of information available on a conventional compact disc. The remaining 14 to 24 minutes are left blank. To take advantage of this unused space, which can be used to store anything from the lyrics of the songs on the CD to digital movies and other relevant information, mixed-mode CDs were created. A mixed-mode CD contains data on the first track and audio on the subsequent CD tracks. However, most audio CDs are not designed to skip the first information track and go directly to the audio on the second and following tracks. Playing the first track of a CD that contains conventional digital data can damage sophisticated stereo components. The CD-Plus, or enhanced CD format, solves this problem by creating a multisession disc. The audio tracks are located on the first session; all supplementary digital data is placed in the second session of the disc. Because all audio CD players are single-session readers only, the second session of the disc remains transparent, and the players play only the audio data on the first session of the disc. Computers equipped with multi-session CD-ROM drives that read both audio and conventional digital data scan the entire disc before proceeding. These multisession CD drives can then be instructed to either play back the audio tracks or read the data stored in the second session of the disc. These changes are all accomplished with no additional investment required for new equipment. The enhanced CD format is expected to increase the marketability of CD-ROMs by expanding the base of both conventional audio-only and multimedia customers.

COMPACT DISC FILE FORMATS

The standard file formats for CD-ROM discs are:

- **HFS:** Stands for the Hierarchical File System, the standard format used by the Macintosh family of computers.

214

- **ISO 9660:** The International Standards Organization file format for CD-ROM discs. The ISO format has been adopted by most CD-ROM manufacturers so that their discs will be compatible with most computers, regardless of the computer manufacturer. The ISO standard is also the format used for accessing Photo CD discs.

- **High Sierra Format:** Part of the ISO 9660 format.

- **Joliet File Structure:** An extension of the ISO 9660, and the basis for the CD Plus specification that allows multisession disc use in conventional audio CD players by placing audio tracks in the first session of the disc. The Joliet system enhances file recognition by lifting restrictions in file and directory names as well as the recognition sequence for multisession CD recording.

DRIVE SPECIFICATIONS

Several specifications describe the performance of a CD drive. The specifications that best describe the overall performance of a CD drive are:

- the rotational speed of the drive

- the average access time the drive requires to retrieve information

- the data transfer rate of the drive, given in kilobytes per second

- the ability of the drive to read either single- or multiple-session discs

ROTATIONAL SPEED OF THE DRIVE

The rotational speed of a CD drive sets the stage for how much data can be transferred. The faster the drive rotates, the greater the scanning velocity of the drive read mechanism. First-generation CD drives rotate at approximately 530 revolutions per minute (rpm) on the inner disc tracks, and about 200 rpm at the outer tracks. Double-speed drives rotate at 1060 rpm on the

inner tracks and approximately 460 rpm at the outer disc tracks. The modern double-speed drive yields a scanning velocity of about 1.2 to 1.4 meters per second. Quad-speed players vary rotational speeds of the drive between 800 to 2000 rpm, while 8-speed units run between 1600 to 4000 rpm. When reading standard audio data, all drives shift back to single speed.

The difference in the rotational speeds of the drive depends upon where the drive's optical pick-up unit happens to be located on the disc. To read data accurately, the drive must maintain a constant data rate moving under the pick-up head. This rate is called *constant linear velocity* (CLV). If the disc were to maintain a constant rotational speed, data on the outside of the disc would move more slowly under the pick-up head than data on the inside of the disc, due to the difference in circumference of the two disc sections. To achieve CLV, the servo motor in the drive must change the rotational speed of the disc as the laser pick-up unit moves closer to either the inside or the outside of the disc.

To ensure an accurate flow of data, the data rate is compared to the frequency of a very accurate clock built into the drive. The servo motor speed is constantly changing based on this comparison, in order to maintain data accuracy.

As the speed of CD drives continue to move upward, problems in reading and ensuring the accuracy of data become more apparent. It takes longer to slow the speed of the drive down than it does to increase it, so larger motors are required as the industry moves from single- and double-speed (2X) to 3X and 8X drives. Faster rotational speeds also mean more possibilities for errors; therefore, the error detection circuitry of the drive must increase in sophistication and bulk in relation to the drive speed. Quad-speed drives are now considered to be the bottom line for satisfactory performance and come standard on most new computers.

DRIVE ACCESS TIME

The access time of the drive depends on how far the drive mechanism has to move to a particular place on the disc to retrieve information, and how quickly this move can be executed. Single-speed drives have access times above 360 milliseconds (thousandths of a second), whereas double-speed drives have access times of less than 350 milliseconds. Four-, six-, and eight-speed drives require faster access times to keep pace with the rotational speed of the disc, which explains, in part, the price barrier that exists between single- and double-speed drives and their higher rotational speed counterparts. Depending upon the manufacturer of the particular drive, access times of typical quad-, six-, and eight-speed CD drives are under 150 milliseconds (ms).

It should be remembered that even thought the access time of CD drives has decreased dramatically, they still lag far behind a typical computer hard drive with typical access times of less than 12ms.

DATA TRANSFER RATES

Data transfer rates affect how smoothly a particular program runs on a CD drive. Higher data transfer rates are required for newer multimedia programs that incorporate text, graphics, audio, and full-motion video segments. Older single-speed drives have data transfer rates of about 150 kilobytes per second. Double-speed drives feature data transfer rates of 300 kilobytes per second. Quad-speed drives, now offered as standard equipment on most computer systems, offer 600-kilobyte-per-second data transfer rates—a function of higher rotational speeds of the drive as well as reduced access time with lighter and more responsive drive heads. Six- and eight-speed drives will undoubtedly replace the quad-speed drive as the standard drive format, with higher speeds and reduced data access times yet to come.

At present, although some commercially-produced CDs are still designed for the information transfer rates delivered by single- and double-speed CD drives, most

titles are optimized for the data transfer rates offered by quad-speed drives. Therefore, buying a 6X or 8X drive will not automatically increase the performance of any particular CD game or program over that achieved with a quad-speed unit. Many industry experts believe that the upper limit of CD drive storage capability and data transfer rates have been reached with the 8X drive. Problems with very high disc rotational speeds and motor vibration at these levels require a new standard, such as the DVD, in order to continue the evolution of this versatile data storage and retrieval medium.

SINGLE- AND MULTIPLE-SESSION READ CAPABILITIES

There are different ways in which data can be recorded onto a compact disc. CDs are most often referred to as either single-session or multisession.

Single-Session Compact Disc. A single-session disk contains one lead-in area, the program area, and a lead-out area. The data in the program area of the disk can be written either all at one time or at different writing times. Writing the data at different writing times does not make a disc a multisession disc. Figure 7.33 is a block diagram of a single-session compact disc.

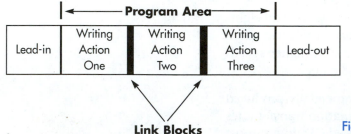

Figure 7.33. Single-session compact disc.

Multisession Compact Disc. A multisession compact disc has more than one lead-in area, program area, and lead-out area. Multisession discs can be written either during one writing session or at different times, depending upon the features of the CD recorder. Multisession discs have the advantage of adding more information to the disc when necessary. An example of this would be the addition of 50 slides to a Photo CD that had 50 slides previously scanned onto it. Figure 7.34 shows a block diagram of a multisession compact disc, showing the two lead-in, program, and lead-out areas that highlight recording sessions #1 and #2.

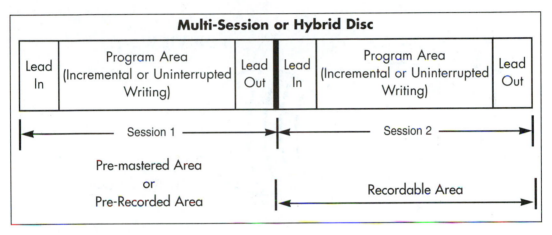

Figure 7.34. Multisession compact disc.

Although double-speed CD drives can read multisession discs, most single-speed drives are single-session readers only. Before purchasing a compact disc drive, investigate its playback features to ensure that it has multisession read-back capabilities.

DATA STORAGE ON A COMPACT DISC

Data is stored on a spiral track that runs from the inside to the outside of the compact disc. The track spacing is very narrow, measuring only 1.6µ (µ stands for a micron; one micron equals one millionth of an inch). When the disc is being manufactured, a laser

beam burns small pits, or indentations, of varying lengths into the disc within the spiral data track. Digital data is either a "0" or a "1." On the compact disc, the change from either a "pit" to a "land" or a "land" to a "pit" represents a "1;" the length of the path between these changes (the length of either the pit or the land) equals a certain number of "0s." One way the manufacturers are able to increase the quantity of data stored on future, higher density CDs is to vary both the length of the pits and the lands burned in to the CD. The arrangement of the data on a compact disc is shown in cross-section in Figure 7.35.

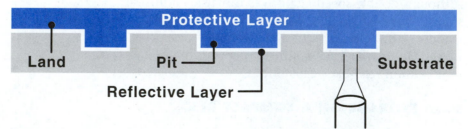

Figure 7.35. Representation of 0s and 1s from the pits and lands on a compact disc.

HOW THE DISC IS MADE

A compact disc starts off as a clear plastic disc, called a *substrate*. The CD recorder burns indentations into the plastic disc to create the pit and land areas representing the digital data. After the data has been burned into the plastic, a very thin layer of aluminum is poured onto the plastic, which adheres to the surface of the plastic and mirrors the pit and land surfaces. The aluminum provides the shiny reflective surface that enables a laser beam to reflect off the pit and land surfaces of the disc when the beam is reading the disc. A plastic coating covers the aluminum, which prevents scratching and oxidizing of the aluminum and keeps it shiny.

THE MASTERING AND PRODUCTION PROCESS

Premastering the Data. Before the actual mastering process can begin, the original data must first be converted into one of the standard CD-ROM formats (ISO 9669, High Sierra, or Apple HFS). This data conversion is referred to as *premastering*. Original customer data, supplied in a variety of digital-tape or hard-drive formats, is translated by the disc manufacturer onto a digital mastering tape. Once the data has been formatted, the premastering process is complete.

Mastering and Disc Production. In the first step of the compact disc production process, a glass master disc is produced. Optically ground glass with a very fine (1/10th micron) photoresist layer is exposed to a laser, which burns the pit and land patterns onto the glass master. When the disc is developed, the exposed parts are etched away and then silver plated, leaving the actual pit structure of the disc (Figure 7.36).

Glass Master

Laser

Silver

Photoresist

Glass

Figure 7.36. Exposing a glass master (Courtesy Disk Manufacturing, Inc.).

221

A negative disc is then electroplated onto the original glass master. When separated from the master, this produces a negative, or *father,* disc. Although this father disc could be used to reproduce compact discs, it would quickly wear out. Therefore, additional "mothers" are fabricated from the father by electroplating the father. Both of these steps are shown in Figure 7.37.

Father

Father

Glass Master

Mother

Father

Mother

Figure 7.37. Electroplating a "mother" from a "father" (Courtesy Disk Manufacturing, Inc.)

A number of stampers are made from each mother image. These stampers are used to reproduce the actual pit structure onto the compact discs (Figure 7.38).

Stamper

Stamper

Mother

Figure 7.38. Making stampers from a "mother" disc (Courtesy Disk Manufacturing, Inc.).

The stamper is used to make the actual compact discs, using an injection molding process similar to the one used to produce conventional records. The stamper creates the pit and land structures on the polycarbonate compact disc (Figure 7.39).

In the final stage of the production process, the information layer of the disc is coated with a micron-thick layer of aluminum, which provides the reflective surface for the laser optical pick-up unit. A lacquer coating is placed over the aluminum to prevent scratching and oxidation. The disc label is then printed on top of the lacquer coating (Figure 7.40).

Figure 7.39. Stamping the compact disc (Courtesy Disk Manufacturing, Inc.).

Clear Disc

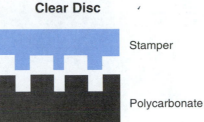

Stamper

Polycarbonate

CD-ROM Disc

Label
Lacquer
Aluminum
Polycarbonate

Figure 7.40. Lacquer coating and label (Courtesy Disk Manufacturing, Inc.).

DESKTOP CD-ROM WRITERS

Although mastering and producing compact discs is an advanced technology, CD systems are available that put the entire production process on the individual desktop at affordable prices. These systems, usually referred to as CD-Rs (for compact disc recorders), are used primarily for producing single discs, referred to as one-offs, and limited-run discs in a variety of computer formats. The input for these systems can come from a variety of media, as shown in Figure 7.41A. A desktop CD-R system is shown in Figure 7.41B.

Figure 7.41A. Input sources for compact disc systems.

223

Figure 7.41B. A desktop CD-R system. These systems produce one-off and limited-run discs, primarily for archiving and testing purposes (Courtesy Data Disc, Inc.).

Desktop CD recorders offer three recording modes to choose from: incremental, single-session, and multi-session. Incremental recording allows the operator to record some data, stop, and then add more information. Before the disc can be read, the session must be closed after the last recording increment. Single session recording necessitates recording the entire CD without interruption. Multisession recording allows for recording data in a series of sessions that appear as separate volumes on the CD. Single- and multispeed recorders are also available.

Desktop CD production systems are not intended to be used for large-scale production of compact discs. Rather, they are intended primarily for multimedia developers who need to produce proof copies prior to disc mastering, or for archiving purposes. Desktop CD-R systems record on gold media. Unlike conventional compact discs, which are silver in appearance and are stamped from a master, CD-Rs use a laser to write to the disc, decomposing an organic dye layer over stationary grooves on the disc. Although they are not stamped, discs produced via a desktop CD-R can be read by conventional CD-ROM drives.

READING DATA ON A COMPACT DISC

When the compact disc is inserted into the CD drive or reader, the data is read from below. Compact discs are more prone to damage from the top, or label side, than from the bottom of the disc. The plastic substrate provides more protection on the bottom of the disc than the relatively thin protective lacquer coating on the label side of the disc. A disc caddy, into which the CD is placed before it is inserted into the drive, adds further protection for the CD during handling. Although new CD drives are caddy-less, the use of a disc caddy offers protection from both scratching and dust accumulation. Dirt and dust on the disc can cause the drive to misread information. For this reason, many professionals feel that CD drives that use caddies are generally preferable to caddy-less systems.

Data is read from the compact disc by passing light from a focused laser beam through the bottom plastic (nonlabel side) substrate of the CD. The laser light is focused on the pits and lands burned into the disc and reflected off the aluminum coating. As the laser moves across the pits and lands in the disc, the level of the reflected light changes. The pits tend to scatter and diffuse the light, whereas the land surfaces reflect light with little change in intensity. A change in the intensity of the reflected light as the laser moves from a pit to a land, or vice versa, is a "1." If the intensity of the light remains constant for a certain period of time, while the laser is over either a land or a pit, the light is interpreted as a "0."

To ensure accuracy, the CD drive has autofocusing capability that keeps the laser at a certain distance from the reflective layer, focused on the center of the data track. Light intensity reflecting off the disc is continuously monitored. The pick-up head can be minutely adjusted to maintain proper tracking position and vertical distance from the disc by small servo motors capable of very fine adjustment.

PHOTO CD TECHNOLOGY

Kodak's Photo CD technology was originally aimed at capturing the consumer photography market. For the first time, it was possible to have photographs taken with an ordinary camera scanned onto a compact disc through the services of the neighborhood photography store. Then, using a CD player, the photographs could be viewed on the family television set.

Rather than finding its widest acceptance in the consumer photography market, however, Photo CD technology continues to make its largest inroads into the desktop and conventional publishing markets. New software tools continue to appear that are designed to find, sort, manipulate, and modify photographic images stored on compact disc. At present there are five major formats for Photo CDs, depending upon the end-use of the material.

- **Photo CD Master Disc.** This is the original Photo CD format designed for the consumer photographer. The disc can hold 100 images at high resolution. The images are stored at five different resolution levels, depending upon the end-use of the picture: 2048 x 3072 is the highest resolution available for preparing color separations and other high-quality color renderings; 1024 x 1536 pixels is intended for high-definition television viewing; 512 x 768 is designed for traditional television viewing; 256 x 384 pixels is made for thumbnail sketching; and 128 x 192 pixels is designed for smaller thumbnails. The master disc also functions as a digital negative, similar to a conventional film negative. The disc can be brought to the photography store and regular color prints can be made from the slides that are stored in digital format on the disc.

- **Pro Photo CD Master Disc.** The pro disc offers a higher level of resolution that can be found on the CD Master Disc. The Pro Photo Disc stores pictures in a resolution level of 4096 x 6144 pixels. Larger film formats such as 120 and 4-inch x 5-inch as well as regular 35mm film, are usually digitized onto the Pro Photo CD Master Disc.

- **Photo CD Portfolio Disc.** The Portfolio Disc format is Kodak's entry into the field of multimedia CD production. The portfolio format enables the desktop computer user to combine text, graphics, photos, and audio to produce interactive multimedia material for presentations, kiosks, and similar displays. Because this system allows the input of material from many different sources, the finished product can be a custom CD that contains edited photographs and other graphic materials.

- **Photo CD Catalog Disc.** The photo catalog format is set up to handle a large number of images at lower resolution for display on regular television sets. Materials such as mail order catalogs and similar products lend themselves to this type of format, because the lower picture resolution is acceptable. Print-quality reproduction is not usually attainable with the lower resolution quality of this format.

- **Print Photo CD Disc.** This format was developed for the color electronic prepress industry. It stores color originals in the CYMK (cyan, magenta, yellow, and black) format necessary for producing color separations.

- **Medical Format.** This format allows data from CAT and MR scans to be stored on compact disc for later analysis or archival purposes.

SUMMARY

The computerization of the graphic arts industry has focused largely on the prepress side of the communications process. The information highway that gets an increasing amount of attention rests largely on the ability to convert and manipulate audio and video data in a digital format.

This chapter examines the methods of inputting a variety of black-and-white and color material, utilizing flatbed and drum scanning technology. Once the data has been input, optical character recognition software makes the text readable and image manipulation software enhances the drawings and illustrations to help define and achieve the desired message.

All digital input devices offer a variety of outputting options. Output depends on whether the data will be printed directly, as in direct-to-plate or direct-to-press technologies, or output to an intermediate processing stage, such as an imagesetter or laser printer, for proofing and further refinement. CD-ROM storage technologies examined will prove to be a major force in the industry as their influence for information storage, retrieval, and multimedia increases in the coming years.

Chapter

8

Illustrations

LINE & HALFTONE

INTRODUCTION TO GRAPHIC ARTS PROCESS PHOTOGRAPHY

Chapter 7 discussed how digital imaging has made significant inroads in graphic design and printing technologies. These inroads have occurred in both the prepress and press ends of the industry. Based on the continued advances of digital technology, one can make predictions about the short- and long-term future of photography within the graphic arts.

Foundry type gave way to the Linotype machine; the Linotype gave way to phototypesetters and photo-typesetters were replaced by laser-driven imagesetters. So too will photographic imaging and traditional prepress procedures be largely replaced by digital images that are manipulated entirely on the computer screen and output directly to a printing press. Film has always been the intermediate step in the production of printed images. This intermediate step will increasingly become a bridge to a future dominated by the digital generation of line and halftone images.

At present, it is possible to produce both high-quality four color process and conventional single-color halftone negatives without the use of photographic film. Waterless printing on presses such as the Heidelberg GTO-DI has eliminated the use not only of film, but also of plate technology as well. Short-run digital offset presses operating at speeds of 4,000 impressions per hour produce images whose quality is, by most standards, quite good. Based on these factors, the question is not if, but when and by what margin silver-based film will be replaced by computerized digitization.

Silver-emulsion-based photography is still a primary method used to transfer images from the typesetter and artist's drawing board to the printing plate. The resolution characteristics of photographic film are much higher than those of present-day scanners. This gives traditional photographic film processing a qual-

ity edge over digital processing techniques. The resolution of high-quality film is equivalent to more than a million lines per inch of resolution. Currently, the best digital scanners deliver less than 10,000 lines per inch of resolution. Photographic film thus holds far more image information than the best digital technology can currently deliver. Although future developments will bring the photographic and digital technologies closer together in terms of quality, photographic processing will continue to be a major influence in the industry in the near future. This chapter familiarizes you with basic techniques used to produce traditional line and halftone photographic negatives. Also, we take a look at how halftone images are generated and output to imagesetters using page composition and photo composition computer software.

TYPES OF CAMERA COPY

Original copy to be photographed can be classified as either line copy or continuous tone copy.

LINE COPY

Line copy includes all that is composed entirely of lines or areas of single tones only. Line copy contains no gradation of tone, shadows, or gray areas. Examples of line copy include typeset copy, pen-and-ink drawings, and photographs that have already been screened and are to be reproduced at approximately the same size as the original.

CONTINUOUS TONE COPY

Continuous tone copy contains both blacks and whites, as well as intermediate shades of gray or tonal ranges, in the original. Examples of continuous tone copy include original photographs, charcoal sketches, and airbrush renderings that incorporate intermediate shades of gray and colors in addition to blacks and whites.

ENLARGEMENTS AND REDUCTIONS

The amount of space allotted for an illustration, as well as the size of the original copy, usually make it necessary to either enlarge or reduce original artwork when preparing line and/or halftone negatives. All enlargements and reductions are based on a scale of 100%, with 100% being at the same size as the original. A line copy negative shot at 200% will be twice the size of the original copy; one shot at 50% will be half the size of the original; and so on.

PROPORTION SCALES

A proportion scale is often used to determine the percentage of enlargement or reduction required, based on the size of the original and the required size of the finished copy. A rotating dial proportion scale is shown in Figure 8.1. With this type of scale, the size of the width or the original on the inside wheel is rotated to align with the desired size of the reproduction on the outer wheel. The percentage of enlargement or reduction needed shows through the window on the inner wheel. All proportion works in a similar manner.

COMPUTATIONAL METHOD

Final enlargement or reduction sizes can be calculated mathematically using the following formula:

$$\frac{\text{Reproduced Size}}{\text{Original Size}} = \text{Percentage of Reproduction}$$

To use this formula, let's assume that an original photograph measures 6 inches wide and we wish to reproduce the illustration 9 inches wide. To calculate the reproduction percentage, we use the formula as follows:

$$\frac{9 \text{ inches final size}}{6 \text{ inches original size}} = 1.5$$

$$= 150\% \text{ reproduction size}$$

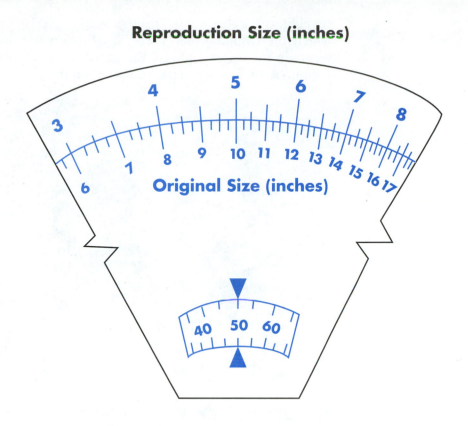

Reproduction Size (inches)

Original Size (inches)

To determine percentages for camera settings:

1. **Turn the inside wheel so that the original size of the copy (measure in inches) is opposite the outside scale for the desired reproduction size.**

2. **Read the percentage in the open window.**

Figure 8.1. A proportion scale.

CROPPING ILLUSTRATIONS

Most original photographs contain at least some portions that are irrelevant as far as the subject matter of the design piece is concerned. These unnecessary portions are marked to be cropped out of the final negative, so as to emphasize and improve the real subject matter of the original. Photographs to be cropped are

covered with either a clear tissue or acetate overlay on which the cropping marks are placed. No marks are made on the original photo. Figure 8.2 shows a photograph with the crop marks indicated on the overlay.

Figure 8.2. Crop marks on a transparent overlay of a photograph.

HALFTONE SCREEN RULINGS

Halftone screens come in different sizes and are categorized by the number of lines per inch that the screen produces. The greater the number of lines per inch of the screen, the greater the detail of the final printed reproduction. Coarse screen rulings such as 65 and 85 lines per inch, are used where detail quality is not important, as in newspapers and tabloid journals. Most texts use screen rulings in the 133 or 150 line per inch range. Where greatest detail is required, screen rulings as high as 300 lines per inch are used. Figure 8.3 compares an illustration reproduced with 65 lines per inch (Figure 8.3A) versus the same illustration with a 150 line per inch halftone screen (Figure 8.3B).

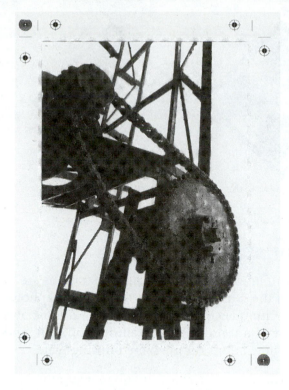

Figure 8.3A. 65 line halftone print. Coarse rulings from 55 to 100 line per inch screens are used primarily in newspapers, supermarket circulars, and similar materials where resolution of the image is not critical.

DOT SHAPES

Continuous tone illustrations can be converted in the halftone process using one of several different shapes of dots in the halftone screen. The most common halftone dot shapes are round, square, and elliptical. Round dots are used most often in making halftone illustrations. Because of the shape of the round dot, more surface of the round dot screen is covered with actual dots than with the other two shapes. Thus, greater detail is evident using round dots than other shapes (note the difference in the clear areas between the round and elliptical dot patterns shown in Figure 8.4).

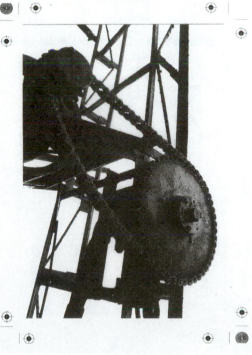

Figure 8.3B. 150 line halftone print. Screen rulings of more than 100 lines per inch give high-quality results and offer sharp image resolutions. These screen rulings are used in textbooks at the lower range and for artistic replication in the upper screen ranges.

235

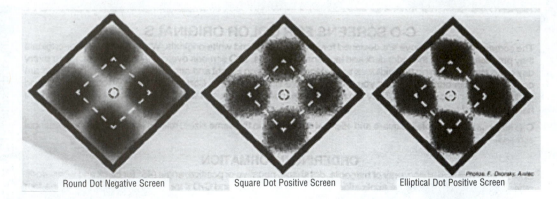

Round Dot Negative Screen Square Dot Positive Screen Elliptical Dot Positive Screen

Photos, F. Dronsky, Amtec

Figure 8.4. Comparison of round, square, and elliptical halftone screen dots (Courtesy, Caprock Developments, Inc.).

Figure 8.5. Layout with both text and continuous tone halftone copy.

COMBINATION NEGATIVES

When both line copy and halftone illustrations are to appear on the same printing plate, one of two photographic techniques is employed. Figure 8.5 illustrates the layout of a typical job containing both text and halftone illustrations on the same printing plate.

The first technique involves exposing one negative which has both the line and halftone illustrations. To do this, the halftone negatives must be contact-printed to produce screened velox prints. The screened velox positives can then be pasted up and photographed along with the other line copy.

The second technique is to photograph the line copy while leaving a space, or window, for the halftone illustration. This blockout will appear on the mechanical or in the negative exactly where the halftone will appear. When either a black or red blockout material is used on the original copy, the blockout will photograph as a clear window on the resulting negative. The halftone negative is then either pasted or stripped into the line negative in the window area. The layout for using the blockout approach is shown in Figure 8.6.

Note the black windows on the layout, which are either drawn or made by using black paper.

Figure 8.6. Black rectangle in a layout used to block out a space for stripping in a halftone negative.

THE CHEMISTRY OF PHOTOGRAPHY

Photography is a chemical process involving the action of visible light on a light-sensitive coating or emulsion covering a piece of film. Let's take a closer look and see what happens when film is exposed to make a picture. The cross-section of a typical piece of photographic film is shown in Figure 8.7.

Protective Layer
Emulsion Layer
Plastic Support Base
Antihalation Backing

Structure of Black-and-White Film

Figure 8.7. Construction of black-and-white film.

Graphic arts film is red-blind film and is known in the trade as *orthochromatic*, or *ortho,* film. Because the film sees the color red as black, or an absence of light, a red safelight can be used in the darkroom when working with ortho film. The use of a red safelight simplifies much of the processing and film- handling procedures.

Most of the film used in graphic arts process camera work uses a base made from relatively thin acetate plastic, between .003 inches and .008. inches. The protective layer in the film helps prevent scratching during normal handling of the film in camera work and chemical processing. The emulsion layer consists of light-sensitive silver halide crystals dispersed throughout a gelatinous emulsion medium. The silver halide crystals produce the final photographic image. The plastic support base is backed up by an anti-halation layer that prevents light that has penetrated through and exposed the emulsion from reflecting off the bottom of the film. Were this light to reflect, it would re-expose the emulsion, producing a ghost or halo image as it traveled back out through the film surface.

During exposure, light that strikes the photographic emulsion causes a chemical change in the emulsion. Until the film is processed, this chemical change is invisible and is called a *latent image*. The term *latent image* means that the light striking the film has been recorded by the emulsion but requires further processing for the image to become visible.

Film processing is accomplished in four steps, utilizing a chemical developer, a stop bath, a fixing solution, and a water wash. The developer reduces the exposed silver emulsion particles to black metallic silver. The stop bath chemically neutralizes the action of the developer, preventing further development of the emulsion once the negative has reached the proper level of development. The fixing solution loosens and begins to remove the unexposed silver particles from the emulsion of the film. A final wash in water com-

pletes the removal of unexposed silver particles from the film and washes away all processing chemicals from the film. After processing, the film is squeegeed and left to dry.

All of these processing steps can be accomplished either manually or by the use of automatic film-processing equipment. The daylight film processor in Figure 8.8 is used to develop film directly from an imagesetter. Note from this illustration that the process employs developer, fix, and washing bath coupled with an automatic film dryer. Feed rollers transport the film or photographic paper from one bath to the other and out to the film dryer.

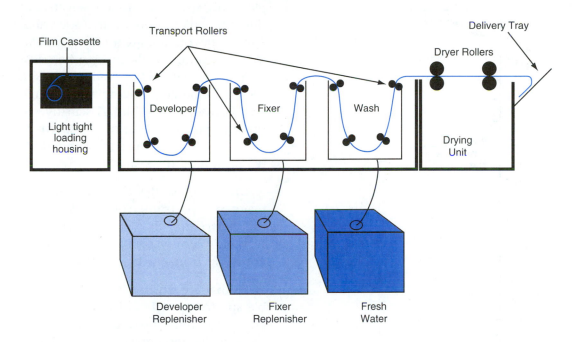

Figure 8.8. Film travel through a typical automatic film processor.

Continuing technological advancements in the area of environmentally friendly films have resulted in films that require no developing chemicals—the processing is done completely with water. This results in a dramatic decrease in the amount of chemical wastes associated with traditional film processing and will no doubt have a significant impact on film processing in years to come.

FILM SENSITIVITY

One method used to rate film is its sensitivity to different parts of either the visible or invisible spectrum. For example, many specialty films are sensitive to the infrared portion of the spectrum. These types of films are used in such varied applications as diagnosing heat loss from buildings and surveillance tasks, such as photographing objects through cloud cover. Ortho film is sensitive to the blue-green portion of the spectrum and, as we have discussed, is blind to the red portion of the visible spectrum.

Figure 8.9 illustrates the entire electromagnetic spectrum. You can see from this illustration that visible light occupies only a very small fraction of the entire electromagnetic spectrum.

Films that are sensitive to the entire visible spectrum, such as black-and-white and color films used in amateur and commercial photography, are referred to as *panchromatic films*. These films contain emulsion layers that are sensitive to red, green, and blue light. Color films have separate dye layers for each of the primary colors (red, green, and blue), but black-and-white films are sensitive to all of the primary colors and record them as different shades of gray.

Wavelength (meters)	Band	Frequency (hertz) (3×10^n)
10^7		10
10^6	AM radio	10^2
10^5		10^3 (3 kilocycles)
10^4	Radio waves	10^4
10^3		10^5
10^2	FM radio	10^6 (3 megacycles)
10		10^7
1	Shortwave radio	10^8
10^{-1}		10^9 (3 gigacycles)
10^{-2}	Microwaves	10^{10}
10^{-3}		10^{11}
10^{-4}	Infrared	10^{12}
10^{-5}		10^{13}
10^{-6}	Red / Yellow / Blue — Visible light	10^{14}
10^{-7}		10^{15}
10^{-8}	Ultraviolet	10^{16}
10^{-9}		10^{17}
10^{-10}	X-rays	10^{18}
10^{-11}		10^{19}
10^{-12}	(Area of overlap)	10^{20}
10^{-13}		10^{21}
10^{-14}		10^{22}
10^{-15}	Gamma rays	10^{23}
10^{-16}		10^{24}

Figure 8.9. The visible portion of the electromagnetic spectrum occupies only a very small band within the overall spectrum.

240

GRAPHIC ARTS PROCESS CAMERAS

Graphic arts process cameras are designed specifically for large-negative format photography. One method of rating these types of cameras is by the maximum size of sheet film that they are capable of exposing. For example, a 14-inch x 18-inch process camera takes a maximum sheet-film size of 14 x 18 inches, and so on. Other terms used to describe graphic arts cameras are as follows:

Darkroom Cameras: These cameras are designed either to be located in a light-tight room, or to have the film loading end of the camera installed in a darkroom, leaving the copyboard controls in a normally lighted room. Figure 8.10A illustrates a horizontal process camera small enough to fit entirely in the darkroom; the camera in Figure 8.10B is normally installed through a wall so that the camera's operating controls are located in the darkroom.

Figure 8.10A. Small horizontal darkroom camera (Courtesy Nuarc Company Inc.).

241

Figure 8.10B. A horizontal darkroom camera designed for through-the-wall installation (Courtesy Nuarc Company Inc.).

Gallery Cameras: Gallery cameras can be used in normally lighted rooms. These cameras have removable film packs that are taken into a darkroom, where the film is loaded. The film holder is then placed back onto the camera and the exposure is made. After making the exposure, the film pack is taken off the camera to the darkroom, where the negative is processed. A gallery camera is shown in Figure 8.11.

Horizontal Cameras: The sliding rails upon which the copyboard and lens board move are horizontal, or parallel to the ground. Horizontal cameras are almost always of the darkroom type and are made to handle large sheet-film sizes. The darkroom cameras in Figure 8.10 are horizontal cameras.

Vertical Cameras: A vertical camera is shown in Figure 8.11. The adjustment rails on this camera are vertical, or perpendicular to the ground. Although vertical cameras take up less floor space than do horizontal cameras, the maximum film size of these cameras is usually limited to approximately 20 inches x 24 inches.

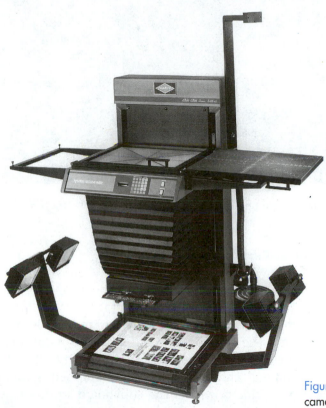

Figure 8.11. A graphic arts vertical gallery camera (Courtesy Nuarc Company Inc.).

CAMERA NOMENCLATURE

We will use the typical horizontal darkroom camera shown in Figure 8.12 for purposes of the following discussion. Controls on the camera are usually separated into those located on either the gallery end or the darkroom end of the camera.

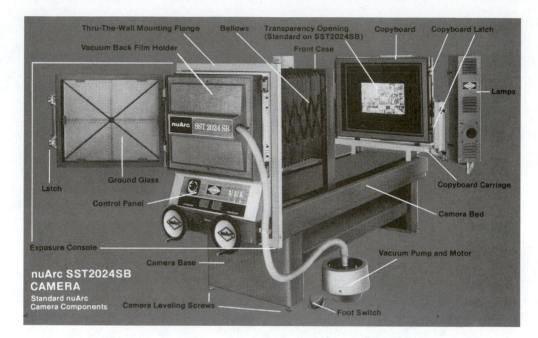

Thru-The-Wall Mounting Flange · Bellows · Transparency Opening (Standard on SST2024SB) · Copyboard · Copyboard Latch

Vacuum Back Film Holder · Front Case

Lamps

nuArc SST 2024 SB

Ground Glass

Latch

Control Panel

Copyboard Carriage

Camera Bed

Exposure Console

nuArc SST2024SB CAMERA
Standard nuArc Camera Components

Camera Base

Camera Leveling Screws

Vacuum Pump and Motor

Foot Switch

Figure 8.12. Standard components of a graphic arts process camera (Courtesy Nuarc Company Inc.).

GALLERY-END CAMERA CONTROLS

The copyboard housing holds the copyboard and camera lighting system. The copyboard moves along the horizontal rails of the camera. Movement along the rails is controlled from the darkroom side of the camera. The copyboard contains alignment marks that help in positioning the copy when it is placed on the camera. The copy to be photographed is usually placed upside down on the copyboard so that it will project right side up when viewed on the ground glass of the camera inside the darkroom. Most cameras allow the lighting system to be adjusted either for normal reflection copy, as in Figure 8.13, or for shooting transparencies with transmission-back lighting, shown in Figure 8.14.

244

Figure 8.13. Process camera lights set up for exposing reflection copy.

Figure 8.14. Process camera lights set up for exposing transparent copy.

Several different types of lighting systems are available for process cameras, including quartz- and mercury-based lamps. Most of these lighting systems provide even illumination for the entire operating life of the illuminating bulb. This property allows for consistent exposures between lamp changes.

The camera lights should be adjusted so that they evenly illuminate all of the copy. Note the position of the camera lights in Figure 8.15, which help provide even illumination over the entire surface area of the copyboard.

Example of Lamp Placement

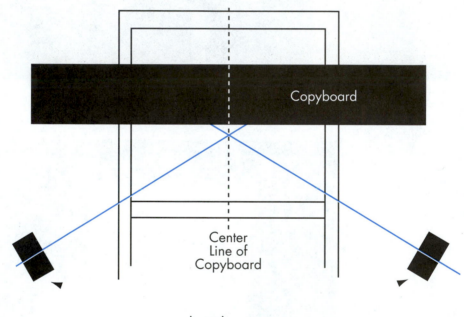

Figure 8.15. Adjusting camera lights for even illumination of the copyboard. Note that the lights are adjusted to slightly overlap the centerline of the copyboard. (Courtesy Nuarc Company Inc.).

The lens aperture control is also located on the gallery end of the camera. Figure 8.16 shows the aperture adjustment ring on the lens. The lens must be adjusted for the size of the enlargement or reduction to be photographed. The use of an aperture adjustment ring, as shown in Figure 8.16, automatically sets the correct enlargement or reduction as well as the aperture, or diaphragm, opening of the lens.

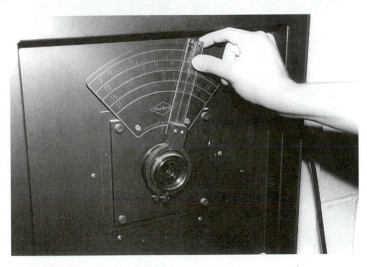

Figure 8.16. Adjusting the aperture or diaphragm opening of the camera lens.

DARKROOM-END CAMERA CONTROLS

All of the operating controls for the camera are located in the darkroom. These controls include the master electrical controls for the camera; the vacuum-assisted film holder and associated vacuum pump; the lens board and copyboard enlargement/reduction controls, with read-out scale; the ground glass for image viewing prior to exposure; and the exposure timing and activation controls. In addition to the typical camera controls illustrated in Figure 8.12, some cameras are equipped with solid-state computerized controls, such as those pictured in Figure 8.17.

Figure 8.17. Solid-state process camera exposure controls (Courtesy Nuarc Company Inc.).

Most process cameras use hand wheels for changing the position of the copyboard and lens board, depending upon the percentage of the enlargement or reduction. Automatic and computerized controls are also available as standard equipment on most cameras. Whether hand wheels or motorized controls are used for setting enlargement and reduction sizes, the lens board and copyboard must both be set to the proper exposure percentages. Automatic cameras feature digital readouts, whereas manual cameras have an illuminated window scale built into the housing of the camera that shows the enlargement/reduction ratios.

Figure 8.18. The ground glass on the camera is used to check for the position of the image as it will appear on the film.

The camera's ground glass is used to check for final position of the copy prior to exposure. The glass hinges down over the rear case of the camera and locks into place in the film plane of the camera. When the camera lights are turned on, the ground glass allows the camera operator to gain a film's-eye view of how the image will appear during exposure (Figure 8.18). Also, the ground glass can be used to check for even illumination of the copyboard. The ground glass must be securely locked in place when not in use; closing the camera back can cause it to fall and break against the locking handle of the camera back.

248

Film is placed by hand onto the film back of the camera and should be carefully positioned according to the guide markers provided on the camera back (Figure 8.19). The camera back has printed lines representing standard film sizes to aid the operator in properly positioning the film. The operator should resist the temptation to place tape on the camera back to mark film sizes, because the adhesive from the tape will stick to the back and scratch the film.

Figure 8.19. Placing film in position on the camera back.

Camera exposure controls similar to the one pictured in Figure 8.19 are multifunctional. This control allows for both setting the exposure time and beginning the exposure sequence which activates the timer, turns the copyboard lights on, and opens the lens shutter simultaneously.

EXPOSING AND DEVELOPING A LINE NEGATIVE

Exposing and processing a line negative is accomplished in five steps:

1. Setting up the darkroom and preparing the film
2. Making camera adjustments
3. Placing copy on the copyboard and adjusting the lights
4. Loading the camera with film and making the exposure
5. Processing the film

We will take a closer look at each of these processing steps for a typical line negative.

SETTING UP THE DARKROOM AND PREPARING THE FILM

Prior to taking any pictures, the film process chemistry should be set up with the film in place, ready for handling under safelight conditions.

The chemistry should be set up using a temperature-controlled darkroom sink whenever possible. Temperature-control sinks will automatically maintain the processing chemistry at the ideal temperature of 68°F. The darkroom sink shown in Figure 8.20 is noncorrosive and large enough to fit all of the trays for processing smaller sizes of sheet film. The processing trays should be set up side by side in the sink. Be sure to use trays that are large enough for the size of film being processed.

Figure 8.20. Temperature-control sink for film processing. The left section of this sink has a temperature controller unit built into the sink; the right side of the sink uses ordinary tap water. (Courtesy Nuarc Company Inc.).

Follow the manufacturer's instructions for the mixing of processing solutions. The film developer is usually sold as two separate stock solutions that are diluted and then mixed together. The developer wears out rather quickly and will have to be replaced after processing several sheets of film. The size of the film also affects the rate of solution depletion. The technician is referred to the manufacturers' recommendations regarding chemical replenishing requirements for specific developers. Replacement of the developer is necessary when the developing solution begins to turn black and negatives take an excessively long time to develop.

Commercial stop bath solutions are of the indicator type. When diluted according to specifications, the stop bath is normally yellow. Under continued use, the stop bath loses its effectiveness and turns from yellow to purple. When this color change takes place, a fresh solution of stop bath is required.

Fixing solution lasts the longest of all the processing chemistry. The fixing solution clears the milky white areas of the film, a process that normally takes one to three minutes. Eventually, though, the fixer will have to be replaced or replenished. Spent fixer should be stored for silver recovery and subsequent disposal as a toxic substance.

The water wash tray can be set up under a faucet or with a water siphon that is attached to the side of the tray and connected to the sink faucet with a hose. When using a darkroom sink that has a built-in wash area, a separate wash tray is not necessary.

The package of film to be used should be placed in a light-tight drawer or box, next to the camera. Light-tight film storage is important in case the darkroom white lights are accidentally turned on or the camera operator forgets to close the box of film.

It should be noted that conventional film developers are classified as toxic substances, making their disposal subject to federal regulations. For specific proce-

dures regarding the disposal of spent chemical processing solutions, see manufacturers' recommendations and the applicable Environmental Protection Agency (EPA) regulations.

MAKING CAMERA ADJUSTMENTS

Basic camera adjustments are setting enlargement and reduction ratios for the lens and copyboards, setting exposure time, and adjusting the lens aperture.

Enlargements and reductions are set on the camera by moving both the lens board and the copyboard to their proper positions along the camera rails. Gauges on the camera indicate the percentage of reproduction that either the lens or copyboard is set for. The camera will yield a 100% reproduction when the distance between the center of the camera lens and the copyboard is the same as the distance from the center of the lens to the film. The process camera acts in a manner similar to a photographic enlarger, whereby the overall size of the enlargement is set by changing the distance from the copy to the camera lens. The fine focus is then set by adjusting the lens board controls of the camera. The camera operator needs to remember that gauges for both the copyboard and the lens board must read the same reproduction percentage; otherwise the final size of the reproduction, focus, or both will be off.

The lens aperture works in conjunction with exposure time, determining how much light comes through the lens system of the camera to expose the film. Developing time for line negatives is not fixed, but rather depends on how much density, or darkness, of the emulsion layer develops. Therefore, light striking the film must be adjusted to permit the negative to develop slowly. This will enable the camera operator to stop the development at any step along the gray scale for precise negative density control. Negative density is both determined and controlled by a 12-step gray scale (to be discussed shortly) that is placed alongside the copy, on the base board but out of the image area.

Sometimes, especially when working with new film or chemistry, trial and error will determine which settings are best and offer the operator the greatest degree of control over the development process. As a starting point, try setting the lens aperture to F16 with an exposure time of 10 seconds. If, when developing the film, the image comes up too quickly and the development of the negative cannot be stopped precisely at any specific step of the gray scale, either the F stop of the lens should be increased (try one step up to F22), or the exposure time should be decreased (try a reduction of 3 to 5 seconds). Conversely, if the image takes too long to develop, try increasing the exposure time from 10 to 14 seconds, and make subsequent adjustments as new test negatives are developed.

PLACING COPY ON THE COPYBOARD AND ADJUSTING THE LIGHTS

The *gray scale*, a quality control tool for judging negative developments (shown in Figure 8.21), must be positioned so that it will show up on the film, yet be out of the image area of the final print. Gray scales can also be placed within the area of the copy itself and be either opaqued or taped out of the final negative during the stripping process.

Figure 8.21. The gray scale is the basic quality control device used in both line and halftone photography (Courtesy Stouffer Graphic Arts, Inc.).

Copy should be centered on the copyboard, using the guidelines printed on the copyboard. When setting the copy in place, be sure to place the 12-step gray scale alongside the copy, but outside of the image area. This set-up is shown in Figure 8.22.

Figure 8.22. Setting up copy for exposure on the camera.

253

The camera lights are set according to the manufacturer's recommendations. Often, cameras have etched adjustment lines, or notches, built into the framework of the light housing to guide the camera operator in properly adjusting the lights. Note the alignment marks in Figures 8.23 and 8.24 for this purpose. Ideally, both banks of lights should be equidistant from the copyboard and evenly illuminate the copy without producing "hot spots" on the original copy.

Adjustment Knob

Support Arm Bracket

Lamp Housing

Support Arm Bracket

Figure 8.23. Setting up alignment notches on the camera lights during final adjustment prior to exposure.

Figure 8.24. Closeup of alignment notches on camera light housing.

LOADING THE CAMERA WITH FILM AND MAKING THE EXPOSURE

Film is loaded onto the camera back with the emulsion side of the film facing up. The emulsion side of the film is the lighter and duller of the two sides of the film. The darker side of the film is the plastic support base. If you hold the film up to the safelight, it will be easy to see which of the two sides of the film is the emulsion, or lighter side (the film will also curl toward the emulsion side).

The film should be placed on the camera using the guidelines printed on the camera back, unless the image placement as shown on the ground glass necessitates a change in the position of the film.

After the film has been placed on the camera back, the vacuum pump is turned on and the camera back is closed and latched. Vacuum keeps the film firmly in place against the camera back during exposure. The sequence begins when the exposure activation button on the timing control panel of the camera is pressed. After exposing, the vacuum pump is turned off, the camera back is opened, and the film is removed from the camera.

PROCESSING THE FILM

For best results, film should be developed as quickly as possible after it has been exposed. The grayscale method of development is one that gives consistently uniform results regardless of development strength or temperature. During processing, the film should always be handled by its edges or corners to prevent scratching and fingerprints.

The negative should be completely immersed in the developing solution. Once immersed, the tray should be continuously agitated during the entire processing procedure (Figure 8.25).

Figure 8.25. Continuous agitation of the film during development ensures proper and even contrast in the film.

As the development proceeds, concentrate on the image of the gray scale. If the exposure time has been properly selected, you will notice that each step of the gray scale comes up in a slow sequence. Ideally, about 15 to 20 seconds will go by as each step of the gray scale becomes visible and then darkens. For best results when photographing normal copy, the development of the negative should be stopped when the gray scale is between a solid step 3 and 4. At this point, the film should be removed from the developer and placed into a stop bath tray. Figure 8.26 illustrates a gray scale developed to between a step 3 and 4. Properly developed negatives will have no more than 3 steps visible in the gray scale.

Using steps 3 and 4 of the gray scale as a development guide will cover most kinds of copy photographed under normal circumstances. For copy other than that considered normal, use the chart in Figure 8.27 for determining proper grayscale step development. Note from this chart that extra heavy copy, with large type and thicker elements to the letters, requires development to a higher step on the gray scale. Copy with smaller and finer type, with lighter type elements in the letters, will be developed to a lower step on the gray scale. As a guide to developer strength, images that take longer than four minutes to develop indicate exhausted developer.

Figure 8.26. Developing line copy to between step 3 and step 4 on the gray scale ensures proper film density and image control for the majority of line copy.

UNUSUAL COPY
EXTRA HEAVY OR EXTRA LIGHT.

Since the average photographer is called on to photograph all types of copy it is often necessary to adjust for these variations in copy density to secure useable and uniform negatives. Good black copy, same size or enlarged can be developed darker to eliminates pinholes. On the other hand copy with light grey lines or greatly reduced negatives must be developed short or the lines will fill in.

To determine the proper step for unusual copy refer to Chart.

CRITICAL STEP CHART
Showing Proper Step for Various Types of Copy
Reductions and Enlargements

Density of Copy	Size of Copy		
	10–40%	40–120%	120–400%
EXTRA HEAVY COPY Black Bold type Etching Proofs Photo Proofs	4 Black	5 Black	6 Black
NORMAL COPY Good black type proofs with fine serifs Pen and Ink Drawings Plated Forms	3 Black	4 Black	5 Black
LIGHT COPY Grey Copy Ordinary Typewritten Sheets Printed Forms Light Lines Good Pencil Drawings	2 Black	3 Black	4 Black
EXTRA LIGHT COPY Extra Fine Lines* Pencil Drawings Extra light grey copy	1–2 Black	2 Black	3 Black

*Difficult fine line copy and fine line reductions can usually be improved by fine line development, or still development (not agitated) in regular developer (refer to the manufacturer's instructions).

Figure 8.27. Unusual copy guide for determining proper grayscale exposure densities. Use this guide when exposing copy that falls outside of the normal range (Courtesy Stouffer Graphic Arts, Inc.).

257

Quick placement of the film into the stop bath is important. Residual development takes place on the surface of the film from the time the negative leaves the developer until the stop bath chemically neutralizes the developing solution on the film surface. Allow the film to remain in the stop bath for approximately 30 seconds, then place it into the fixing solution. The film should be fixed from three to five minutes. One procedure is to leave the film in the fixer twice as long as it takes for the milky areas on the negative to clear. The film is then placed in the wash tray or wash area of the sink.

Washing film after chemical processing is an important step that helps to ensure that no chemical residue is left on the film. Wash the film for 30 minutes in running water whose temperature is as close to the temperature of the processing chemistry as possible. After washing, place the film in a film dryer, if one is available, or in a drying cabinet where it can drip dry. After the film has dried, it should be handled carefully to prevent scratching the emulsion side of the negative.

With this basic understanding of line art photography, let's move on to examine how continuous tone copy is produced using halftone photographic processing.

HALFTONE PHOTOGRAPHIC PROCESSING

As an increasing amount of traditional halftone photography moves to a totally digital platform, using scanners, computers, and high-quality output software, process camera halftone production is on the wane. However, the principles of halftone reproduction, whether they are carried out using a conventional process camera or a computer, are essentially the same. This knowledge base thus applies to both the traditional and the digital methods of halftone production. In this section, we look first at traditional photographic principles and then at computerized methods for producing halftone negatives.

WHY HALFTONES?

A close examination of any printed illustration reveals that the tonal range of a printed product comes not from printed shades of gray, but rather from a series of small dots of varying sizes that, when viewed from a distance, give the viewer the impression of full tonal range. These dots are referred to as *halftone dots* and are responsible for the optical illusion of the many shades of gray that make up the overall contrast range of a typical illustration.

Halftone dots are required for continuous tone reproduction because a printing press is only capable of printing either ink or nothing. Printing presses cannot print normal gradations or tonal ranges of a color as they appear in black-and-white or color photographs. They can, however, print black dots of different sizes to give the illusion of tonal range. How the sizes of these dots affect our perception of a printed illustration is demonstrated in the following figures. At first glance, the pictures in Figures 8.28A and B look very similar. The photograph in Figure 8.28A was reproduced using a halftone screen ruled at 85 lines per inch. The photograph in Figure 8.28B was reproduced using a finer screen, ruled at 150 lines per inch.

To see the difference in detail between these two screen rulings, note the comparison of the enlarged sections of the screen rulings in Figures 8.29A and B. The detail reproduced from the 150 line screen in Figure 8.29A is far greater than that of its coarser, 85 line per inch counterpart in Figure 8.29B.

Figure 8.28A. 85 line halftone illustration.

Figure 8.28B. 150 line halftone illustration.

259

Figure 8.29A. 150 line screen from Figure 8.28B, enlarged to show detail.

Figure 8.29B. 85 line screen from Figure 8.28A, enlarged to show detail.

BREAKING UP THE PICTURE INTO DOTS

To break up an illustration into a series of dots, a halftone screen, containing a built-in dot structure, is placed over the film during exposure of the original illustration on the camera. Although early halftone screens used for this process were made from two sheets of glass with perpendicular lines bonded together, most halftones are now processed using screens made from plastic, called *contact screens*. The

dot pattern produced from a contact screen is nearly clear in the center of the dot, and becomes progressively grayer or darker as you move away from the center of the dot.

During camera exposure, light reflecting from the dark, or shadow, areas of the original is relatively weak. This light only passes through the center, clear areas of the halftone screen. This produces a corresponding small dot on the negative. Light reflecting from the highlight, or bright, areas of the original is strong enough to penetrate the outer areas of the contact screen dot, which produces a relatively larger dot on the negative. Light reflecting from the middle tonal areas of the original penetrates the center clear areas of the contact screen as well as part of the grayer areas, exposing about half of the dot area from the halftone screen onto the negative. Note the dot patterns created from 85 and 133 line screens in Figure 8.30.

TYPES OF CONTACT HALFTONE SCREENS

Several different types of contact screens are available. Which one you use depends on the type of copy being photographed and the particular screening effect desired. Some of the more popular types of screens available are the following.

Gray Contact Screens: Gray screens are the standard contact screen containing vignetted dots. Gray screens are used for direct-screen halftones for color separation purposes, as well as for photographing 262 black-and-white original copy.

Magenta Contact Screens: Magenta screens are used primarily for photographing black-and-white original copy. Because of their color, they are not used for making color separations. Using yellow and magenta filters with magenta screens enables the camera operator to increase or decrease the contrast range of the halftone negative.

Figure 8.30. Enlarged dot patterns of 85 and 133 line halftone screens.

PMT Gray Contact Screens: These screens are used in the diffusion process transfer, photo mechanical transfer (PMT) process for making screened paper prints (positives) from original camera copy. PMT prints are for combination negatives that require screened continuous tone copy to be pasted up and photographed along with all of the text and other line copy (see "Shooting Halftone Prints as Line Copy" later in this chapter).

Special Effects Screens: There are many screens available for producing interesting and unusual special effects on the negative. These screens are used in the same way as conventional contact screens. Some of the effects available are shown in Figure 8.31.

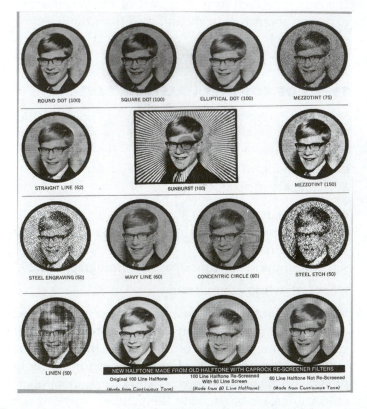

Figure 8.31. Special-effects halftone contact screens (Courtesy Caprock Developments, Inc.).

262

Auto Screen Film: Auto screen film has the halftone screen rulings built into the emulsion of the film. This eliminates the need for a conventional halftone screen when exposing continuous tone copy on the camera. The emulsion on the film, which acts in same the way as the halftone screen, contains thousands of dots that increase in sensitivity from the center to the outside area of the dot. The size of the resulting dot in the film depends upon the amount of light reflecting from the original camera copy. Darker areas expose only the center of the dot in the film, and lighter areas expose correspondingly larger areas of the dot pattern, similar to the exposure pattern in regular film using a contact or glass halftone screen. Auto screen film is available only in a 133 screen ruling.

STOCHASTIC SCREENING

We can see how halftone screening presents an optical illusion to the viewer. When working with black-and-white illustrations, the halftone screen prints evenly spaced rows of dots that vary in size throughout the illustration. The varying size of the dots allows more or less of the white paper on which the image is printed to show through, producing the different shades of gray. When working with full-color illustrations, the same theory as in black-and-white screening applies; however, four successive colors are printed over one another, using transparent inks, to reproduce the primary colors of red, green, and blue.

Whereas conventional halftone photography uses the same number of dots in the highlight as in the shadow areas of the print, and varies the size of these dots from 10% to 90%, stochastic screening uses dots that are all the same size, but varies the space between the dots. Stochastic screening is sometimes called *frequency modulation* or *FM screening,* meaning that the dots vary in frequency or number. Because stochastic screening techniques rely on what appear to be randomly placed dots rather than uniformly distributed

dots, line or screen ruling terms have no application within this technique. Figure 8.32 contrasts the differences in dot patterns between conventional halftone and stochastic screening processes.

Section of a typical halftone picture (enlarged).

Section of a stochastially screened picture (enlarged).

Figure 8.32. Comparison of conventional halftone and stochastic screen dot patterns.

One major advantage of the stochastic screening process is the elimination of moire patterns. When rescreening black-and-white halftone originals or printing four color separations, the placement of dots is a critical factor relating to moire patterns. If overlapping dots do not fall at just the right angle, or interfere with one another, then a moire pattern will develop. Because stochastic screening uses randomly placed rather than uniformly placed dots on the page, no moire pattern can develop. (See Figures 8.37A and B for more discussion relating to moire patterns).

Most imagesetter manufacturers have stochastic screening software available for their machines. New software continues to offer increased dot sizes for stochastic screening, making the process workable for a larger variety of offset duplicators and presses (stochastic screening software can now produce the equivalent of a 5% dot). Stochastic screening will likely become as much of a standard as conventional halftone screening techniques in the near future.

DENSITOMETRY

The determination of how much light is reflected from original art copy, or is transmitted through a photographic negative, falls within an area known as *densitometry*. Densitometry deals with how dark different areas of a photographic negative or positive are, or how dark or light different areas of either original artwork or printed copy are. The density, or darkness, of a photographic negative or positive comes from the amount of silver dye developed in the film or photographic paper. In printed copy, density is caused by the light-stopping ability of the pigments of the printing ink that are deposited on the paper by the printing press. The final printed quality of halftone illustrations depends on the density of the various tonal areas in the original, and how accurately these tonal ranges are copied in the resulting halftone negative and transferred to the printing plate. A basic understanding of densitometry is therefore essential to evaluate and maximize the quality of the entire halftone photographic process. Four qualities can be measured in densitometric terms: opacity, density, transmittance, and reflectance. Each of these terms is explained in more detail here.

Opacity: *Opacity* is the ability of a substance (like the developed silver particles in the emulsion layer of a piece of film) to prevent light from passing through. Opacity is measured in decimal numbers ranging from 1 to 100. The higher the number, the greater the opacity, or light-stopping ability of the photographic emulsion.

Density: *Density* is the same thing as opacity, but is measured by a densitometer with readings that run on a scale from 0 to 4.0 (the higher the number, the greater the density). Densitometer readings can be in either analog or digital format, depending on the densitometer. Figure 8.33A shows a digital read-out reflection densitometer; Figure 8.33B highlights the analog version. Note in Figure 8.33B that the analog scale fea-

tures both the density readings and the equivalent percentage of reflectance.

Figure 833A. Digital read-out reflection densitometer (Courtesy Macbeth, Inc.).

Densitometers of the type shown in Figure 8.33 are available either as reflection units used for measuring density in original reflection copy, or as transmission units used to determine the transmission from photographic negatives or positives. The use of densitometers to take either transmission or reflection density readings eliminates any outside stray light as a variable. This allows all densitometer readings to be taken from a specific starting point, allowing for control of comparable density readings.

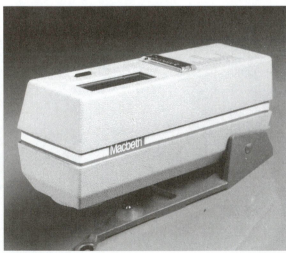

Figure 833B. Digital read-out transmission densitometer (Courtesy Macbeth, Inc.).

Transmittance: *Transmittance,* or *transmission,* is the amount of light striking a photographic negative that actually makes it through the emulsion layer in a particular section of the negative. Transmittance is expressed as a percentage of transmitted incident light and is a function of the dot size of the negative. For example, a transmittance of 10% is ¹⁄₁₀ of the incident light, and would occur at a point in the negative with a 90% dot. Transmission readings are taken from both photographic negatives and positives.

Reflectance: *Reflectance,* or *reflection,* is the percentage of incident light that is able to reflect off the copy (a photographic print, for example) in a particular tonal range. Reflectance will vary with the brightness of illumination as well as the type and color of paper used for the print. For example, a perfect halftone print would yield a 50% dot in the gray areas. The reflectance in this section of the print would be 50%. Conversely, an area of a print with a reflectance of 5% (an area of the print that was reflecting 1/20 of the incident light) would be a very dark gray or black in tone. Reflection readings are taken from photographic prints and similar original artwork.

Figure 8.34 shows a simple relationship between density and transmission of light. In this example, each additional layer of density reduces the transmission of light by a factor of 10.

By measuring the whitest white and the darkest shadow area with a densitometer, the overall contrast range of the original illustration or photograph can be determined. This contrast range is used in determining exposure times when making a halftone negative, and is discussed in the next sections.

MAKING A HALFTONE NEGATIVE
The steps involved in producing a halftone negative are: calibrating the camera with a halftone computer; determining proper exposure times; setting up the camera and making the exposure; and processing and evaluating the halftone negative.

Figure 8.34. Density relationship between transmission and reflection of light.

Transmission and Density Re
All numbers represent units of light.

267

Most halftone negatives are shot using a plastic contact screen. The screen, as we saw in Figure 8.32, has an emulsion side, and a base side. Contact screens, like ordinary photographic film, will curl toward the emulsion side of the screen. The film is first placed on the vacuum back of the camera, emulsion side up. The contact screen is then placed over the film, emulsion side of the screen against the emulsion side of the film (Figure 8.35).

Figure 8.35. Placing a halftone screen over ortho film to expose a halftone negative.

Note from the illustration in Figure 8.35 that the physical size of the contact screen must be larger than the physical size of the film in order for the screen to be held in place by the vacuum back of the camera when the camera is closed. Thus, when using 10-inch x 12-inch ortho film for shooting halftone negatives, an 11-inch x 14-inch contact screen should be used, and so on.

MAIN, FLASH, AND BUMP EXPOSURES

Most halftone negatives require at least two separate exposures to capture all of the detail in the original subject. These exposures are referred to as a *main* and

a *flash* exposure. The main exposure is made through the lens of the camera with the copy in the copyboard, and captures the major detail and highlight and middle areas of the original copy. A flash exposure is made by opening the film back of the camera and exposing the film/screen sandwich to a yellow filter lamp placed above the camera. The flash exposure is used to bring up detail in the shadow areas of the original (the clear areas of the negative). The flash exposure hardens the small dots that have begun to form in the negative, but did not receive enough reflected light from the copy to form the hard dots that will give good shadow detail.

Sometimes, a third exposure, called a *bump exposure* is taken to increase detail in the highlight area of the original. This exposure is made with the screen removed and is discussed shortly.

The purpose of making all three is to allow the camera to capture the overall contrast range of the original copy, which is usually greater than the camera can capture through one main exposure alone. Flash and bump exposures extend the contrast range of the camera, bringing up details in both the highlight and shadow areas of the original that would otherwise be lost if only a main exposure were made.

Let's examine each of the steps involved in making a traditional halftone negative. This process begins with calibrating a process camera for halftone work.

CALIBRATING PROCESS CAMERAS

The primary method for determining proper exposure times for main and flash exposures for a variety of reflection copy, regardless of the density range of the original, is to calibrate the camera to a base point. In this process, the operator determines how much density the camera is capable of capturing with one main exposure. The calibration process also enables the operator to calculate the proper times for flash exposures. These procedures are accurate only for the camera being calibrated, using

a specific kind of film, developer, lighting conditions, and halftone screen. Should the camera exposure lights be changed, the brand of film or contact screen change, or the chemistry switched from one manufacturer to another, the camera should be recalibrated to take into account the new variables introduced into the photographic process.

Calibration procedures can be performed using either a Kodak Graphic Arts Exposure Computer, with its accompanying reflection density guide, or a standard reflection gray scale (the type used for making line photographs) whose different steps have been calibrated with a reflection densitometer.

DETERMINING THE PROPER FLASH EXPOSURE

The purpose of the flash exposure, as explained earlier, is to harden the halftone dots in the shadow areas of the negative. These are the dots that, because of a relatively low level of light reflecting from the original copy, did not harden sufficiently during the main exposure. Left alone, these dots will be too small to hold on the negative and resulting printing plate, causing a loss of detail in the shadow areas of the resulting print. Before flash exposures can be performed, it must be determined how many seconds it takes for a specific flash lamp to produce a hard 10% dot on the film under the test exposure conditions. (The term *flash lamp* refers only to the flash exposure procedure—the lamp does not flash on and off). The basic flash time is determined by exposing a piece of film, with a halftone screen on top of it, to the flash exposure lamp for a variety of times to determine which exposure time results in a hard 10% dot on the film (Figure 8.36).

During this examination, the strip that gives a good, hard 10% dot, similar in structure to the 10% shadow dot found in the main exposure test negative, will show the best flash exposure time. Ideally, the exposure time required to produce this dot is in the 16- to 25-second range. If the dot was produced using a very short exposure time, the flash lamp should be moved

270

away from the back of the camera, decreasing the light intensity from the lamp. Also, the manufacturer's instructions should be checked to ensure that the maximum wattage of the light source does not exceed specifications.

PROCESSING AND EVALUATING THE HALFTONE NEGATIVE

The halftone negative evaluation process focuses on an examination of the dot patterns in the negative and how these dot structures correspond to the tonal range in the original artwork. Ideally, the halftone negative will enable a printing plate to be made that will print a close reproduction of the original.

Highlight areas from the original illustration should yield about a 90% dot on the halftone negative. A 90% dot on the negative should give a good, solid 10% dot on the printing plate. Conversely, shadow areas from the original illustration will yield a 10% dot on the halftone negative, resulting in a 90% dot on the printing plate. Because of the pressure exerted by the offset blanket during the actual printing process, halftone dots on the plate tend to fill in. Dot spread, or gain, can be controlled by having well-formed dots in both the negative and the plate. Middle tones should range in dot size

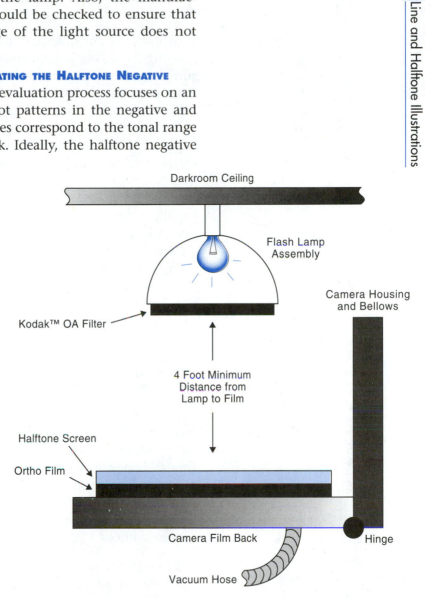

Figure 8.36. Setting up the process camera for a halftone flash exposure test.

from about 30% to 65% or 70%, and should reflect the overall tonal range of the original photograph or of the illustration.

When relating the quality of the halftone negative to the original artwork, remember that the main exposure determines the dot size and structure in the highlight areas; the flash exposure determines the dot size and detail in the shadow areas; and the bump exposure controls details in the highlight areas. If a main exposure is too long, the detail in the highlight areas of the original will be lost, as the dark areas of the halftone negative will tend to close up completely and lose the small 10% dots. Thus, for larger dots in the highlight (transparent area of the halftone negative), decrease the main exposure. For smaller transparent dots in the highlight area, increase the main exposure. To increase dot size in the shadow areas of the negative, lengthen the flash exposure. For smaller dots in the shadow area, decrease the flash exposure. To bring up details in the highlight areas, experiment with different bump exposure times.

SHOOTING HALFTONE PRINTS AS LINE COPY AND RESCREENING

Once a continuous tone illustration or photograph has been screened and printed, it contains a series of halftone dots which, although breaking up the printed image into darker and lighter areas, represents a single tonal image. Halftone negatives can be made from these prescreened originals by treating them as ordinary line copy and photographing them on the camera without a halftone screen.

Halftone prints can be pasted up on a mechanical alongside other traditional line copy and photographed as one piece of line copy. Care must be taken when using halftone prints as line copy if either enlargements or reductions are required. For example, an original halftone print with a screen ruling of 100 lines per inch reduced to 75% will have a screen ruling of 150 lines per

inch. Screen sizes finer than 150 lines per inch will tend to fill in on certain types of presses and should therefore be avoided. Conversely, the 100 line per inch original, if enlarged at 200 percent, will have an equivalent screen ruling of 50 lines per inch. This will result in a print whose screen ruling may be too coarse from a visual or design point of view.

It is sometimes desirable to rescreen a halftone print for different reasons. If enlargements or reductions will result in objectionable screen sizes, or the screen pattern of the original is too fine to be reproducible on the camera while keeping the detail of the original intact, the original halftone will have to be rescreened.

The major problem encountered when rescreening a halftone print occurs when the dot pattern of the screen used in the camera interferes with or mismatches the dot pattern on the original print. This mismatch is called a *moiré pattern* which can be seen by comparing the two printed photographs in Figures 8.37A and B.

Figure 8.37A. Original screened photograph.

Figure 8.37B. Moiré pattern caused by screen interference

273

To minimize the possibility of moire patterns occurring on a rescreened negative, the contact screen on the camera should be rotated so that its angle is different from the screen angle used to make the original print. Also, a finer or coarser contact screen can be used for rescreening than was used to make the original halftone.

DIFFUSION TRANSFER PROCESSING

The diffusion transfer process produces opaque positive prints, as well as screened halftones, on photographic paper from photographic positive originals. The screened prints are sometimes referred to as *screened velox prints*. Because they are screened, they can be pasted up on mechanicals and photographed along with the remainder of the line copy, without the need for special halftone photographic techniques.

The diffusion process uses a special transfer film and receiving paper. The transfer film is placed in the camera (and covered with a special halftone screen if a screened velox is to be made) and the exposure is made. To process the print, the transfer film is placed in contact with the receiving paper and sent through an activating solution in the processor. As the transfer film goes through the activator, the image is developed and transferred from the film to the receiving paper. A pair of rollers in the processor squeezes the transfer film and receiving paper together as they leave the processor. Under the pressure from the rollers, the image is transferred from the film to the receiving paper. This paper-and-film sandwich is then peeled apart after the manufacturer's recommended time, usually 15 to 30 seconds. Note the transfer of the image from the film to the paper shown in Figure 8.38.

Because diffusion processing involves image transfer, the normal rules for lightening and darkening a print are reversed. To darken the transfer positive, exposure time should be reduced; conversely, to lighten the print, the exposure time should be increased. Expo-

sure times between 10 and 20 seconds are the norm for this procedure.

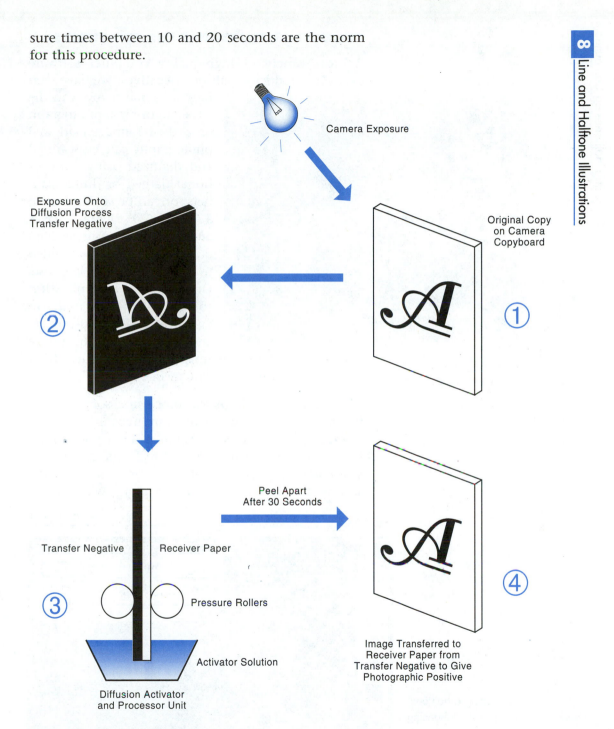

Figure 8.38. The diffusion transfer process.

PRODUCING HALFTONES ON COMPUTERS

A great variety of high-quality computer software exists for producing halftone negatives. We have seen

how original copy can be either an original photograph or a digital image. Original photographs can be scanned and digitized using conventional flatbed or drum scanners, or can be scanned onto a Photo CD. Digital images are also produced using digital cameras and downloaded to the computer for later use. Once digitized, application software can be used to enhance, modify, customize, and color-correct an image

Figure 8.39. Generating a halftone image on the computer—cropping the image.

before sending it to the imagesetter to produce either positives, negatives, or plate media.

Once under control of the processing software, the image can be manipulated and output as shown in the following illustrations. In Figure 8.39, a photograph has been imported from a Photo CD and a cropping size has been selected (note the scissor icon on the screen that appears after the cropping window has

Figure 8.40. Generating a halftone image on the computer—enhancing the image.

276

been drawn). Figure 8.40 highlights the controls used to manipulate both brightness and contrast. Figure 8.41 illustrates the method for selecting halftone screen sizes, angles, and shapes when working with black-and-white illustrations. Figure 8.42 shows the control bar used when selecting screen sizes and angles for producing color separation negatives from full-color originals.

Figure 8.41. Generating a halftone image on the computer—selecting screen sizes and angles.

SUMMARY

This chapter covered the basic photographic techniques used in process camera work to produce both line and halftone negatives. The skills developed in producing line negatives provide the foundation for the more intricate techniques needed to produce high-quality halftone negatives from original continuous tone illustrations and photographs. Also, a basic technique for digitizing and outputting halftone negatives was discussed.

Figure 8.42. Generating a halftone image on the computer—making selections for outputting color separation negatives on an imagesetter.

In addition to developing an understanding of the techniques associated with process camera work, an additional issue for the student and technician alike concerns the increasing digitization of the photographic process and its impact on the future of traditional process camera work. Given continued advances in direct-to-plate and direct-to-press technologies, the nature and impact of conventional line and halftone photography will change dramatically in the coming years. Some experts predict the end of the traditional darkroom and associated photographic processes in short order; others foresee a more gradual, extended shift in technologies. Regardless of individual opinions, certain fundamental changes within this field have already taken place.

For example, this book does not cover traditional photographic color separation camerawork. Software technology now makes it possible and commonplace to produce color separations automatically from photographs imported into page composition or photo retouching programs. The tedious process of separating full-color originals into component negatives on the camera is no longer necessary. Taking this process one step further, the computer operator can now produce color separations directly on either a plate or the printing press. Proofing, once the domain of the color separation house or printer, can be done on affordable dye sublimation or wax thermal printers, with exacting results.

Traditional camera processing will no doubt continue as an integral graphic arts process for many years to come. However, changes are on the horizon. Both students and technicians will need to keep up with these changes to position themselves for the photographic and digital imaging world of tomorrow.

Chapter

9

Stripping & Plate Making

Printing Area Limit

Alignment Grid (throughout - shown in one sector only)

Top of Paper

Layout Grid

Pinbar Plate Clamp Holes (Top of Plate)

Center Line

Outside Paper Margins

Tail Clamp Holes

INTRODUCTION

The various elements of a job, including line and halftone photographs, computer-generated artwork, and text copy, come together during final image assembly. The product of this final layout, called the *mechanical,* is referenced in chapter 1. After all of the copy has been photographed, the negatives are properly positioned and taped onto a goldenrod masking sheet in preparation for platemaking. This process is referred to as *stripping* and the masking sheet is called a *flat.*

Stripping has traditionally been a manual process. All of the individual negatives from the page are placed onto the sheet of goldenrod paper. Using current technology, image assembly can also be performed on the computer. Computer assembly eliminates the manual processing involved in combining line and halftone negatives onto a single flat. Pages that have been made up on the computer are usually output to an imagesetter, which produces one negative containing all of the page elements. This negative is then stripped onto a sheet of goldenrod prior to platemaking.

Technological innovation continues to impact the traditional techniques used in stripping and platemaking. For example, some imagesetters are able to output on printing plate media as well as conventional film and paper. The development of platesetting machines enables the graphic designer to go directly from the computer to the printing plate, bypassing the intermediate steps of photographic processing, stripping, and platemaking. Pushing the technology even further, we now have offset presses that can develop the printing image directly on the plate cylinder of the press. Although direct-to-press technology continues to gain a foothold in the industry and marks an emphasis in technological innovations, conventional platemaking will continue to play an important, if not dominant, role in the immediate future.

This chapter examines the procedures involved in stripping a flat and then using the flat to make a printing plate.

THE GOLDENROD SHEET

Stripping procedures are performed using sheets of specially prepared paper known called *goldenrod paper* or *stripping sheets*. The yellow color of the goldenrod sheet enables it to prevent the transmission of actinic light. *Actinic light* is light in the ultraviolet portion of the spectrum given off by platemakers that causes a photochemical change in the light-sensitive emulsion on the printing plate.

SHEET SIZES

Goldenrod sheets are made to match the exact size of the printing plate for a specific printing press. For example, an A.B. Dick 360 press uses an 11-inch x 18½-inch printing plate (outside dimensions). The goldenrod supplied for this press also measures 11 inch x 18½ inches. An A.B. Dick 9500 series press uses plates measuring 13 inches x 19⅜ inches, which requires goldenrod flats of the same dimensions.

When the stripping is completed, the masking sheet represents, in effect, a duplicate of what the printing plate will look like in reverse. The position of all the elements on the printed sheet can be determined by closely examining the flat. Proper positioning of all elements on the flat, called *imposition,* is critical. Figure 9.1 shows a completed flat, ready for exposure onto a photographically sensitized printing plate.

Figure 9.1. A stripped flat, ready for exposure onto an offset printing plate.

RULED MASKING SHEET

Most of the goldenrod used for small offset presses and duplicators comes with ruled dimension and reference lines already printed on the sheet. These lines show the position of critical margins and distances that the stripper must take into account when placing negatives onto the flat. Large printing presses generally use unlined goldenrod. Figure 9.2 highlights the most important dimensions of a typical flat.

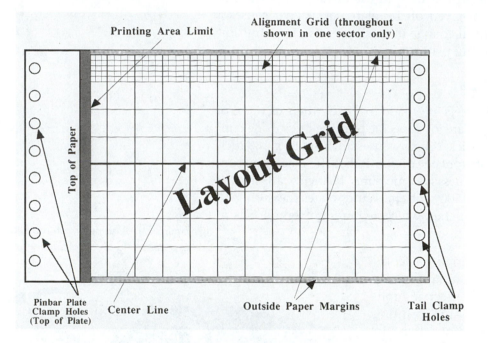

Figure 9.2. Layout dimensions of a typical sheet of goldenrod used on small sheet-fed offset presses. Larger presses use unruled goldenrod sheets, which are marked up for the specific job prior to stripping.

Note the series of perforated holes shown on the top and bottom of the goldenrod in Figure 9.2. These holes line up with pins projecting from clamps on the plate cylinder of the press. The clamps hold the printing plate firmly in place during printing. These bars are called *pin-bar plate clamps* and are located at both the top and bottom of the plate.

The *gripper margin*, located on the top edge of the gold-enrod, is about ⅜-inch wide, depending upon the specific printing press. During printing, a series of gripper fingers pulls the paper between the blanket and the impression cylinder. Because these grippers physically cover the sheet of paper during this process, the gripper margin represents a nonprinting area on the sheet. Note from Figure 9.2 that the top edge of the gripper margin is also the leading edge of the sheet of paper. When stripping a job, the area represented by the nonimage gripper margin must be carefully considered; the top of the printed image can only come up to the bottom of the gripper margin. If a particular printing job requires that an image be printed closer to the top of the sheet than the gripper margin allows, a larger sheet of paper must be used and then be trimmed after printing.

Three additional references on the goldenrod are the center line, the outside margins of the standard sheet size being used, and a ruled grid pattern, which is usually spaced at ¼-inch intervals. The grid makes it easier to keep all of the negatives straight when placing them on the flat.

PAGE SEQUENCING AND SIGNATURES

One sheet of paper with a number of pages printed on it is referred to as a *signature*. After printing, the signature moves to a bindery area where it is folded so that all of the pages are in proper sequence. A book or booklet may contain more than one signature, depending upon its size. Signatures are often printed in 4-, 8-, 12-, 16-, 32-, and 48-page formats, depending on the size of the press and the length of the book or magazine being printed. Figure 9.3 shows the folds that are required to make 4-, 8-, and 16-page signatures, along with their corresponding page positions on the flat.

Figure 9.3. Four-, eight-, and sixteen-page signatures with their positions on the flat.

IMPOSITION

The proper placement of the image on the page is called *imposition*. Several factors affect imposition, including the design of the piece to be printed, the size of the printing press, and the size and type of paper being used to print the job. Proper imposition results in a job that requires a minimum amount of press time, a minimum amount of paper stock for printing, and the least amount of finishing operations (trimming and folding, for example). Some of the common types of imposition are as follows:

One-Sided Imposition: In this technique, a single plate on the press prints on one side of the sheet of paper only. One-sided imposition is used in printing simple, single-sided jobs on small offset presses and offset duplicators.

Sheetwise Layout: This format is used when two sides of the sheet are to be printed with two different images. Two separate printing plates are used in this format.

Work and Tumble: In work and tumble, one printing plate is used to print two passes of the sheet of paper. After the first pass, the sheet is rotated 180 degrees, with the bottom of the sheet on the first pass being fed into the press first on the second printing pass. This results in the imposition of the printed job as illustrated in Figure 9.4, where the top and bottom of the sheet become a completed set.

Figure 9.4. Work- and tumble-format.

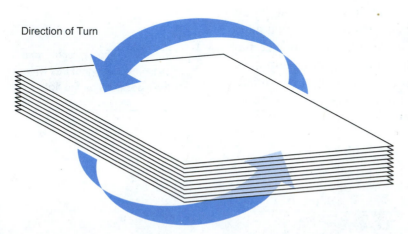

Direction of Turn

Direction of Turn

Work and Turn:
In the work-and-turn format, one printing plate is used to print both sides of the sheet. After the first press run, the paper pile is turned over and the back side of the sheet is printed (Figure 9.5).

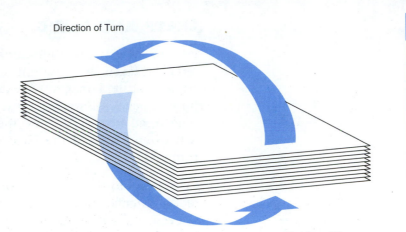

Direction of Turn

Direction of Turn

Figure 9.5. Work- and turn-format.

After the sheets have been printed they are trimmed to final size. Figure 9.6 shows the layout for a four-page and an eight-page booklet, showing both fold and trim lines. Trimming also separates the pages of the folded signature.

FOUR PAGES

Fold Fold

Trim

EIGHT PAGES

Fold

Fold

Trim

Figure 9.6. Typical layout, including fold and trim marks.

CREEP AND BLEED

Prior to stripping, two additional considerations must often be taken into account; creep and bleed. *Bleed* refers to printed images that extend to the edge of the printed page. Allowances must be made when stripping bleed images, because the actual printing area will extend beyond the page size after it has been trimmed.

Creep refers to the tendency for the center pages of a saddle-stitched book to creep forward, giving rise to uneven edges prior to trimming. Creep is shown in Figure 9.7.

Measured Creep at
Spine and Outer Edge

Figure 9.7. Creep is measured from the spine to the outer edge of a book or pamphlet.

Creep allowance for center signature pages must be considered by the stripper whenever perfect alignment of all pages in the signature is critical. In many instances, such as the printing of small pamphlets and booklets, creep may not be critical in the stripping process. The best way to determine creep allowance is to make measurements from a dummy of the job that is made from the same paper stock that will be used for the printing. After folds are made in this dummy, actual creep measurements can be determined.

STRIPPING PROCEDURES

The stripping process is used to hold the assembled negatives in place during the making of the printing plate. In this section, we look at procedures used for stripping a single page as well as single- and multicolor images, on preprinted and blank masking sheets. Preprinted masking sheets are generally used for smaller offset presses. Larger presses do not use the preprinted masking sheets; however, the procedures shown here can be used with either blank or preprinted goldenrod. When using blank goldenrod sheets, the stripper must first draw all of the critical margins and specifications on the goldenrod prior to stripping.

STRIPPING A SINGLE PAGE

Before starting, the stripper examines the job sheet for information or specifications that must be followed (see Figure 1.34, illustrating a sample job sheet). The stripping process is usually performed on an illuminated light table (Figure 9.8).

Figure 9.8. An illuminated light table.

The backlighting on the light table provides the illumination required for the stripper to work with the negatives and goldenrod. Many light tables also come with adjustable steel straightedges and rules along the bottom and left or right edges. These rules are used in aligning the negatives and goldenrod, ensuring straight and level positioning of all negatives.

Negatives can be stripped with the emulsion side facing either up or down. There are advantages and disadvantages to each method. The stripping procedures outlined here are based on stripping the negative with the emulsion side down. In this position, the reference lines on the goldenrod and the negative are easy to see, and the flat can be more easily manipulated than with the emulsion facing up. Also, the emulsion side of the negative is less prone to scratching when it is facing down.

1. Carefully position the goldenrod on the light table, using either the built-in rules or a T-square. Place the goldenrod either horizontally or vertically, depending on the page layout of the job. When it is properly lined up, tape only the top corners of the goldenrod in place with red litho tape, as shown in Figure 9.9.

Figure 9.9. Goldenrod positioned on a light table in preparation for stripping.

2. Identify the gripper margin, center line, and outside paper margins of the sheet size to be used in printing. Cut a notch in the leading edge of the flat for reference purposes. This notch sets off the leading edge of the flat and helps prevent placing the bottom edge of the negative at the leading edge of the flat by mistake (Figure 9.10).

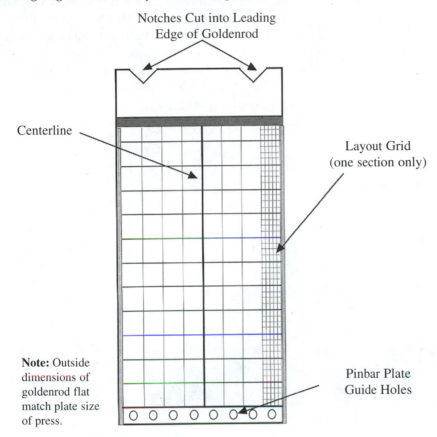

Notches Cut into Leading
Edge of Goldenrod

Centerline

Layout Grid
(one section only)

Note: Outside dimensions of goldenrod flat match plate size of press.

Pinbar Plate
Guide Holes

Figure 9.10. Notches in the gripper margin on the flat mark the leading edge of the flat and printing plate.

3. Trim all negatives to within ½ inch of their image areas. The ½-inch margin is used for taping the negatives to the flat.

4. Lift the bottom edge of the flat and place the negative, emulsion side down, with the base of the film against the bottom side of the goldenrod. Position the negative, using the center lines and grid pattern to properly line up the images on the negative with the reference marks on the goldenrod. If corner marks were drawn onto the final mechanical, these marks will have transferred onto the page negatives. Corner marks are useful in helping to properly line up the negatives with the reference marks on the masking sheet (Figure 9.11).

Figure 9.11. Corner marks aid in lining up the negative on a flat.

5. After the negative has been positioned, cut a small diamond-shaped hole through the goldenrod masking sheet. This hole should be located over a nonimage area of the negative. When cutting the hole, apply just enough pressure, with either a razor blade or a sharp knife, to cut through only the masking sheet and not through the negative. After this hole has been cut, place a piece of litho tape over the hole, taping the negative to the bottom side of the goldenrod. This tape keeps the negative in position while you turn the

flat over to permanently tape the negative to the masking sheet (Figure 9.12).

Figure 9.12. Cutting a small hole in the goldenrod allows you to tape the negative to the flat to hold it in place temporarily while the flat is turned over.

6. *Carefully turn the goldenrod and negative assembly over and permanently tape the negative to the back side of the goldenrod.* Use a small piece of litho tape at each corner of the negative (Figure 9.13).

Figure 9.13. Negatives are permanently taped to a flat using only a small strip of tape in each corner.

7. *In order for the image areas of the negative to be exposed onto the printing plate, you must cut the goldenrod covering the image areas on the negative away with a sharp knife or razor blade.* The procedure is referred to as *cutting a window* over the image area of the flat and is illustrated in Figure 9.14. Again, practice is required to cut through only the goldenrod, and not through the negative as well. This procedure should be practiced several times, using scrap film and goldenrod. One technique that is useful in developing window-cutting skills is to place a piece of thin plastic or clear photographic film under the goldenrod, on top of the film. The clear plastic provides a protective surface over the actual film and protects it while the beginning stripper learns the feel and technique involved in cutting windows properly.

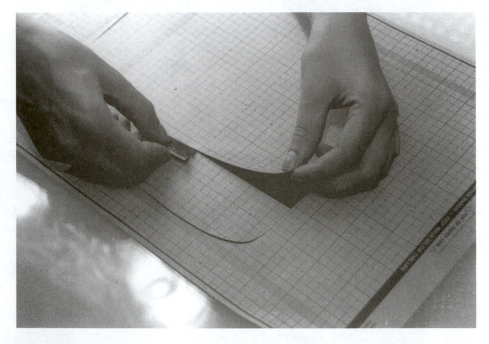

Figure 9.14. Cutting a window into a flat. Care must be exercised when cutting windows to ensure that the cut goes through the goldenrod only, and not through the negative.

8. Exposure control devices, such as gray scales, dot gain scales, and the like, are stripped into the flat at this time. The exposure control devices are stripped into the flat in the nonimage areas of the printed sheet (Figure 9.15). Most often, they are located outside the trim size of the finished sheet, so they are available to the press operator to look at during the entire press run. After the job has been printed, the images of these quality control devices are trimmed during the finishing process. The use of control devices, whether for checking the print quality on the press or for ensuring proper exposure of the printing plate, is explained in the instructions that accompany these products.

Figure 9.15. Quality control devices, such as the negative gray scale in this illustration, are stripped into the goldenrod along with all line, halftone, and composite negatives. Star targets, registration, and crop marks should be exposed on the negative during photography or imagesetter output.

OPAQUING NEGATIVES

Offset negatives often contain small scratches or pin-sized holes that allow unwanted light to come through the negatives. If left untouched, this light would expose the printing plates, causing the dots and scratches to print on the finished copy. To eliminate unwanted light coming through the negative, opaque solutions are applied to the negatives, in effect painting over these pinholes and scratches.

Opaquing is done after the windows have been cut into the flat. Opaquing solutions are applied, either with a very fine brush or with a fine-point opaquing pen, to the base side (nonemulsion side) of the film (Figure 9.16). Opaquing the base of the film prevents a build-up of opaque solution on the emulsion side. This allows the emulsion of the negative to be in direct contact with the plate. Applying opaque to the emulsion side of the negative places a layer of separation between plate and negative, causing possible distortion of the plated image. (Figure 9.17).

Figure 9.16. Negatives are opaqued after they have been stripped into the flat. The opaquing is done using either an opaquing pen or liquid opaque applied with a fine camel-hair brush.

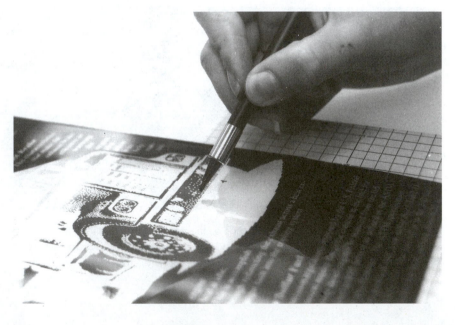

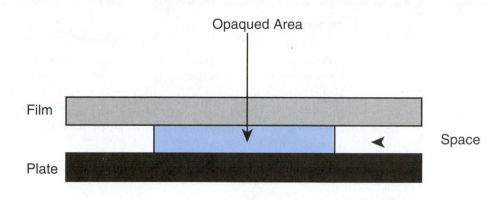

Opaqued Area

Film

Plate

Space

Image Distortion Through Improper Opaquing

The opaquing fluids are water soluble, so if you make a mistake during application, you can remove it with a damp cloth and reapply it when the negative has dried. Be sure to use only a soft, lint-free cloth when removing opaquing fluid to prevent the negative from becoming scratched.

STRIPPING MULTICOLOR AND MULTIFLAT IMAGES

In many instances, more than one flat is required for a particular job, even if the specifications call for only one color. In some single-color jobs that contain both line and halftone copy, the line copy may be stripped onto one flat and the halftone negatives stripped onto a second flat. These two flats are called *complementary flats.* Multicolor work often requires the use of separate flats, one for each color. However, if the colors do not overlap, one flat can be used through which several plate exposures are made. Each of these stripping techniques is described shortly.

Multiple color or complementary flat images are stripped following the same procedures used when stripping single-color work. The following are methods that can be used when registering multiple flats for either single or color separation work.

Figure 9.17. Image distortion can occur if opaque is applied to the wrong side of the negative.

295

REGISTER PINS

Metal pins, called *register pins,* are commonly used for registering two or more flats. The pins are taped to the light table to hold the flats in position while stripping. Holes are punched into the goldenrod sheets to line up with the taped pins. In this technique, all of the flats are held in the same position during stripping and platemaking (Figure 9.18).

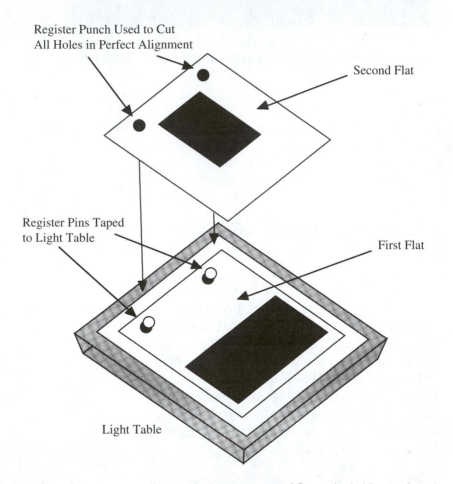

Register Punch Used to Cut
All Holes in Perfect Alignment

Second Flat

Register Pins Taped
to Light Table

First Flat

Light Table

Figure 9.18. The use of metal register pins allows multiple negatives and flats to be held in perfect alignment. This is especially useful when doing color separation or work requiring close registration tolerances.

Figure 9.19 shows a multicolor job prepared using a separate flat for each printing color. After the flats have been prepared, they can be lined up, one over the other, on the register pins on the light table to check for stripping accuracy and proper registration.

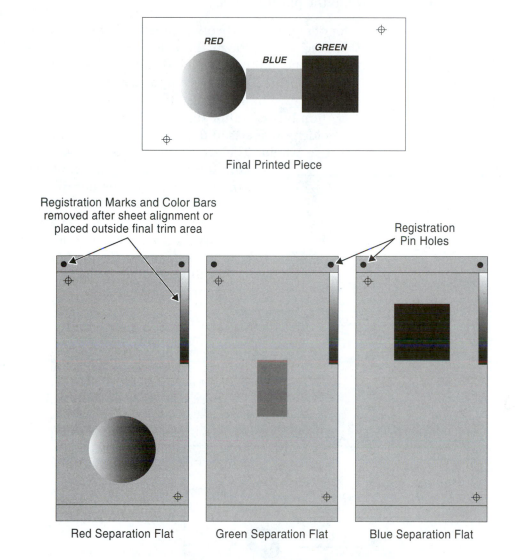

Figure 9.19. A three color job using a separate flat for each color.

RUBY MASKING FILM FOR MULTICOLOR STRIPPING

Ruby-colored film is a plastic base masking film that is cut by hand to expose window areas on the flat. This film is most often used in preparing multicolor printing jobs that use only one flat for multiple exposures onto the printing plate.

A lot of multicolor artwork requires close tolerances in stripping, even though the colors may not directly overlap one another as they do in color separation printing. Figure 9.20 shows how a ruby masking sheet would be used in preparing a three color job. Because ruby film blocks actinic light in a manner similar to the goldenrod, it acts in the same way a photographic negative would. The red and blue separation ruby masking sheets in Figure 9.20 could be used to make photographic positives in the process camera, or the ruby film could be used to cover sequential areas of a negative. This would allow one negative to be used for multiple exposures to produce three separate printing plates from the same negative.

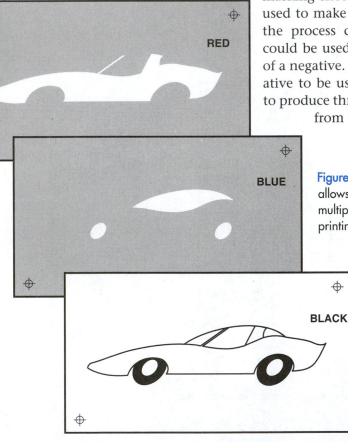

RED

BLUE

BLACK

Figure 9.20. Ruby masking film allows you to use one flat for making multiple exposures in a multicolor printing job (Courtesy Ulano, Inc.).

When using ruby sheet masking material, the ruby film can either be registered with the pins on the light table or taped directly to the flat. Windows are cut into the ruby film with a sharp knife and then peeled off the clear backing sheet to uncover the areas to be exposed onto the plate (Figure 9.21). The cut should go through the ruby mask, but not through the plastic support base of the film. After all cuts have been made, the ruby material is stripped away, leaving the masking material in place.

COMPLEMENTARY FLATS

When image tolerances in a job are very tight and successive plate exposures (*burns*) are to be made, it is usually easier to prepare separate flats rather than to try to strip negatives very close together. Jobs that contain both text and continuous tone illustrations or captions that are butted up against the illustrations are usually made up using separate flats. These flats are referred to as *complementary flats*.

When preparing complementary flats, register pins should be used to ensure proper registration of all of the flats with one another. Sometimes two complementary flats can be taped in proper registration to an underlying sheet of goldenrod (Figure 9.22). A window that is large enough for both flats is cut into the base sheet of goldenrod. When making the plates using this goldenrod base, the proper flat is folded down into position over the goldenrod window for plate exposure, while the other flat is folded out of the way (Figure 9.23). This sequence is repeated for each of the negatives that make up the flat.

STEP AND REPEAT

The step-and-repeat procedure is used when the same image appears many times on the printed page. Figure 9.24 shows one step-and-repeat method in which the front and back side of two jobs are ganged up on one mechanical layout. A second method of step-and-repeat processing involves making one photographic image which is placed in a step-and-repeat platemaker.

Figure 9.21. Cutting ruby masking film. (Courtesy Ulano, Inc.).

299

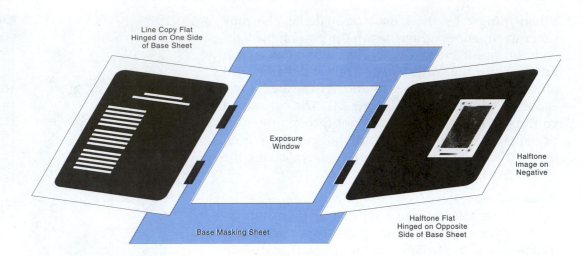

Figure 9.22. When setting up complementary flats, each negative is placed along the border of the exposure window and hinged in place using tape.

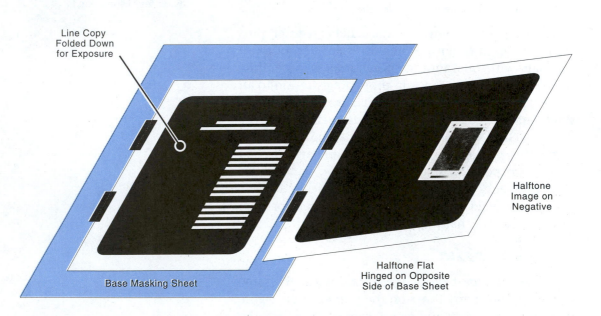

Figure 9.23. When making exposures using complementary flats, the negative to be exposed is folded down over the exposure window, while the other negative(s) remain hinged out of the way.

Figure 9.24. The step-and-repeat process saves time by preparing only one image that is used to make multiple exposures by either manually or automatically moving the exposure unit.

The image is either manually or automatically moved to each required position on the plate, and a separate exposure is made at each location. Modern step-and-repeat machines rely on computer programming which allows the exact placement of all images.

SCREEN TINTS

If the original artwork does not contain any tints or shades, they can be added during the platemaking process, if required. Chapter 5 showed how the use of tint screens can add emphasis to the printed page. Tint screens can be added during the platemaking process by using commercial tint screens that are stripped into the flat (Figure 9.25).

The flats with the screens are exposed onto the plate in a separate exposure sequence from that of the stripped flat containing the line and halftone negatives. Commercial tint screens are available in a variety of tint sizes and patterns.

Top of Paper Guide Line

Figure 9.25. Screen tint stripped into flat for separate exposure on an offset plate.

PROOFING THE FLAT

After the flat has been prepared, it is usually proofed to check for proper registration of all elements and to make sure that all of the pinholes, unwanted scratches, and so on have been properly masked and opaqued. Also, because the flat is usually prepared from negative images, it is hard to visualize what the completed design will look like when printed. Proofs yield positive images for examination. Three types of proofs are generally used in single-color as well as multicolor applications: press proofs, photomechanical proofs, and digital color proofs.

Pulling a press proof involves making a printing plate and setting up the press with the same ink and paper that will be used during the actual printing process. Press proofs are, in effect, small press runs—a duplication of the actual printing of the job. For this reason, press proofs are generally reserved for long-run, high-quality projects.

Photomechanical proofs use inexpensive photosensitive materials that are exposed through the flat. These proofs offer a rendition of what the finished job will look like without using the actual paper or printing

inks. Blueline and brownline photographic papers are often used for this purpose. Also, there are products on the market that can be exposed and processed without any chemicals.

Photomechanical proofs of a color job involve the use of either transparent or opaque base materials. When using transparent proofs, each color is exposed onto a separate sheet of clear acetate that develops to a specific color. After all the exposures are made, the sheets are registered and lined up on top of one another to approximate the colors and look of the finished job.

Opaque proofs are made by using a paper or plastic opaque support base on which sensitized sheets or toners are added. Each sheet or toner represents one color. Each color requires a separate exposure and development. The colored sheets and toners represent specific process color inks. After all the exposures have been made, the finished sheet yields a high-quality representation of the finished job.

The availability of color ink-jet technology, coupled with affordable pricing, has greatly simplified the color proofing process. What was once a technology reserved only for high-end work has now become common practice in the everyday proofing process. Ink-jet technology, introduced in chapter 1, has several advantages over its photomechanical and press-proof counterparts. The digital proofing process, from computer screen to color printer, is much faster than other photomechanical or pressroom proofs. Also, the drop in price of these printers during the past several years has made digital proofing cheaper than most other alternatives.

CARE OF FLATS

Most flats contain negatives that are not only valuable, but are often used again in the future. As negatives scratch easily, completed flats should be protected in a nonabrasive paper folder and placed flat in a drawer,

and should never be bent or folded. Cabinets and storage shelves can be purchased or built specifically for this purpose. A cabinet of this type is shown in Figure 9.26.

Figure 9.26. Cabinets that allow for the storage of flats and film negatives should provide adequate space for flat storage of all materials. (Courtesy NuArc Co., Inc.).

OFFSET PLATEMAKING

Offset lithographic printing started out by using images drawn on specially prepared stones. Today, offset printing holds a position of dominance in the printing industry. Images from a printing plate are offset to a rubber blanket and then printed onto a sheet or web of paper as it moves through the press. The lithographic stone shown in chapter 1, Figure 1.7, has been replaced by the modern offset printing plate (Figure 9.27).

Figure 9.27. Imaging an offset printing plate. The image on the plate is a photographically set grease-base image that attracts the grease-base printing ink. The nonimage areas on the plate are the shiny aluminum areas that accept water and repel the grease-based inks when wet.

Lithography is based on the chemical principle that oil and water do not readily mix. The image areas on the printing plate are grease-receptive. The nonimage areas of the plate are water-receptive. The plate is first wet down with a dampening solution referred to as a *fountain solution*. The nonimage areas of the plate accept the wetting agent, which is repelled by the

grease-receptive image areas on the plate. Next, as the ink rollers pass over the plate, the grease-based offset ink is transferred to the grease-receptive image areas of the plate. The ink is repelled by the wet, nonimage areas. This separation of oil and water is the basic principle underlying most of the technical aspects of image quality in traditional offset lithography.

Unlike the old litho stones, which were prepared in reverse and characterized the early history and art-form era of lithography, present-day offset plates are prepared in the positive. During printing, the image is offset from the positive plate onto a rubber blanket, printing the image on the blanket in the negative, or *wrong-reading* format. The rubber blanket then transfers a right-reading image to the paper. This process is highlighted in Figure 9.28.

Figure 9.28. The image from an offset plate is transferred to a rubber blanket cylinder positioned below and in contact with the plate cylinder.

PLATEMAKING AND PROOFING EQUIPMENT

Traditional procedures used in platemaking are under assault from advances in direct-imaging technology. In spite of these technological advances, plate processing remains relatively unchanged and continues to account for the majority of high-quality offset printing images. The equipment used for platemaking can also be used for proofing flats. Platemaking equipment consists of a light source, vacuum frame, and sink for developing and processing the plates. Computerized equipment is also available for high-volume plate processing.

The pieces of equipment used to make plates are called *platemakers* or *exposure units*. A traditional combination vacuum frame and exposure unit flip top platemaker is shown in Figure 9.29. Figure 9.30 highlights a computerized imaging system for exposing plates as well as a variety of other light-sensitive materials.

Figure 9.29. A Flip-Top® vacuum frame and exposure unit used to expose offset printing plates. The flat and plate are placed on a rubber blanket, which is then sealed. A vacuum ensures that the plate and flat are held in intimate contact during the exposure sequence. A variety of light sources are available for exposing the plates. (Courtesy Nuarc Company, Inc.).

Figure 9.30. Computerized tabletop system used for a variety of exposure projects, including platemaking. (Courtesy Nuarc Company, Inc.).

The platemaker in Figure 9.29 is a combination vacuum frame and light source. The flat and unexposed plate are positioned under the contact frame of the platemaker, on top of a rubber cushion blanket. When the frame is closed over the flat/plate sandwich, a vacuum pump is turned on, which enables the rubber cushion to push the flat and plate in close contact with one another up against the glass contact frame. Once the correct amount of vacuum has been reached, the frame is flipped over so that both flat and plate are facing the light source for exposure. Computerized exposure systems provide the same functions, but use automated vacuum and exposure functions.

A number of different light sources are used to provide the high-intensity light in the blue and ultraviolet portions of the spectrum that we have referred to as *actinic light*. The light source is located at the base of

the platemaker and is activated from a control panel on the front of the platemaker. Note the separate controls on the panel for adjusting vacuum and exposure times (Figure 9.31).

Figure 9.31. Computerized controls used on platemaking systems (typical) (Courtesy Nuarc Company, Inc.).

Developing sinks are specially designed to facilitate the platemaking process. The sinks are constructed from either fiberglass or stainless steel and come with a built-in drain board. During development, the plate is placed on the drain board and all of the chemical processing takes place in the sink. Many sinks are also equipped with temperature-controlled water supplies as well as a plate clamping arrangement. The clamp is used to hold the plate in place during application of the developing and desensitizing solutions. A developing sink of this type is shown in Figure 9.32.

Figure 9.32. Sink used for processing water-soluble-chemistry offset printing plates (Courtesy Nuarc Company, Inc.).

LITHOGRAPHIC PLATE TECHNOLOGY

Several different types of offset plates are currently in use. The majority of plates used are known as *presensitized,* in which the light-sensitive emulsion is applied during manufacture of the plate. Plates can be sensitized on either one or both sides. Plates are made from a variety of materials, depending upon the length of the press run and the type of work to be printed.

PLATE CLASSIFICATIONS

Offset plates have three basic component parts: the base of the plate, a covering over the base, and the plate coating.

Plate bases are fabricated from either aluminum sheet, paper, or foil-laminated paper. Aluminum plates are the choice for long print runs of more than 10,000 copies. Paper and foil/paper combinations are reserved for short print runs of less than 5,000 copies. The basic classifications of offset plates are as follows:

Direct-Image Plates: Direct-image plates are usually made from paper. The image can either be drawn or typed directly onto the plate. After imaging, an etching solution is wiped onto the plate to fix the image and make the plate more water-receptive. Direct-image plates are used for short runs only, as they begin to break down under the continued influence of the fountain solution and ink after only a few hundred copies.

Presensitized Additive Plates: Additive plates are those in which the developing solution is applied during plate processing, after exposure. The image developer is thus "added" during plate processing, although the photographic emulsion coating on the plate is factory-applied.

Presensitized Subtractive Plates: Subtractive plate processing is a one-step process. After exposing the plate, a special processing solution removes all

of the image lacquer from the nonimage areas of the plate. The developing lacquer is therefore removed, or subtracted, from the plate during processing.

Negative-Acting Plates: Negative-acting plates are those in which the image areas of the plate are hardened and made permanent after exposure to light. Negative-working plates use standard negatives stripped into a flat, which produces positive images on the plate.

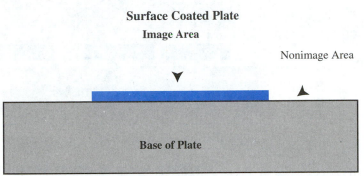

Surface Coated Plate

Image Area

Nonimage Area

Base of Plate

Both the image and nonimage areas of the printing plate are on the same plane.

Figure 9.33. Surface-coated presensitized offset printing plate.

Positive-Acting Plates: In a positive-acting plate, light striking the plate softens the emulsion, which becomes the nonimage area. The nonimage areas are removed during plate processing. Positive-acting plates are made using photographic positives rather than photographic negatives.

Surface Plates: On surface plates, the presensitized coating sits directly on top of the surface of the plate. A typical surface-plate coating is illustrated in Figure 9.33. Because the emulsion of the plate is applied as a coating or layer on top of the plate, surface-coating plates are used for short print runs of no more than 5,000 copies. As the plate begins to break down, the emulsion comes off the surface of the plate.

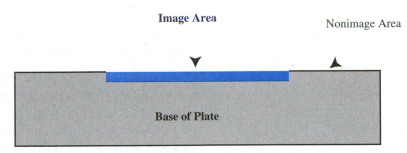

Deep Etch Plate

Image Area

Nonimage Area

Base of Plate

The image area of the plate is etched below the nonimage surface area of the plate.

Figure 9.34. Deep-etched presensitized offset printing plate.

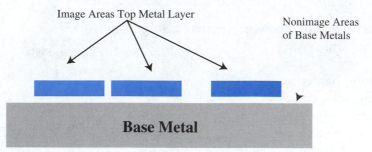

Multi-Metal Plates

Image Areas Top Metal Layer

Nonimage Areas
of Base Metals

Base Metal

A combination of metals are electroplated to one another. The image
area depends upon the types and numbers of metals used to make the plate.

Figure 9.35. Bimetallic presensitized offset printing plate.

Deep-Etch Plates: Deep-etch plates are made by bonding the emulsion coating of the plate onto the base material. The coating is actually etched onto the surface of the plate, making deep-etch plates more suitable for long print runs than surface-coated plates. A cross-section of a deep-etch plate is shown in Figure 9.34.

Bimetallic Plates: Bimetallic plates are made from two dissimilar metals that are bonded together. One of the metals is for the grease-receptive image areas, the other metal forms the water-receptive non-image plate areas (Figure 9.35). Bimetallic plates hold up well during long press runs and are used almost exclusively for this purpose.

Direct Photographic Plate Processing: In the direct photo technique, original copy is placed on the copyboard of a camera and projected through a camera lens directly onto a roll of plate material. After exposure, the plate is cut to the proper length and is fed through an automatic processor that is built into the camera. Some photo direct systems can also transport the plate directly to the press after processing and automatically attach it to the plate cylinder and then remove it from the press after printing. Direct photographic plates are usually reserved for small to medium print runs of less than 5,000 copies.

Electrostatic Plates: The electrostatic process, originally aimed at the photocopy market (and highlighted in chapter 1), has been used to make offset plates for many years. Electrostatic plates utilize a special image carrier referred to as a *plate master*. The image is projected onto the electrostatic plate master, after which toner is applied and fused to the plate surface. The image is sent through a fixing solution, similar in concept to the etching solution used on direct image masters, and is then ready for printing. The fused toner becomes the grease-receptive image area of the plate.

PLATE EXPOSURE AND PROCESSING

The following discussion concerns exposure and processing an offset plate. The procedures that are illustrated show the steps performed in preparing a presensitized, negative-acting, subtractive (one-step) plate. The procedures used for other plate types (presensitized, positive-acting, subtractive plates, for example) are similar to those described here. The reader is urged to follow the manufacturer's instructions supplied with each package of plate and chemistry regarding specific processing techniques, as well as the proper disposal of solid and chemical wastes associated with plate processing.

Figure 9.36. Plate development area set up on a laboratory work bench.

1. Setting up the developing area and processing chemistry. The work area should be set up with soft cotton litho wipes, a pad of newsprint with a top slip sheet, and soft sponges, as shown in Figure 9.36. Offset plates should always be handled by the gripper and tail edges only. Only subdued room lights should be used if plate processing will be performed in a room other than a darkroom. Plates left exposed to normal fluorescent or incandescent room lights will become exposed and useless after only a few short hours.

2. Mounting the flat and plate in proper position in the platemaker. Presensitized plates should be stored in a cool, dry location. When a plate package is opened to remove a plate, it should be kept out of direct room lighting, and the carton should closed and returned to its proper storage area after use. When the platemaker is opened, the operator should make sure that the spring hinges on the contact frame are working properly and are able to keep the frame hinged in the open position. The goldenrod flat is placed directly on top of the plate and lined up perfectly along the top and right or left edges (Figure 9.37).

Figure 9.37. Proper alignment of the presensitized plate with the flat during exposure is critical for proper position of the image during printing. Although printing presses are capable of making some adjustments for images that have been exposed crookedly on the plate, these adjustments are generally limited in scope.

3. Setting exposure time on the platemaker and exposing the plate. Before exposing the plate, ensure that the glass in the contact frame is clean. Use a good-quality glass cleaner when cleaning the contact frame. Also, check the rubber cushion under the frame to make sure it is clean.

Some plate manufacturers include recommended exposure times for their plates based on the type of platemaker and light source being used. Standard practice suggests that the operator take a series of trial exposures to determine the best exposure times, given the individual conditions in the shop. Trial exposures

are performed by cutting the plate into small pieces. Separate exposures at different time intervals are then made using a 21-step negative gray scale or plate control wedge placed on top of each of the small plate samples. After developing, the exposure that yields the proper grayscale sample can be used as a basis for future exposure times. See Figure 9.38.

Figure 9.38. A 21-step grayscale is indispensable when making a series of test exposures to determine the proper exposure time for a particular type and brand of offset printing plate.

If the second side of the plate is to be exposed, change flats and repeat the exposure sequence at this time.

4. Preparing the plate for processing. Before processing the plate, make sure that the work area is clean and free of debris. This area should be flushed and the water squeegeed away.

There are many ways to set up a plate for processing after it has been exposed. One method is to use a plate clamping device. A pad of newsprint is placed under the plate and the plate is clamped at both the top and bottom edges. This procedure holds the plate firmly in place during the application of all processing chemicals. Chemicals and litho cotton pads should be close at hand. A second method is to place the plate in a clean developing sink and wet the underside of the plate to keep it from sliding during processing.

5. *Applying developer to the plate.* The temperature of the plate, as well as all processing chemicals, should be between 70° and 75°F. Pour developer onto the plate surface. Although the amount of developer needed varies from one manufacturer to another, it is good practice to use approximately one ounce of developer per square foot of plate surface area. Spread the developer evenly over the plate, using a figure-8 motion. Allow the developer to sit on the plate for about 10 seconds before continuing (Figure 9.39).

Figure 9.39. Developer or similar processing chemistry is applied to the offset plate after exposure to bring up the image and make it permanent on the plate surface. The use of a developing sponge with a figure-8 motion helps to ensure even development of the image and avoids scratching of the plate surface.

6. *Developing the plate image areas.* Using a circular motion, work the developer onto the plate with a moderate amount of pressure. Continue this motion until the nonimage areas on the plate are clear and appear as a shiny aluminum surface (Figure 9.40).

Figure 9.40. Developing the image area of the plate with a plate developing sponge. All of the developer or sensitizer must be removed during the developing process if the plate is to print properly.

Remove the excess developer and undeveloped plate coating with a plate squeegee. Some plate manufacturers call for a second coat of solution to ensure that all of the image areas on the plate have been properly developed. Check halftone screen areas carefully for proper development.

Squeegee off the remaining chemicals and wash the plate with water to remove all remaining developing chemicals and plate coating. If the second side of the plate is to be processed, use the same developing procedures for the second side of the plate as outlined in steps 1–6.

7. *Drying and preparing the plate for storage or printing.* Place the plate on a smooth surface or clean countertop and clamp the plate at both ends. If the plate is to be printed immediately, it is mounted on the press at this time (press operation is covered in chapter 10).

If the plate will not be printed right away, then the image areas of the plate must be protected and sealed to prevent any oxidation from taking place on the plate surface. This is true even if the plate is to be printed in just a few hours after it has been exposed.

Commercially prepared plate preserving solutions are available for sealing plate surfaces. When using these products, the manufacturer's instructions should be followed. One long-standing method of plate preservation is the use of gum arabic solution. Gum arabic is sold in concentrated form and is diluted 1:8 with water before use. (Different dilution specifications may be given by different plate manufacturers or even for different plates from the same manufacturer. Consult the specifications that come packaged with the plate.)

Dilute only as much gum arabic as you will be using at one time (one to two ounces per plate should be sufficient). Apply the gum arabic to the plate surface with a soft litho wipe, spreading the solution evenly from one side of the plate to the other. Allow 15 minutes for the gum arabic to dry. When the plate has dried, put a cover sheet over the image side of the plate (or on the top and bottom if both sides of the plate have been processed) and place the plate in a suitable storage area (Figure 9.41).

Figure 9.41. Covering an offset plate with a slip sheet for protection.

SUMMARY

Prior to printing, all of the various components of the job come together in the stripping process. Assembling negatives containing line art, text, and halftone illustrations within the specifications of the customer and graphic designer is the job responsibility of the stripper.

The traditional methods used in stripping involve the determination of paging and signatures required prior to beginning the stripping process. Imposition and page layout must be decided upon early in the process to maximize press time and plate space while minimizing all costs. Whether the job is a single- or multicolor piece, proper imposition of the graphic elements onto the goldenrod is critical. Several methods for ensuring proper registration of images on one or more flats exist, including the use of register pins and masking sheets. In most instances, the flat is proofed prior to platemaking to ensure that all job specifications have been properly satisfied.

Plates are prepared from the flats after the flats have been proofed for accuracy. Platemaking is a contact printing process. The flat is placed on top of a presensitized plate and exposed using a light source that produces high-intensity actinic light. Actinic light causes a chemical change in the emulsion coating of the printing plate. Subsequent development of the plate after exposure brings up the grease-receptive image areas of the plate and removes the emulsion coating from the nonimage areas.

Any one of a variety of plates is selected for a particular printing job, based primarily on the number of copies required: paper plates for short-run typed or drawn copy; presensitized aluminum plates for medium copy work; and deep-etch or bimetallic plates for long print runs. In many instances, the size of the job and resulting press size will also affect the choice of printing plate.

Summary

Stripping and platemaking have been heavily impacted by advances in computer technology and application software. The traditional methods of stripping flats and making plates can now be handled by a computer in their entirety. These procedures take the form of outputting complete pages from the computer to an imagesetter. The output of the imagesetter can be on a photographic negative, photographic positive paper, or plate material. Negative output from the imagesetter is stripped onto goldenrod flats, whereas photographic positives are used as final copy for photographing from a mechanical to the finished negatives prior to printing. Plate material from the imagesetter can be mounted directly on the press for printing. Direct-to-press technology, a process in which the computer outputs directly onto the printing press, continues to improve in quality and sophistication and will become more widespread as this technology advances.

Chapter

10

Offset Printing & Postpress

FUNDAMENTALS

INTRODUCTION TO OFFSET PRINTING

Offset lithography, the dominant printing process of the twentieth century, was invented in the year 1798 by Alois Senefelder, a Bohemian actor and playwright. Senefelder experimented with many different methods for cheaply reproducing manuscripts. His experiments began with drawing and etching images on copper engraving plates. Senefelder eventually focused his attention on drawing images in reverse on Bavarian limestone, using a material that was a mixture of lampblack, soap, wax, and rainwater. When the stone was wetted with a solution of water and gum, the stone retained moisture on the nonimage areas. The grease-based image areas repelled the water. When a fatty-based ink was applied to the stone, the still-wet stone repelled the ink in the nonimage areas but accepted the ink in the image areas on the stone. Placing a piece of paper over the inked image, and applying pressure to the stone/paper sandwich, transferred the image from the stone to the paper. The lithographic process was born!

Senefelder also worked extensively with a related process called *image transfer*. In the image transfer process, the work to be printed is first drawn on a piece of proof material using a fatty-based ink. The image from the proof is then transferred under pressure to the stone as a reverse image. Working in this way, the original image need not be prepared in reverse, but is simply transferred onto the lithographic stone after it is prepared. However, lithographs that are drawn directly on the stone, as is the method with many artistic renderings and multicolored lithographs, must be drawn in reverse to produce a positive final image.

THE OIL-AND-WATER PRINCIPLE

The word *lithography* comes from two Greek words meaning "stone writing." Technically, lithography is a chemical image transfer process, based on the princi-

ple that oil and water are two immiscible liquids—that is, they do not readily mix. In current practice, the image areas on the lithographic printing plate are grease-receptive; the nonimage areas are water-receptive. Note the image on the aluminum offset plate as it is installed onto the offset printing press in Figure 10.1.

Figure 10.1. Image and nonimage areas on an offset printing plate.

Another term for lithography is *planography,* which means a printing process in which the image and nonimage areas are on the same level or "plane." Planographic printing and lithography are generally used interchangeably.

Throughout its history, lithography has always been a significant avenue for artistic expression. For example, stone lithographs, exemplified by the works of Currier and Ives in America during the late nineteenth century, are highly prized works of art. Many artists currently use lithography as the medium of expression for depicting portrait, landscape, still life, and other original formats for lithographic prints.

The term *offset lithography* was coined when the process incorporated transfer or offset of the image from the original stone or plate onto a rubber blanket. The blanket in turn transferred its image onto a sheet of paper. Offset printing allows more flexibility in the printing process than direct lithography, in that images are produced as positives rather than negatives. This greatly simplifies image preparation. The speed and quality of the offset process continued to increase during the early part of the twentieth century, and as a result became the dominant printing process by the middle of the century.

The reader should distinguish between traditional offset lithographic printing and the newer technology of waterless offset printing. Conventional, or wet, offset utilizes the chemical process of oil-and-water separation to distinguish between the image and nonimage areas. Waterless printing, however, does not use the oil-and-water separation principle. Rather, waterless relies on temperature control, specially manufactured printing plates, and specially formulated inks that adhere only to the image areas on the waterless plate.

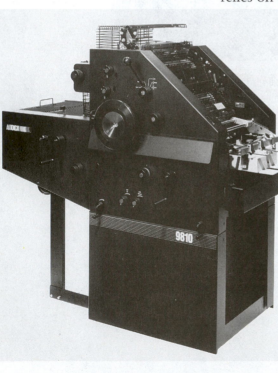

TYPES OF OFFSET PRESSES AND DUPLICATORS

A distinction is made between the terms *press* and *duplicator*. Although offset presses and duplicators use the same operating principles and have the same nomenclature, the differences between presses and duplicators lie in the maximum image sizes that can be printed, the operating speeds of the machines, and the length of the press runs for which the machines are normally used.

Figure 10.2A. Single-color offset press (Courtesy A.B. Dick Co., Inc).

Traditional offset printing presses can accommodate image sizes of 40 inches x 50 inches (or larger, in some cases), with operating speeds of more than 20,000 impressions per hour (iph). Offset duplicators are usually restricted to image sizes of 11 inches x 17 inches or less, with operating speeds of less than 10,000 iph. Offset duplicators are most often used in quick-print and in-plant facilities where press run requirements are generally less than 10,000 copies. Also, the quality of the images produced by small duplicators cannot approach the image quality of commercial offset presses. Offset duplicators are designed to be run by one operator, with training generally restricted to the operating characteristics of one specific machine. Large presses require extensive training and experience on the part of the operators and are often equipped to print multiple colors.

Figure 10.2B. Four color sheet-fed offset press (Courtesy SIRS, Inc).

SINGLE- AND MULTICOLOR PRESSES

Offset presses can be equipped to print either one or more colors simultaneously in a single printing pass. The number of colors capable of being printed depends on the number of printing "heads" built into the unit. Note the difference between a single-color offset duplicator and the four color offset press in Figures 10.2A and B. Single-color presses can often be equipped with an auxiliary, second color printing unit. These two-color heads are designed with their own separate inking system and form rollers, and share the same blanket as the original press. A two-color add-on printing head is illustrated in Figure 10.2C.

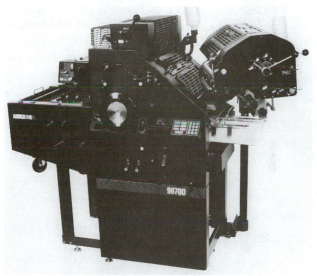

Figure 10.2C. Two-color printing head installed on a single-color offset press (Courtesy Townsend Industries, Inc).

SHEET-FED AND WEB-FED PRESSES

The terms *sheet-fed* and *web-fed* refer to the paper feed mechanisms of not only offset presses, but gravure and flexographic printing presses as well.

Sheet-fed presses feed paper that has been cut into various standard (and sometimes nonstandard) sheet sizes. An infeed table mechanism controls the pick-up and insertion of each individual sheet of paper into the press through the use of air and vacuum controls that are adjusted according to the size, weight, and thickness of the paper being printed.

Web-fed presses use large rolls of paper that feed the press in a continuous stream. On the output or delivery side of the press, the web is cut into individual sheets of paper depending upon the specifications of the job. Figure 10.3 shows the travel path of a typical web-fed four color offset printing press. After the paper has been printed, several options are available for the paper, depending on the requirements of the particular job. For example, if the paper is to undergo a coating process, it would go to the rewinder. If the job calls for individual sheets to be folded into signatures for a book, the paper is fed first to a sheeter, where it is cut into individual sheets, and then to a folding machine. The term *Standard Web Offset Process* (SWOP) comes from the widespread use of web presses in commercial printing applications.

PERFECTING PRESSES

Perfecting press are equipped to print on both sides of the sheet of paper during a single press run. On both sheet-fed and web-fed presses, this is accomplished by turning the web or sheet of paper 180 degrees during its travel through the press. The press must be equipped with an additional printing head for perfect printing.

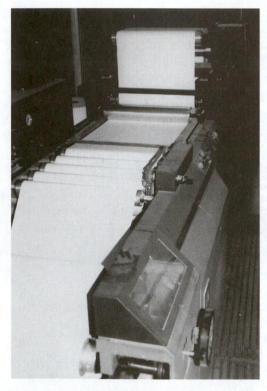

Figure 10.3. Web-fed offset press (Courtesy SIRS, Inc.).

OFFSET PRESS CYLINDER DESIGNS

Three different cylinder designs are used in offset presses. Three designs focus on the press cylinders and their relationship to one another. The press cylinders have four main functions:

- The plate cylinder, designed to hold the plate or master material.

- The blanket cylinder, to which the image is transferred from the plate cylinder.

- The impression cylinder, which acts to back up the paper during image transfer from the blanket cylinder.

- The delivery cylinder, which aids in depositing the printed sheets in a receiving tray or bin.

Use of the fourth (delivery) cylinder is usually restricted to large-format, high-speed commercial offset presses.

Figures 10.4A, B, and C show two-, three-, and four- cylinder offset press designs.

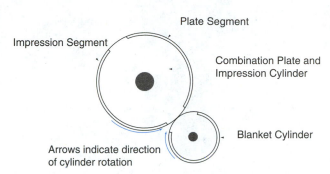

Figure 10.4A. Two-cylinder offset press design.

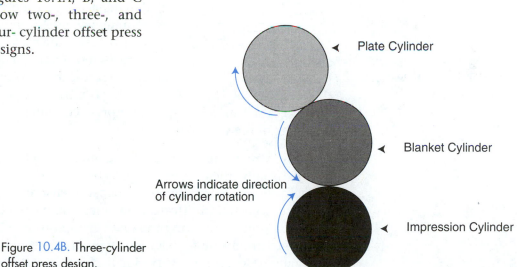

Figure 10.4B. Three-cylinder offset press design.

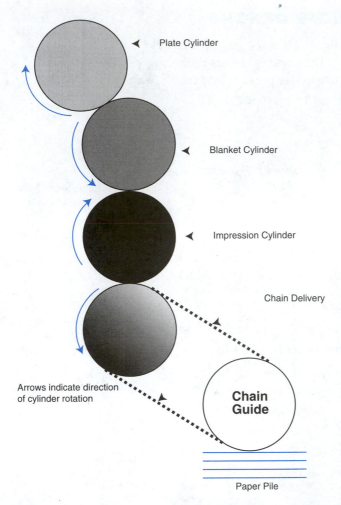

Plate Cylinder

Blanket Cylinder

Impression Cylinder

Chain Delivery

Chain Guide

Arrows indicate direction of cylinder rotation

Paper Pile

Figure 10.4C. Four-cylinder offset press design.

The two-cylinder configuration is used primarily in small offset duplicators. The two-cylinder design utilizes a combination plate and impression cylinder that is twice the diameter of the blanket cylinder. During operation, the plate cylinder transfers its image to the blanket cylinder. As the cylinders continue to rotate, the impression segment of the plate cylinder comes around to back up the blanket cylinder as the image is transferred from the blanket to the paper. The elimination of one cylinder (the separate impression cylinder) in no way affects the print quality or speed of the press.

Three- and four-cylinder designs are used widely in commercial offset presses. The three-cylinder design is also dominant in the manufacture of smaller presses that feature maximum sheet sizes of 11 x 17-inch and 17 x 22-inch paper. The gearing mechanism of the press coordinates the timing of the cylinders.

These presses feature an adjustment mechanism which allows the printed image to be moved both vertically and horizontally on the paper to ensure proper image registration. Horizontal image movement is usually done by moving the plate clamp on the plate cylinder from side to side. This type of adjustment is usually restricted to very small distances, because

moving the paper position is an easier way to make large changes in image position from side to side. The vertical adjustment feature on many presses can be restricted to an inch above and below a main set point; other presses allow vertical image movements of about 12 inches. The vertical adjustment can work in a number of ways and usually changes the relationship between the blanket and impression cylinder in order to change the position of the printed image on the paper.

The four-cylinder configuration in Figure 10.4C features a fourth (delivery) cylinder and chain delivery system. The chain delivery allows for high-speed placement of the paper into a delivery bin in sheet-fed presses.

All press cylinders are arranged so that they can conveniently be cleaned from the front of the press. Safety covers are incorporated into the design of the press. Small presses use clear plastic covers and large presses use hinged steel covers to protect the press operators. The covers are moved out of the way during the cleaning process (Figure 10.5).

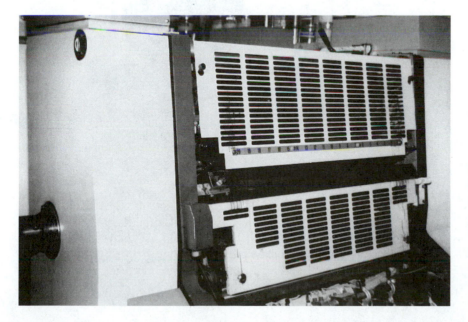

Figure 10.5.
Protective covers installed on an offset press prevent injury when the machine is running. The covers swing out of the way when installing plates or cleaning the rollers.

THE INK DISTRIBUTION SYSTEM

The purpose of the ink system is to deliver a uniform layer of ink across the entire image area of the printing plate. The inking system has three basic components: the ink fountain, the distribution rollers, and the ink form rollers. Figure 10.6 illustrates the configuration of a typical inking system used on a three-cylinder offset press. Note the relationship of the ink and fountain rollers to the plate cylinder, along with their direction of rotation. Cylinder rotation is important to ensure that the plate is dampened before it passes under the inking rollers.

Refer to Figure 10.7 as you read the following discussion of the ink roller configuration of typical offset printing presses.

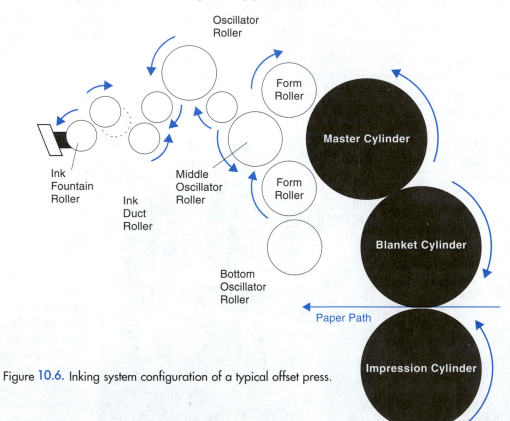

Figure 10.6. Inking system configuration of a typical offset press.

THE INK FOUNTAIN

The ink fountain acts as a reservoir from which ink is fed into the roller distribution system. The ink fountain consists of a shallow tray with a steel "doctor blade," which meters an even amount of ink from the tray onto the ink fountain roller. The amount of ink delivered to the fountain roller is determined by the space between the doctor blade and the roller. This space is adjusted by a series of screws that either increase or decrease the space between the doctor blade and roller. Also, a ratchet adjustment determines the distance, or *dwell* that the fountain roller turns during each rotation of the press. That rotation determines how much fresh ink the fountain roller picks up during each revolution of the printing press.

The amount of ink passed onto the roller system from the ink fountain is critical. Too much ink delivered to the plate will cause the image to be either too dark or will make it difficult to properly adjust the balance between the ink and water delivered to the printing plate. This results in a poor quality print. Conversely, too little ink results in faded and washed-out images, rather than impressions with sharp colors and tones.

INK DISTRIBUTION ROLLERS

The distribution rollers in the inking system further enable the press to place just the right amount of ink on the printing plate. The more distribution rollers in the system, the greater the control the press operator has in determining the amount of ink delivered to the plate (see Figure 10.7). Note from this illustration that there are different-sized rollers with different functions in the typical inking system. The ductor roller, nearest to the ink fountain, serves as the mechanism from taking ink from the fountain roller and depositing it into the distribution system. It does this by ducting back and forth between the ink fountain and distribution roller. Each time it comes into contact with the fountain roller, it picks up ink and then ducts

back to contact the first roller in the distribution system. In this way ink is transferred from the fountain to the distribution rollers.

The remainder of the rollers in the distribution system thin out the ink across the roller surfaces and grind out any minor imperfections that might remain in the pigment. Note the large oscillating roller in Figure 10.7. The weight and oscillating motion of this roller help to grind and spread the ink uniformly across the distribution system. This ensures that the right amount of ink reaches the form rollers for maximum print quality.

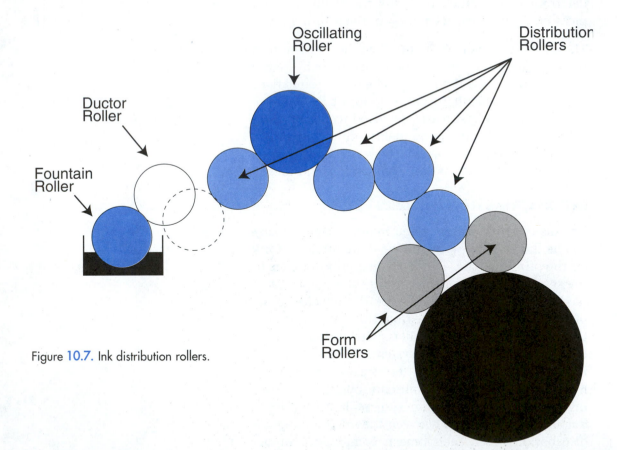

Figure 10.7. Ink distribution rollers.

332

INK FORM ROLLERS

The ink form rollers are the last rollers in the distribution system chain and are the only ones that directly contact the printing plate (Figure 10.7). The greater the number of ink form rollers, the better the image quality, because control of the ink reaching the printing plate is of utmost importance.

THE DAMPENING SYSTEM

The dampening system supplies moisture to the printing plate. This moisture repels printing ink from the nonimage areas of the plate. The wetting agent used on many offset presses is a combination of water and an additive called *fountain concentrate,* which extends the surface tension of water. The use of a fountain concentrate gives the resulting solution greater coating properties than just plain water. Alcohol and water are also used in combination as the wetting agent. Whatever the combination used, the dampening agent is usually referred to as *fountain solution.* Waterless offset presses do not use fountain solution to coat the nonimage areas of the printing plate, but rather use special plates and heat-sensitive printing inks to prevent ink from adhering to the nonimage areas of the waterless printing plate.

The chemical composition of fountain solution is important in maintaining print quality. Test kits for checking the pH (relative alkalinity) and purity of the fountain solution should be used for consistent, high-quality printing.

The dampening system is similar in roller design and configuration to its ink system counterpart. Dampening systems are either of the direct or combined type (sometimes also called *continuous* or *conventional* and *integrated*).

CONVENTIONAL DAMPENING SYSTEMS

Conventional dampening systems deliver the fountain solution to the printing plate using a delivery system that is totally separate from the ink delivery rollers. Figure 10.8 illustrates a conventional, or direct, dampening system.

To increase fountain absorption and provide a constant level of water delivered to the printing plate, cotton covers called *molleton covers* are used on the water ductor and dampening form rollers. The ductor roller serves the same purpose in the water fountain system as it does in the inking system—to duct between the water fountain and distribution rollers and transfer fountain solution to the roller distribution system. The water form roller is the last in the series and applies the wetting agent directly to the printing plate.

Figure 10.8. Direct dampening system on a two-cylinder offset press.

Note from the illustrations that in both conventional and integrated dampening system designs, press rotation is set up so that the plate first comes into contact with the dampening system before the inking system. This rotation ensures that there will always be an adequate supply of fountain solution coating the nonimage areas of the plate prior to the plate being inked.

INTEGRATED DAMPENING SYSTEMS

Integrated dampening systems, which are sometimes referred to as *indirect dampening systems*, carry both the ink and fountain solution on the same set of rollers. In the integrated system, the press rollers are first inked before water is added to the fountain system. The water fountain roller (which has been inked), contains a series of fine indentations across its surface. During operation, water is carried in these fine indentations along with the ink and is delivered to the printing plate from the same form rollers. Figure 10.9 illustrates an integrated dampening system. Integrated fountain systems are used on both small and large offset presses.

PAPER DELIVERY SYSTEMS

Paper delivery systems are designed to receive the printed sheets of paper, as they come out of the printing section of the press, and deliver them to a pile for finishing or further processing. The delivery systems are of two types: receiving tray chute and chain delivery systems.

CHUTE RECEIVING TRAY SYSTEMS

The chute tray delivery system is the simplest and least expensive type of paper-receiving device. Tray chutes are found only on small sheet-fed offset dupli-

Figure 10.9. Combination dampening system on a three-cylinder offset press.

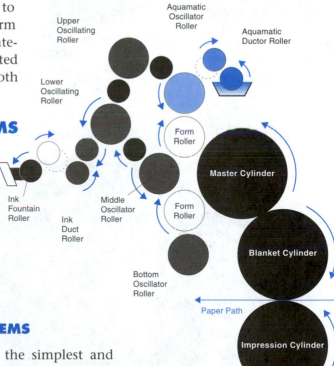

335

cators. The receiving tray is attached directly to the back side of the press, in line with the paper output from the impression and delivery cylinders. Figure 10.10 shows the configuration of a chute delivery unit on a small offset duplicator.

Figure 10.10. Chute delivery system on a small offset duplicator.

The side and back guides of the delivery system are adjustable for different sizes of paper. The guides also line up the system with the position of the printed sheet as it exits the press. Delivery systems also have side and top joggers, which push against and help to align each sheet of paper as it drops into the delivery tray.

CHAIN DELIVERY SYSTEMS

Chain delivery systems use a gripper bar that grabs the printed sheet as it leaves the printing cylinders. The gripper bar is attached on both ends to continuous chains that move the bar over a delivery tray where the paper is dropped onto a receiving board. The bar then moves back to the delivery end of the press, where a new sheet of paper is grabbed for transport back to the delivery area. The chain delivery system in Figure 10.11 uses two gripper bars for paper delivery.

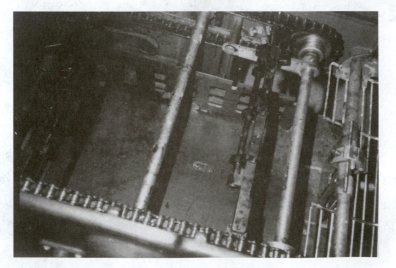

Figure 10.11. Chain delivery system.

Some chain delivery systems drop the paper onto a stationary board or tray; others use a receding stacker. The receding stacker is adjusted to automatically lower as paper is delivered to the delivery area. This keeps the top of the paper pile at a constant height, making it easier to unload the printed sheets during the printing process.

Another advantage of receding stackers is the large volume of paper they can accommodate. This makes frequent emptying of a paper feed tray unnecessary. Because most offset presses and duplicators can accommodate several thousand sheets of paper in the feeding section, receding stackers cut the "down time" on a press caused by frequent loading or unloading of the delivery system.

Now that we are familiar with the basic operating components of offset printing presses, let's see how a typical job is printed.

PRINTING A JOB

The paper feed, delivery, ink, and water systems should all be adjusted before printing any job. To successfully print any job, the four systems just described must be properly set up so that they will work together.

We will examine each of the system component adjustments that are made before printing the job. For purposes of our discussion, we will refer to controls and components on small sheet-fed duplicators, although the same concepts apply to large commercial machines as well.

ADJUSTING THE PAPER FEED AND DELIVERY TABLE

The first series of adjustments on a press requires setting up the paper feed and delivery system. The paper must feed evenly through the printing heads and drop off properly into the receiving system. The ink and fountain systems are adjusted after the paper feed and delivery have been properly set up.

On presses other than web-fed configurations, the paper is fed from a paper pile using a combination of air and vacuum controls and stationary guide bars. The front paper guides are first set to line up the paper from front to back, as shown in Figure 10.12. These guides also act to align the paper from side to side.

Figure 10.12. Side and front paper feed table guides. The guides should be set up so as not to pinch the paper stack, while allowing enough freedom for the sheets to feed freely.

Side guides at the rear of the paper feed table are adjusted to the size of the paper stack and hold the paper firmly in place without binding. If the guides are too tight, the paper will not feed properly. The rear moveable guides are set from a guide bar holder, which helps to maintain the paper stack in proper position from front to back (Figure 10.13). As with the front guides, the rear moveable guides must be adjusted so that they do not bind against the paper stack. Note that the feed system of a large sheet-fed offset press incorporates a separate feeding table equipped with its own controls, separate from the press controls (Figure 10.14).

Figure 10.13. Adjustable rear paper feed table guides.

Figure 10.14. Sheet feeder on a commercial offset press. This feeder has its own separate control panel. (Courtesy SIRS, Inc.)

The paper delivery tray should be checked to ensure that the printed sheets fall properly onto the tray. If the delivery mechanism incorporates a side jogger to align the sheets, make sure that the jogger contacts the delivery pile properly, without interfering with incoming sheets as they are dropped onto the delivery pile.

ADJUSTING THE AIR AND VACUUM CONTROLS

A combination of air and vacuum is used to feed paper in a press. A stream of air flutters the sheets on the top of the paper pile, keeping them separated and at the correct height for proper feeding. Vacuum sucker feet pick up the top sheet and move it into the press. Adjustment of air and vacuum is critical: too much vacuum or too little air can cause double sheets to be picked up and fed into the press; too little air or vacuum will cause sheets to be fed either improperly or not at all. The proper combination of air and vacuum must be maintained throughout the entire press run. Note the air pump and suction controls on the main control panel of the commercial offset press in Figure 10.15.

ADJUSTING PAPER REGISTRATION CONTROLS

Proper registration of the paper in the printing press is a function of two procedures: setting up the paper on the feeder table and final registration of the paper as it enters the press itself. Some offset duplicators use the position of the paper on the infeed table as the only registration control. Other presses use a conveyor tape feed mechanism which enables the operator to make final paper adjustments before the paper enters the printing head. A conveyor tape feed registration system of this type is shown in Figure 10.16.

Figure 10.15. Air pump controls. On large presses, the air and vacuum controls operate from a master control panel. On small offset duplicators, one motor controls the air/vacuum pump.

Figure 10.16. Tape feed registration system (typical). The incorporation of a tape feed system gives the press operator a high degree of control over registration of the image on the paper.

The incorporation of a conveyor tape feed registration system gives the press operator more control in maintaining the quality and registration of the printed image than is possible with direct-feed presses. Some direct-feed systems use micrometer adjustments on the feed table to maximize paper registration.

After the feeder and registration controls have been adjusted, a sheet of paper should be fed into the press using the automatic feed controls. At this time the press operator can make sure that all air, vacuum, and paper positions have been properly adjusted. Small presses can be manually rotated, and large presses jogged, to move the paper through the printing unit to check for proper adjustment and registration.

DOUBLE SHEET DETECTION

After the feed and delivery ends of the paper feed system have been adjusted, the press should be turned on and a dozen or so sheets automatically fed through the machine, as a final check of all adjustments. Most

presses have double sheet detectors to prevent feeding two sheets of paper into the print head at the same time. Double sheets are deflected into a receiving bin or tray out of the line of the normal press feed. Although the principles involved in double sheet detectors are similar from one press to another, specific adjustments vary by manufacturer. The operator should consult the press instruction manual regarding all adjustments.

INKING THE PRESS

The configuration and operation of typical offset inking systems was discussed earlier. Whether a press is inked before or after the paper feed is adjusted is at the discretion of the operator. One key to quality offset printing is to ink the press so that there is neither too much nor too little ink on the system rollers. On presses with integrated ink/water systems, the press is inked before the fountain solution is added.

Figure 10.17. Ink fountain doctor blade adjustment screws. The screws should be adjusted prior to inking up the press, to establish control over the ink distribution. As the press is running, these adjustment screws can be further adjusted to fine-tune the amount of ink delivered to the printing plate.

The first step in this process is to properly adjust the ink fountain adjusting screws before placing ink on the fountain roller. The set screws that apply pressure against the doctor blade determine the space between the blade and the ink fountain roller (Figure 10.17). This space in turn determines how much ink is passed onto the fountain roller as the press rotates. The screws should first be tightened (turned clockwise) until resistance is felt as the doctor blade touches the fountain roller. Then the screws are rotated counterclockwise one-quarter of a turn.

342

Ink can be added to the fountain either from an ink cartridge gun or a can. A bead of ink should be placed on the top of the fountain roller and not inside the fountain. The ink fountain roller can be rotated by hand until the ductor roller is in contact with the fountain roller. At this point, the fountain roller can be turned by hand to transfer ink from the fountain to the ductor roller. The thickness of the bead of ink transferred to the ductor, as well as the evenness of the layer of ink from one side of the ductor to the other, should be carefully observed. A thin layer of ink should be maintained from the ink fountain to the ink ductor roller. A slight hissing sound coming from the contact of the two rollers, along with an orange-peel appearance on the ductor roller, are two indications of ink consistency (Figure 10.18).

When first inking a press, one should start with a light rather than a heavy ink layer. It is always easier to add ink, either by increasing the ratchet control or by opening up the doctor blade adjustment screws, than to deal with a press that is overinked.

Figure 10.18. Transferring ink from the ink fountain to the ink ductor and distribution system. A ratchet control determines how far the ink fountain turns during each rotation of the printing press.

343

Once the preliminary doctor blade adjustments have been completed, the press is turned on, allowing the ink system rollers to ink up completely. This process should take between 30 to 60 seconds.

The amount of ink transferred from the fountain to the inking system can also be adjusted by the ratchet control. Therefore, the combination of the pressure screws against the ink fountain, as well as the ink fountain ratchet control, determines how much ink will reach the printing plate.

When printing a job that requires dense ink coverage, such as full-page illustrations, more ink is required to be delivered to the plate than with a job consisting of only line copy and text. If the job to be printed has all or most of the illustrations on one side of the page, the ink fountain pressure screws will have to be adjusted to deliver a greater amount of ink to that side of the plate.

ADJUSTING THE DAMPENING SYSTEM

Fountain concentrate is added to the water fountain according to the manufacturer's instructions. Small offset presses use fountain solution that is fed from a small bottle into the water fountain (Figure 10.19). Commercial presses use large-capacity jugs (see foreground of Figure 10.20) to supply the fountain solution. Presses with conventional dampening systems usually have roller covers on both the ductor and form rollers. These systems need to be run until the molleton-covered rollers are damp. Integrated systems do not have covered rollers and need be run in for only a few seconds to get an adequate amount of fountain solution to the form rollers. The press operator should always check the pH of the fountain solution. On a scale from 0 to 14 (0 is a highly acid solution; 14 is a highly basic, or alkaline, solution), offset press pH readings should be between 4.5 to 5.5 (acidic solution). Also, consult the plate manufacturer's recommendations for maintaining proper pH of the fountain solution based on the requirements of the printing plate.

Figure 10.19. Small offset duplicators deliver fountain solution from a small bottle that rests in the fountain reservoir.

After these preliminary adjustments are complete, we can begin printing. The first step is to mount the plate to the plate cylinder.

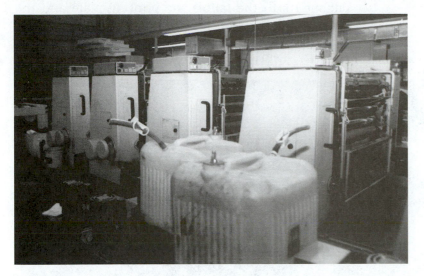

Figure 10.20. Commercial offset presses use five-gallon (or larger) jugs to deliver fountain or commercial dampening solutions to the distribution system on the press. (Courtesy SIRS, Inc.)

MOUNTING THE PRINTING PLATE

The plate is mounted on the plate cylinder using a pin-bar or straight-edge clamp on the plate cylinder. Pin-bar holes on the plate match up with the holes punched into the head and tail of the printing plate. In Figure 10.21, the operator lines up the holes and pin-bar clamp while maintaining even pressure on the back of the plate to keep the plate from folding or creasing.

Figure 10.21. Mounting a pin-bar offset plate onto an offset duplicator.

345

The plate is advanced onto the plate cylinder until the tail clamp on the plate cylinder comes around. The pins on the tail clamp are inserted into the holes punched into the tail of the printing plate and the clamp is then tightened. After the plate is mounted, a cotton pad is used to prewet the plate before the press is started up (Figure 10.22).

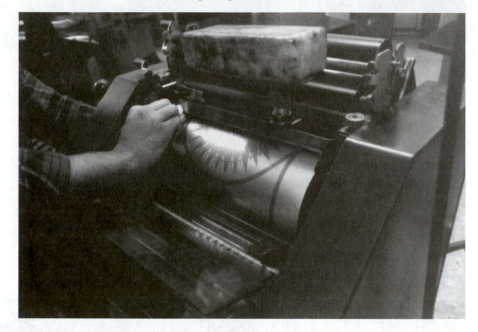

Figure 10.22. Prewetting the printing plate with fountain solution prevents the entire plate from inking up when the press is first started.

PROOFING THE IMAGE

After the plate is prewetted, the press should be turned on to pull a proof of the printed image. Proofing in this manner ensures that the plate is printing correctly and that the image is properly positioned on the paper.

On presses with combination dampening systems, the press need only run for a few seconds before the form rollers are lowered into contact with the plate cylinder. On presses with molleton-covered direct dampening systems, the machine should run for about 30 seconds to allow the form rollers to become sufficiently damp before they are placed in contact with the plate cylinder.

The press is run for a few revolutions with the form rollers in contact with the plate, then turned off. The plate is inspected to ensure that it is inked up only in the image areas. There should be a thin coating of moisture on the nonimage areas, which should be clean and free of ink.

Any blemishes or ink on the nonimage areas of the plate should be removed before printing. If the plate is inking up in the nonimage areas, small corrections can be made. Use a soft rubber eraser dipped in fountain solution to erase unwanted image areas from the plate (Figure 10.23). If large areas of the plate are inking up in the nonimage areas, check the negative and plate. Improperly developed plates will ink up in the nonimage areas due to residual developer left on the plate surface.

If a plate was processed more than about an hour before being printed, the aluminum surface of the plate may have oxidized. This will cause the surface of the plate to become grease- or ink-receptive. In either of these two cases, the plate will have to be made over again.

Figure 10.23. Small blemishes can be erased from the offset plate with a soft pink eraser (the type found on the end of No. 2 pencils) dipped in fountain solution. Dipping the eraser in fountain solution lubricates the eraser and prevents it from scratching the plate.

If the plate checks out properly, turn the press on, put it in the impression mode, and pull one or two print proofs. One or two sheets of paper are run through the press, which is then turned off. The printed sheets should be deposited in the delivery tray for inspection.

Press operators should get into the habit of turning the form rollers off every time the press is stopped. This will keep the plate free of roller impression marks when the press is started up again. Also, when the press is stopped for more than about 15 or 20 seconds, the moisture in the nonimage areas of the plate evaporates, drying it out. If the press is started while the plate is dry, the plate may completely ink up. If this happens, it will take about a minute of press operation before the ink and water balance on the plate is restored between the image and nonimage areas.

As the press run begins, final adjustments can be made for optimum quality by fine-tuning the ink and water balance on the plate.

ADJUSTING THE IMAGE FOR BEST QUALITY

Almost all of the problems associated with the quality of the printed image in wet offset printing relate to the balance of ink and water delivered to the printing plate. The press operator should try to achieve the best image using the least amount of water and ink. Problems can also be caused by improperly adjusted or glazed rollers, improper roller pressure, and glazed, damaged, or improperly packed blankets. Ink and water balance adjustments can only be made while the press is running, so some paper waste is inevitable until the best quality is achieved.

There are many benchmarks of quality printing. First and foremost is even ink coverage across the image; text should be printed in solid colors and not grayed-out. Solid colors should print with full, even intensity and coverage across the page. When printing multiple colors, each color should be in proper registration to the others.

When printing halftones, there should be minimum dot gain in the picture. (Dot gain comes from improperly exposed plates or negatives, improper pressure between the press rollers, or overinking. These conditions cause the dots to grow in size in relation to the size of the dot on the original halftone negative.) There are several devices that usually accompany the printed image and act as quality control (QC) devices and allow the press operator to continually inspect the printed sheets. Many of the QC devices are stripped into the flat and print outside of the main image area. This enables continual inspection of the quality of the printed job and enables the QC strips to be trimmed off after the press run is completed. Figure 10.24 illustrates the most commonly used QC strips that accompany a typical printed image: two star targets at diagonal corners to check for dot spread, two registration marks at each corner of the picture, trim marks, and a 10-step gray scale.

Figure 10.24. Offset print with accompanying quality control strips. The star targets at the top left and bottom right corners are used to show dot gain. The targets begin to fill in at the center when press gain is present. The gray scale is used to determine overall density range of the print.

The eight **registration marks** placed in pairs at each corner of the illustration allow for the printing and alignment of colors in multicolor separation prints. Also, during stripping, the registration marks allow for pinpoint positioning of the image on the flat for accuracy.

Star targets are placed at diagonal corners in Figure 10.24. The star target shows the amount of ink spread. As ink spread increases, the center wedge of the target begins to fill in with ink. The target also shows the amount of ink slur, or line doubling, in addition to spread. Ink slur occurs in a specific direction, and is indicated on the star target by distorted wedges or changes in the shape of the circle at the very center of the target.

The **crop marks** which appear at each of the corners of the illustration are used for final trimming.

The **gray scale**, discussed in chapter 9, is a basic QC device which gives an indication of the overall contrast range that the press is capable of capturing via the halftone screen.

Color bars are used in color separation negatives to give the press operator a visual indication of the colors resulting from the overlay of transparent color separation inks.

The use of a good-quality magnifying lens, called a *linen tester*, is an invaluable aid for close inspection of all negatives and prints, and facilitates the quality control process (Figure 10.25).

Figure 10.25. A linen tester, or loupe, used for magnifying small areas of prints, negatives, and plates.

TROUBLESHOOTING POOR IMAGE QUALITY

Four major types of problems are associated with the quality of the image in the offset printing process. These problems are: image scumming, image blurring, image wash-out, and hickeys.

IMAGE SCUMMING

Scumming is a condition in which the image picks up ink in the nonimage areas. There are two main causes of scumming: either too much ink or too little fountain solution reaching the plate. In the case of too much ink, the rollers will give off a loud hissing noise when the press is running, and the rollers will take on a textured appearance from the heavy layer of ink. Conversely, if too little water is available to the plate for repelling ink, then scumming will also occur.

As a general rule, always try to subtract rather than add ink or water to solve a problem. For example, in a typical scumming situation, it is preferable to subtract ink rather than add water to clear up the problem. Remember, use the least amount of ink and water necessary to achieve a quality result. If the dampening system is operating incorrectly, or if there is not a sufficient quantity of fountain solution available in the water fountain, then more must be added. Increasing the ratchet adjustment of the fountain roller will increase the amount of fountain solution delivered to the plate.

Adjustments to clear up scumming problems must be made while the press is running. On conventional dampening systems, these adjustments may take two dozen printed copies before the changes are noticeable. Integrated dampening systems take less time for the results of changes in either ink or fountain solution adjustments to be seen on the prints.

IMAGE BLURRING

Image blurring is sometimes referred to as *image doubling*. Causes of double-printed images are loose blankets on the blanket cylinder and too much impression

pressure. Before beginning any press run, the operator should make sure that the blanket is adjusted tightly on the blanket cylinder. Also, the impression pressure should be set according to the manufacturer's specifications. The operator can try backing off on impression pressure to see if a blurred image problem disappears when the impression pressure is reduced.

WASHED-OUT COPY

Washed-out copy occurs when areas that should be black print as gray. This overall gray, low-contrast appearance to the copy is caused by an imbalance in the amount of ink and water reaching the plate. An early sign of wash-out is water that can be seen either spraying off the rollers or dripping from the bottom of the roller distribution system. In this instance, too much water is flooding the plate, not allowing a sufficient quantity of ink to reach the image areas of the press. Following the rule of using the least amount of ink or water for proper image balance, the remedy for this situation is to cut back on the dampening system feed controls. Wash-outs can also be caused by too little ink feeding to the plate cylinder. If too little ink is suspected, the ink covering on the rollers should be carefully examined, and the ink feed readjusted if necessary.

Another cause of wash-out is incorrect pressure adjustments between the plate to blanket and blanket to impression cylinders. These pressures should be checked and readjusted according to the manufacturer's specifications.

HICKEYS

Printer's *hickeys* are small dots or blemishes that print on the sheet in either the image or nonimage areas. Hickeys are caused by small bits of either ink or paper that become attached to the plate or blanket cylinder. These particles ink up and transfer the image to the press sheet or appear as uninked small round areas in the solid image areas of the print. If hickeys are found, the press should be stopped and the piece of ink or

paper removed from the plate or blanket. After the particle is removed, the blanket should be cleaned before printing continues.

PRINTING COLOR SEPARATIONS

If a single-color press is used to print three or four color separations, certain orders of the color printing sequence yield better results than others.

The tried and true method for printing color separations is to go from light to dark, beginning with yellow, then magenta, cyan, and black.

If the color separation is combined with conventional text and/or line drawings to be printed in black on the same page, the color sequence would be to print black first, then yellow, magenta, and cyan.

A third sequence of printing uses cyan first, followed by yellow, magenta, and black. Because the cyan printer often resembles a conventional halftone, with the greatest amount of detail, this detailed image is apparent on all of the remaining color prints and makes registration of the following colors somewhat easier.

Regardless of the sequence used in color process printing, it is important to clean the press properly between colors to prevent contamination of any ink with the color that preceded it. One method that reduces ink contamination is to clean the press after one color has been printed, ink up the press with the next color to be printed, and immediately clean it up before printing and then re-ink it. This method preconditions the rollers to the next color of ink and is referred to as a *color wash-up*.

CLEANING AND STORING PLATES

After a press run is completed, the plate must be taken off the press, cleaned, and preserved, if it is to be used again. Properly cleaned and preserved plates will last a

long time. Improperly cared for, the plates will be use-less only a few hours after printing.

The plates should be cleaned with blanket wash using a soft cotton pad to prevent scratching. When the plate is free of ink, a solution of gum arabic and water is applied over the surface of the plate using a soft cotton press pad. The gum arabic/water solution coats and seals the plate, preventing the aluminum plate surface from oxidizing. The gum arabic must be diluted from its concentrated form, using a solution of 50% gum arabic and 50% water, or other dilutions as recommended by the manufacturer.

When the gum solution has dried, the plates should be stored in a folder or protective sheet to prevent scratching. Gummed plates can be stored either flat in drawers or hung vertically in a plate cabinet.

It is always a good idea to make and process a printing plate just before it will be printed. This method eliminates storage and preservation problems. However, if a plate must be made several hours or days before it will be printed, it must be preserved with gum arabic. When the plate is ready to be printed, the gum arabic is taken off with water, either in a plate sink or directly on the press, using cotton pads dipped in fountain solution to dissolve the gum arabic. After the gum has been dissolved and removed, the plate is ready for printing.

CLEANING THE PRESS

Several methods are used to clean presses. No matter which method is used, cleaning a press is always a dirty job.

One effective cleaning method is to use clean-up mats on the plate cylinder. The clean-up mat is attached to the plate cylinder in the same manner as a regular plate (Figure 10.26).

Figure 10.26. Attaching a clean-up mat to a small offset duplicator. The mat acts like a huge blotter when blanket wash cleaning solvent is sprayed onto the rollers during clean-up.

Before cleaning begins, the ink fountain should be removed from the press and cleaned. The water fountain should also be drained at this time. If cleaning a conventional dampening system, make sure that the molleton-covered water form roller is in the "off" position before using any clean-up mats. If the press to be cleaned uses an integrated dampening system, the water fountain should be drained before cleaning.

The clean-up mat which is the same size as the printing plate, is made from a highly absorbent material similar in appearance and absorbency to a desk blotter. When the clean-up mat is attached to the plate cylinder, blanket wash is sprinkled over the main oscillating roller, with the ink form rollers in the "on" position.

Cleaning an offset press is never an easy job, whether it be a small sheet-fed duplicator or a larger web-fed press. Note the use of protective gloves during the clean-up process on the two color sheet-fed commercial press in Figure 10.27.

Figure 10.27. This press operator wears gloves when cleaning up a large, commercial-sized printing press. Regardless of the method used, cleaning a press is always a dirty job! (Courtesy SIRS, Inc.).

Blanket wash dissolves printing ink. The solution works its way over the distribution system to the form rollers and into the absorbent clean-up mat. Clean-up mats must be changed frequently to clean the press thoroughly. The operator will notice that after the fourth or fifth clean-up mat, the rollers become cleaner, and the clean-up mat takes longer to become soiled with the ink/blanket wash mixture.

Clean-up mats can be used on both sides and should not be thrown away if they are dirty on only one side. After they dry out, they can be turned over and used again.

After the rollers are cleaned, the ink and water fountains should be reattached to the press. If a film of ink still remains on the rollers, it can be removed by hand with a soft cloth and blanket wash.

MAINTENANCE PROCEDURES

Offset presses are complicated machines and require a regularly scheduled maintenance program if they are to

remain in good operating condition. Press manufacturers have recommended maintenance schedules for their machines, which should be carefully followed.

Critical maintenance procedures involve lubrication of the chain delivery system and roller and motor bearings, and maintenance of the air blower assembly. Many electric motors are equipped with factory-sealed bearings that are lubricated for the life of the motor and need no regular lubrication. However, paper lint and dust can clog the air cooling fins and openings on the drive and compressor motors. These motors should be inspected frequently and any lint build-up removed to prevent the motors from overheating. Roller bearings are accessible under the protective cover of the machine and require frequent lubrication to perform properly (Figure 10.28).

If the press is equipped with a chain delivery system, the chains must be lubricated and kept free of paper or other foreign objects that might cause the chains to jam or jump out of timing.

Figure 10.28. Lubricating roller bearings.

Most presses use solid-state sensors for double sheet and jam detection. These sensors accumulate dirt and paper lint and should be cleaned after each press run (Figure 10.29).

Figure 10.29. Cleaning press sensors after a press run. These sensors control automatic cut-off switches when they detect a jam or other malfunction. Because of their location, they often build up a significant layer of paper lint or printing ink in short order and should be cleaned each time the press is used.

POSTPRESS OPERATIONS

A wide variety of finishing and binding operations occur after a job has been printed. Finishing techniques such as trimming, scoring, embossing, and laminating, as well as a variety of binding techniques available for combining multiple pages into finished signatures, pamphlets, and books, are some of the more common finishing operations. We will look at some of these finishing options in more detail.

FINISHING TECHNIQUES

The most common finishing techniques include cutting and trimming, collating, folding, numbering, slitting, embossing, die-cutting, coating, and laminating. Some of these processes are performed on the printing press using specialized equipment, whereas others require separate machines.

PAPER CUTTING

Most printed material has to be trimmed at some point during its production. Almost all of the production-sized paper cutters presently sold are microprocessor-controlled (note the digital control pad in Figure 10.30 and available as either floor or table model units shown in Figures 10.30 and 10.31).

Figure 10.30. Computerized industrial-size paper cutter. These cutters can be programmed to perform a series of cuts, depending upon the requirements of the job. Air blown out through a series of small holes in the bed of the cutter enables the operator to move large, heavy stacks of paper easily as the job is cut and turned. (Courtesy SIRS, Inc.)

Figure 10.31. Small office-sized tabletop paper cutter (Courtesy Martin/Yale, Inc.).

359

The floor-model cutter in Figure 10.30 can be programmed, through its built-in microprocessor, to automatically move and cut the paper for more than 3,000 total cuts in a specific sequence. Some of these systems are available with built-in video monitors that enable the machine operator to accurately track the cutting details of a particular job. Large-format paper cutters are usually hydraulically operated and are capable of producing several hundred pounds of force per inch on the cutting blade. Safety features are built into these machines to automatically shut down the cutter in case of a malfunction. However, as with all power equipment, the operator must exercise great care during operation if accidents are to be prevented.

For smaller jobs, the tabletop cutter pictured in Figure 10.31 is an ideal choice. Small tabletop cutters are not usually computer-controlled, but use hand controls to move and position the paper for various cuts and trims.

FOLDING, SCORING, AND PERFORATING

Many modern paper-folding machines are multifunctional and perform a variety of finishing operations simultaneously. For low run requirements, the tabletop paper folder in Figure 10.32 is standard equipment in many offices and small print shops.

Figure 10.32. Tabletop paper-folding machine. This machine can perform both single and double folds on letter- and legal-size paper. (Courtesy Martin/Yale, Inc.).

When large printing jobs require controls that allow for simple or complex folding operations at speeds ranging from 2,000 to more than 20,000 sheets per hour, a folder such as the machine shown in Figure 10.33 is called for. The unit in Figure 10.34 combines folding abilities with scoring, perforating, and creasing capabilities.

Figure 10.33. Large-capacity paper folder operates at speeds between 2,000 and 4,000 copies per hour (Courtesy Martin/Yale, Inc.).

JOGGING

Joggers are used to evenly align all of the sheets in a paper stack. Paper should be jogged before it is placed in the printing press and also before trimming, to ensure accuracy of the trimmed sheets. Paper joggers come in different sizes and work by rapidly vibrating the paper pile against a top and bottom stationary guide. The vibration evenly aligns all of the sheets in the paper pile in only a few seconds. The jogger pictured in Figure 10.35 is a small benchtop unit that handles sheet sizes up to 17 x 22 inches.

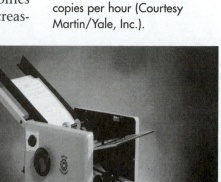

Figure 10.34. Scoring, perforating, and creasing machine (Courtesy Rosback Inc.).

Figure 10.35. Tabletop paper jogger (Courtesy Martin/Yale, Inc.).

COLLATING

Collating is the process of putting all the printed pages in correct order. Collating can be done either on a printing press with a built-in collator or with a separate collator unit. Built-in collators have become virtually standard equipment on high-volume copiers and digital printing presses. On offset duplicators and commercial printing presses, however, collating is usually done as a finishing process, because even a single sheet may contain two or more pages that must first be trimmed before they can be collated. Collators can be purchased as simple multistation systems or as multifunction controlled units pictured like the one in Figure 10.36, which not only collates, but folds and stitches as well. These collators incorporate automatic miss, double sheet, and jam detectors to monitor the paper feed and collating operation, and shut the collator down if any problems develop.

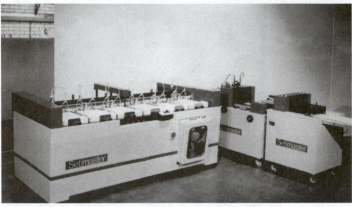

Figure 10.36. Multifunction collator (Courtesy Rollem Corporation of America).

DIE-CUTTING

Die-cutting is the process of cutting a sheet of paper or cardboard into a shape. For example, the familiar envelope must first be die-cut into the specific shape before it can be folded and glued to make the actual envelope. Die-cutting is a process external to the printing operation and is usually performed after the piece has been printed. Die-cutting forms are made by cutting the pattern for the shape of the cut into a piece of plywood and then inserting specially manufactured steel cutting dies into the saw kerf. Figure 10.37 shows a simple geometric form designed to cut out lightweight

Figure 10.37. Steel cutting rule in die-cutting form. The shape to be cut is laid out and then cut from a piece of ¾-inch plywood. The steel die is placed into the groove left from the saw kerf.

paper shapes. Note the foam rubber lining the steel die. The rubber is used to prevent the cut paper from sticking to the die after it has been cut. In Figure 10.38, a die-cutting form used to cut out a box window in a sheet of paper is locked up in a press chase before the die-cutting operation begins.

COUNTING

Printing presses and finishing machines like stitchers and collaters have built-in counters. Sometimes secondary portable counters are also used to give a precise count of the number of pamphlets, pages, or individual sheets actually produced after the finishing processes are completed. The counter in Figure 10.39 is built in to the control panel of a sheet-fed press to keep track of finished sheets.

Figure 10.38. Die-cutting form locked up in chase, ready to be placed in the printing press.

Figure 10.39. Electronic counter on commercial offset press.

363

THERMOGRAPHY (RAISED PRINTING)

The thermography process imparts a raised surface to conventionally printed material. A resin powder is applied to wet printing ink and heated. Under the influence of the heat, the powder melts, but remains raised from the surface of the paper, leaving a raised letter in both appearance and feel. For this reason, thermography is sometimes referred to as *imitation engraving,* and is widely used in the printing of a variety of invitations, business cards, and specialty items. Thermography units come in both tabletop and floor-model units. The tabletop thermography unit shown in Figure 10.40 requires the operator to manually apply powder to the freshly printed piece which is then placed on the conveyor belt. The belt carries the sheet under the oven unit, which heats and melts the resin powder, leaving a raised image of the type or illustration that was coated with the powder.

Figure 10.40. Tabletop thermography raised printing machine (Courtesy Sunraise, Inc.).

Large production-model raised printing units like the machine in Figure 10.41 apply the resin powder to the printed form, vacuum off the excess powder, and deliver the finished sheet automatically. Thermography powder comes in a variety of colors as well as clear resin. This enables the printer to keep the original color of the printed material or change it, based on the color of the powder used.

Figure 10.41. High-volume thermography machine with automatic powder application and removal unit (Courtesy Sunraise, Inc.).

EMBOSSING

Embossing imparts a raised image to the actual paper by the use of an embossing die. A common example of embossing is the seal used by a notary public when notarizing a document. The principle of the embossing process in shown in Figure 10.42.

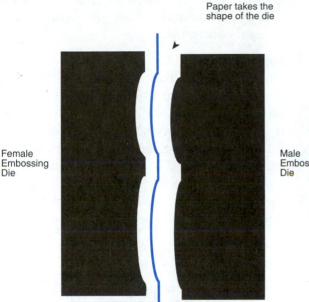

Paper takes the shape of the die

Female Embossing Die

Male Embossing Die

Figure 10.42. Principle of an embossing die.

Embossing is often used in the production of high-quality printed material such as corporate and business stationery, as well as for specialty marketing brochures and literature. Embossing is an external process, performed on special equipment using male and female dies to make the raised designs on the paper.

NUMBERING

Many items, such as theater, movie, and stadium seating tickets, all require that each individual ticket be numbered. Presses can be equipped with numbering machines, or the process can be done manually after the sheet has been printed and trimmed. Figure 10.43 shows a tabletop numbering machine with automatic feed designed to handle small jobs.

Figure 10.43. Small numbering machine (Courtesy Count Numbering Machine, Inc.).

When the numbering requirements of a job are more demanding than can be met with a small tabletop unit, a large-format numbering machine is required. Numbering machines of this type can handle multiple numbering heads. Some of these units can also score, slit, and perforate in addition to numbering. A machine of the type illustrated in Figure 10.44 can number several thousand sheets per hour and is microprocessor-controlled.

DRILLING

Drilling holes in paper, for use in either conventional loose-leaf binders or other types of binding systems requiring drilled holes, continues to be a mainstay binding technique. Paper drills are available as either single- or multiple-spindle machines, as shown in Figure 10.45. The drills incorporate a tapered shank that holds the drill bit firmly in place in the drill chuck, and are available in many different sizes.

Figure 10.44. Large-format numbering machine (Courtesy Count Numbering Machine, Inc.).

Figure 10.45. Multiple-spindle paper drill (Courtesy Rosback, Inc.).

COATING AND LAMINATING

For a variety of reasons, many printed jobs are coated after they have been printed. For example, art reproductions are sometimes given a protective varnish coating after printing to preserve the appearance of the image. Coatings are usually applied from one of the print heads on a printing press. A variety of coatings are available to both protect and preserve the printed product, depending upon its final destination and use.

Laminating is a process in which a film or plastic is adhered to the printed product after it has been printed. This plastic coating adds stability to the thinner papers used for printing from ink-jet and electrostatic printers. Laminating or sealing the finished job also adds protection to guard against water, dirt, oils, wrinkling, and tearing. Most laminating is done on large-format products (30 x 40 inches and larger) used for signs and advertising posters. A large format laminating machine is shown in Figure 10.46.

Laminators can also be used for image transfer. These machines enable the transfer of images produced by electrostatic printers to both rigid and flexible base materials, depending upon the end use of the product. Signs, banners, and a variety of outdoor-use printed products benefit from this image transfer process.

Figure 10.46. Large-format numbering machine (Courtesy Seal Corporation, Division of Hunt Manufacturing, Inc.).

BINDING TECHNIQUES

A variety of techniques are used to bind the pages of a document together. Four major binding methods are side and saddle stitching, edition bindings, perfect bindings, and plastic bindings. Most large printing facilities have a variety of binding equipment located either in the pressroom or in an adjacent area to facil-

itate the binding of documents after they have been printed and finished.

EDITION BINDING

The hardcover textbooks with which we are familiar are known as *edition bindings*. Edition bindings are made up of individual signatures that are first sewn together. After sewing, a hard cover is glued onto end sheets that

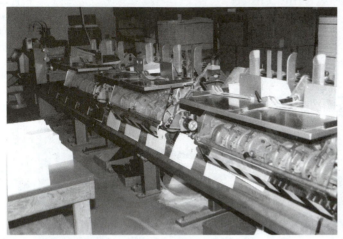

hold the cover in place. Edition binding is the most expensive type of binding and usually is reserved for textbooks and other relatively expensive editions. In Figures 10.47A through C, signatures for an edition binding are folded, assembled, stitched, and completed automatically along one continuous production line. Working in this manner, one operator keeps the production line operating by ensuring that the feed bins along the line are continuously filled.

Figure 10.47 A–C. Gathering and assembling signatures in an automated production line. (Courtesy SIRS, Inc.)

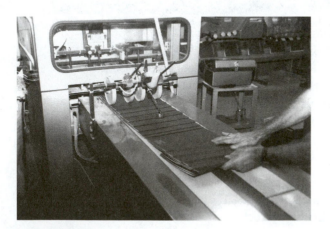

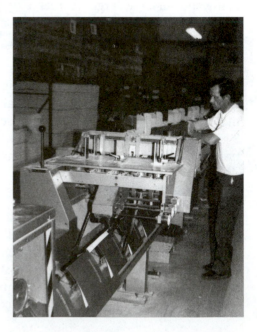

PERFECT BINDING

Perfect binding is a padding type of binding process. In perfect binding, the spine of the book is first trimmed and then inserted into a binding machine where a special flexible binding adhesive is heated and applied to the book spine. A perfect binding machine of this type is shown in Figure 10.48.

Figure 10.48. Perfect binding machine (Courtesy Rosback, Inc.).

Perfect binding is fast, durable, and inexpensive. Typical perfect binding machines can bind about 150 books per hour. The phone book and Yellow Pages are examples of perfect-bound documents and hold up well under rough and abusive treatment. For small perfect binding jobs and making pads, tabletop padding presses can also be used.

PLASTIC BINDING

Plastic binding is a popular method for binding small reports, presentations, and similar documents. The plastic binding combs come in a variety of colors and sizes, depending upon the thickness of the document or pamphlet to be bound. A small office-sized binding system includes a machine for punching the holes as well as a unit to insert the plastic combs into the document after the holes have been punched (Figure 10.49).

Figure 10.49. Small office plastic binding machine (Courtesy General Binding Corporation.

369

The holes that are punched in this system are rectangular and match the shape of the plastic binding combs. For small short-run jobs, manual hole punching is generally used. For larger jobs, however, an automatic hole puncher is usually required. In Figure 10.50, the pamphlets to be bound are stacked up and automatically fed into the punching unit. After the holes have been punched, the plastic binding combs are manually inserted into each document (Figure 10.51).

Figure 10.50. Automatic hole-punching machine used in plastic binding (Courtesy General Binding Corporation).

SIDE AND SADDLE STITCHING

Of all the ways to put two or more pieces of paper together, stapling is still probably the simplest and cheapest method available. Stapling a document through its side (side stitching) or stapling a signature through the center fold (saddle stitching) continues to be a primary binding technique. Stitching machines are available for either manual or automatic stitching operations. Small elec-

Figure 10.51. Inserting plastic binding combs into a pamphlet (Courtesy General Binding Corporation).

trically operated stitchers can perform both side and saddle stitching operations on pamphlets and books up to about ¼-inch thick. Larger and thicker documents require a heavy-duty stitching machine like the one shown in Figure 10.52.

Integrated machines such as the unit pictured in Figure 10.53 combine the functions of many machines, including folding, scoring, perforating, collating, and stitching, in one bindery production unit. These systems are used in integrated printing plants that require complete bindery operations in addition to the normal printing functions.

Figure 10.52. Heavy-duty stitching machine used for sewing edition bindings (Courtesy Rosback, Inc.).

Figure 10.53.
Integrated system combining all bindery functions into one machine (Courtesy Rosback, Inc.).

ENVIRONMENTAL SAFETY CONSIDERATIONS FOR OFFSET PRINTING

Environmental safety should always be the first consideration in the workplace. Numerous improvements in both products and technology continue to have a major influence on all facets of the graphic arts industry. The federal Occupational Safety and Health Administration (OSHA) is responsible for setting and enforcing safety guidelines in the workplace. OSHA makes regular inspections of all workplaces to ensure safety code compliance, and has enforcement powers that range from fines to plant lock-outs for regulation noncompliance.

Environmental considerations fall into several major categories that all graphic designers and printing technicians should be aware of: noise levels, odor, indoor and outdoor air pollution, chemical safety, and hazardous waste management. These areas are not mutually exclusive and there is often a great deal of overlap between them.

NOISE LEVELS

Whereas graphic design studios are generally quiet, almost everything in a pressroom makes noise. The standard unit of noise measurement is the decibel. One decibel (dB) is the amount of sound barely audible to the human ear. An increase of 10 decibels indicates a doubling of sound intensity. Continued and regular exposure to sound intensities of 90 decibels will eventually cause hearing loss, and exposure to sound levels of 130 decibels can cause immediate and permanent hearing loss. Presses and folding equipment are major contributors to noise pollution. If the workplace has consistent levels of 85 dBs, then all workers must be tested with audiometers on a regular basis. If exceptionally high noise levels are suspected, the workplace should be tested and appropriate actions taken to minimize worker exposure in these areas.

CHEMICAL SAFETY

People working within a print shop are continually exposed to potential health threats from the chemical compounds in printing inks, solvents, darkroom chemicals, and other cleaning solvents. The Hazard Communications Standard of OSHA requires that management keep all workers informed of proper methods for the handling, use, and storage of hazardous chemicals. This includes a responsibility on the part of management to maintain a current inventory of all chemicals and to generate a written policy statement and list of procedures to follow when using those specific chemicals.

All chemicals must be properly labeled, with the appropriate material safety data sheets on file. The material safety data sheet for a specific product is divided into separate sections which contain the following information:

- The manufacturer's name and address
- The hazardous ingredients of the product

- Physical data, including boiling point, percentage of volatile compounds, etc.
- Fire and explosion information
- Health hazard data concerning inhalation, skin contact, etc.
- Reactivity data concerning the stability of the material
- Spill and leak procedures to be followed
- Special protection information regarding ventilation requirements, exhaust, and general mechanical requirements
- Special precautions to be taken concerning storage and handling
- Cautionary information regarding empty containers and chemical emergencies
- Shipping data
- Miscellaneous product and safety data

INDOOR AIR POLLUTION

Indoor air pollution is on the increase as commercial buildings continue to become more energy-efficient. The energy conservation features that allow buildings to minimize heat loss also cut down on the number of normal exchanges between inside and outside air. Whereas conventional building construction would allow five or more complete air exchanges in a building each hour, highly energy-efficient construction often cuts this air exchange down to fewer than one or two per hour. Under these conditions, odors and fumes can accumulate inside the building.

OSHA has established guidelines that list the upper limits in parts per million (ppm) for many pollutants. The higher the upper limit for a particular substance, the less hazardous it is. Also, the guidelines specify which vapors must be exhausted to the outside air from within the workplace.

Because individual reactions to any substance will vary, both material safety data sheets and written procedures for dealing with problems should be posted and known to all employees and management personnel.

HAZARDOUS WASTE MANAGEMENT

Every chemical that enters the printing plant must eventually leave in one form or another. If the chemical does not become part of the printed product or leave as a vapor, it becomes waste material that must be dealt with. The Environmental Protection Agency (EPA) lists four characteristics, any of which qualify a substance as hazardous waste:

- A liquid having a flash point of less than 140°F. The *flash point* is the lowest temperature at which a substance will ignite when exposed to an open flame.

- A substance deemed to be corrosive, with a pH of less than 2.0 or greater than 12.5.

- Unstable, potentially reactive products.

- Toxic substances.

After any of the chemicals that fit these above guidelines have been used, they must be labeled, stored, and disposed of in a manner approved by the EPA.

Most print shops now follow two basic philosophies regarding hazardous waste:

- If it is not used or made, it need not be disposed of.

- Once generated, hazardous waste must be stored and disposed of in the proper manner.

Also, alternate chemicals and materials, such as soy-based printing inks, water-based plate processing systems, and fountain solutions that do not contain alcohol, are presently available and can greatly reduce the amount of toxic material generated by a print shop. Many new materials designed to reduce the amount of toxic and hazardous waste are continually being developed to maximize worker safety.

SUMMARY

The actual process of offset printing, though familiar to most graphic arts and printing technology students, is often foreign to many graphic designers and artists. Based on the oil-and-water principle, roller configurations and press cylinder designs all influence the quality of the final printed piece.

The material in this chapter serves as a preparation for beginning experiences in offset printing. Knowing how to set up the paper feed, ink, and dampening systems on an offset press enables the student to take those first hesitant steps into the fascinating world of watching a graphic design become a reality.

All the processes covered in this chapter, from press configuration to finishing operations and binding techniques, enable the designer or printing technician to communicate across traditional work boundaries. This facilitates the entire production process from initial design to the finished printed product.

Chapter

Designing for Production

Hot Dog or Hamburger **Silver Medal Rolls**	12-oz. pkg.	**.99**	Any Variety, Ice Cream **Kobbler Cones**	1.5 to 5-oz. pkg.	**1**⁹⁹
Specialty **Dessert Shells**	4-oz. pkg.	**.99**	Plus Deposit Where Required **Coksi 3-Liter**	**2** btls.	**$3**
Any Variety Reg. or Mini **Yahara Pita Bread**	8-oz. pkg.	**.99**	Vanilla, Chocolate or Strawberry **Wafer Cookies**	6.2 oz. bags	**1**⁹⁹
Any Variety **Cheese Wads**	24-oz. pkg.	**.99**	You Know–For Kids **JuiceUP**	**4** pack	**$2**⁴⁹
12 pack **HighLife German Muffins**	24-oz. pkg.	**1**²⁹	6.5 to 7-oz box Any Variety **Kobbler Eat'Ems**		**1**⁶⁹

INTRODUCTION

This chapter is an in-depth study of several common graphic design jobs, explaining the special characteristics of each. We begin with a brief review of the graphic design process emphasized throughout this text and then address the following areas: logo design, newsletter design, advertising design, and catalog design. Each area focuses on particulars relating to the individual topic and the decisions made by designers in choosing the best means of communicating their clients' messages.

GRAPHIC DESIGN PROCESS APPLIED

The process of graphic design problem-solving was addressed at length in chapter 4. In review, the process is a series of steps to assure that your design will satisfy both your client's needs and your own creativity. The basic steps include defining the problem; developing and setting up a budget and schedule; gathering information; creating several ideas from thumbnail sketches to final comps; presenting your ideas to the client; evaluating those ideas with the client; making necessary changes; producing the design; and making a final evaluation of the design project. By following this process in any design project, you build in ways to check your progress and evaluate your work. It is recommended that the design process be used in the following examples, although we will not list all of the steps here.

DESIGNING LOGOTYPES

Logo design is usually the first project that young designers attempt. Whether given as an assignment in high school or done for a friend's band, a logo is an important design element. It functions as a simple visual reminder of the group it represents. Logo design has been covered extensively in the history of graphic design, from the beginning of civilization, and continues to be one of the major areas in which graphic designers work today.

When creating a logo, it is important for the designer to remember that the image will be used in various applications, from business cards to (possibly) the tails of airplanes. Therefore, the designer must create an adaptable design, one that looks good whether reproduced at one-half inch or ten feet across. Most good logos are kept simple so that detail will not get lost by scaling the logo. Figure 11.1 shows an example of how a well-designed logo will reproduce at various sizes without losing its impact.

There are two basic kinds of logos: image-based and typographic. Each type has its own unique characteristics, and both kinds may be used with one another in a single design.

IMAGE-BASED LOGOS

Image-based logos can be broken into three categories: pictograms, ideograms, and abstract logos. Each has its own special characteristics, and some logos may fit into more than one category at a time.

PICTOGRAM LOGOS

Although pictograms date back to early cave drawings, it is unlikely that they were used for advertising at that time. Rather, they were a way for early humans to communicate with one another. Pictograms were often part of ritual celebrations.

A *pictogram* is a simple representation of any single thing—be it an animal, the sun, or an object such as a tool. This basic representation gives a direct interpretation of the design.

Figure 11.1. A well-designed logo scaled to many sizes retains its identity.

When choosing a pictogram logo, it is important to ensure that the chosen image will represent an organization in a positive light and that the image directly relates to the company. For example, if you are creating a logo for a company that only deals in one item, such as a publishing company that produces books, a logo with a book would be appropriate. The pictogram is widely used today; two examples are shown in Figure 11.2.

IDEOGRAM LOGOS

The *ideogram logo* is an image that represents an idea, illustrated through the use of a picture. The typographic symbol "$" is not a picture of the American dollar, yet it is immediately recognized as representing it.

Ideogram logos are more difficult to design than pictograms, because each person will not necessarily read the ideographic image in the same way. It is important, therefore, to do more research in the design and presentation stages of projects that involve ideograms.

A good example of a current ideogram logo is the one for AT&T (Figure 11.3). Designed to represent lines of communication encircling the globe, the logo uses the visual imagery of a sphere with lines across it. The sphere does not read as the earth directly, but the abstract elements are used to imply a larger idea.

Figure 11.2. Examples of pictogram logos.

ABSTRACT LOGOS

Once businesses moved into a corporate structure where many different kinds of businesses were owned by a larger concern, designers found it harder to use pictograms to represent the larger corporation. One single image could not represent a corporation whose subsidiaries might include the manufacture of foodstuffs, clothing, movies, and communications, for example. Abstract logos could be created to give the corporation a dynamic look, though not featuring the image or idea of any single product.

Figure 11.3. Logo for AT&T. (Courtesy American Telephone & Telegraph Co.)

Figure 11.4 shows two abstract logos. Note how simple design elements are combined in unique ways to create these logo designs.

Although abstract logos are the most common type in use today, the root of their design is not always pure abstraction. In some cases, the designer will take an image and abstract it. In Figure 11.5, two logos are shown where images have been abstracted. In the Ace logo for a visual arts organization, an abstracted eye becomes the centerpiece

Figure 11.4. Abstract logos work best when created from basic geometric elements.

of the design. In the Rocklin Opticians logo, a pair of eyeglasses is represented in a simple line drawing to act as a complement to the type.

Figure 11.5. An abstracted image logo.

381

TYPOGRAPHIC LOGOS

Often a designer will choose not to use an image logo at all, but to design a logo by creating a unique version of the company's name (Figure 11.6). These typographic logos communicate the name of the company as the most important feature.

When designing a typographic logo, the designer must find a typeface that will capture the personality of the company. This can be done either by creating the type from scratch or by modifying an existing typeface. The designer should not simply take a readily available typeface and set it straight, as such a logo would be too easy to reproduce by others on a computer. An existing typeface should be modified so that it can be used only in its modified form (Figure 11.7). This can be scanned or saved as an EPS file for use by others at the company.

RENNSPORT MOTOR WORKS
Service • Modifications on BMWs and other fine cars

Figure 11.6. Typographic logos.

ATLAS
Original type

ATLAS
Modified type as logo

Figure 11.7. Creating a logo through modification of an existing typeface.

382

LOGO PRODUCTION

The final production of logos is done either on a computer or by hand. Logos created on the computer are done using a drawing program such as Adobe Illustrator, where the final design can be saved as a separate file and given to the client. Type used in such a way should always be converted to outlines, as the client's company may not have the needed font loaded on its computer. Hand-drawing may be necessary if you are creating unique lettering or flowing lines, neither of which can be done easily on the computer. Many hand-lettered logos are scanned and digitized so they can easily be placed in other documents and scaled to size quickly.

DESIGNING EFFECTIVE NEWSLETTERS

Newsletters are typically in-house publications for companies and special-interest groups, created to disseminate information to a certain group of people. They may range in size from a single sheet to a multiple-page document. Most often they have to be created on a small budget and are published on a regular basis. Because of this, the designer must create a flexible layout that can be quickly produced with each new edition. Many designers produce the initial structure, or format, for the magazine and have someone else change the information each time.

WHAT SHOULD BE INCLUDED

Items to include in a newsletter vary according to content, but the same design elements are used in most newsletters. The following paragraphs review some of the most important elements.

GRID STRUCTURES

The starting point in the design of a newsletter is the development of a grid system. With this grid, you will set up the number of columns, width between columns, and margins. Any repeating elements, such

as page numbers, volume number, and date, are also positioned at this time.

A first step in the design process is to find out how much copy will have to be set for each issue. This information will help to determine how many pages will be needed. At the same time, a tentative budget should be made up. Find out how many copies are to be printed and get estimates to find out how many pages and what kind of printing the client can afford.

Once it has been determined what you will be able to produce, based on the budget, use the proper paper size for the newsletter to begin the grid design.

The first step in creating the grid is determining the page margins. *Margins* are the space left on the top and bottom, left and right sides of the page. If you are creating a multiple-page newsletter, the margins usually mirror themselves across a spread. Elements such as the page number, issue date, and volume number may be placed in the margins. These usually also mirror their positions across a spread, as shown in Figure 11.8.

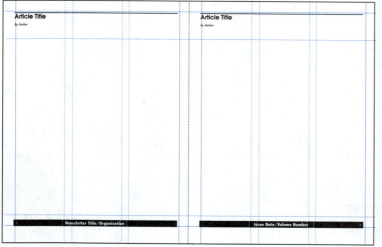

Figure 11.8. A grid design for a two-page spread.

Grid columns help in placing text. The most important decision in creating columns is the amount of the space between columns, referred to as the *gutter*. Too little space does not provide enough of a visual break when reading. If a narrow space must be used, a break can be created by the use of a vertical rule, as shown in Figure 11.9. Too much space will create a visual separation between columns, resulting in copy that appears to be disconnected and not part of the same story, as in Figure 11.10.

Figure 11.9. Use of a vertical rule to divide two columns.

consectetuer sed ea adip iscing elit, sed diam ad nonummy nibh euis mod tincidunt ut laoreet dolore magna aliquam erat wisi volut pat. Ut wisi enim ad minim veniam, quis nos trud exerci tation ullam corper suscipit lob ortis nisl ut ea aliquip ex ea commodo fihn si dolos | toinummy nibh euis mod tincidunt ut laoreet dolore magna aliquam erat wisi volut pat. Ut wisi enim ad minim veniam, quis nos trud exerci tation ullam corper suscipit lob ortis nisl ut tation ullam corper suscipit lob ortis ea aliquip ex eal ullam corper suscipit lob ortis .

Figure 11.10. Too much space between columns results in a visual break that disassociates the two columns.

consectetuer sed ea adip iscing elit, sed diam ad nonummy nibh euis mod tincidunt ut laoreet dolore magna aliquam erat wisi volut pat. Ut wisi enim ad minim veniam, quis nos trud exerci tation ullam corper suscipit lob ortis nisl ut ea aliquip ex ea commodo fihn si dolos

toinummy nibh euis mod tincidunt ut laoreet dolore magna aliquam erat wisi volut pat. Ut wisi enim ad minim veniam, quis nos trud exerci tation ullam corper suscipit lob ortis nisl ut tation ullam corper suscipit lob ortis ea aliquip ex eal ullam corper suscipit lob ortis .

A good grid will provide flexibility for many successive layouts. For example, even though you may be using only a two-column format for most text, by creating a four-column grid you build in additional ways in which the grid can be used. This allows for flexibility in picture placement. Figure 11.11 shows several layouts created from the same four-column grid.

Figure 11.11. Various layouts created from a four-column grid design.

MASTHEAD

The *masthead*—the name of the newsletter—is positioned on the first page. It is either designed by you or provided by the client. The masthead creates a personality for the newsletter and although its position on the page may vary, as seen in Figure 11.12, it is the highest priority element on the first page. The masthead may be just a name, but usually also includes a line of explanation, such as "The Newsletter of the (name of organization)." The masthead tells the reader what the newsletter is about.

Figure 11.12. Two examples of masthead layouts.

Designing a masthead is like designing a typographic logo. It should have its own unique character and communicate the personality of the organization.

TEXT, HEADINGS, AND SUBHEADINGS

After the grid design has been completed, some thought should be given to the type that will fill it. Text type should be chosen so that varying amounts of copy will fit in from issue to issue and still be easy to read. After receiving the copy for the first issue, try setting it in several different typefaces to see not only how it looks, but

also how much room the copy set in each typeface requires. When it has been set, you will be surprised to see that some typefaces take up much more room than others, given the same amount of original copy!

Once the text type has been chosen, the type for headings and subheadings is selected. This type is normally bolder than the text in order to stand out from it. Often, designers use a bolder version of the text font for headings, but other times a different font is chosen to contrast with the text. Figure 11.13 illustrates examples of both approaches.

Subhead

In this example, the subhead typeface is a heavier weight of the text face. In treating the subhead in this way, the type family remains the same and the style of the design fits together seamlessly. Here, it would make sense to continue using the same family for italics, bold weights, etc.

Subhead

Here, a contrasting san serif typeface is used to contrast the text. This calls more attention to the subhead, and gives it a different feeling than in the example on the left. It would still be best to use the same family of text for italics, bold weights, etc., which appear in the text.

Figure 11.13. Two approaches to subheadings.

For headings, experiment with the size of the type as well as the font. Depending on the length of the titles, it may be necessary to use a more condensed font than that used for text, so that the titles will fit properly in the space available.

BOXES, SHADING, TINTS, AND CONTRASTING ELEMENTS

Articles such as charts and sidebars must be separated from the main text. There are various methods by which to do this. An outlined or shaded box will help to separate specific text, even though it is in the same font as the body copy. When using color, the shading can be made into a tint of color to separate the box.

Another way to separate one text element from another is through the use of a contrasting typeface or setting. In the example in Figure 11.14, text has been separated by using different sizes and weights. In Figure 11.15, the text is separated by the use of different line spacing.

This text copy is set in 12 point Goudy. Leading has been set at 14 point. In this example, you can see that although the text and sidebar column are relatively close together, the size and weight differences between the text and the sidebar help to separate them. The sidebar in this case stands out from the text and becomes a dominant feature in the design.

This column has been separated from the text by use of a bolder weight of the text face Goudy. The size has also been increased to 14 point to make it stand out from the text.

Figure 11.14. Text separated by size and weight.

Here, the text copy is also set in 12 point Goudy. Leading has been set at 14 point. Once again, the sidebar is relatively close, but the change in leading separates the text from the sidebar. In this example the sidebar does not become as dominant a feature as in figure 11.14, but functions as a supplemental feature to the text.

The text in this column is the same as the text—12 point Goudy. The column has been separated from the text by use of a larger amount of leading—20 points.

Figure 11.15. Text separated by different leading.

ARTWORK

Artwork (photographs or illustrations) may be placed on the page in several ways. To maintain a strict grid, artwork can be placed to align directly to the grid (Figure 11.16). For a more informal look, text can be made to flow around the image, as displayed in Figure 11.17. Many times a designer will combine both techniques in the same piece.

Figure 11.16. Artwork aligned to the grid.

Figure 11.17. Text flowing around an image.

Less important images can be screened into the background with text flowing over them, as in Figure 11.18 (when choosing to do this, be careful not to make the image too dark, or it will be difficult to read the text over it). Also, remember that the image will function more as an effect than by showing any detail. If the image has to be shown in detail, it may be possible to place the full image on the page and use a portion of it as a background screen (Figure 11.19).

Figure 11.18. A screened background image.

Figure 11.19. Use of a repeated image for a background screen.

It is very important to include a credit line for the photographer or illustrator of each image. There are several ways to do this. Among the most popular is placing the name in small type along the side of an image, along the bottom of the page, or in the page gutter (the meeting point of two pages in a spread). Also, credits can be listed on one of the back pages of the newsletter.

WHITE SPACE

In any page layout, it is crucial to balance the text with white space. This allows the reader a visual break and can help to balance a composition. In Figure 11.20, two examples of a newsletter layout are shown. In the one on the left, very little white space was left. In the one on the right, white space was used to balance the composition. Which one would you rather read?

Figure 11.20. Use of white space in two contrasting layouts.

NEWSLETTER PRODUCTION

Newsletter production has become much easier with the advent of the computer and page layout programs such as QuarkXPress and Adobe PageMaker. In these programs, it is a simple job to set up a grid or template and place text and illustrations. The computer also allows changes to be made quickly when needed.

Extra care in proofing the newsletter for typographic errors must be taken, as it will often be the designer's responsibility to make sure the final job is correct before sending it to the printer.

DESIGNING DISPLAY ADVERTISING

Newspaper and other display ads make up a large part of a small design studio's work. They are quick to produce, and because many businesses need to run them weekly or monthly with only slight changes, display ad work is often steady repeat business.

Although display ads vary from business to business, some of the most commonly used elements and options are presented here.

BASIC ELEMENTS

Most display ads contain information about the business, such as the logo, address, telephone number, and business hours. Also, one or more featured items may appear in the ad, such as goods on sale or new items in stock.

Figure 11.21 displays a promotional ad for an eyeglass store. In it, the logo is featured at the top, with a line of copy about the store. This is a fairly simple ad to produce.

CALLOUTS, ARTWORK, PRICES, AND WHITE SPACE

Ads usually contain elements such as photographs of the products advertised, prices for each item, and callouts for item information. Balancing these elements within the given space can be a challenge for even an experienced designer. It is important to prioritize these elements to create a design that makes efficient use of the space, allowing enough white space to prevent the ad from becoming too cluttered.

Figure 11.22 shows an ad for a supermarket. In this instance, the designer must prioritize the different elements so that each item is readable. This ad is more of a design challenge because the various items are competing for the reader's attention. Notice how the typography helps to separate the items and prices from one another.

Figure 11.21. A newspaper promotional display ad.

Hot Dog or Hamburger **Silver Medal Rolls** 12-oz. pkg.	**.99**	Any Variety, Ice Cream **Kobbler Cones** 1.5 to 5-oz. pkg.	**1**⁹⁹
Specialty **Dessert Shells** 4-oz. pkg.	**.99**	Plus Deposit Where Required **Coksi 3-Liter**	**2** btls. **$3**
Any Variety Reg. or Mini **Yahara Pita Bread** 8-oz. pkg.	**.99**	Vanilla, Chocolate or Strawberry **Wafer Cookies** 6.2 oz. bags	**1**⁹⁹
Any Variety **Cheese Wads** 24-oz. pkg.	**.99**	You Know—For Kids **JuiceUP**	**4** pack **$2**⁴⁹
12 pack **HighLife** **German Muffins** 24-oz. pkg.	**1**²⁹	6.5 to 7-oz box Any Variety **Kobbler** **Eat'Ems**	**1**⁶⁹

Figure 11.22. A complex advertisement.

LAYOUT OPTIONS, COLUMN DESIGNS

When creating an ad for a newspaper or magazine, the designer has to work strictly within the standards of that publication. Before beginning to design, the specifics of column width and total ad height must be known. Often clients will already be aware of these requirements, so ask them first. Newspapers charge for space by the column inch, so be sure to design your ad to fit within the client's budget.

When designing the ad, consider where it will be placed. If possible, pick up a copy of a previous edition of the publication to see what other ads are in the section in which your client will be advertising. This will help you to make design decisions that make your ad stand out from the other ads on the same page.

ADVERTISING PRODUCTION

The production of ads involves combining many different elements. It is important to work out design ideas through thumbnails and rough form to explore how these various elements will relate in the final ad. As production time for ads usually is limited, a computer can greatly assist in the process, and should be used for final layouts. For the most part, laser prints will be fine for final artwork to be reproduced in newspapers, due to the relatively low quality of newspaper printing.

For printing photographs, most newspapers use a large screen of around 65 to 100 lpi for best reproduction. Newsprint absorbs ink and finer screens will clog when printed, leaving blotches and other inconsistencies in the printed illustration.

DESIGNING CATALOGS

Designing a catalog is a complex task that involves the coordination of many different parts into a cohesive whole. Because of this, there are important design decisions to be made during the process.

WHAT SHOULD BE INCLUDED—CHOOSING A FORMAT

Like other design projects, the initial client meeting will help to determine many factors, including the type of catalog, what products will be featured, and the budget available for photography, illustration, and printings. Because catalogs are time-driven pieces, due dates for the finished design should be set at the initial meeting.

COMBINING TEXT AND GRAPHICS

In designing a catalog, the designer will be working with other professionals, and good communication with everyone involved in the project is necessary. The most important people in this group are the photographer and the copywriter, whose combined work will be the backbone of the design. Open communication with both of them is essential to prevent problems in getting all of the elements together on time.

The photographer is responsible, under your direction, to provide shots of all of the items to be displayed in the catalog. For a large catalog, this could mean choosing from hundreds of photographs. It is important that these photos have a consistency of color, lighting, and style, and it is the designer's responsibility to see that these prerequisites are met.

The copywriter will be working with the client on item descriptions and prices. This copy is subject to change at any time during the process. When designing a catalog, you must be prepared to make copy changes up until press time.

FORMAT CONSIDERATIONS

To keep the catalog design flowing smoothly, the designer should a develop flexible grid system in which to work. As explained in the newsletter section, catalog design also uses the grid as its foundation. Designing a grid that will adapt to the many different kinds of elements to be employed in the catalog will save you time later on in the process.

The designer needs to know whether the photographs will appear in boxes or be silhouetted. Silhouetted photos require a special set-up to make the silhouetting process easier, and this should be discussed with the photographer. The photographer should be given a rough comp of the catalog before shooting begins, so that each photo can be shot specifically for its placement within the catalog.

CATALOG PRODUCTION

The production of a catalog means dealing with all of the various elements and personnel discussed thus far. Although text and page layout may be accomplished through use of the computer, the quality of the reproduction from a desktop computer is not high enough for placement of color photographs, although computer output can be used on the layout for position only. Instead, photographic images, provided as 4 x 5-inch transparencies from the photographer to the printer, are used here. The transparencies are scanned on the printer's high-end equipment to the specifications of the rough layout.

When creating the rough layout on a computer, you can scan in a low-resolution version at 72 dpi for dis-

play and cropping purposes. This will save disk space, as the low-resolution scan will create a small file size. The use of these 72 dpi scans is referred to as *FPO,* or *for position only,* and will give the printer the necessary information on cropping and silhouetting. This information can be shown to the printer in a laser-printed version of the document. FPO files cannot be used for final output, of course, because of their low resolution. Figure 11.23 shows the quality of a 300 dpi scan compared to a 72 dpi FPO scan.

Scan 300 dpi Scan 72 dpi *FPO*

Figure 11.23. A 300 dpi scan compared to a 72 dpi FPO scan.

Another way of showing an FPO image is to paste a photocopy of the image, scaled and cropped, into a separate photocopy of the mechanicals. Whether scanned or photocopied into position, this dummy copy of the document provides the printers with the visual information they will need to produce the job accurately.

The final typographic layout of the catalog may be given to the printer on disk or provided as a series of mechanicals. Photographs and illustrations are given to the printer as the actual artwork or in photographic transparency format for scanning into the layout on high-end equipment. Today, catalogs are increasingly produced on CD-ROMs for distribution, rather than being printed in hard-copy form.

SUMMARY

In this chapter, we discussed many of the challenges each of these specific design jobs creates for the graphic designer. With a good understanding of the graphic design problem-solving model, you should be able to handle any production problems you will face as a graphic designer.

Final Thoughts

Computerization, coupled with the increasing globalization of commerce and individual access to virtually unlimited information, shapes our society and the world of work in a new and unique way. How does today's student deal with some of the trends that are emerging?

- A personal computer will, in all likelihood, be out of production within 12 to 18 months after its purchase and become technologically obsolete within the next 2 years.

- A software application program mastered by the graphic designer will most likely be replaced by an updated version of the same program, complete with new commands and options, within 2 years. These revisions, although usually built on previous software versions, may require considerable relearning of the program.

- Half of the technical information learned during an undergraduate education will be technologically obsolete within five years after graduation. This "half-life" of relevant information will continue to decrease in the coming years.

- The average person can be expected to change not only jobs, but also an entire career, every eight years.

- As graphic arts technology becomes increasingly affordable, jobs traditionally sourced out will increasingly be undertaken in-house. This trend will place new demands and responsibilities on personnel in both the design and production ends of the industry.

One solution to overcoming these obstacles is to approach subject content with an emphasis on core concepts to be learned and problems to be solved, rather than specific skills to be acquired, wherever appropriate. To this end, this text discusses, for example, how object-oriented graphic design programs function, rather than describing specific commands used to draw a circle or a square. Knowing what a computer program is doing is more important than mastering a specific skill. If you know the concept, the skill can be mastered in any program and on any operating platform.

What problems does the graphic designer face when approaching a client for this first time? Once these problems have been identified, benchmarks can be set up by the designer to help ensure successful completion of the job. Although the authors could offer a generic framework to follow in this regard, more learning takes place and problems are more successfully solved by identifying and discussing these highlights. This enables the designer to construct his or her own solution to a wide range of problems with a built-in flexibility not possible otherwise.

Neither has it been the intent of the authors to diminish the importance of acquisition and mastery of the skills necessary to create, design, and successfully print any project. This text devotes considerable time to the technical aspects of computer and photographic imaging, composition, and printing. The acquisition of any set of skills, however, must be framed within the overall context of technological advance and change. The reader need only think back to the venerable Linotype operator, a backbone of the graphic arts industry, whose job disappeared practically overnight with the introduction of the first-generation photographic and software-driven digital typesetting machines.

During the preparation of this text, many decisions were made regarding information that should be included and that which was best left to upper level curricula. Although sometimes difficult, the authors are confident that this text contains material that is appropriate for beginning students interested in graphic design and printing technology specifically and the graphic communication arts in general. We welcome any suggestions or comments that students and teachers care to share with us to improve this text in future editions.

Martin Greenwald and John Luttropp
Department of Fine Arts
Montclair State University
Upper Montclair, NJ 07043

E-Mail addresses:
luttropp@saturn.montclair.edu
greenwaldm@saturn.montclair.edu

Appendix I
Design Professional Organizations and Associations

American Center for Design
233 East Ontario St.
Chicago, IL 60611
312-787-2018

American Institute of Graphic Arts
164 5th Ave.
New York, NY 10010
1-800-548-1634

Art Directors Club of New York
250 Park Ave. South
New York, NY 10001
212-674-0500

Art Directors Club of Los Angeles
7080 Hollywood Blvd.
Los Angeles, CA 90028
231-465-8707

Graphic Artists Guild
11 West 20th St.
New York, NY 10011
212-463-7730

Graphic Arts Technical Foundation (GATF)
11 West 20th St.
New York, NY 10011
212-463-7730

Society of Environmental Graphic Designers
47 Third St.
Cambridge, MA 02141
617-577-8225

Society of Publication Designers
60 W. 42nd St.
New York, NY 10017
212-697-1246

Type Directors Club
60 E. 42nd St.
New York, NY 10165
212-983-6042

Appendix II
Suggested Readings

BOOKS

AIGA. Graphic Design: *A Career Guide and Educational Directory.* AIGA Press, 1993.

Aker, Sharon Zardetto. *The Mac Almanac.* Ziff-Davis Press, 1994.

Berger, John. *Ways of Seeing.* Penguin Books, 1972.

Bierut, Michael; William Drenttel, Steven Heller & D.K. Holland, ed. *Looking Closer: Critical Writings on Graphic Design.* Allworth Press, 1994.

Blackwell, Lewis. *20th Century Type.* Rizoli, 1992.

Gottschall, Edward M. *Typographic Communications Today*. MIT Press, 1989.

Graphic Artists Guild. *Handbook of Pricing & Ethical Guidelines*, Eighth Edition. Graphic Artists Guild, 1994.

Hollis, Richard. *Graphic Design: A Concise History.* Thames & Hudson Ltd., 1994.

Igarashi, Takenobu, & Diane Burns. *Designers on Mac.* Gingko Press, 1992.

Lupton, Ellen and Miller, J. Abbott. *Design Writing Research*, Kiosk, 1996.

Meggs, Philip B. *A History of Graphic Design*, Second Edition. Van Nostrand Reinhold, 1992.

Rand, Paul. *A Designer's Art.* Yale University Press, 1985.

Spiekermann, Erik, & E.M. Ginger. *Stop Stealing Sheep & Find Out How Type Works.* Adobe Press/Prentice Hall Computer Publishing, 1993.

PERIODICALS

Adobe Magazine
411 First Ave. S.
Seattle, WA 98104-2871

American Printer
Intertec Publishing
P.O. Box 12901
Overland Park, KS 66282-2901

Communication Arts
410 Sherman Ave.
P.O. Box 10300
Palo Alto, CA 94303

Emigré
4475 "D" St.
Sacramento, CA 95819

Eye
P.O. Box 1584
Birmingham, AL 35201-1584

Graphis
Graphis U.S. Inc.
141 Lexington Ave.
New York, NY 10016

How
1507 Dana Ave.
Cincinnati, OH 45207

ID
440 Park Ave. S.
Floor 14
New York, NY 10016

National Association of Desktop Publishers Journal
Desktop Publishing Institute
462 Old Boston Street
Topsfield, MA 01983-1232

Print
104 Fifth Ave.
New York, NY 10011

Publish Magazine
Integrated Media, Inc.
501 Second Street
San Francisco, CA 94107

Quick Printing
PTN Publishing Company
445 Broad Hollow Road
Melville, NY 11747

Step-by-Step Graphics
Dynamic Graphics, Inc.
6000 North Forest Park Dr.
Peoria, IL 61614

Tech Directions
Prakken Publications, Inc.
275 Metty Drive, Suite 1
PO Box 8623
Ann Arbor, MI 48107-8623

The Technology Teacher
International Technology Education Association
1914 Association Drive
Reston, VA 22091

U&lc
International Typeface Corporation
866 Second Ave.
New York, NY 10017

Wired
520 Third St.
Fourth Floor
San Francisco, CA 94107

X-Ray Magazine (for Quark Users)
X.Alt Publishing
530 Hampshire Street, Suite 401
San Francisco, CA 94110